Hajj

journey
to the heart
of Islam

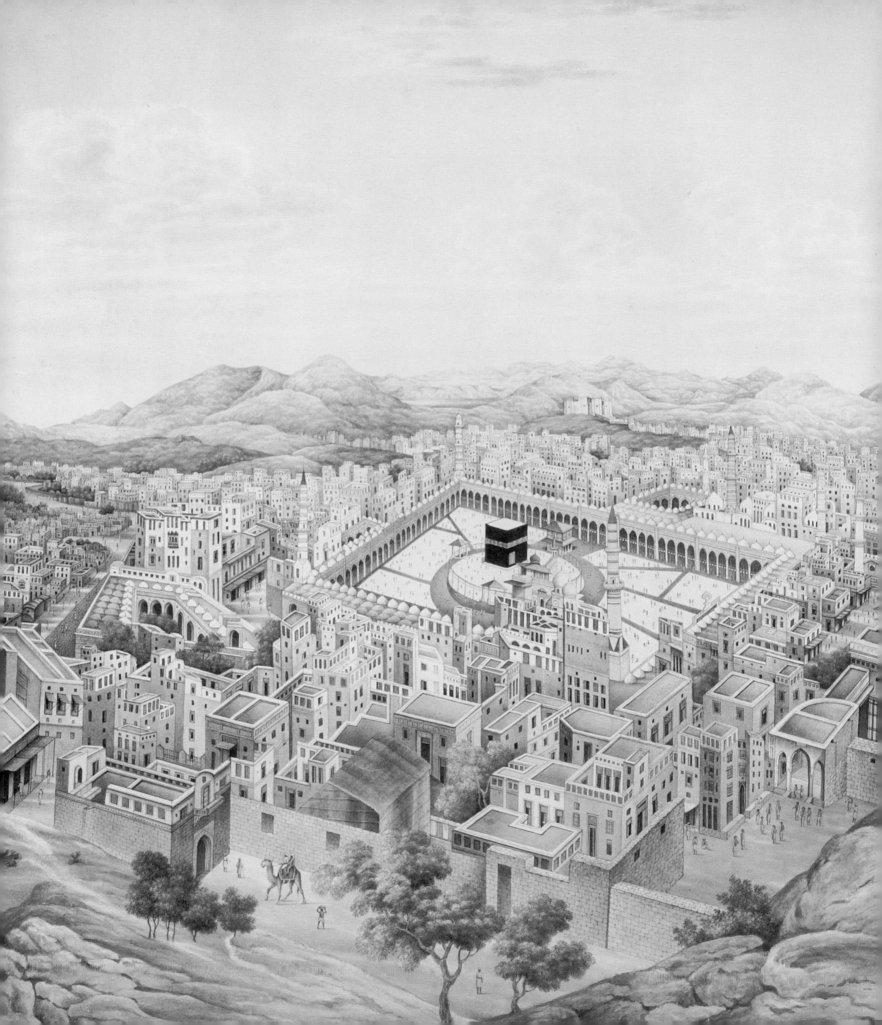

Hajj

journey
to the heart
of Islam

Edited by Venetia Porter

with

M.A.S. Abdel Haleem
Karen Armstrong
Robert Irwin
Hugh Kennedy
Ziauddin Sardar

THE BRITISH MUSEUM PRESS

This publication accompanies the exhibition *Hajj: journey to the heart of Islam* at the British Museum from 26 January to 15 April 2012.

This exhibition has been made possible by the provision of insurance through the Government Indemnity Scheme. The British Museum would like to thank the Department for Culture, Media and Arts Council England for providing and arranging this indemnity.

Research supported by the Arts and Humanities Research Council.

Arts & Humanities
Research Council

Venetia Porter, M.A.S. Abdel Haleem, Karen Armstrong, Robert Irwin, Hugh Kennedy and Ziauddin Sardar have asserted the right to be identified as the authors of the chapters listed on the Contents page opposite. Further contributors are listed on p. 7.

First published in 2012 by The British Museum Press
A division of The British Museum Company Ltd
38 Russell Square, London WC1B 3QQ
britishmuseum.org/publishing

A catalogue record for this book is available from the British Library

ISBN (cased) 978-0-7141-1176-6
ISBN (paperback) 978-0-7141-1175-9

Designed by Bobby Birchall, Bobby&Co.
Printed by Printer Trento S.r.l, in Italy.

The papers used in this book are recyclable products made from wood grown in well-managed forests and other controlled sources. The manufacturing processes conform to the environmental regulations of the country of origin.

FSC
www.fsc.org
MIX
Paper from
responsible sources
FSC® C015829

Half-title page:
Piece of Ka'ba curtain (detail) brought back from Mecca as a souvenir
Cotton, silk and gold thread
75 x 88.5 cm
Museum Volkenkunde, Leiden

Frontispiece
Panoramic view of Mecca (detail), *c.*1845 by Indian cartographer Muhammad Abdallah.
Ink and opaque watercolour on paper 62.8 x 88 cm
Nasser D. Khalili Collection of Islamic Art

Opposite
Pilgrimage certificate (detail), dated 836 AH/AD 1433
Coloured inks and gold on paper
212 x 28 cm
British Library, London

p. 6
Dala'il Khayrat, 'The signs of Benediction' by al-Jazuli (detail), with the tombs of the Prophet Muhammad and caliphs Abu Bakr and Umar, who are buried at Medina
Probably Patani Thailand, 19th century
European paper, pigment, gold leaf and ink
16 x 10.5 cm
National Library of Malaysia, Kuala Lumpur

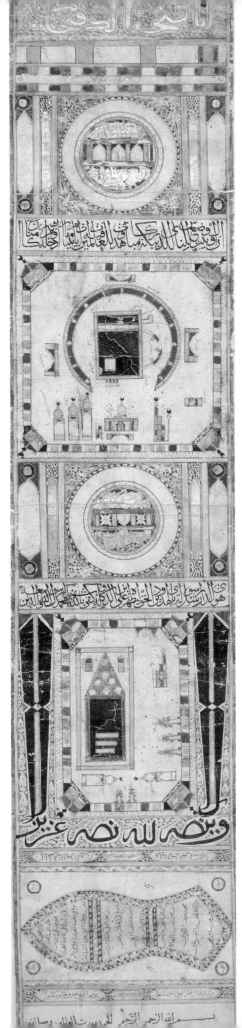

Contents

Contributors

Major contributions by:

M.A.S. Abdel Haleem
 King Fahd Professor of
 Islamic Studies
 School of Oriental and
 African Studies
 University of London

Karen Armstrong
 Independent scholar, London

Robert Irwin
 Independent scholar, London

Hugh Kennedy
 Professor of Arabic
 School of Oriental and
 African Studies
 University of London

Venetia Porter
 Curator of Islamic and Modern
 Middle Eastern Art
 The British Museum

Ziauddin Sardar
 Independent scholar, London

Additional contributions by:

Silke Ackermann
Anna Ballian
Peter Barber
Annabel Teh Gallop
Tim Insoll
Qaisra Khan
Charlotte Maury
Mina Moraitou
Nahla Nassar
Sam Nixon
Andrew Petersen
John Slight
Nina Swaep
Muhammad IsaWaley
Jan Just Witkam

Advisory Board:

Syed Mokhtar Albukhary
M.A.S. Abdel Haleem
Maqsood Ahmed
Aaqil Ahmed
Hamida Alireza
James Allan
Karen Armstrong
Doris Behrens-Abouseif
Ahmad al-Dubayan
Annabel Teh Gallop
Tim Insoll
Robert Irwin
Hugh Kennedy
David Khalili
Nahla Nassar
Andrew Petersen
James Piscatori
Saad Abdulaziz al-Rashid
Tim Stanley
Sali Shahsivari
John Slight
Sharaf Yamani

Lenders

Apart from the British Museum, the objects included in the exhibition *Hajj: journey to the heart of Islam* have been kindly loaned by a number of private and public collections and institutions. The British Museum would like to thank all the lenders for their generosity. Private lenders who wish to remain anonymous are not listed.

Peter Symes, Sydney, Australia
Museum of Islamic Art, Cairo, Egypt
Bibliothèque Nationale de France, Paris, France
Musée du Louvre, Paris, France
Galerie Christian Nagel, Berlin, Germany
Benaki Museum, Athens, Greece
Chester Beatty Library, Dublin, Ireland
Museum of Islamic Art, Kuala Lumpur, Malaysia
National Library of Malaysia, Kuala Lumpur, Malaysia
Institut des Sciences Humaines, Bamako, Mali
Mamma Haidara Library, Timbuktu, Mali
Tropenmuseum, Amsterdam, Netherlands
Leiden University Library, Leiden, Netherlands
Museum Volkenkunde, Leiden, Netherlands
Museum of Islamic Art, MIA, Doha, Qatar
Mohammed A. Hafiz, Jedda, Saudi Arabia
King Abdulaziz Public Library, Riyadh, Saudi Arabia
National Museum of Saudi Arabia, Riyadh, Saudi Arabia
King Saud University Museum, Riyadh, Saudi Arabia

Dar al-Kiswa, Mecca, Saudi Arabia
Aga Khan Collection, Geneva, Switzerland
Mohamed Ali Foundation, from the archives of the Khedive Abbas Hilmi II deposited at Durham University Library, Durham, UK
Edinburgh University Library, Edinburgh, UK
Angus Sladen, Estate of Lady Evelyn Cobbold, London, UK
Arcadian Library, London, UK
The British Library, London, UK
Edge of Arabia Gallery, London, UK
Joss Graham, London, UK
The Khalili Family Trust (Nasser D. Khalili Collection of Islamic Art), London, UK
Dr & Mrs Nurmohamed, London, UK
Royal Geographical Society, London, UK
Victoria and Albert Museum, London, UK
Victoria Miro Gallery, London, UK
Ashmolean Museum, Oxford, UK
Bodleian Library, Oxford, UK
Lady Bullard, Oxford, UK
Museum of the History of Science, Oxford, UK
Thomas Cook Archives, Peterborough, UK
Harvard Art Museums, Cambridge, MA, USA

Forewords

The King Abdulaziz Public Library is pleased to be coordinating the Kingdom of Saudi Arabia's participation in this unique exhibition about the Hajj at the British Museum.

Saudi Arabia takes its responsibility towards the ten million Muslims who perform the Hajj and Umrah pilgrimages annually with the utmost seriousness and care. Pilgrims come from every corner of our world and the three million on Hajj represent the greatest peaceful gathering on earth. *Makkah Almukarrama-Saudi Arabia* is the cradle of Islam, and the *qiblah* of more than 1.6 billion Muslims who turn to it five times daily during prayer. The Kingdom aims to offer pilgrims the highest quality of hospitality and continues to develop the holy places of Makkah and Medinah in order to improve services for these guests of God. Saudi Arabia believes service to pilgrims is an honour, a trust, and a responsibility.

We hope that this exhibition will be a source of inspiration and enlightenment for all who visit it.

Faisal bin Muammar
General Supervisor
King Abdulaziz Public Library, Riyadh

We are pleased to support the British Museum exhibition *Hajj: journey to the heart of Islam.* Hajj is a momentous event in the lives of Muslims, a pilgrimage many undertake from all corners of the globe. We hope that everyone who experiences this exhibition will leave with a greater understanding of the history, power and importance of the journey and of the people who make it.

Mukhtar Hussain
Global CEO HSBC Amanah & CEO HSBC Malaysia

HSBC Amanah has supported the exhibition's international reach outside the Kingdom of Saudi Arabia.

Understanding Hajj is integral to an understanding of Islam. Every Muslim aspires to make that journey. It is one of the five pillars of Islam. But it is the only one which non-Muslims can neither observe nor take part in. It is important therefore to find other ways to explore that experience and to understand what it means to Muslims now, and what it has meant through the centuries. That is the purpose of this exhibition. For the British Museum, which has had objects from the Islamic world in its collection since its foundation in 1753, an exhibition on this subject fits with our guiding principle of using objects and the forum of an exhibition to try to understand the complex world in which we live. To evoke and explain this remarkable annual gathering of Muslims across time and across the globe we have drawn together objects from key public and private collections. These help us to tell the story of that spiritual journey and to convey the intensity of this collective but also very private act of faith.

We are most indebted to HRH Prince Mohammed bin Nawaf Al Saud, Ambassador of the Kingdom of Saudi Arabia at the Court of St James, for guidance and encouragement. This exhibition is the result of a close and happy co-operation between the British Museum and the King Abdulaziz Public Library. We are grateful to our colleagues there for their unstinting help.

It would not have been possible to put on an exhibition of this kind without the generous support of HSBC Amanah who have shared our vision. I am also most grateful to the AHRC who have helped us carry out the research needed to underpin the exhibition and to our many lenders, particularly the Khalili Family Trust.

The Museum and its partners hope that this exhibition will introduce the subject of Hajj to those for whom it is unfamiliar and present it afresh to Muslims who know it better than anyone else.

Neil MacGregor
Director, The British Museum

Preface and Acknowledgements

Preface

Hajj: Journey to the heart of Islam is an exhibition that tells the story of the phenomenon of the Hajj, unique among world religions, from its beginnings until the present day. This book was conceived as a companion to the exhibition rather than a conventional catalogue. Our intention has been to gather the history, the voices of pilgrims and the material culture associated with Hajj together in one place. We felt this was greatly needed because the story of Hajj crosses so many very different disciplines, from religion, history and archaeology to anthropology, travel and art history, each of which often forms the subject of self-contained publications. We therefore brought together a group of distinguished scholars who themselves take us on a journey and help us delve deeper into the subject. Karen Armstrong invites us to look at Hajj within a broader context of pilgrimage; M.A.S. Abdel Haleem explains the rituals of Hajj and their meaning and also gives us an insight into the experience of a Hajji in rural Egypt. Hugh Kennedy explores the history of the Hajj in early Islam and then focuses on two key travellers, Nasir-i Khusraw and Ibn Jubayr, whose fascinating accounts provide such insight not only into the practicalities of the journey but the deeper meaning of why they undertook it. When you compare the writings of these early pilgrims with those of today it is clear that, although the method of travel and Mecca itself may have changed over time, the act of pilgrimage – that need to touch the holy place, the reactions to seeing the Ka'ba at Mecca for the first time – have not changed at all. Robert Irwin picks up the history in the thirteenth century and, in a veritable *tour d'horizon*, he introduces us to more travellers and tells the story of Hajj during the Mamluk and Ottoman periods, through into colonial times and up to the twentieth century. It then falls to Ziauddin Sardar to bring us up to the present day: he looks at how the enormous growth in numbers has changed Hajj in the modern era and demonstrates how it is organized today.

Running in parallel with the history of Hajj is the story of the material culture that surrounds it, whether paintings evoking the journey; archaeological finds from the Hajj routes; manuscripts, historic photographs and tiles illustrating the holy sanctuaries at Mecca and Medina; certificates and pilgrim guides commemorating the experience; or scientific instruments for determining the direction of Mecca. In addition, there are the objects taken by pilgrims on Hajj or brought back as souvenirs, and the beautiful textiles made annually especially for the Ka'ba. The works of photography, painting and sculpture by contemporary artists add a further dimension to the art of Hajj. All of these complement and personalize the history, allowing us to glimpse the experience through individuals, deepen our understanding and see how art has been used in the service of Islam. These objects, many of which are included in the exhibition, are illustrated throughout the book; some are highlighted in themed spreads on subjects such as 'sacred geography', the tiles of Mecca and Medina, the Futuh al-Haramayn manuscripts and the sacred textiles. There is also a focus on particular Hajj routes, with detailed maps: across Africa, from Syria and Cairo, and that remarkable endeavour, the Hijaz Railway.

Endmatter and conventions

At the end of the book is an extensive bibliography of works cited in the text and some further reading. The travellers' narratives are treated separately and have their own section. The objects that also feature in the exhibition are listed at the end, with publication details where relevant.

As regards the spellings of Arabic words. We have opted for simplicity. The only transliteration is for the letter '*ayn* and the *hamza* where they occur in the middle of a word (as in Ka'ba or Qur'an). Dates are given in AD form unless otherwise noted. For the translations from the Qur'an, we have generally used the translation by M.A.S. Abdel Haleem.

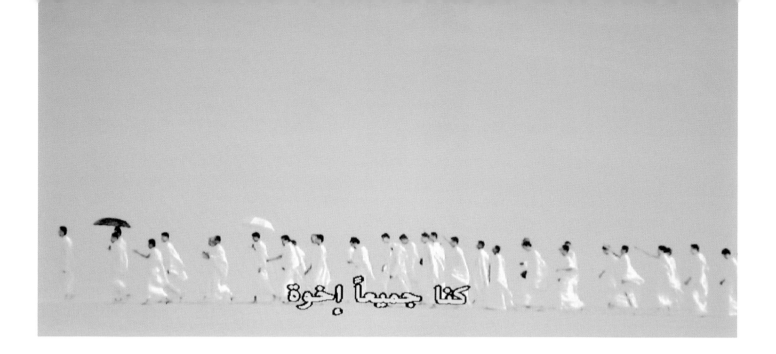

We were all brothers, 2010
Ayman Yossri Daydban
Lightbox 1/3
77.5 x 153 cm
Mohammad A. Hafiz

Ayman Yossri has captured this scene from a film about Malcolm X (d. 1965) which had Arabic subtitles into a still photo, manipulating the image to apply light and shadows where appropriate. Malcolm X undertook his Hajj in 1964 and was particularly struck by the spirit of unity that bound all races and peoples.

Acknowledgements

This project began in 2009 with a visit by Neil MacGregor and myself to Saudi Arabia where we met their Royal Highnesses Prince Sultan bin Salman, Prince Faisal bin Abdullah and Princess Adelah bint Abdullah. Their enthusiasm gave us the encouragement we needed. The early and very generous promise of support from HSBC-Amanah allowed the project to get off the ground and here I would like to thank Marah Winn-Moon, Head of Cultural Sponsorship at HSBC in particular. Qaisra Khan came in as project curator and we began our work in earnest on the exhibition structure, finding objects and expanding the scope to include in-depth contact with Muslim communities across the UK. At a later stage, the Arts and Humanities Research Council (AHRC) provided further generous support focusing on the research. Here I would like to thank my colleague JD Hill for his valuable help in the preparation of the application. We were able then to expand the team to include the researcher John Slight, and to create a legacy for the project through an association with Sean McLoughlin from the University of Leeds, recording the experience of Hajj of UK Muslims. (The AHRC are also supporting an academic conference, the proceedings of which will be published as a companion volume to this book.) The King Abdulaziz Library agreed to become organizational partner on the exhibition, facilitating loans from the Kingdom of Saudi Arabia, and I am extremely grateful to HRH Prince Mohammed bin Nawaf Al Saud, HE Faysal bin Muammar,

Abdulkareem Zaid, Fahad Abdulkareem, Omer Sheikh and Jennifer Zulfiqar for all their assistance in this regard. We also established an advisory board who have provided a wealth of advice in very many practical ways and their names are listed with the list of contributors at the beginning of the book.

Working on this project, I have encountered whole-hearted enthusiasm and support for our endeavour from friends and colleagues around the world, and there are many people to thank. Neither this book nor the accompanying exhibition could have been achieved without a number of key people. My first adviser and mentor was James Allan, whose pioneering exhibition *Pilgrimage: The Sacred Journey* in 2006 was an important source of inspiration. He provided me with much needed guidance and support in the early stages, particularly as regards the structure and content of the exhibition. Other key supporters at that stage were Tim Stanley and Annabel Gallop, who helped and encouraged in a myriad of ways, as did HRH Prince Hassan bin Talal.

For the organization and preparation of this book I am especially grateful to Malise Ruthven, who worked with us closely, and my close colleagues Qaisra Khan and John Slight, who both contributed much and helped our editor Coralie Hepburn and myself to bring it all together.

For the chapters in the book, I would like to thank most warmly our main authors, Karen Armstrong, M.A.S. Abdel Haleem, Hugh Kennedy, Robert Irwin and Ziauddin Sardar, for their excellent contributions and for their forbearance.

In addition to their work we have had considerable help from a number of people in key areas. In connection with the themed spreads, Tim Insoll went to Mali on the Museum's behalf to help us source objects to include in the exhibition and brought back Hajj-related items for the collection. His main contribution to the book is the thematic spread on Africa. In this area we were also helped by another archaeologist and expert in the field, Sam Nixon. Andrew Petersen introduced me to the Hajj forts of Jordan, and I am grateful to him for sharing his knowledge so generously and for his particular help on the spreads relating to the Syrian Hajj route and the Hajj forts. Sami Abd al-Malik has also been extremely generous in providing a great deal of information on the Hajj route across Sinai. For sharing their deep knowledge of the Darb Zubayda and the routes across Arabia and for their unswerving support throughout this project, I am greatly indebted to Saad al-Rashid and Muhammad Thenayian. Silke Ackermann helped me to understand the complexity of the instruments made to ascertain the direction of Mecca and sacred geography, and Muhammad Isa Waley has worked with us closely, particularly on the manuscripts of the Futuh al-Haramayn, beautifully translating large sections for our use in the book and elsewhere. For advice on the complex subject of the archive photographs I am most grateful to William Facey, Badr al Hage, Carney Gavan and Richard Fattorini. We also received a great deal of advice and practical help from John Herbert who shared his photographs of the Darb Zubayda and much else; from Peter Sanders, Ovidio Salazar and Alnoor Merchant.

In terms of the objects, the Khalili Family Trust have provided us with a large number from their rich collection, and I am extremely grateful to David Khalili for engaging so willingly with us in this project. His help and that of Michael Rogers and Nahla Nassar have been invaluable. Nahla has worked tirelessly with us and has contributed her own extensive knowledge on the textiles associated with Mecca and Medina. My colleagues at the British Library have been a great source of support from the beginning when they agreed to lend some of the great treasures of their collection including one of the oldest Qur'ans in existence. They also provided advice on the choice of objects from their collections and subsequent help on captions and much else besides, and I am greatly indebted to them: Colin Baker, Annabel Gallop, who with her colleagues Ali Akbar in Jakarta, and in Aceh, Syukri Zulfan and Salman Abdul Muthalib, helped on a number of the South Asian manuscripts; Peter Barber, John Falconer, Marion Wallace and Barbara O'Connor. Similarly my thanks go to my colleagues at the Victoria and Albert Museum, Tim Stanley, Mariam Rosser-Owen, Susan Stronge, Rosemary Crill and Marta Weiss; at the Arcadian Library I would like to thank the Chairman for so generously lending us a number of marvellous books from the collection and to his colleagues Robert Jones and Ben Cuddon for their help; at the Chester Beatty Library I would like to thank Elaine Wright and Michael Ryan for agreeing so readily to lend some of their beautiful manuscripts; at the Bodleian Library my warmest thanks go to Colin Wakefield and Gillian Evison; at the Ashmolean Museum, Alessandra Cereda; at the Benaki Museum I am extremely grateful to Mina Moraitou, Anna Ballian and Maria Sardi for all their support; at the Louvre, to Sophie Makariou, Charlotte Maury and Carine Juvin, whose scholarly work on the *Routes of Arabia* exhibition (2010) proved invaluable for this project; and at the Bibliothèque Nationale, Marie-Geneviève Guesdon. My Dutch colleagues at the Tropenmuseum Amsterdam, the Leiden University Library and the Museum Volkenkunde were enthusiastic from the start and opened my eyes to the fascinating world of Snouck Hurgronje and their rich collections pertaining to South-East Asian Islam. Here I would like to thank Mirjam Shatanawi, Luis Mols, Aarnoud Vrolik and Graeme Scott with whom I spent many happy hours looking at wonderful objects only a fraction of which could we eventually include in the exhibition. At the Museum for Volkenkunde I would like to thank Stephen Englesman, Anne Marie Worlee and John Sijmonsbergen. In

addition I would like to thank Jan Just Witkam for help on a number of the Leiden University Library objects and thanks also to J.A.N. Frankhuizen at the Library, and Djurke Van der Wal for sharing her expertise on the Snouck Hurgronje photographs. In Malaysia my thanks go to Syed Mokhtar Albukhary, whose exhibition and book *En Route to Mecca* is one of the few to have focused on the Hajj and is also a mine of information. I would also like to thank his colleagues Nurul Iman Rusli and also Lucien de Guise; and in the National Library, Faizal Hilmie Yusof. At the Thomas Cook archive I would like to thank Paul Smith. In Timbuktu I am extremely grateful to Ali Ould Sidi and Abdel Kader Haidara and, for early advice on West African manuscripts, Paulo Farias and to Sekou Berte who facilitated Tim Insoll's trip to Mali on the British Museum's behalf. For help with the British Library Hajj certificate I am extremely grateful to Farhana Mannan who shared her PhD research with me on the Sandal of the Prophet from her thesis 'Commemorative Shrines dedicated to the Prophet and his Family in Bengal' as did Farouk Yahya with his MA dissertation on the Patani *Dala'il al-Khayrat*. For the translation of the Aga Khan's Hajj certificate I am grateful to Muhammad Jozi and Shahrokh Ramzjou.

I am also grateful to Angus Slayden for the loan of the material relating to Lady Evelyn Cobbold; Muhammad Hafiz for the works by Ayman Yossri and Abd al-Nasser Gharem; and to Mr Abdulaziz al Turki, who made possible the acquisition of the photogravures of *Magnetism* by Ahmed Mater for the museum; also to the Prince Abbas Hilmi for the loan of the Abbas Hilmi album and to Jane Hogan at Durham University Library for all her assistance on this; to Lady Margaret Bullard for agreeing to the loan of Sir Reader Bullard's *kiswa* fragment; Mary McWilliam and Glen Lowry at Harvard Art Museums for allowing us to borrow the magnificent Hajj banner; Jim Bennet at the Museum of the History of Science for the loan of the Moroccan astrolabe; Peter Symes for his advice on Hajj rupees, Benoit Junod from the Aga Khan Trust for Culture. For the modern art, thanks go to Idris Khan and Victoria Miro for the loan of *Seven Paths*; and to Stephen Stapleton and Aya Moussavi for all their help as regards the Saudi artists.

There are also others to thank: for early advice on textiles I am grateful to Hulya Tezcan and Selin Ipek and for other help in Turkey to Zeren Tanindi, Nurhan Atasoy, Selen Etingu and Bora Eskiner. Thanks are also due to Nasser Rabbat, Julian Raby, Nick Warner, Margaret McMillan, Christopher Baily, Linda Komaroff, Jonathan Bloom, Sheila Blair and Sheila Canby. Finally to Michael Wolfe and F.E. Peters whose publications on the Hajj were the starting point for all the work we did.

It remains to thank most wholeheartedly my colleagues within the British Museum, starting with Carolyn Marsden-Smith and the Hajj core project team, David Francis, Jonathan Ould, Nicholas Newberry, Matthew Weaver and Emeline Winston. I would also like to thank Jessica Harrison-Hall, Mark Macdonald, Hugo Chapman, Sona Datta, Richard Blurton and Sacha Priewe as well as Dudley Hubbard, who took wonderful photographs in Jordan, and Ivor Kerslake and John Williams. Warmest thanks go in particular to my friends and colleagues in the Middle East Department: Fahmida Suleman, Louisa Macmillan and Ladan Akbarnia, and also to Sarah Choy and Wendy Adamson, John Curtis and Jonathan Tubb. I would also like to thank Justin Morris, Joanna Mackle, Hannah Boulton, Margaux Simms, Caroline Usher, Clare McDowall, Jennifer Suggitt and Andrew Burnett. At British Museum Press, our editor Coralie Hepburn has been magnificent and has miraculously held this all together. I am extremely grateful to her. Thanks also to Rosemary Bradley. For the beautiful design of this book I would like to thank Bobby Birchall; for the picture research, Axelle Russo-Heath; for the production work, Melanie Morris; for proofreading, Jane Lyons; for the maps and artwork, Matt Bigg; and for the hard work of editing, Nina Shandloff. I am grateful also for additional help from some wonderful volunteers: Judith Henon, Rosa Sinclair-Wilson and Nina Swaep, who also helped us on the Dutch documents.

Finally, deepest thanks go to Qaisra Khan who has worked tirelessly and with such good humour on both the exhibition and the book and to John Slight who has also helped enormously in very many ways. I am greatly indebted to them both for their enthusiasm and commitment. My final thanks go to Neil MacGregor, whose initial vision and continuing encouragement have helped to make this project such a rewarding experience, and to my husband Charles and our daughters Emily and Rhiannon, whose love and support have sustained me throughout.

Venetia Porter

Chronology

DATES	EVENTS	States which control the Holy Cities of Mecca and Medina
600–700	622: The Prophet Muhammad (d.632) and followers leave Mecca for Medina. This event is called the *hijra*. 624: While leading the noon prayers in Medina, the Prophet Muhammad receives revelations from God to change the direction of prayer – *qibla* – from Jerusalem to Mecca. 632: In the year of his death, the Prophet Muhammad performs his first and only Hajj, called the Farewell Pilgrimage. This establishes the pattern of the Muslim Hajj as practised today. 637–44: Umayyad Caliph Umar (635–644) orders the first extensions and enlargements of the Holy Mosque. Umar and his successor Uthman (644–656) lead the Hajj in person. 683–92: Companion of the Prophet Ibn al-Zubayr (d.692) rebels against the Umayyads in Mecca. He rebuilds the Ka'ba and Holy Mosque at Mecca in 684. 693: Ibn al-Zubayr's rebellion is defeated. The Umayyads demolish al-Zubayr's Holy Mosque and Ka'ba, and reconstruct them according to plans from the time of the Prophet Muhammad.	*632–61: After the Prophet Muhammad's death, the early Islamic state is led by the four Rightly Guided Caliphs – Abu Bakr (632–4), Umar (635–44), Uthman (644–56) and Ali (656–61)* *661–750: The Umayyads rule the Muslim world from Damascus*
700–900	777: Abbasid Caliph al-Mahdi (775–85) distributed 30 million silver Iraqi dinars, 300,000 gold Egyptian dinars and 200,000 gold Yemeni dinars in Mecca and Medina during his Hajj. 786–809: Abbasid Caliph Harun al-Rashid (786–809) and Queen Zubayda establish the pilgrim route from Kufa to Mecca, the Darb Zubayda, and spend lavishly on improvements to Hajj sites in Mecca. The period from 750–810 is seen as a Golden Age for the Hajj. After this period, settlements on the Darb Zubayda such as Rabadha go into decline.	*750–1258: The Abbasids, with Baghdad as their capital, rule a huge empire which includes Spain, North Africa, the Middle East and Iran*
900–1100	930: Many pilgrims are killed during the Hajj when the Qarmatians, a Shi'a Ismaili group, enter Mecca and steal the Black Stone from the Ka'ba. The Stone is finally returned in 950. 1045–50: Persian traveller Nasir-i-Khusraw (d.1088) makes the Hajj four times.	
1100–1200	1115–16: Crusader activities in the Levant lead to pilgrimage caravans across Sinai being disrupted. 1174: Saladin (1174–93) abolishes the unpopular tax on pilgrims. 1184: Ibn Jubayr (d.1217) arrives in Mecca for Hajj from Al-Andalus (Spain).	*1169–1252: The Ayyubid dynasty, founded by Saladin (1174–93) ruled Egypt, the Levant, Yemen and the Hijaz from their capital in Cairo*
1200–1300	1266: Mamluk Sultan Baybars (1260–77) is the first ruler to send the *Mahmal* with the pilgrimage caravan to Mecca, which included the *kiswa*, the cloth that covers the Ka'ba. Baybars goes on Hajj in 1269, and patronises building work on the Holy Mosque at Mecca.	*1250–1517: The Mamluk Sultans, based in Cairo, rule over Egypt, the Levant and the Hijaz*
1300–1400	1324: Malian Emperor Mansa Musa (1312–37) arrives in Mecca from Timbuktu and performs Hajj. 1325–6: Moroccan traveller Ibn Battuta (d.1369) goes on Hajj and visits Medina.	
1400–1500	1433: The fleet of Ming admiral Zheng He (d.1433) visits Jedda; some of his retinue perform the Hajj. Mamluk Sultan Qaitbay (1468–96) commissions restoration work and further additions to the Prophet's Mosque at Medina and the Holy Mosque at Mecca. 1453: The Ottomans conquer Constantinople (Istanbul). 1496–7: West African ruler Askia Mahmud (1493–1528) goes on Hajj.	
1500–1600	1503: Italian traveller Ludovico di Varthema travels to Mecca from Damascus disguised as a Mamluk soldier. In 1510 he publishes the first European account of the Holy Cities. 1500s: Conflict between Portuguese and Ottomans for control of Red Sea and Indian Ocean affects the passage of pilgrim ships. Portuguese make an unsuccessful attack Jedda in 1517. 1510s: Ottoman Sultan Selim I (1512–20) introduces the practice of the *Sürre* or purse for the Hajj caravan from Damascus. 1550s–1650s: The height of Ottoman power sees successive Sultans make their imprint on the Holy Mosque at Mecca, as a measure of their piety and a projection of their authority.	*1517–1803: The Ottoman empire conquers Egypt, Syria and the Hijaz from the Mamluks in 1517*

	In 1551–2 Sultan Suleyman the Magnificent (1520–1566) commissions the re-building of the Ka'ba roof and the construction of a minaret for the Holy Mosque. Under Suleyman's orders, the famous Ottoman architect Sinan (d.1588) designs the Suleymaniyya (Tekkiye) Mosque in Damascus (1544–67), which served as an assembly point for pilgrims.
	1577–81: The aunt of Mughal Emperor Akbar (1556–1605) and a retinue of royal ladies travel to the Hijaz for Hajj. Their stay causes a rupture in diplomatic relations between the Mughals and Ottomans.
1600–1700	1671–72: Ottoman traveller Evliya Çelebi (d.1682) journeys from Istanbul to Mecca via Damascus to perform Hajj.
	1685: Joseph Pitts (d.1730s), an English slave who was held captive in Algiers and converted to Islam, accompanies his owner on Hajj. Pitts is the first English person to go on Hajj.
1700–1800	1700s: Increased Bedouin attacks on Ottoman Hajj caravans.
	1757: During an especially tragic pilgrimage season, 20,000 pilgrims die from Bedouin attacks, heat and lack of water.

1800–1900	1814–15: Swiss traveller J.L. Burckhardt (d.1817) joins the Damascus pilgrimage caravan and goes on Hajj in disguise.	*1803–12/13: First Saudi State emerges in central Arabia and expands into the Hijaz*
	1832: The first cholera epidemic in Arabia.	*1814–1916: The Ottoman empire re-establishes control over Mecca and Medina*
	1853: Victorian explorer Richard Burton (d.1890) performs Hajj disguised as an Afghan doctor.	
	1864: Ruler of the Indian Princely State of Bhopal, Nawab Sikander, Begum of Bhopal (1860–8), performs Hajj.	
	1865: A massive cholera epidemic kills 15,000 pilgrims, and leads to the institution of international quarantine arrangements in the Red Sea by the Ottomans and European colonial powers.	
	1880: Egyptian official Muhammad Sadiq Bey (d.1902) takes the first photographs of Mecca.	
	1884–5: Dutch orientalist Snouck Hurgronje (d.1936) goes to Jedda and Mecca, and trains doctor Abd al-Ghaffar in photography.	
	1885: Persian traveller Mirza Muhammad Hosayn Farahani (d.1912) goes on Hajj.	
	1886–93: Thomas Cook becomes the official travel agent for the Hajj from British India.	
1900–2000	1900: Ottoman Sultan Abdul Hamid II (1876–1909) orders the construction of the Hijaz Railway from Damascus to Medina, which receives public subscriptions from across Muslim world. The railway opens in 1908.	*1916–24: Hussein, the Sharif of Mecca (1908–24), hereditary governor of the Hijaz and the Holy Cities, rises up against his Ottoman masters with British and French support – the Arab Revolt – and establishes the short-lived Kingdom of Hijaz*
	1916–18: The Arab Revolt against the Ottomans instituted by Sharif Hussein of Mecca (1908–24). T.E. Lawrence (d.1935) assists the Arab forces in blowing up parts of the Hijaz Railway.	
	1924–5: King of Nejd Abdal Aziz Ibn Saud (1902–53) assumes sovereignty over Mecca and Medina.	
	1932: The foundation of the Kingdom of Saudi Arabia. Abdal Aziz Ibn Saud becomes the Servant of the Two Holy Sanctuaries and the first King of Saudi Arabia.	*1924–present: conflict between Hussein, the Sharif of Mecca, and Abdal Aziz Ibn Saud leads to the Hijaz being incorporated into the Saudi state*
	1933: Lady Evelyn Cobbold (d.1963) is the first British woman to perform Hajj.	
	1955–2005: Saudi Arabia extends the Holy Mosque at Mecca in five major phases to accommodate growing numbers of pilgrims. A new Hajj terminal opens at Jedda airport in 1981.	
	1964: African-American activist Malcolm X (d.1965) performs Hajj.	
2000–2012	2010: The Mecca Metro opens to transport pilgrims to the holy sites.	
	2011 to present: Continued development of the Holy Mosque and the surrounding area by the Kingdom of Saudi Arabia.	

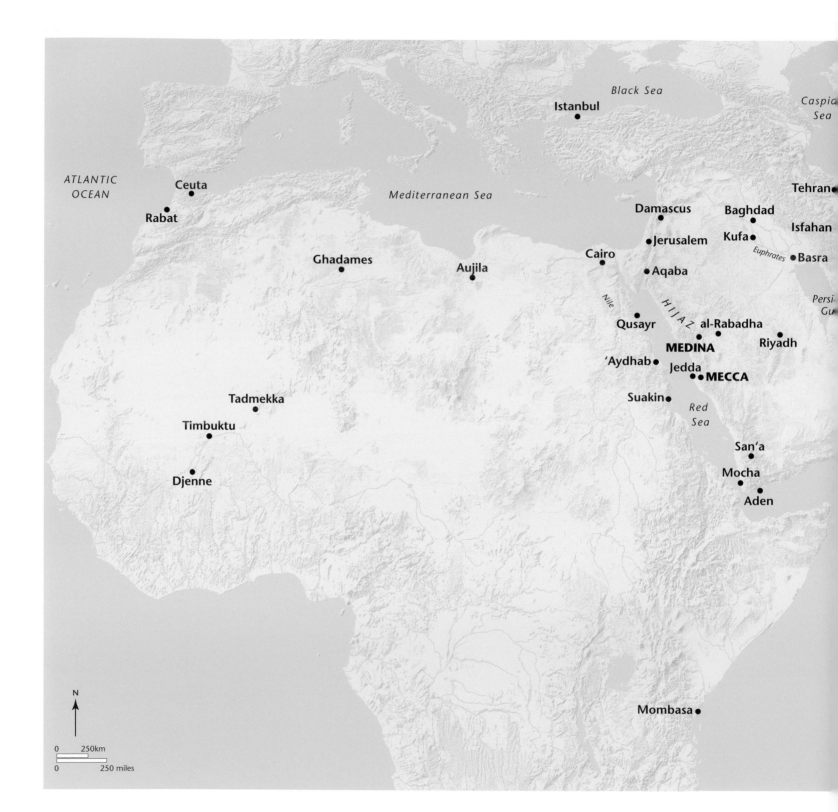

Black Sea

Caspian Sea

ATLANTIC OCEAN

Istanbul

Mediterranean Sea

Ceuta

Tehran

Rabat

Damascus

Baghdad

Jerusalem

Kufa

Isfahan

Ghadames

Cairo

Euphrates

Basra

Aujila

Aqaba

Persian Gulf

Nile

HIJAZ

Qusayr

al-Rabadha

MEDINA

Riyadh

'Aydhab

Jedda

MECCA

Tadmekka

Suakin

Red Sea

Timbuktu

San'a

Mocha

Djenne

Aden

N

Mombasa

0 250km

0 250 miles

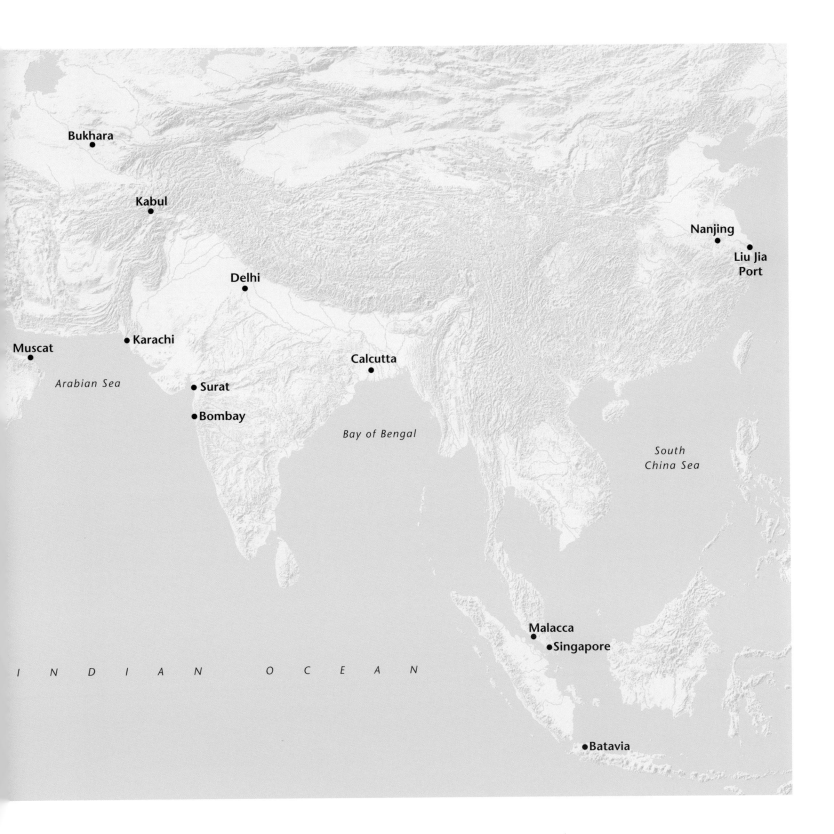

Bukhara

Kabul

Nanjing

Liu Jia
Port

Delhi

Muscat

Karachi

Arabian Sea

Calcutta

Surat

Bombay

Bay of Bengal

*South
China Sea*

I N D I A N O C E A N

Malacca

Singapore

Batavia

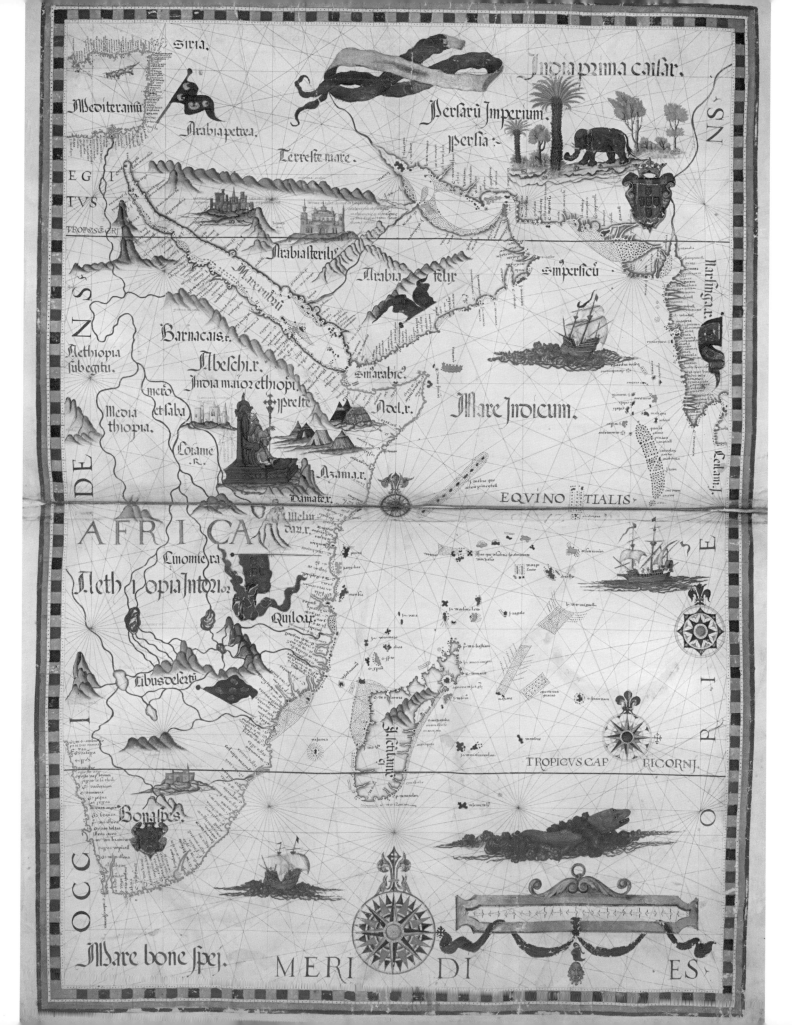

Introduction
PILGRIMAGE: Why Do They Do It?

If we want to understand the contemporary world, we need an informed and balanced understanding of Islam, and there can be no better introduction to the dynamic and values of Muslim faith than the Hajj pilgrimage. But to the secularly inclined, pilgrimage appears hopelessly archaic and it is even religiously suspect to some Protestant sensibilities. So how can a pilgrimage take us 'into the heart of Islam'? When we watch vast crowds of Muslims performing these arcane rites, which, like any ritual, can seem bizarre to an outsider, we may be tempted to conclude that Islam, as its detractors claim, is indeed incompatible with modernity.

Yet if we look at the history of human spirituality, the Hajj is profoundly typical. Long before human beings began to map their world scientifically, they developed a 'sacred geography'.[1] Anything in the natural world that stood out from its surroundings was believed to give human beings direct access to the divine world, because it spoke of something else.[2] In that arid region of the Hijaz, the spring of Zamzam may have made Mecca a holy place long before a city was built there.[3] The life-sustaining and purifying qualities of water have always suggested the presence of sacred power. Hence for centuries Hindu pilgrims have immersed themselves in the sanctity of the River Ganges and congregated in the holy city of Varanasi through which it flows.

In our scientifically oriented society, we see symbols as essentially separate from their referent, but for most of human history a symbol participated in the reality it represented and gave people access to an elusive reality that could not be demonstrated rationally.[4] From time immemorial pilgrims have revered such sacred mountains as Meru in India, Fuji in Japan and Zion in Palestine as the 'centre' of the world, not in any literal sense, but because their grandeur and beauty manifested the mysterious essence of the cosmos.[5]

So compelling is this practice that it has stubbornly surfaced in traditions whose founders had no time for it. The Buddha was very scathing about pilgrimage,[6] but from a very early date pilgrims gathered at places associated with key moments of his life (such as Bodhgaya where he achieved enlightenment) and at the stupas containing his relics. Jesus said that the time for holy mountains was over;[7] it was

only pagans, argued the Egyptian scholar Origen (185–254), who sought the divine in 'a particular place'.[8] But by the end of the sixth century Christian pilgrims were flocking in droves to Jerusalem and to shrines housing the relics of their martyrs. Guru Nanak (1469–1539), founder of Sikhism, said that pilgrimage was worthless,[9] but this did not stop the Golden Temple at Amritsar becoming a holy place for Sikhs. The Hajj may be the only pilgrimage required of all Muslims as one of the five pillars of Islam, but in addition the Shi'a have their own pilgrimage to Karbala in Iraq, where Imam Husayn, the Prophet Muhammad's grandson, was martyred, and crowds of African pilgrims visit the shrines of such Sufi saints as Ahmadu Bamba (d. 1927) in Senegal.

Why do they do it? Because pilgrimage was an early form of tourism that facilitated travel at a time when it was dangerous and expensive? Chaucer's Wife of Bath, en route to Thomas Becket's tomb in Canterbury, is an indefatigable tourist and has already visited Jerusalem (three times), Rome, Compostela and the Magis' tomb in Cologne.[10] But pilgrimage was no picnic; it could be demanding and even perilous. It can certainly be financially beneficial. The Hajj was crucial to the development of commerce in Mecca,[11] and in India pilgrimage boosts local economies, as a religious festival usually coincides with a major market.

But the remarkable similarity of pilgrim ideology and practice across the board suggests that we are dealing with something more fundamental. The experience of ecstatic 'ascent' is crucial: hence the ubiquitous ziggurats and pyramids, which enabled pilgrims to climb symbolically through the cosmos to meet their gods, and the widespread imagery of the cosmic pole, tree or ladder, an 'axis' linking the underworld, earth and heaven.[12] The Cosmic Pillar was central to Indian Vedic ritual;[13] and we find the Sacred Ladder in Jacob's numinous dream at Bethel[14] and the *mi'raj* which took Muhammad from Jerusalem to the divine throne.[15]

Equally pervasive is the symbolism of the paradisal golden age at the beginning of time – a myth found in nearly all cultures. It expresses not a historical reality but our innate conviction that human life was not meant to be so unsatisfactory, flawed and tragic.[16] The Garden of Eden was an experience of primal wholeness. Before the fall of Adam and Eve, no gulf yawned between the human and the divine; there was no sharp divide between the sexes, and no absolute distinction between good and evil.[17] Solomon's temple in Jerusalem was apparently designed as a replica of Eden,[18] and pilgrims who made the 'ascent' ('*aliya*) up the sacred hill of Zion to take part in the temple ritual felt that they recovered – if only momentarily – an Edenic *shalom*, a word

usually translated as 'peace' but which really means 'wholeness, completion'.[19] Similarly, in the Islamic world, traditions developed claiming that the Ka'ba is the highest spot on earth, because the polar star shows that it is opposite the centre of the sky;[20] that the Ka'ba marks the place where human life began, where the Garden of Eden was located, where Adam named the animals, and where all the angels and spirits (except Iblis) bowed down to the first man.[21] Sacred places are often associated in this way with the beginnings of life, since they so obviously connect heaven and earth. Hence John Donne recalled on his deathbed that the Holy Sepulchre Church in Jerusalem stands on the site of Eden: 'We thinke that *Paradise* and *Calvarie, Christ's Crosse*, and *Adams tree*, stood in one place.'[22]

Fig. 2
The shrine of Karbala in Iraq
Hemchander Bhargava, Dariba Delhi,
print no. 150
Early 20th century
Coloured inks on paper
19.1 x 26.4 cm
British Museum, London

*The mosque in Karbala is the site of the
burial place of Imam Husayn, the third Shi'a
imam, who died at the battle of Karbala in
680. It is the focus of pilgrimage for Shi'a
Muslims, who gather there particularly
during the month of Muharram when Imam
Husayn's martyrdom is commemorated.*

Like the religious quest itself, the pilgrimage begins with the perception that something is wrong. Yet we have a unique capacity for *ekstasis*, which enables us to 'stand outside' the ills that flesh is heir to and glimpse something that transcends mundane experience. Hence pilgrims seek a place where the sacred is known to have broken through to our flawed and mortal world. Sometimes this happened in a dream, like Jacob's; sometimes in a cosmic event (as when a meteor, later known as the Black Stone, hurtled from heaven to Mecca); and sometimes in an extraordinary spiritual attainment, such as the Buddha's achievement of nirvana, a martyr's heroism or, according to Sufi belief, a mystic's achievement of union with God, which creates an 'axis' (*qutb*) linking earth and heaven.[23]

Realizing that their immediate environment cannot satisfy their deepest needs, pilgrims seek a 'therapy of distance'.[24] They make a symbolic break with profane existence (often making a vow or donning special clothes) and leave the spiritually peripheral for the 'centre'. The hardship of the journey separates them from their ordinary lifestyle: they may have to abstain from sex or abjure any form of violence. The rigours of the road symbolize the difficulty of the 'ascent'; and social norms are subverted, as rich and poor walk together as equals.

The pilgrimage is an initiation, a ritualized ordeal that propels participants into a different state of consciousness. Ritual is an art that many of us have lost in the West, and some pilgrims are doubtless more skilled at it than others. The efficacy of a rite does not depend on credulous belief. In traditional society, ritual was not the product of religious ideas; rather, these ideas were the product of ritual.[25] The Sanskrit for a place of pilgrimage is *tirtha*, which derives from the root *tr*: to 'cross

over'. When they arrive at their destination, pilgrims perform other rites, carefully crafted to help them make that transition to the divine.

Sometimes pilgrims imitate the actions of archetypal figures associated with the shrine and, by repeating these paradigmatic gestures, leave their profane selves behind and momentarily become something greater.[26] In Vedic ritual, the ceremonial building of a fire-altar symbolizing the cosmos was modelled on the work of the creator, Prajapati, and gave participants godlike status.[27] In Mecca, pilgrims re-enact the story of Hagar and Ishmael.[28] Walking in the footsteps of Adam, Abraham and Muhammad, they circle the Ka'ba seven times, a meditative exercise similar to the Buddhist *mandala*, in which they leave the ego behind and become one with the press of the people.[29] In Jerusalem, Christians make the Stations of the Cross along the Via Dolorosa. In Karbala, the Shi'a weep aloud as the *rawda*, a formal recitation of Husayn's story, brings this timeless tragedy into the present.

The architecture of a shrine often symbolizes the process of 'ascent'. A Hindu temple looks like a mandala from above; inside, exuberant ornament gives way to the stark darkness of the inner sanctum, representing interiority. In entering such a shrine, pilgrims enter imaginatively into a different state of being; the very iconography directs them beyond themselves. The Dome of the Rock in Jerusalem, the first great Islamic building ever to be constructed, became the archetypal model of all future Muslim shrines. It commemorates the Prophet's miraculous 'night journey' (*mi'raj*) from the Ka'ba in Mecca to the Temple Mount in Jerusalem, where he was greeted by all the great prophets of the past. The story symbolizes Islam's reunion with the other Abrahamic faiths. Then the Prophet ascended from the Mount through the seven heavens until he reached the divine presence, forging in his own person a link between heaven and earth and tracing the path that all of us must take in our return to the source of being. Hence the architecture of the Dome symbolizes the path of all mystical ascent: the rock symbolizes the earth, starting point and origin of the quest; it is enclosed in an octagon, which in Sufi philosophy represents the first step away from the fixity of the square and the beginning of ascent to wholeness, symbolized by the perfect circle of the dome.[30]

To the uninitiated, pilgrimage may seem incoherent and contradictory. Yet these contradictions are essential to the ritual, because the sacred lies beyond categories and we domesticize and distort it if we try to confine it in neat, discrete concepts. The initiation of pilgrimage teaches participants to appreciate the

essential paradox of religious thought, to go beyond duality, and thus enter the primal vision of Eden.

This is difficult for those unfamiliar with the logic of ritual and myth. In popular modern parlance, the word 'myth' has come to mean something that is not true, and this has made religion difficult for many Western people. But for most of human history the word 'myth' (from the Greek *muthein*, 'to close the eyes or the mouth' and hence suggesting silence and obscurity) was more correctly understood as referring to those dimensions of human experience that are not readily amenable to logical discourse. A myth is more than a natural occurrence. It is also and essentially a programme for action. A mythical story can place us in the correct spiritual posture, but it is up to us to make the next step. If we do not do this, the myth remains opaque and incomprehensible. A myth makes no sense unless it is somehow translated into practical action. Sometimes this requires an ethical practice, sometimes in a ritual re-enactment, which reveals the truth of the myth at a level deeper than the rational.

A pilgrimage is just such a ritual. It is a practice which, if performed with imagination and care, enables people to enter a different, timeless dimension. It liberates us from the surface of our lives. Over the centuries, it has been found to work in this way. Hence pilgrimage is still popular, even in our secularized world. In Britain, crowds gather annually at the ancient pilgrimage site of Glastonbury for a music festival that brings them intimations of transcendence. Washington, DC, capital of the world's first secular republic, has been built in such a way that it conforms to the archetypal model of many classical holy cities: pilgrims process round the shrines of the great presidents; the Vietnam Memorial in its subterranean pit represents the underworld; and the pinnacle of the Washington Monument on its sacred hill points to heaven. By leaving our ordinary lives behind, turning ourselves physically towards the centre of our world, returning symbolically to the beginning, submitting ourselves to the demanding rites of the pilgrimage, and living kindly and gently in a properly oriented pilgrim community, we can learn that life has other possibilities. The contradictions and ardours of the rites can propel us beyond our normal preoccupations into a different state of mind so that, if we have been skilful, mindful pilgrims, we have intimations of something else, a mode of reality that can never be satisfactorily defined. Perhaps in studying the Hajj, therefore, we can learn not only about Islam but also to explore untravelled regions within ourselves.

Fig.3
Miscellany of Iskandar Sultan, an
illustrated compendium of texts copied
by Muhammad al-Halva'i and Nasir
al-Katib, made for Jalal al-Din Iskandar
ibn Umar Sheikh (d. 1415), grandson
of Tamerlane (Timur)
Shiraz, dated 813–14 AH/AD 1410–11
Opaque watercolour, ink and gold
on paper
18.1 x 12.5 cm
British Library, London

*This double-page opening, fols 362b.–
363a., is an illustration of a text on Islamic
jurisprudence according to the school of Abu
Hanifa. On the left it depicts the Ka'ba and
the holy sanctuary at Mecca. Angels hover
above the throng of male pilgrims, who
are in their* ihram *clothing. On the right a
pilgrim caravan approaches the city. The
text in Persian above the painting on the
right talks about the restrictions on someone
who is in the state of* ihram. *During the
five years (1409–14) that Iskandar Sultan
ruled the southern Iranian province of Fars,
manuscripts of great refinement were made
in the royal atelier. The other texts in this
volume comprise a selection of religious
and lyric verse and treatises on astronomy,
astrology, geometry and alchemy.*

بسم الله الرحمن الرحيم

The Importance of Hajj: Spirit and Rituals

The pilgrimage to Mecca (Makkah al-Mukarramah) is the fifth pillar of Islam, after the declaration of faith (*shahada*), ritual prayer (*salat*), obligatory alms (*zakat*) and the fast (*sawm*) of Ramadan. It is an obligation on all Muslims, attested by the Qur'an, the supreme authority in Islam; the Hadith (traditions of the Prophet), the second authority; and the consensus of Muslim scholars. From its institution as a pillar of Islam, the word Hajj has applied only to the pilgrimage to Mecca: no pilgrimage to any other place is called Hajj.

The Hajj rites are fixed and have been handed down through the ages, and all Muslim pilgrims must fulfil each of the required acts. In this way the Hajj connects Muslims historically through the generations as well as geographically to other Muslims around the world at any particular time. It is one of the most important unifying elements in the Muslim community (*umma*), and it is a journey that marks a huge change in the spiritual and social life of each individual.

THE ORIGIN OF HAJJ

According to the Qur'an, Hajj did not start with the Prophet Muhammad but thousands of years before, with the Prophet Abraham. Most of the Hajj rituals are based on the actions of Abraham and his family.

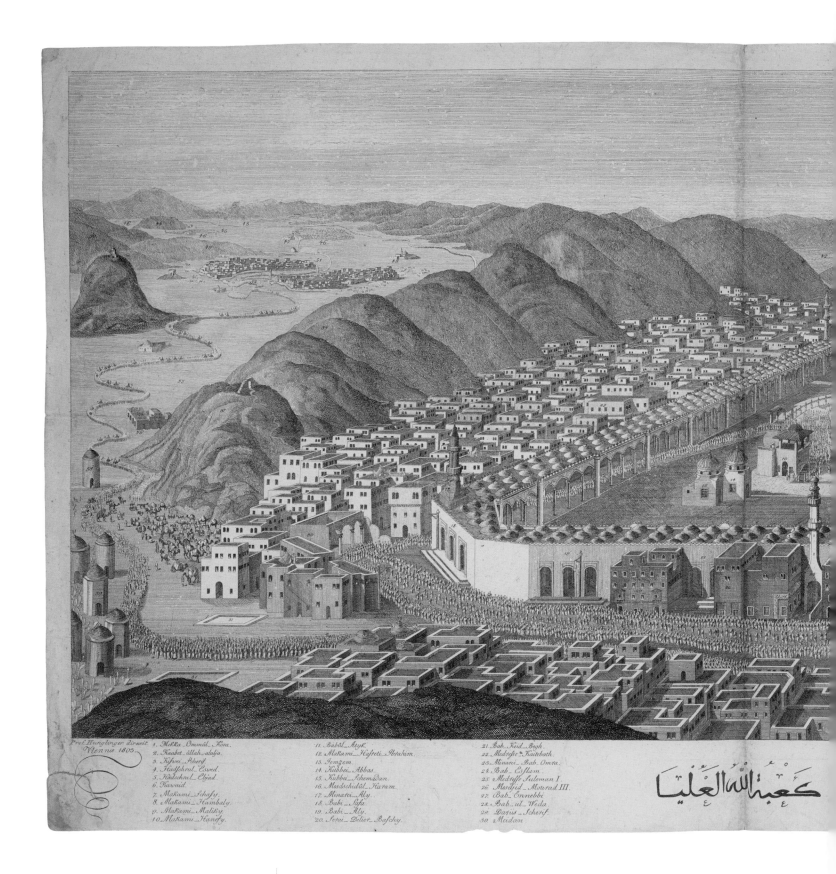

Pref. Hunglinger direxit.
Vienne 1805

1. Mekka Ommül Kora.
2. Kaabet üllah alaßa.
3. Kißvei Scherif.
4. Hadschrul Eswed.
5. Hädschrul Olyad.
6. Kuwaid.
7. Makami Schafy.
8. Makami Hambaly.
9. Makami Maliky.
10. Makami Hanefy.

11. Babül Atyk.
12. Makami Hafreti Ibrahim.
13. Zemzem.
14. Kubbei Abbas.
15. Kubbei Schemidan.
16. Mesdschidül Haram.
17. Minarei Aly.
18. Babi Safa.
19. Babi Aly.
20. Serai Deliet Baschy.

21. Bab Keid Bogh.
22. Medreße Kaitebath.
23. Minarei Bab Omra.
24. Bab Esßlam.
25. Medreße Suleman I.
26. Mesdjid Mourad III.
27. Bab Ennebbi.
28. Bab ul Weda.
29. Daris Scherif.
30. Meidan.

كعبة الله العُلْيا

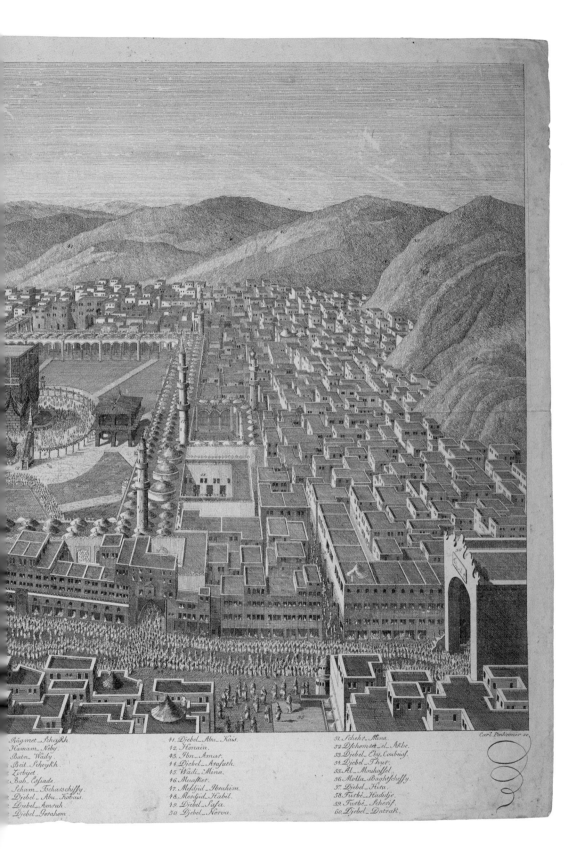

Fig. 5
Bird's-eye view of Mecca
Carl Ponheimer, Vienna, 1803
Engraving
49.7 x 88.3 cm
British Museum, London

*This panorama of Mecca was drawn by
the Austrian orientalist Andreus Magnus
Hunglinger, who accompanied Constantine
Ludolf, minister of the King of the Two
Sicilies, to Constantinople. He based the
panorama on an illustration in Ignace de
Mouradgea d'Hosson's* Tableau Général
de l'Empire Ottoman, *published in 1787,
some of the original engravings of which
had been destroyed by a fire in Pera in
1791. Hunglinger's engraving, which differs
from d'Hosson's in some details, numbers
sixty buildings in Mecca, each of which has
a caption below. Pilgrims from as far as
the mountain of Arafat (top left) are seen
arriving for Hajj. Neither d'Hosson nor the
engravers he worked with actually went
to Mecca but based the description and
drawing on existing illustrations and the
accounts of Turkish pilgrims.*

'The first House [of worship] to be established for people was the one at Bakka [an old name for Mecca]. It is a blessed place; a source of guidance for all people; there are clear signs in it; it is the place where Abraham stood to pray; whoever enters it is safe. Pilgrimage to the House is a duty owed to God by people who are able to undertake it. If anyone denies this, God has no need of anyone.'[1]

When Abraham's second wife Hagar and her young son Ishmael were cast out at the instigation of Sarah, his first wife,[2] he took them to the valley of Mecca.[3] Tradition relates that he gave her a bag of dates and some water but told her that he had to go back, leaving her and Ishmael in Mecca. When he reassured her that it was the will of God that he should leave them there, she accepted her fate, and when the water ran out she began to search for more. She ran to and fro between two hillocks that became known as Safa and Marwa.[4] She had left Ishmael nearby and when she returned to him she found that water was gushing from a spring in the ground near him, which became known as Zamzam.[5] Some traditions attribute this miracle to an angel's intervention and some to the baby kicking the sand with his heel. Hagar's running (sa'i) became one of the rituals of the Hajj, as did drinking the water of Zamzam.

Abraham came back to visit Hagar and Ishmael from time to time. When Ishmael grew up, he would help his father in a very important task in Mecca: rebuilding the Ka'ba (a cube-like building). According to tradition, it was Adam who originally

built the Ka'ba, but by the time Abraham came to Mecca it was no longer there. God showed Abraham the place where the Ka'ba had been.[6] During the process, tradition tells us that Abraham set the Black Stone in the wall of the Ka'ba[7] and when it was finished, he and Ishmael both walked round it seven times.[8] This became an essential ritual of the Hajj, known as *tawaf* (going round). God ordered Abraham and Ishmael to keep the Ka'ba clean from idolatry.[9] Abraham, the model of a true monotheist, prayed that God would protect him and his offspring from worshipping idols.[10]

Abraham was also the supreme example of submission to God. This is clear from his obedience to his vision that he should sacrifice his son.[11] According to tradition,[12] when Abraham set out to fulfil the vision, Satan tried to tempt him not to do it, saying, 'God did not tell you to do this. It was just a dream. How can you kill your son for a dream?', so he stoned Satan seven times. Satan went to Ishmael and to Hagar and tried to tempt them, and they each stoned him seven times. This is the basis of the stoning of the pillars (*Jamarat*) in the valley of Mina, near Mecca. When Abraham was preparing to sacrifice Ishmael, '[God] ransomed him with a momentous sacrifice',[13] and the ritual animal sacrifice of Hajj in Mina commemorates this event. Ishmael remained in Mecca, married and had descendants there.

Since the time of Abraham, the Ka'ba has remained the most important religious feature of Mecca. Pilgrimage to the Ka'ba continued as a tradition among the Arabs[14] until the time of Muhammad, but by then the pure monotheistic faith had been lost and Arab tribes had placed their idols in and around the Ka'ba, perpetuating the religious significance of Mecca. Mecca was also a prominent trading centre in Arabia, a stage on the trade caravan route between Yemen and Syria. Tribes would come to perform the Hajj, worship their idols and trade there.

The Qur'an and the Prophet Muhammad confirmed the importance of Mecca, not only because of the Ka'ba and Hajj, but also because the Ka'ba became the *qibla* (direction of prayer) for Muslims, which they face in their *salat* (the five ritual daily prayers), the second pillar of Islam. Before the Prophet Muhammad and his followers emigrated to Medina in 622, they had prayed in the direction of Jerusalem, a city meaningful to Muslims because of its connection with earlier prophets before Muhammad in whom Muslims also believe.[15] It was also the point to which Muhammad had made his 'night

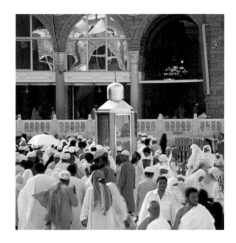

Fig. 6 Opposite
Section from the cover of the
Maqam Ibrahim
Cairo, Ottoman Egypt, 19th century
Embroidered silk
200 x 125 cm
Nasser D. Khalili Collection of
Islamic Art

This is the fourth and last panel for the Maqam Ibrahim (see fig. 7). It is embroidered on to a piece of the overall covering (kiswa, see p. 257) of the Ka'ba and includes verses from the Qur'an from sura 2 (al-Baqara) and sura 3 (Al-Imran). The names of the Prophet's grandchildren, Hasan and Husayn, are inscribed. The first three sections around the textile would have referred to the Prophet and the 'Rightly guided caliphs'.

Fig. 7 Above
The sanctuary at Mecca during Hajj.
The Maqam Ibrahim, the place where
Abraham stood in prayer, is encased
in a brass structure
Photo: Peter Sanders, 1995

Fig. 8
Proxy Hajj certificate, dated 1192 AH/
AD 1778
Probably Hijaz, made by an Indian
artist
Ink, opaque watercolour and
silver on paper
85 x 44.5 cm
Aga Khan Collection, Geneva

*The sanctuary at Mecca is depicted with
the key monuments annotated. The Persian
text below the picture indicates that the
document was created by Sayyid Ali Vali, a
servant (khadim) and teacher (mu'allim)
in the sanctuary at Mecca, several months
after he had performed Hajj at the request
of Bibi Khanumji for a certain Nawab
Ali Khan. As usual with such certificates,
the rituals are described. He must have
undertaken this Hajj between the 8th and
10th of Dhu'l Hijja 1192 (28–30 December
1777) and composed the text two and
a half months later. At the base of the
certificate is al-Sayyid Ali's seal, and on the
sides the word* kooreh, *meaning 'approved'.*

journey', when the five daily prayers became an obligation on all Muslims. In the second year after the Prophet emigrated to Medina, he was yearning to pray towards Mecca, an even older place of worship, established by Abraham. It was also his beloved birthplace. So God directed the Prophet[16] to pray towards the sacred mosque there. This reconnected the Prophet and the emigrant Muslim community to Mecca and heralded the time when the Ka'ba could be restored to the worship of the one God, the fundamental belief of Islam, in accordance with the old tradition of the 'father of prophets', Abraham.

After Mecca surrendered to the Prophet Muhammad in 630, twenty-one years into his mission, he cleansed the Ka'ba of idols, reinstated the original pure faith and, in the final year of his life (632), he performed Hajj, setting finally the detailed rites to be followed by all Muslims, saying, 'Follow in your rites what I have done.' He gave his farewell sermon on this Hajj, stressing the equality and brotherhood of believers and the rights of women.

THE CONDITIONS OF HAJJ

Hajj is obligatory only on those men and women who are Muslims, free, adult, sane, healthy enough and with the financial means to do it. If the route is not secure the obligation ceases. It should not be financed by debt: all outstanding debts should be paid before embarking on it. Nor should the pilgrim's family be left without support. Those who have the means to do the Hajj but are prevented by old age can pay for someone else to do the Hajj on their behalf. (If someone dies having made a will asking that the Hajj be done for him, usually his adult children would undertake it for him or deputize another.) Every year there are people doing the Hajj for someone else, but the person deputized must have done his own Hajj already. There is no obligation on young children to do Hajj and if they do, it does not cancel their obligation to do it as an adult. Nevertheless, when a woman lifted a child up to the Prophet on his Hajj and said to him: 'Is there a Hajj for this one?' He replied, 'Yes, and you will have the reward.'[17]

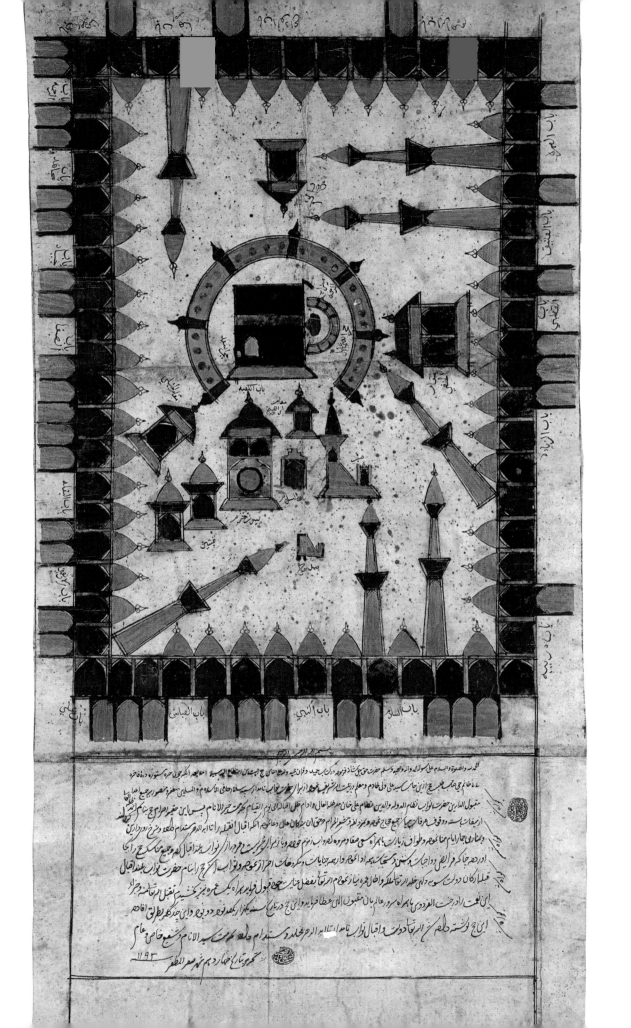

PERFORMING THE HAJJ

Fig. 9
Masjid al-Shajara (mosque of the tree)
at the *Miqat* of Dhu'l Hulayfa
Photo: Qaisra Khan, 2010

There are five fixed places (Miqat) within a radius of Mecca, which pilgrims must not cross before they are in a state of ihram *if they are intending to perform Hajj or* umra. *Dhu'l Hulayfa, more than 300 km from Mecca, is the one for those who approach Mecca from Medina. The others are Juhfa (190 km to the north-west), Qarn al-Manazil (90 km to the east), Dhat Irq (85 km to the north-east) and Yalamlan (50 km to the south-east).*

The Qur'an states that Hajj should take place 'in the specified months',[18] and these are the last three months of the Muslim calendar, known as *Miqat Zamani* (fixed times). Although the main acts of the Hajj take place in five days during the twelfth (and last) of these, 8th–13th Dhu'l Hijja, a pilgrim can start going into consecration (*ihram*) for Hajj earlier, from the beginning of the tenth month (Shawwal). The Muslim calendar is lunar, which means the Hajj takes place progressively across all four seasons over time rather than in the full heat of summer every year. Minor pilgrimage, *umra* (a ritual visit), can take place at any time of the year. Traditionally Ramadan (the ninth month) is the most popular time for this: sometimes more than a million people come.

Ritual consecration (*ihram*) for Hajj starts at specified fixed places, known as *Miqat Makani*, on the roads to Mecca from the various directions. The closest

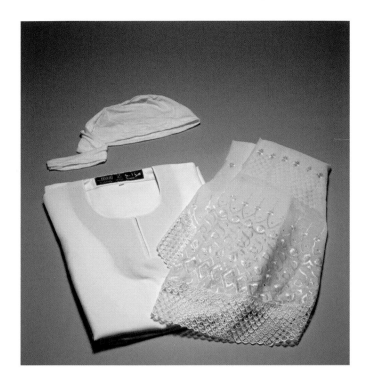
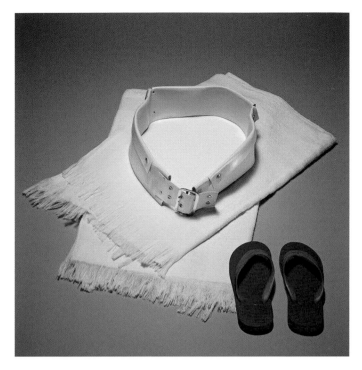

of the *Miqat* to Mecca (Yalamlam) is the one on the road from the Yemen, 50 km (31 miles) away. The furthest one (Dhu'l Hulayfa) is only a few kilometres from Medina, which is over 300 km (185 miles) from Mecca. In the days before modern transport this meant lengthening the period of consecration to include this arduous journey but also to provide more spiritual blessing. There are also *Miqat* for pilgrims coming from Iraq, Syria and Egypt. Pilgrims arriving by plane are alerted by the airline staff when they pass over these *Miqat*.

On arrival at the *Miqat*, pilgrims must enter into *ihram*. It is recommended that they have a full body wash[19] and perfume themselves, and men must change into the *ihram* clothing, consisting of two pieces of seamless white cloth (such as towels), one fixed round the waist and the other covering the top of the body. These can be secured with pins or a belt. Footwear should also be simple and not sewn. Women's clothing for Hajj is normal and can be any colour, although usually they choose white, but they should not cover their faces.

Once the pilgrims are in *ihram* they must not use perfume, shave, cut their hair or nails, or have sexual intercourse. Entering into *ihram* is a high spiritual moment, one the pilgrims have long anticipated. They begin the

Figs 10–11
Ihram garments for women (left) and men (right) acquired in Mecca, 2010
British Museum, London

talbiya, chanting in Arabic '*Labbayk allahumma labbayk . . .*' 'Here I am, Lord, responding to Your call [to perform the Hajj].' This is constantly repeated during the Hajj, especially when meeting other pilgrims, moving from place to place, and after the daily prayers. The pilgrims are unified by chanting in the same language and also by their simple clothing, worn by people of every status, colour, language and background.

Fig. 12 Right and opposite below
Kitab Manasik al-Hajj ala Arba'at Madhahib (A guide for the pilgrimage rituals, according to the four schools of law)
Early 15th century
26.5 x 18 cm
Leiden University Library, Leiden

Written in naskh *script by an anonymous Hanafi jurisprudent, the illuminated title page of the manuscript (right) shows the ex-libris of the Mamluk sultan Jaqmaq Abu Sa'id (842–57 AH/AD 1438–53), who was known for his piety, humility and philanthropy. He performed the pilgrimage in or around 1434, before ascending to power, so the manuscript is apparently not directly connected to his own pilgrimage. The author of this guide dedicated his work to the Mamluk sultan al-Mu'ayyad, who can be identified as al-Mu'ayyad Sayf al-Din Tatar (1412–21). Such royal guides elaborate on situations that may make the state of* ihram *invalid. At the end of the work prescriptions are given for the visit (ziyara) to the grave of the Prophet Muhammad in Medina, with an exact description of the* Mawqif al-Nabi, *the place in the mosque at Medina where one should stand in order to be 'as if in gardens of paradise'.*[20]

Abraham prayed that God would make Mecca secure. Pilgrims must not hunt, kill any animal or cut any plant. Pilgrims must also refrain from indecent speech, misbehaviour and quarrelling,[21] all very fitting, considering the huge crowds in the limited spaces. The Prophet emphasized that those who performed the Hajj without committing these forbidden acts would return home as free from sin as on the day their mother gave birth to them.

Throughout the Hajj period and during the different rituals, there are special *du'a* prayers for pilgrims to say, many of which were spoken and recommended by the Prophet Muhammad. There are handbooks of these prayers, written in Arabic, and also transliterated (but still in Arabic) with translations for non-Arabs. Pilgrims prefer to recite them in Arabic, in the words uttered by the Prophet himself, and consider them more effective than any other prayer. Each group, large or small, has a guide (*mutawwif*) who chants, and they repeat the prayers after him, interspersed with the *talbiya*. All this intensifies the spirituality of the Hajj season and makes it very special indeed.

Most of the pilgrims arrive by air and sea at Jedda and travel by road from there to Mecca. All this is arranged through the *mutawwif*, who takes the

Fig. 13 Above
Modern guidebook entitled *Hajj and Umrah made easy*
15 x 9 cm
British Museum, London

Guidebooks known as manasik *are an important tool for helping pilgrims to understand what they will be undertaking on the Hajj and the meaning behind the rituals. Pilgrims study these before departure and keep the text with them at all times during Hajj.*

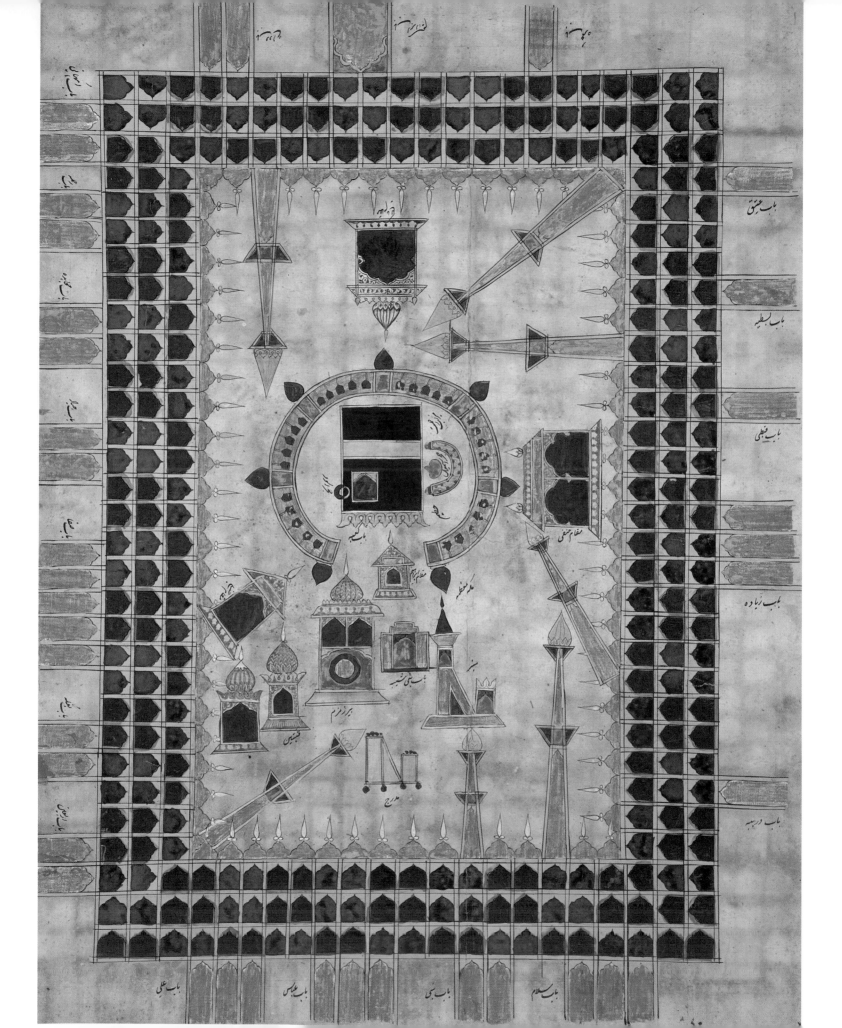

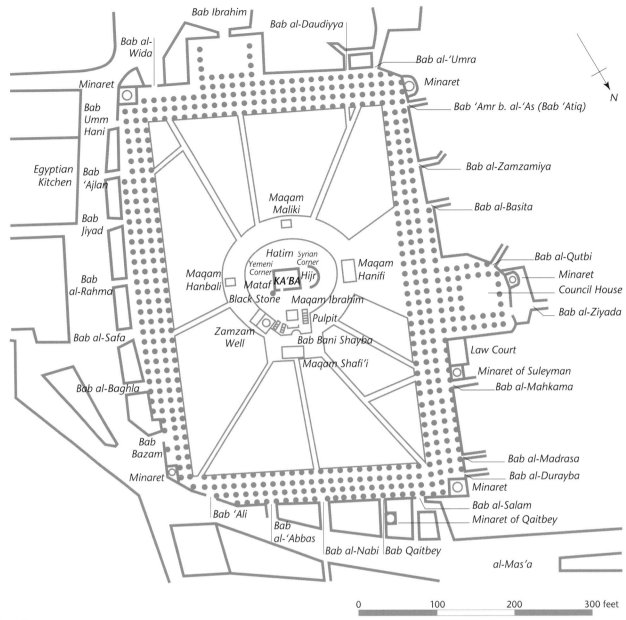

Bab Ibrahim

Bab al-Daudiyya

Bab al-Wida

Bab al-'Umra

Minaret

Minaret

Bab 'Amr b. al-'As (Bab 'Atiq)

Bab Umm Hani

Egyptian Kitchen

Bab 'Ajlan

Bab al-Zamzamiya

Maqam Maliki

Bab al-Basita

Bab Jiyad

Bab al-Rahma

Maqam Hanbali

Hatim

Syrian Corner

Yemeni Corner

KA'BA

Hijr

Maqam Hanifi

Bab al-Qutbi

Minaret

Council House

Bab al-Ziyada

Mataf

Black Stone

Maqam Ibrahim

Zamzam Well

Bab Bani Shayba

Pulpit

Bab al-Safa

Maqam Shafi'i

Law Court

Minaret of Suleyman

Bab al-Mahkama

Bab al-Baghla

Bab al-Madrasa

Bab al-Durayba

Minaret

Bab Bazam

Minaret

Bab al-Salam

Minaret of Qaitbey

Bab 'Ali

Bab al-'Abbas

Bab al-Nabi

Bab Qaitbey

al-Mas'a

N

0 100 200 300 feet

Fig. 14 Opposite
Painting of the holy sanctuary at
Mecca, from a Hajj certificate
Probably made by Indian craftsmen
in Mecca, 17th–18th century
Ink, gold, silver and watercolours
on paper
64.7 x 47.5 cm
Nasser D. Khalili Collection of Islamic Art

*This colourful painting of the sanctuary
at Mecca is based on a prototype that
goes back at least to the 13th century.
The two-dimensional view became the
standard way to depict the sanctuary on
Hajj certificates, in manuscripts such as the
Dala'il Khayrat and the Futuh al-Haramayn,
and on tilework.*

Fig. 15 Above
Plan of the holy sanctuary at Mecca

*The sanctuary area as drawn here covers
an approximate area of 28,000 sq. m.
It has 24 gates. At the centre of the
sanctuary is the Ka'ba, with the Black Stone
built into the south-eastern corner. On
the eastern face of the Ka'ba is a place of
particular sanctity called the hijr. This area
is defined by the hatim, a semi-circular wall.
The well of Zamzam is located on the
south-west side.*

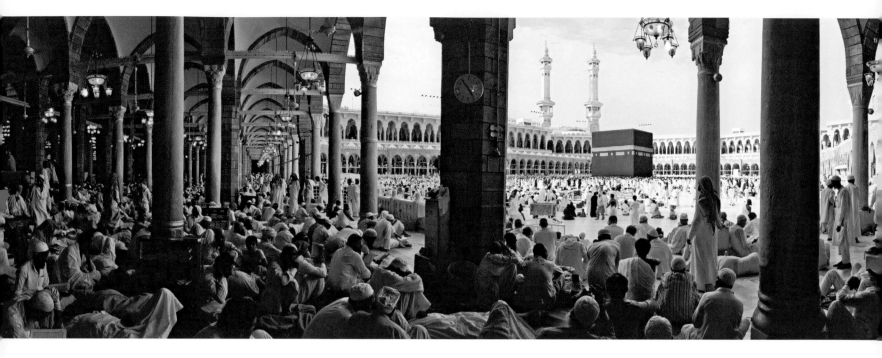

pilgrims in *tawaf* around the Ka'ba. As guide and agent he takes care of the pilgrims' travel and accommodation throughout the visit. Having arrived at Mecca and been shown to their lodgings, the pilgrims make their first visit to the *haram*, the sacred precinct, with its grand mosque. The first glimpse of the minarets and mosque is an unforgettable experience shared with huge numbers from all over the world, most of whom are seeing it in person for the first time. It is recommended that as they go in through the Gate of Peace (Bab al-Salam)[22] they recite in Arabic: 'Lord, open the gates of Your mercy for me. You are peace, from You comes peace, give us Your greeting of peace and admit us to Paradise, the land of peace. Glory be to You, Lord of Majesty and Honouring.'

On entering the mosque, it is the Ka'ba that attracts the pilgrims' eyes. There they will glorify Allah and repeat:

'There is no god but Allah, alone with no partner. Dominion and praise belong to Him, and He has power over all things. Peace be upon our Prophet Muhammad and on his family and companions. Lord, increase this House in honour, glory, reverence and respect and increase those who glorify it and visit it, make pilgrimage to it and increase their respect and goodness.'[23]

Pilgrims approach the Ka'ba, happy to be at the actual building that

Muslims face in their daily prayers all their lives and after death when they are buried. They go as near as possible to the Ka'ba and do *tawaf* (walking round it) seven times, anti-clockwise, starting from the eastern corner in which the Black Stone is embedded, so re-enacting the actions of the Prophets Abraham, Ishmael and Muhammad and all succeeding generations of Muslims. Every time they pass the Black Stone, if possible they should kiss, touch or point to it, saying '*Allahu akbar*', 'God is greater'. While walking round the Ka'ba pilgrims continually recite prayers as mentioned above, particularly: 'Lord, give us good in this life and good in the hereafter and protect us from the torment of the Fire.'[24]

Those near the Ka'ba often lay their hands on the wall or reach for the velvet cover, praying most earnestly for the heartfelt needs of themselves, members of their families and those who have asked them to pray. The pilgrims do the *tawaf* together, men, women and children from all nations. The infirm are carried on litters by strong men. This ritual continues night and day. Following this it is recommended to do two *rak'at* (prayer cycles) at the Maqam Ibrahim (the place where Abraham stood in prayer, now protected by a glass and gold case) near the Ka'ba.[25]

Fig. 16
The holy sanctuary at Mecca photographed through the colonnade
Photo: Peter Sanders, late 1990s

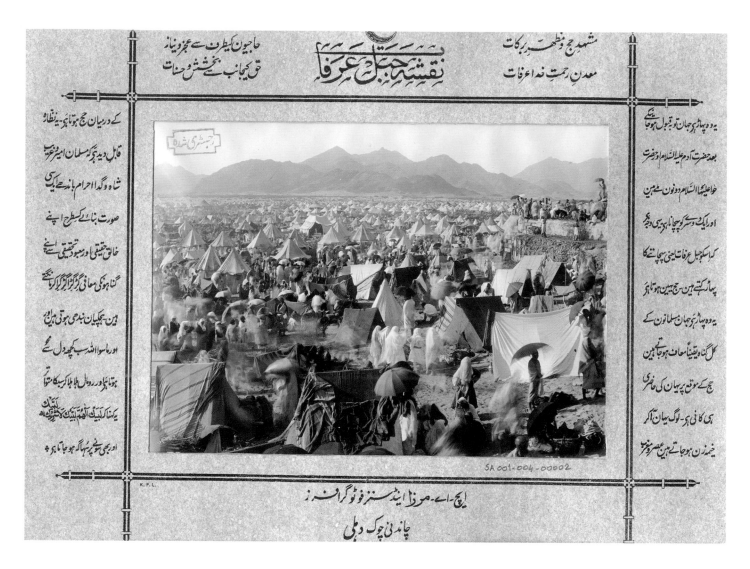

Fig. 17
The rituals at Arafat
H.A. Mirza from the Debbas Album
Delhi, 1907
Gelatin silver print on blue-tinted mat
with Urdu text in red ink
34.5 x 43 cm
King Abdulaziz Public Library, Riyadh

The Indian photographer Husayn Mirza intended his photographs to serve as a guide to South Asian pilgrims going on Hajj. He wanted the viewer to feel that 'he is actually sitting or standing at that place'. 'At the time of the hajj, attendance here is quite overwhelming. People come and pitch tents, with the [act of] *hajj occurring between the afternoon and sunset prayers. It is indeed a sight worth seeing – the manner in which Muslims, rich and poor, king and beggar, all wearing the* ihram *and looking alike, beseechingly ask for forgiveness of their sins from the true Creator.'²⁶*

Fig. 18 Opposite
The rituals of Hajj

The rituals of Hajj begin with a series of short rites within the sanctuary at Mecca, which include circumambulation of the Ka'ba (tawaf), praying behind the Station of Abraham and passing between the hills of Safa and Marwa (sa'i). The pilgrim will then embark on rituals outside the sanctuary, visiting the holy sites of Mina, Arafat and Muzdalifa, in a series of demanding and emotional rites.

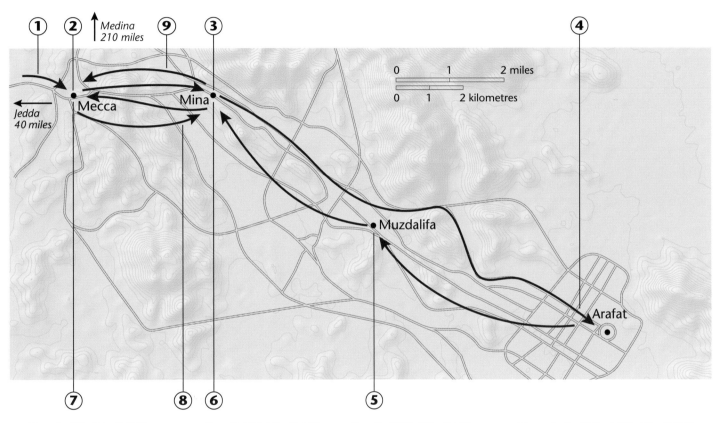

Day 1: 8th Dhu'l-Hijja

1 Miqat
Arrival and change into Ihram

2 Mecca
Circling the Ka'ba (*tawaf*)
Passing between the hills of Safa
and Marwa (*sa'i*)

3 Mecca to Mina
Encampment

Day 2: 9th Dhu'l-Hijja

4 Mina to Plain of Arafat
Day of vigil (*wuquf*)

5 Arafat to Muzdalifa
Collecting stones

Day 3: 10th Dhu'l-Hijja

6 Muzdalifa to Mina
Stoning largest pillar (*jamarat*)
The day of Eid

7 Mina to Mecca
Circling of the Ka'ba

8 Mecca to Mina

Days 4–6: 11th–13th Dhu'l-Hijja

9 Mina then return to Mecca
Stoning all pillars

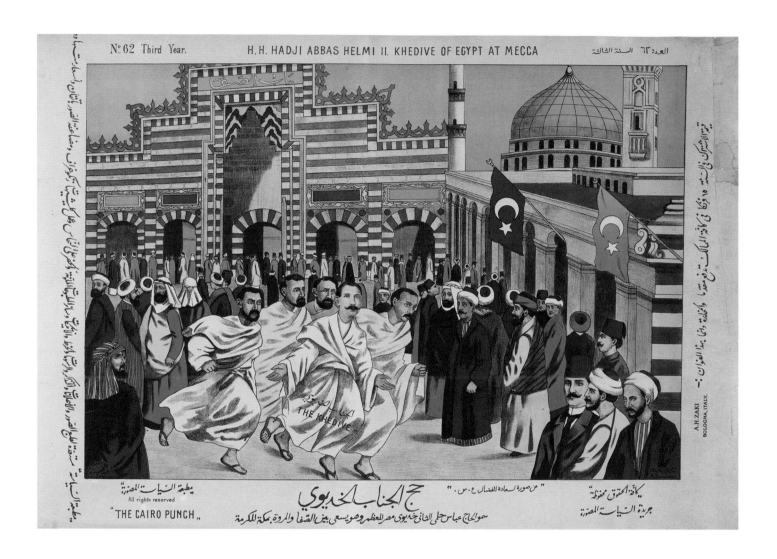

Fig. 19
H.H. Hadji Abbas Hilmi II Khedive of
Egypt at Mecca
Popular print, *The Cairo Punch*, no. 62,
'Third Year', early 20th century
48.8 x 69.5 cm
British Museum, London

*Abbas Hilmi II, the last Khedive of Egypt
(1892–1914), led the Hajj in 1910. He took
photographs along the way. Here he is shown
performing the ritual of sa'i. The Cairo Punch
(al-Siyasa al-musawwara), owned by A.H.
Zaki, published a series of prints between
1910 and 1932 which represented key events
in the Middle East between those years.*

To the east of the Ka'ba is the well of Zamzam, now underground. Drinking
from this is a special ritual that reminds the pilgrims of Hagar's search for water.
This is commemorated further by going to the *mas'a* (the place of hurrying), now
covered and like a massive corridor, three storeys high, to help accommodate
more pilgrims. This runs between the two hillocks of Safa and Marwa and is
about 410 m (1,350 ft) long. The pilgrims walk along this corridor from Safa
to Marwa and back, altogether seven times this distance, all the time repeating
traditional or individual prayers, especially on the hillocks. Part of the corridor
is marked with green lights as a place for trotting rather than walking, again
in commemoration of what Hagar did. When I did *sa'i* myself I recalled that my

parents took these very steps years ago, so did their parents and many ancestors back to the time of the Prophet himself and earlier. My skin quivered as I felt, 'Now I am connected, I am fulfilled.'

On completion of this ritual, those who are doing the *umra* (minor pilgrimage) early can emerge from the state of consecration by shaving or cutting some of their hair and do the rest of the Hajj later. Those who are doing the Hajj straight afterwards continue to complete the special rituals at the appointed times.

Fig. 20
Pilgrim's manual of holy places, fol. 8b
India, 18th century
Watercolour on paper
21.1 x 30.4 cm
Bodleian Library, Oxford

The illustration shows the Ka'ba in the centre with the Black Stone represented as a circle at the upper left-hand corner. Four domed structures represent the four schools of Islamic law. It also shows the garden of Zamzam and the footprints of Abraham's son Ishmael at the lower left.

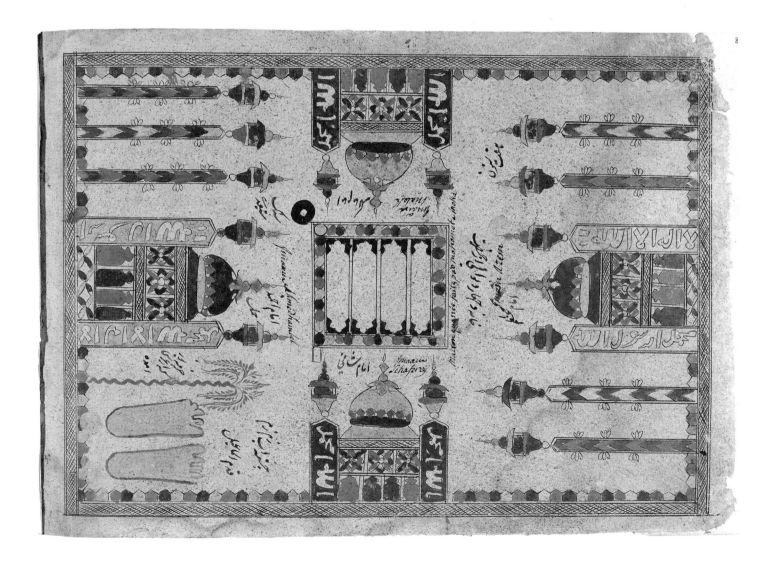

A Guide for Pilgrims

The idea of writing a guidebook for those making the pilgrimage to Mecca, whether for Hajj or for *umra*, is not such a recent one. In the early 16th century a man named Muhyi al-Din Lari (d. 1526) composed such a work in verse. Muhyi came originally from Persia, but he dedicated his work to Muzaffar al-Din ibn Mahmud Shah, ruler of Gujarat in western India. The guidebook, called Futuh al-Haramayn – meaning, roughly, 'Revelations of the Two Sanctuaries' (Mecca and Medina) – was composed in Persian, which for nearly eight centuries was the main language of government and culture in much of the Indian subcontinent.

Muhyi's book seems to have enjoyed much success. A number of manuscripts have survived, at least twelve of which have colophon inscriptions indicating that they were produced in Mecca itself. While the Persian text is composed in ornate and emotional language it does describe in full the rituals of Hajj, both compulsory and voluntary, and in the correct order. The detailed identifying inscriptions are either in Persian or Arabic or both, and sometimes even in Ottoman Turkish.

One of their most interesting features is that all the known copies contain colourful illustrations, some of which are of excellent quality, which are stylized rather than strictly accurate representations of places of interest in and around the holy cities of Arabia, including particularly important areas of the Masjid al-Haram or holy sanctuary of Mecca. The sequence of illustrations generally adheres neatly to the textual order, with later manuscripts illustrating the complete order of the Hajj rituals. Other texts, however, illustrate sites not mentioned in the text, such as Jerusalem. The illustrations of the specific sites differ from one manuscript to another in some details. These compositions are not only informative but also highly decorative, making them a useful and striking addition to the text. Hence Futuh al-Haramayn can be described as an early guidebook, complete with illustrations to guide pilgrims and verses to delight them – and perhaps also as a souvenir of the journey of a lifetime.

Fig. 21
Arafat, fol. 23b of Futuh al-Haramayn
Mecca, late 16th century
22.7 x 14.2 cm
Chester Beatty Library, Dublin

'The mountain of which Arafat is the name
is more lofty than all other mountains are.
Its skirts are filled with the Compassion of God;
around it mankind and angels assemble.
Its shadow betokens the cool shade that God
provides in the courtyards of Paradise.
Though smaller in form than other mountains,
in meaning it is higher than all of them.
The Four Waymarks [mil] marking the bounds of Arafat
At Arafat, awed by its glory and distinction,
men and angels stand in rows on every side.
On the plain stand four waymarks which indicate,
without speaking, the bounds of the Standing-Place'[27]

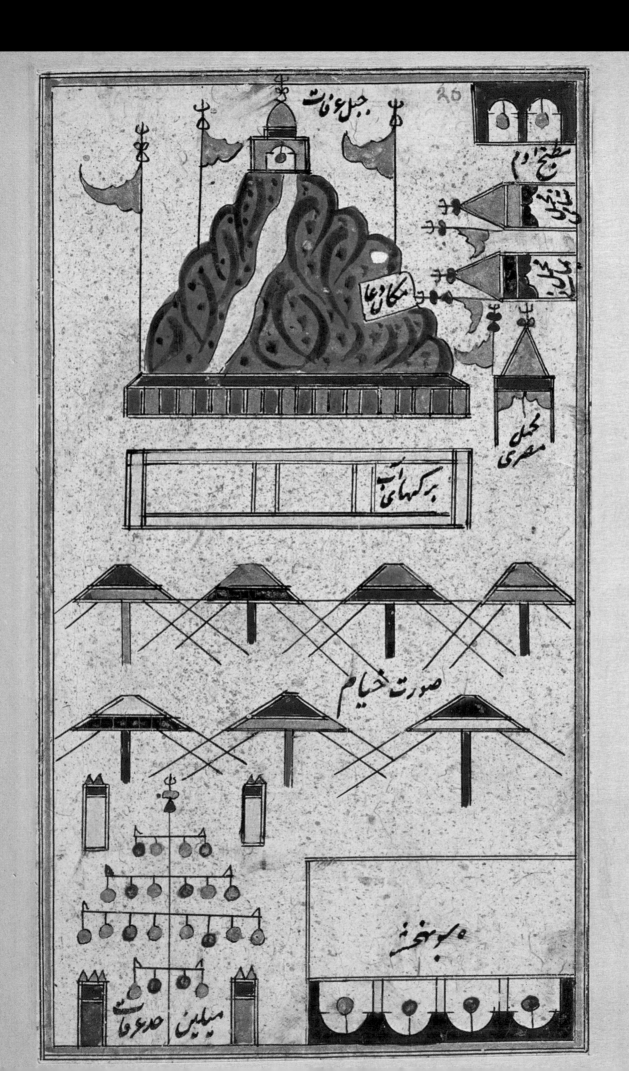

THE PEAK OF HAJJ

On 8th Dhu'l Hijja the pilgrims go to Mina, a valley about 5 km (3 miles) from the Ka'ba, to spend the night there. On the morning of the 9th, they proceed towards Arafat,[28] a plain 14.5 km (9 miles) from Mina, where the central rite of the Hajj, *wuquf* (staying) on Arafat, takes place from noon to sunset. If any pilgrim misses this, his Hajj is not valid and has to be done again another year. This does not apply to any other rite, all of which can be done over a longer period or compensated for with an offering. When they reach the Namira mosque on

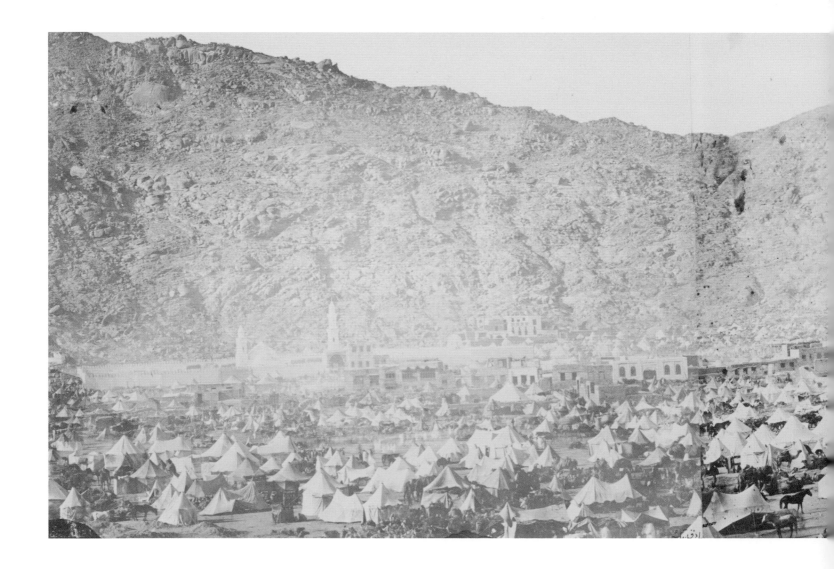

Arafat, the pilgrims do ablutions and pray the midday and afternoon prayers together, shortened, in congregation. After this they remain on the plain of Arafat until sunset, praying. Excellent facilities are now provided by the Saudi government for shade and shelter, food, drink and ablutions. This is the time for the pilgrims to read the Qur'an, glorify God and pray for forgiveness and everything else. Particularly recommended for glorification and repetition is this prayer: 'There is no God but Allah alone, with no partner. Dominion and praise belong to Him, who gives life and death. Goodness is in His hands and He has power over everything.' Pilgrims normally face towards the Ka'ba while

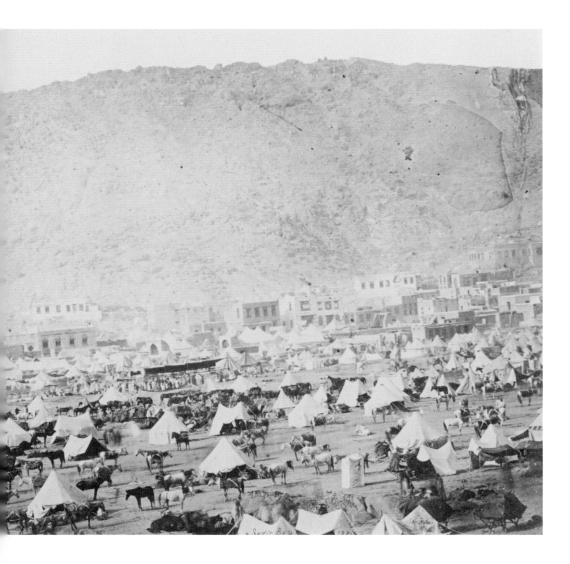

Fig. 22
Camping at Mina
Photo: Sadiq Bey, *c.*1880
Albumen print
24.2 x 48.7 cm
Victoria and Albert Museum, London

Sadiq Bey was the first photographer to take photographs of the Hijaz and the Hajj (see p. 208). In 1880 he joined the Hajj caravan from Egypt and took a series of photographs of the holy places during Hajj. This evocative image captures the valley of Mina, with mosque and buildings in the background and the pilgrims, their animals and their tents.

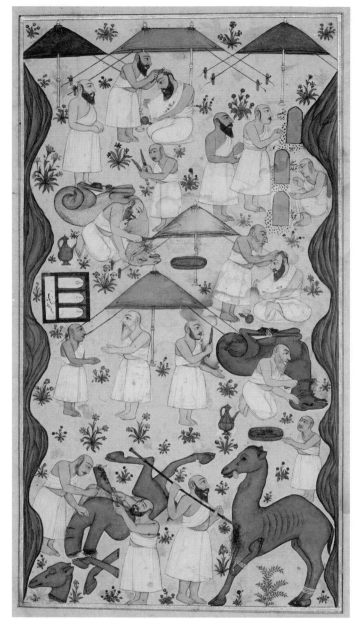

reciting these prayers, as they do for the five daily prayers, believing they are more likely to be accepted.

After sunset, the pilgrims pour away from the plain of Arafat and go to Muzdalifa, another plain 9 km (5.5 miles) from Arafat on the way back to Mecca, a tremendous migration that continues throughout the night. In Muzdalifa the pilgrims pray the two evening prayers combined and spend the night in prayer, reading the Qur'an or sleeping under the stars. There they collect the pebbles they will need in the morning and the following days to stone the *Jamarat*: forty-

nine at least, plus another twenty-one for those who spend an extra day in Mina. In the morning they go to Mina to stone the biggest pillar (*Jamarat al-Aqaba*) using seven pebbles, in commemoration of Abraham. Then the sacrifice of animals takes place, again in memory of Abraham and the substitution of a ram for his son. The Qur'an says: 'Eat some of it and feed the poor . . . It is neither their meat nor their blood that reaches God, but your piety.'[29] That day (10th Dhu'l Hijja) is Eid al-Adha, a great feast throughout the Muslim world. After the sacrifice pilgrims shave or cut their hair to mark the end of the consecrated state (*ihram*) and are allowed everything except sexual intercourse.

Following that, the pilgrims go to Mecca to do the obligatory *tawaf al-'ifada*, marking the departure from Arafat, and go to their accommodation in Mina to rest. After this *tawaf*, marital relations are permitted again. They spend the night there and from midday on 11th Dhu'l Hijja they cast more stones at the three *Jamarat* pillars: seven pebbles each. This is another very congested place, and great efforts are made to facilitate the ritual, most recently by replacing the pillars with large walls. There are now five levels of walkways to accommodate the large numbers of pilgrims. The stoning is repeated on the 12th and some people stay for a further stoning on 13th Dhu'l Hijja.

The pilgrims finally return to Mecca where they perform the *tawaf al-wada'* (the farewell *tawaf*), the last rite of Hajj, and they are now free to go home.

Fig. 23 Opposite
Pilgrims performing rites of Hajj, fols 10a and 10b from the Anis al-Hujjaj (The Pilgrim's Companion) by Safi ibn Vali c.1677–80, India, possibly Gujarat
Ink, watercolour and gold on paper
33 x 23.2 cm
Nasser D. Khalili Collection of Islamic Art

This text was written during the year-long Hajj of its author Safi ibn Vali, undertaken in 1676 and supported by Zib al-Nisa, daughter of the Mughal emperor Aurangzeb (1658–1707). The text gives advice on all aspects of the journey by ship and once in Arabia the places to visit during Hajj and the rituals to be observed. These two illustrations show the rites at Mina and Muzdalifa (on the left), where the pilgrims can be seen collecting stones. On the right are the rituals at Eid, with pilgrims having their heads shaved and animals being slaughtered for the sacrifice. Other pilgrims throw stones at the Jamarat.

Fig. 24
Pilgrims collecting stones at Muzdalifa
Photo: Peter Sanders, 2003

Fig. 25
The sanctuary at Medina, fol. 9b from
the Dala'il al-Khayrat by al-Jazuli (d. 1465)
Ottoman Turkey, Late 17th–18th century
Ink, gold and opaque watercolour on
paper
20.4 x 12.3 cm
Nasser D. Khalili Collection of Islamic Art

This copy of the Dala'il only depicts Medina,
unlike others that depict Mecca as well, and
the sanctuary is drawn three-dimensionally.
The domed tomb of the Prophet Muhammad
is surmounted by a fiery nimbus. This and
the other tombs of Abu Bakr and Umar
as well as Fatima's garden are identified.
Outside the sanctuary are labelled the
mountains of Hira and Uhud as well as a
group of finely drawn monuments which are
the mosques of Abu Bakr, Umar, Uthman
and Ali.

In the intervals between the rituals pilgrims are allowed to trade, 'seeking some bounty from [their] Lord'.[30] A vast *suq* (market) surrounds the sanctuary. They are expected by their families and friends to bring back something as a blessing: prayer beads, prayer mats, clothing, perfume, Zamzam water. Many pilgrims make a point of bringing back sealed containers of Zamzam water to be sprinkled on their shroud when they die, and into their grave. Zamzam water is celebrated as giving healing and great blessing. It is also drunk in company with others when pilgrims return home. In the villages, it is a very special privilege indeed to be given a sip of Zamzam water. Other kinds of souvenirs are also available, and even a head cap or a scarf from Mecca has great significance for the person receiving it.

VISITING MEDINA

Pilgrims aim from the beginning to combine their Hajj with a visit to Medina and the Prophet's mosque and tomb, either before or after the Hajj. Again this will be arranged by their agent and, once settled in Medina, they head immediately to the Prophet's mosque. Great joy is experienced when approaching the mosque and seeing the lofty minarets and the characteristic green dome over the Prophet's tomb. There is more flat space in Medina, so the expansion of the mosque is extensive and impressive, the centrepiece being the Prophet's tomb, his *minbar* (pulpit) and the original space of the mosque, called the *rawda* (meadow), described as one of the meadows of Paradise, so people make a special effort to pray there. It is very moving to face the gate to the Prophet's tomb and greet him as if he were alive and could respond to the greeting (part of the normal daily prayers): 'Peace be to you Prophet and the mercy and blessing of God'. Visitors add, 'I bear witness that you are the servant and messenger of God, that you have delivered the message and discharged the trust and advised the community.' They then pray to God for whatever they need. As this is a very special opportunity for spiritual recharging, pilgrims make a point while in Medina of performing as many of the daily prayers as they can in the Prophet's mosque. Many also visit the adjacent cemetery which contains the remains of the Prophet's companions and relatives.

Pilgrims who have time can also visit the many historical sites around Medina and some also take the chance to add to their stock of souvenirs and

gifts. Visiting Medina has become much easier these days due to modern transport – one hour by plane, several hours by coach – compared to only two or three generations ago, when the journey was still made on camels and it could take eleven days.

Having done the Hajj and visited the Prophet, the pilgrims have fulfilled all that they came for and can now go home, hopefully as free from sin as the day they were born and full of blessing, spiritually charged. They hope to have achieved the merits of the accepted Hajj. The Prophet's wife, Aisha, asked him, 'Considering the great merit of *jihad*, should we women not engage in it?' He answered, 'You women have the best *jihad*, the accepted Hajj.' She said, 'Since I heard this I have not stopped doing Hajj.'[31]

The Prophet also said: 'Spending during Hajj is akin to spending in the cause of Allah, and every dirham thus spent will be rewarded seven hundred times over',[32] and 'The reward of the accepted Hajj is no less than Paradise.'[33]

Fig. 26
The mosque of the Prophet Muhammad at Medina
Photo: Qaisra Khan, 2010

The Dala'il al-Khayrat

Abu Abdallah Muhammad ibn Sulayman al-Jazuli (d. 1465) was a Moroccan religious scholar and member of the Shadhiliyya Sufi order. He had a vast following and his book of prayers, one of the most popular throughout the Islamic world, has been constantly reproduced. The book, whose full title is *Guidelines to the Blessings and the Shining of Lights, giving the saying of the blessed prayer over the chosen Prophet*, is a manual of devotion which consists of an introductory prayer, an enumeration of the virtues of the Prophet, a list of his names and a description of the tomb of the Prophet in Medina. The structure of the prayers encourages the reader to bestow blessings on the Prophet on certain days of the week, Monday through to Monday.

It is possible that al-Jazuli composed this prayer book in order to create a harmonious body of prayers that was coherent when collectively recited. This may be the reason why over time the Dala'il gained great popularity within the Sunni world and is still widely used today.

The book is most commonly illustrated with images of the sanctuaries of Mecca and Medina. However, early examples feature only the Prophet's mosque. Illustrations range from the diagrammatic to the highly detailed and usually refer to the subject of the introduction, which is a short description of the burial chamber of the Prophet in the mosque in Medina. This is usually depicted in the form of a niche with a lamp, under which are the graves of the Prophet and his companions Abu Bakr and Umar. Sometimes the grave of Fatima (the daughter of the Prophet) is also depicted. Later illustrations include the *minbar* and *mihrab*, too.

'On the day when there will be no ancestors, no wealth and no sons (that is, to speak up for us). And have us drink at his Purest pools! To drink from his Fullest chalice! And Facilitate for us a visit to Your Sacred place [Mecca] and his Sacred Place [Medina] before you cause us to die! And make our stay at Your Sacred Place and His Sacred Place, the blessing and peace of Allah be upon him, last until we pass away.' (From the 8th part to be read on a Monday)

Fig. 27
Dala'il al-Khayrat, fols 17b–18a
India, Deccan, *c.* 17th century
Gold and coloured inks on paper
24 x 15 cm
British Library, London

Wherever the manuscript was reproduced, the paintings took on the local style. The onion-shaped domes of the mosque at Medina are characteristically Indian. All other elements of the representations of Medina and Mecca maintain the same elements and style as seen in Hajj certificates and manuscripts of the Futuh al-Haramayn and the Kitab Mawlid al-Nabi.

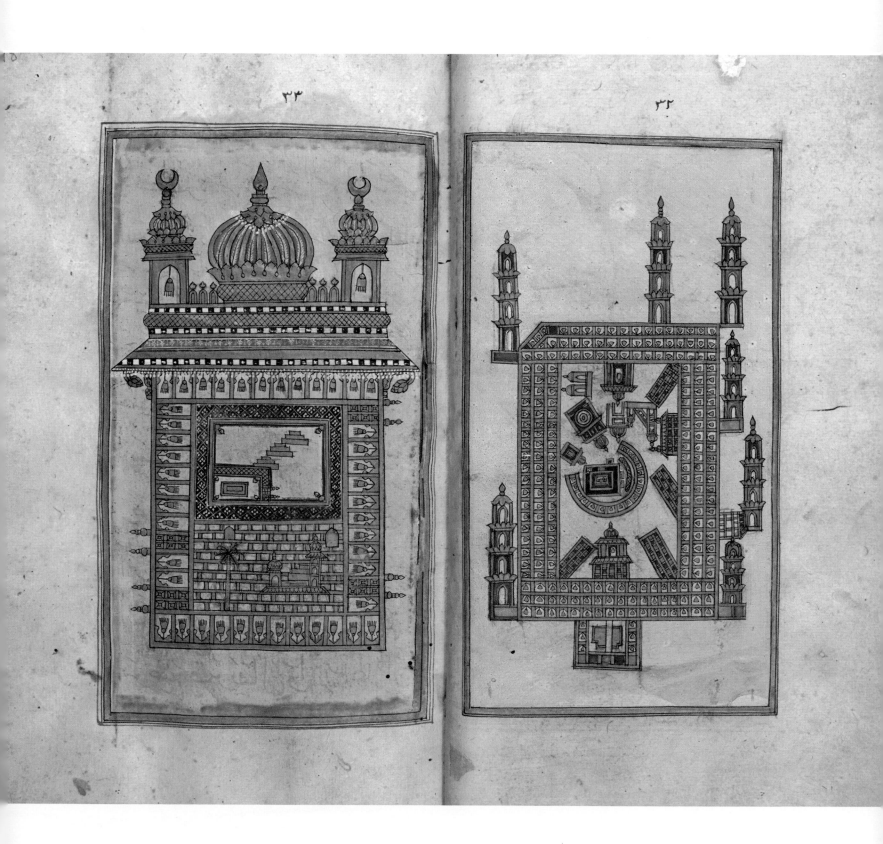

Fig. 28
Kitab Mawlid
East Coast of the Peninsula,
Malaysia, 19th century
European paper, pigment and ink
23.5 x 16 cm
National Library of Malaysia,
Kuala Lumpur

*The Kitab Mawlid, by the religious scholar
and poet of Medina Ja'far ibn al-Hasan
al-Barzanji (d. 1766), is a popular text
on the life of the Prophet Muhammad.
It is recited particularly at celebrations of
the birth of the Prophet, which was on
the 12th of the month of Rabi' al-Awwal
571. Like the Dala'il al-Khayrat, the text
includes paintings of the Prophet's mosque
at Medina (left) and the sanctuary at Mecca
(right). The prominant use of red is typical
of Malay manuscript illumination. Around
the painting of Mecca, there are two verses
from the Qur'an along the side which begin
'the first house was made for the people at
Bakka' (3:96–7). The texts on the Medina
page are Hadith of the Prophet: 'Whoever
goes on Hajj and does not visit me [i.e. my
grave] has abandoned me' and 'Whoever
visits my grave gains my blessing'.*

محمد

اين له

On completing the Hajj, pilgrims acquire a new title: *hajji* for a man, *hajja* for a woman. Especially in rural areas in Muslim countries, this is a mark of the greatest honour.

HAJJ IN THE VILLAGE

Hajj is more keenly felt and has more impact on people in Muslim villages than in the cities. In terms of aspiration to perform Hajj, preparation and follow-up, it is a greater event. I witnessed this as I grew up in our village, al-Asadiyya in Sharqiyya, the eastern part of the Egyptian delta. The 'village' even then had about 10,000 inhabitants. There were only a few people who were known for being *hujjaj* (plural of *hajj*). The fact that it is obligatory only once in a lifetime, and of course the difficulty of finding the means, makes people postpone it, always aspiring to do it sometime in the future. I remember a poor widow with two daughters who saved for years, dreaming of the day when she could go on Hajj – and eventually she did. When I think of her diligence, I remember the Hadith about God rewarding spending on Hajj seven hundred times.

Normally people would go in groups. Women would travel with their husband or a male relative, never on their own. Traditionally this was a condition, right from the beginning of Islam, because the journey was so long, hard and hazardous. Jurists today are of the opinion that provided there is good company, with whom the woman will be safe, she can go without a male relative. This is what happens now with the arrangement of Hajj groups.

Because of their meagre means, pilgrims would prepare in advance all the provisions they would need, including a large sack of thin, toasted bread to last them for the whole period. They would collect everything – rice, ghee, old cheese, sugar, salt, soap – on the assumption that it would be much more expensive elsewhere. Everyone in the area would know the planned day of departure, and two or three days beforehand people would come in groups, especially in the evening, to see the pilgrims and ask them to pray for them in Mecca and Medina. This made the pilgrims the centre of attention even before they left, raising their profile in the village.

In those days the nearest train station that would take them to Suez was some 20 km (12.5 miles) away, requiring transport by camel, and a huge number of people would come to see the caravan set out. On reaching Suez,

Fig. 29
Textile for the Prophet's mosque at
Medina
Silk with gold and silver-gilt wire
289 x 136 cm
Nasser D. Khalili Collection of Islamic Art

*The Medina textiles are made for different
locations within the mosque of the Prophet.
This example, probably for one of the
mihrabs, bears the name of the Ottoman
Sultan Selim III (1789–1807) who ordered
it to be made. His name appears in a
roundel at the base of the textile and in the
teardrop between the candlesticks with the
date 1218 AH/AD 1803 (the numeral 1 is
mistakenly written as 2). The texts from
the Qur'an consist, on the sides, of sura 59
(al-Hashr), 59:22–4, which include some of
the names of God, and, at the top, sura 49
(al-Hujurat), 49:3: 'Those that lower their
voice in the presence of the Prophet, their
hearts has God tested for piety, for them is
forgiveness and a great reward'. Another
text talks about the value of prayer upon the
Prophet. Roundels around the sides have the
words Allah, Muhammad and the names of
the four 'Rightly guided caliphs'.*

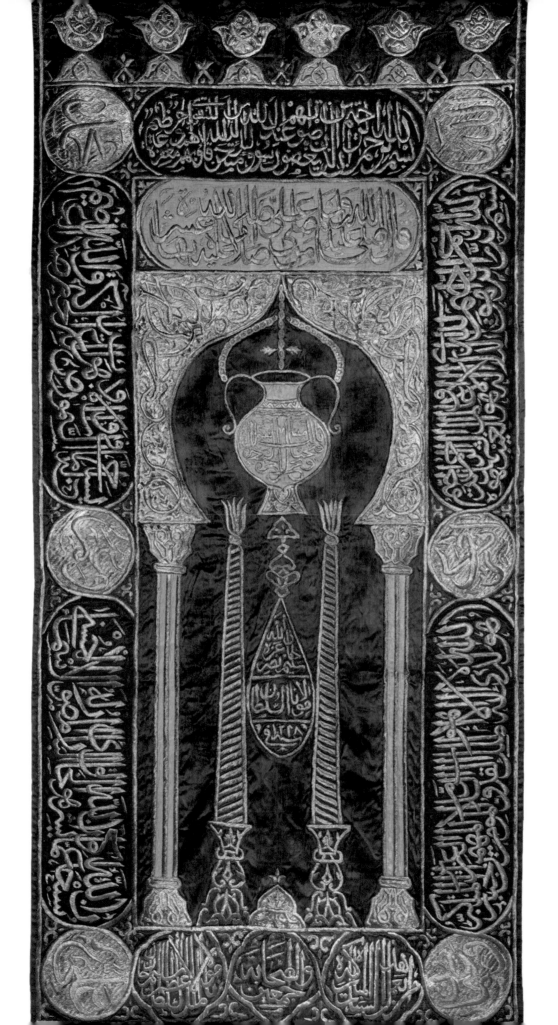

Fig. 30
Painted house in a village between Luxor
and Aswan in Egypt
Photo: Khaled Hafez, 2009

The painted scene celebrates the pilgrim's
return with music. The inscriptions are
prayers offered to the Prophet and the
words 'Hajj mabrur wa dhanab maghfur'
('May the Hajj be accepted [by God] and
sins forgiven'). It is signed by the artist Eid
Yassin Ali.

we were told, they might have to stay overnight in the open before they could get on to a boat. Most of these people were poor, so they would stay on the deck, but no one cared: they were going on the Hajj, a privilege for a very select few. Comfort was never expected on Hajj, anyway. The boat took several days to get to Jedda. All the arrangements would already have been made by the Hajj agents, who would see to their housing, normally in large dormitories in Mecca. In all the Hajj took two months or more. I remember my parents telling me that on their first Hajj they covered the distance between Medina and Mecca by camel in eleven days. By the end of their lives, they would go by air and complete the whole Hajj and visit to Medina in less than ten days, reducing the

time spent away from the village and the impact of their absence. My father did the Hajj numerous times. He used to say, 'Some people go on an annual holiday; for me it is Hajj.' He would not have been allowed to do this now, with the introduction of quotas due to the explosion in numbers.

While on Hajj, pilgrims would be expected to write letters to their families back in Egypt, to reassure them that all was well (it is not unknown for people to die on Hajj, which is sad but still considered a blessing). As a schoolboy I became known for my skills in reading and writing letters, services for which I would be paid a small fee. The letters from Mecca would be read many times over as more people came to hear the news, after which they would be carefully

Fig. 31
Painted house in al-Asadiyya in the province of Sharqiyya in the Nile Delta, Egypt
Photo: Abdel-Haleem Said, 2010

On the right is the Ka'ba with pilgrims around it, and on the left is an aeroplane with the name of the artist Abdallah al-Bana. In the centre in calligraphy are the words 'al-Hajj Arafat'.

stored away. I learned to use highly charged language, begging the pilgrims particularly to remember various people in their prayers. I think some pilgrims managed to write twice and then send a telegram from al-Tur in Sinai, where they would be quarantined for a few days on their return to Egypt.

As the pilgrims' return drew near, their families would make special preparations. Most important was to whitewash the front and reception rooms of the houses. This gave scope for limited artistic talents to make special pictures on the front of the house. The preferred motifs were a ship with a steaming funnel, camels and orange trees, and of course some verses from the Qur'an in connection with the Hajj and short prayers like *Hajj mabrur*: 'May the Hajj be accepted [by God]'. As I recall, the colour schemes included green, mauve and orange. This of course gave the families great distinction in the village, lasting for a long time: everyone who passed by the houses afterwards would remember the occasion. Again food would be prepared in advance for all those who wished to visit the house and welcome the pilgrims back. Better-off families would have a sheep slaughtered, while others would have geese, ducks, rabbits or chickens.

On the appointed day of the pilgrims' arrival, their families would go to meet them at the train station and bring them home on camels, accompanied by a band. As they approached their houses there would be a chorus of *zaghrada* (trilling, high-pitched expressions of joy) and great celebration. Sweet syrupy drinks were served, of a kind normally drunk only at weddings, the circumcisions of boys and when welcoming *hajjis*. The pilgrim himself was the centre of attention, sitting in the biggest reception room, and successions of visitors would come to embrace him, children kissing his hand. He would tell everyone his stories of what had happened while on Hajj and on the way back. The *hajja* would be similarly welcomed in the women's quarters. There would be plenty of food, as the families and visitors would bring gifts – dry rice, live poultry, sometimes even a small lamb. This went on for days. After all, the preparation had been lengthy and the experience was rare. Great prestige came with being called *hajji*, the highest rank you could obtain in the village unless you were the mayor. All this acclaim would make others even more eager to have the experience of doing Hajj themselves, in order to join such an elite.

I have recently revisited the village and found a new world. There are now many secondary schools, with university education accessible only forty

minutes away by bus. There are satellite dishes, computers, mobile phones and supermarkets. People buy their bread from shops instead of baking it at home, but even with all these changes, the attachment to Hajj remains the same. They still whitewash and decorate their houses with quotations from the Qur'an and Hadith, but with images of jumbo jets replacing the older steamships and camels. Here at least the status of being called *hajj* or *hajji* is as high as ever.

Fig. 32
Pilgrim's house in Jerusalem
Photo: Emily Tripp, 2011

The Ka'ba with minarets behind is in the centre with the words 'Welcome to the hajjis' above.

Sacred Geography

'The Ka'ba with respect to the inhabited parts of the world is like the centre of a circle with respect to the circle itself. All regions face the Ka'ba, surrounding it as a circle surrounds its centre, and each region faces a particular part of the Ka'ba.'[34]

The requirement to pray in the direction of Mecca (or rather, the Ka'ba) was not a problem for Muslims living in close proximity to Mecca. However, as soon as communities sprang up in areas further afield, the determination of the *qibla* became a major challenge. Initially this challenge was met by means of so-called 'folk astronomy': traditional knowledge about the

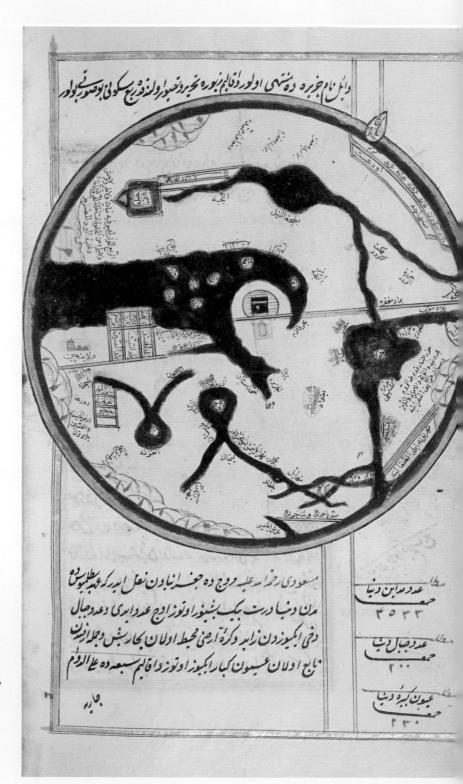

Fig. 33 Right
World map (fol. 90b) pasted into a copy of the Tarih-i Hind-i Gharbi, the 'History of the West Indies', a Turkish work on the discovery of the Americas, compiled *c*.1580 by anonymous Ottoman author
Ottoman *nasta'liq* script, illuminations and illustrations, dated 3 Muharram 1060 AH/ AD 1650
Manuscript on burnished European paper
23.2 x 13.6 cm
Leiden University Library, Leiden

The projection of the world as shown on this map can already be seen in the earliest surviving world maps of the Muslim geographers which date from at least the twelfth century. The map shows south at the top, north at the base. It has legends in naskh script and is a paste-in, for which space was reserved by the copyist. The Ka'ba at the centre is characteristically shown with its kiswa and hizam.

Fig. 34 Opposite page
Nautical atlas of Ahmad al-Sharafi al-Safaqusi, dated 979 AH/AD 1571–2
Drawing on paper
26.8 x 20.7 cm
Bodleian Library, Oxford

Al-Sharafi belonged to a family of cartographers living in Sfax in Tunisia. The map shows a series of cities or regions in groups of three within mihrabs *in a ring around the Ka'ba: for example, Baghdad, Kufa and Basra in Iraq (at 8 o'clock), and al-Nuba, al-Maghasir and Takrun in Africa on the opposite side. These placings were not scientifically computed. In the centre are the Ka'ba, the Maqam Ibrahim and the well of Zamzam. In Maghribi script, the text above the map reads: 'A circle for ascertaining the right direction towards Mecca for each country and a guide for facing Mecca', and below: 'God the exalted says in the text of his wise book, and wherever you are face towards it [the Ka'ba]'.*

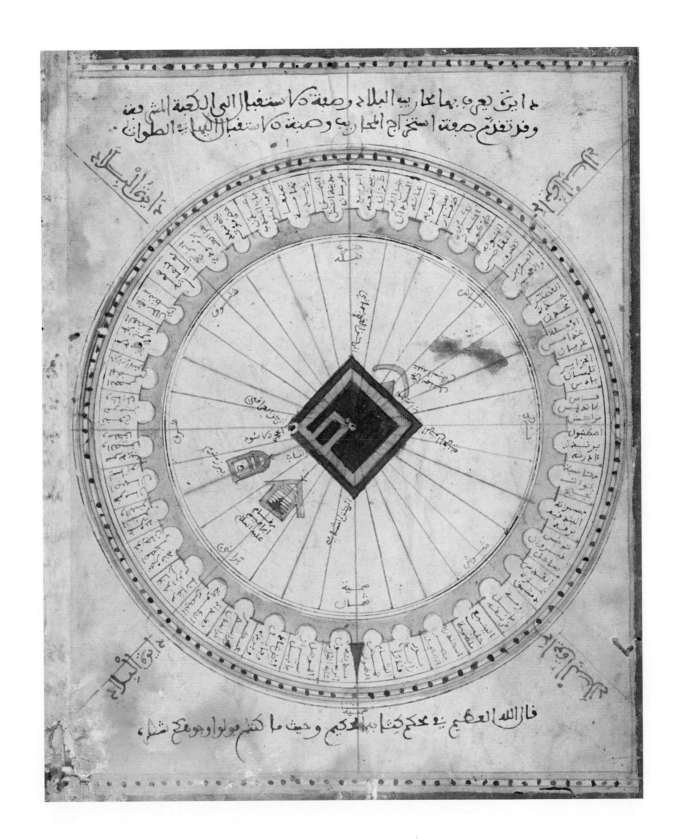

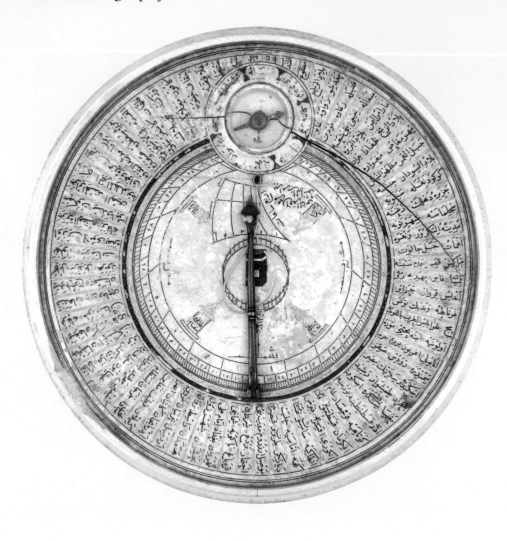

Fig. 35 Left
Qibla indicator and compass made by
Bayram ibn Ilyas in 990 AH/AD 1582
Painted ivory
Diameter 11 cm
British Museum, London

*Around the rim of the instrument are 72
sectors covering the main regions and cities
of the Islamic world. In the centre is the
Ka'ba and a sundial for use with a string-
gnomon which is oriented towards the
celestial pole. The magnetic compass is at
the base. Around the Ka'ba are marked the
four schools of Islamic law (Shafi'i, Maliki,
Hanbali and Hanafi).*

Fig. 36 Opposite
Qibla indicator and compass dated 1151
AH/AD 1738, made by Barun al-Mukhtara
Painted and lacquered wood
Diameter 30 cm
Museum of Islamic Art, Cairo

*Barun al-Mukhtara created this genre of
qibla indicator for the Ottoman grand
vizier Yegen Mehmet Pasha in the 1730s.
It consists of a European map showing
the landmass north of the equator with
a magnetic compass and an additional
pointer at Mecca. Below is a list of countries
and cities with their coordinates. The top of
the box has a topographical illustration of
the sanctuary at Mecca. Below, the text in
Ottoman Turkish describes how the compass
should be used, and at the end are the
signature and date. The back is elaborately
decorated with arabesque designs.*

astronomical alignment of the Ka'ba which could usefully be employed
in different locations for finding the *qibla*. This led to the development in
the ninth century onwards of a 'sacred geography', according to which
different regions in the world were associated with certain astronomical
phenomena. Maps were drawn and instruments developed which gave
an indication of the direction of prayer for a large number of locations.
These maps and instruments are strictly speaking not scientifically
accurate, but rather offer an approximate solution that was satisfactory
for most purposes.[35]

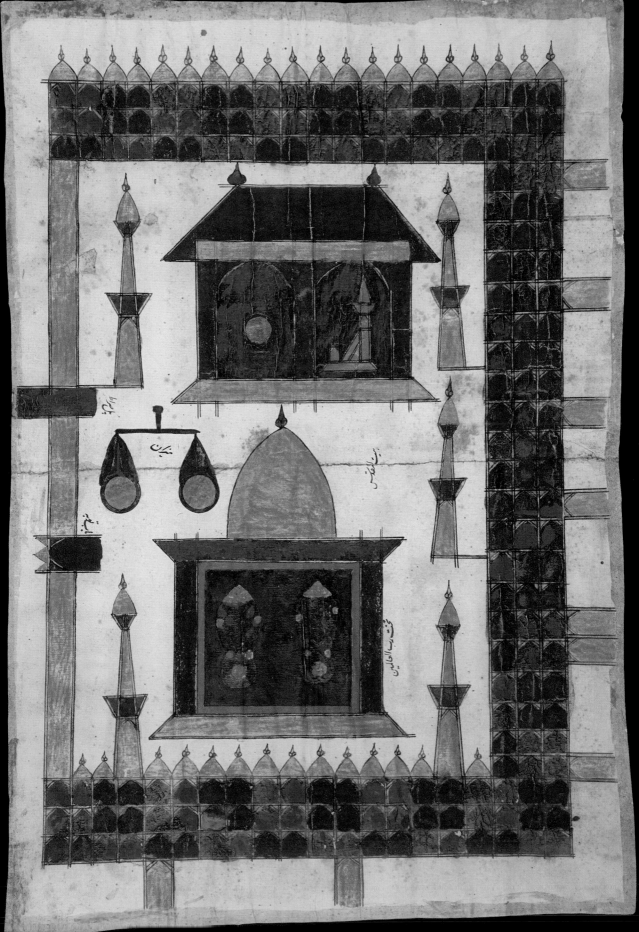

Journey to Mecca:
A History

Islam emerged in a Near Eastern world in which pilgrimage to holy places was already a well-established custom. In the Christian countries of Syria, Palestine and Egypt, pilgrimage to the shrines of saints and martyrs had developed over the previous three centuries. Jerusalem, of course, was the most important of these. From the fourth century onwards, pilgrims had been making the arduous journey there from as far away as western France, and the donations they brought and the buildings they endowed were a major contributor to the economic prosperity of the area. There were established routes to travel and guidebooks to consult.

Jerusalem was the best documented but by no means the only site that attracted pious visitors. The shrine of the great Symeon Stylites, which contained not only the grave of the saint but the remains of the pillar on top of which he had spent the last twenty years of his life, had been beautified by imperial patronage and attracted vast numbers of visitors from all over northern Syria. The shrines of St Thecla in Cilicia (now southern Turkey) and St Menas, in the desert outside Alexandria, were equally famous and well attended. The Arab Christians of the Syrian desert had their own particular focus of devotion at the shrine of the warrior St Sergios at Sergiopolis/Rusafa in the northern Syrian desert. In many of these cases, pilgrimage and commerce went hand

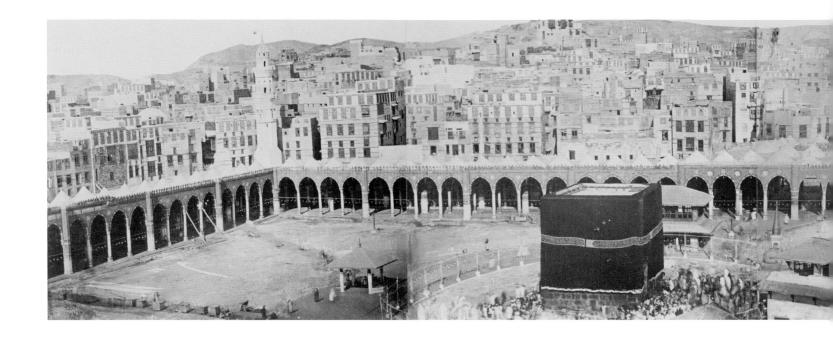

Fig. 38 View of the holy sanctuary
at Mecca
Photo: Sadiq Bey, *c*.1880
Albumen print
21.3 x 61.5 cm
Victoria and Albert Museum, London

*View from the east of the holy mosque with
the city of Mecca in the background. Sadiq
Bey probably took this photograph from one
of the mosque's minarets. In the courtyard
of the mosque, from left to right, can be
seen the Maqam Maliki, the Ka'ba, Maqam
Hanifi (behind the Ka'ba), the structure
erected over the Zamzam well, and the
Maqam Shafi'i.[1]*

in hand: people came together to pay their respects to the saint, certainly, but
they also came to buy and sell among the great throngs of people at the times
of the great feasts. The holy site of Mecca (Makkah al-Mukarramah) and the
pilgrimages associated with it were part of a widespread phenomenon in the
late antique Near East.

There can be little doubt that Mecca owed its existence as an urban
community in the late sixth century, when the Prophet Muhammad was
growing up there, to the shrine (*haram*) and the building known as the Ka'ba
which lay at its heart.[2] The environment of Mecca was unsuitable in almost
every way for large-scale settlement: there was no permanent stream and
virtually no agricultural land, it very seldom rained and when it did, the water
came in violent and destructive torrents. The wells, including the sacred well of
Zamzam, yielded limited quantities of water. Only the shrine, with its mysterious
and numinous black stone, and the visitors it attracted could account for the
survival of the town.

Muslim tradition points to a clear pattern of religious observances, very
ancient in origin, which were purified of their pagan accretions by the Muslims
and whose form was established in its final form by Muhammad's 'Farewell
Pilgrimage' in the last year of his life. According to the Muslim accounts, the

shrines had first been established by the Prophet Abraham and it was here that he settled his slave concubine Hagar and her son Ishmael, at a safe distance from his vengeful wife Sarah and her son Ishaq (Isaac) in Palestine far to the north. Abraham was a true servant of God, but his descendants had abandoned the true religion and lapsed into paganism. During the course of the sixth century, Mecca had been taken over by one Qusayy and his tribe of Quraysh (the tribe to which the Prophet Muhammad belonged) and they had restored and developed the shrine, attracting pilgrims and supervising the trading fairs which were held, not in the town itself, but at a variety of sites in the vicinity. Muhammad's achievement was to restore the position of the Ka'ba and the *haram* around it to its original Abrahamic role as a centre of a monotheistic cult.

There are, however, indications that the story was a bit more complex and that the Muslim Hajj was in many ways different from the pilgrimage practices of the immediate pre-Islamic period. There is evidence that there were originally two major pilgrimages during the year, the Hajj and the *umra*. The Hajj, when it took place in the spring, brought pilgrims to the holy sites of the Mecca area; the *umra*, then normally performed in the month of Rajab, was especially concentrated on the Ka'ba and the *tawaf* around it, and the running between Safa and Marwa, still an important part of the Hajj ritual. It seems as if the Prophet Muhammad and the early Muslims consolidated these two celebrations into one Hajj, while the *umra* became a lesser pilgrimage that could be performed at any time of the Muslim year. We can see further evidence for this in the fact that some of the main rituals of the Hajj take place at a distance from Mecca and the Ka'ba. The most significant of these is undoubtedly the vigil (*wuquf*) at the mountain of Arafat, about 9 km (5½ miles) away from the holy city. Its role can only be explained if it is seen as a survival of a pagan ritual, now thoroughly Islamized. This suggests that a number of different cults were subsumed in the new form of Hajj which was to become a fundamental part of the Muslim faith.

The Well of Zamzam

The presence of water is likely to have been the reason why a sanctuary was first established at Mecca. According to Muslim tradition, the spring or well of Zamzam appeared to Hagar and Ishmael after they had been abandoned in the desert by Abraham. Later, because of the sins of the Arab tribe of Jurhum, the spring disappeared and was rediscovered by the Prophet's grandfather Abd al-Muttalib. The indication of where to dig was revealed to him in a series of dreams: 'Dig Zamzam! What is Zamzam? It never runs dry and is not found wanting.'[3] This story is elaborated in the Compendium of World Chronicles by Rashid al-Din, illustrated here. Abd al-Muttalib sets off with his son al-Harith and digs where he was told:

'Where a white-footed crow pecks on a group of ants, you will know you have what was wanted [Zamzam] and its existence and description. When the morning came, he took the horse and took his son al-Harith with him. They then went to the existing and described place and stopped near it. They saw a crow that was pecking on there. Then, Abd al-Muttalib preceded there. He then dug there with his axe, which was seen by Quraysh, and they laughed at him and marveled at him. He found an overflowing well after a short time.'[4]

One of the rituals of Hajj is to drink from the spring of Zamzam and to bring the water back to relatives and friends. Pilgrims either use the containers they have brought with them or acquire some specially while they are in Mecca. These containers are called *zamzamiyyas*.

The water of Zamzam has been used for other purposes, too: Qur'ans were sometimes copied with ink made from it and it was also held to have protective powers.

Fig. 39
Zamzam water flask
Egypt, 14th–15th century
Glazed earthenware
c. 31 x 15 cm
Museum of Islamic Art, Cairo

Fig. 40 Right
Abd al-Muttalib and al-Harith about to discover Zamzam, fol. 41b from the Jami al-Tawarikh (Compendium of World Chronicles) by Rashid al-Din
Iran, 706 AH/AD 1306–7
39.5 x 27.5 cm
Edinburgh University Library, Edinburgh

وسببه ان عبد المطلب راى فى المنام ان شخصا قال له احفر طيبة وغاب شخصه ولم يدر عبد المطلب ما طيبة وفى الليلة الثانية رآه على

الاول فقال له احفر برة وعبد المطلب لم يدر ايضا ما برة وفى الليلة الثالثة رآه على النعت فقال احفر مضنونة ولم يدر عبد المطلب ما مضنونة وراه بعد ذلك

فقال احفر زمزم انك ان حفرتها

عبد المطلب ما زمزم قال تراث

ولا تندم تسقى الحجيج الاعظم يعنى بابك

ذم منزم خاتمة به كما هو مذكور نه

من الرمال عند قرية النمل وقال

والتم عند نقرة الغراب الاعصم

المطلب موضعها ونعتها فلما اصبح

نجا الى ذلك الموضع المنعوت

ذلك الموضع فتقدم عبد المطلب

من قريش وهم يضحكون عليه وتعجبون

مطبوعة فلما اراده قريش ان فذ بال

من ابينا اسمعيل عليه السلام لنا منها

فى ذلك اختلافا شديدا فبنوا

قبائل قريش نادعوا فى ذلك وقالوا لا نبدا من نصب بيننا حكم بيننا وبينكم فيها واتفق راى الجمع على ان فصل هذا الحكم عند كاهنة بالشام

سعد هذيم واخذ عبد المطلب معه جماعة من اصحابه المرافقين له من بنى عبد مناف، واخذ لهم زوادة ومزادة

لا تندم زمزم انك حضرتها

من ابيك الاعظم لا تندم اذ

الاعظم اسمعيل عليه السلام لاز

قصته ونعتها وانها بالموضع الفلا

ذلك عبارة مبهجة بين الف

عند قرية النمل فعرف عبد

اختلاف الناس واخذ ابنه الحرث

فوقف قريبا منه فراى غرابا

ذلك الموضع فضرب به بفأسه

منه فوجد بعد برهة قليلة

بغيته ومراده قالوا لهذه ميا

منام مع عبد المطلب وبقى

حفريين زمزم ٥

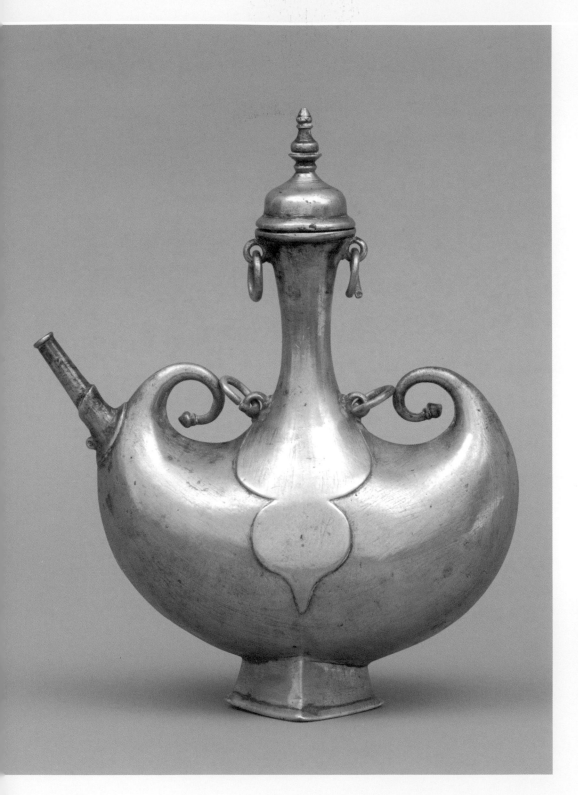

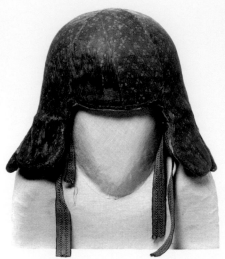

Fig. 41 Left
Zamzam water flask
Probably Deccan, India, 17th century
Brass
Museum of Islamic Art, Kuala Lumpur

An example of this shape of flask being used can be seen in the painting of North African pilgrims (see p. 153, fig. 106).

Fig. 42 Above
Tipu Sultan's helmet
India, 18th century
Quilted cotton and velvet
33 x 42 x 30 cm
Victoria and Albert Museum, London

This helmet belonged to Tipu Sultan, ruler of Mysore in southern India (1782–99). It was taken from his palace at Seringapatan after he was defeated and killed by the British. Inside the helmet is a phrase embroidered in Persian stating that it had been dipped in water from the well of Zamzam and was thus impenetrable.

Fig. 43 Left
Zamzam water bottle
19th century
Glass
20 x 8 cm
Museum Volkenkunde, Leiden

This bottle was brought back by the Dutch orientalist Snouck Hurgronje from his sojourn in Mecca (see p. 190). He was interested to test the water to find out its chemical composition.

Fig. 44 Left
Zamzam water container
Acquired in Mali in 2010
Plastic
Diameter 7 cm
British Museum, London

Fig. 45 Right
Zamzam water flask
China, 19th century
Porcelain, leather, string and sealing wax
22.5 x 12 cm
British Museum, London

Chinese porcelain exported to the Middle East was used as containers for Zamzam water. There are similar examples in Topkapi Palace, Istanbul.[5]

THE EARLY ISLAMIC HAJJ

The first Muslim Hajj after the surrender of Mecca to the Muslims in 630 was led not by Muhammad but by his close follower Abu Bakr, later (632–4) to be the first caliph of Islam. They went to Mecca, Mina and Arafat, the recognized Hajj sites. The sources make it clear that henceforth idolaters were to be forbidden to take part in the Hajj, which now became an exclusively Muslim pilgrimage. Abu Bakr also forbade the practice of performing the *tawaf* naked, which had been a characteristic part of some of the pre-Islamic rituals.

It was the 'Farewell Pilgrimage' of March 632, the year of the Prophet's death, that established the pattern of the Muslim Hajj as it is practised down to the present day. It was both the first and the last Hajj he led. The compilers of collections of Hadith repeatedly refer to Muhammad's pronouncements on such complex matters as the nature of *ihram* dress and the rituals to be performed at different times of the Hajj. While there may still have been debate about some of the procedures, the basic framework of a specifically Muslim Hajj had been established and, as far as we can tell from the historical record, apart from a short period during the First World War it has been performed by Muslims every year since then without interruption.

Muhammad himself had led the Hajj of 632 and in doing so, he established a precedent whereby the leadership of the Hajj was considered the responsibility of the leader of the Muslim *umma* (community), or his designated deputy. This was to have a profound effect on the nature of the Hajj, an effect which has lasted to the present day. Patronage of the Hajj became one of the indications of leadership of the wider Muslim world. Along with the leadership of the *jihad* or holy war in the form of the annual *sa'ifa* or summer expedition against the ancient enemy, the Byzantines, it was a sign of authority within the *umma*. Until the tenth century, the identity of the leader of the Hajj was always recorded in the major chronicles along with other major officers of state, provincial governors and so on. While the sources do not always give the same names for any given year, there is enough agreement to give us a general picture, and the attention the sources give to this issue shows how important the Hajj was considered as an expression of power and leadership of the *umma*. This brought with it obligations as well. With leadership of the Hajj went the responsibility for the safety and protection of the pilgrims, preserving them both from the

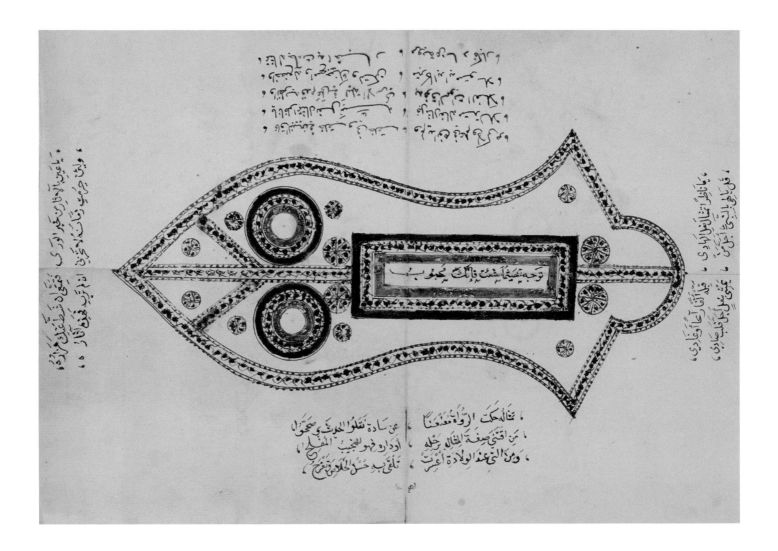

perils of thirst and hunger and the depredations of the Bedouin tribes who inhabited the areas through which the pilgrims passed. Failure to protect the Hajj could seriously undermine the standing of the ruler among all his Muslim subjects, as both the Abbasids in the tenth century and the Ottomans in the eighteenth were to discover.

The immediate successors of the Prophet continued the tradition of leading the Hajj in person. For thirty years after his death, until the accession of Ali in 656, the caliphs were based in Medina, conveniently close to Mecca. The evidence suggests that the caliph Umar ibn al-Khattab led the pilgrims every year of his reign (635–44) and his successor Uthman ibn Affan continued the

practice until the year of his death (656). This period of more than twenty years when the Hajj was led by the caliphs in person consolidated the idea that the leadership of the Hajj was a sign of the leadership of the entire Muslim community. Under Umar and Uthman this caused no real problems but when in subsequent years the caliphate was contested between rival claimants, control of Mecca and the leadership of the Hajj was an effective way in which the claimants could assert their rights. It was an important source of publicity at a time when Muslims from all over the Dar al-Islam (the lands of Islam) would gather and then take home to their land of origin, be it Spain or Central Asia, the news of who was in charge. When communications were necessarily slow and intermittent, the Hajj was a major forum for the dissemination of information. The leadership of the Hajj, and the whole gathering in fact, had become an important political issue. The early caliphs also began another

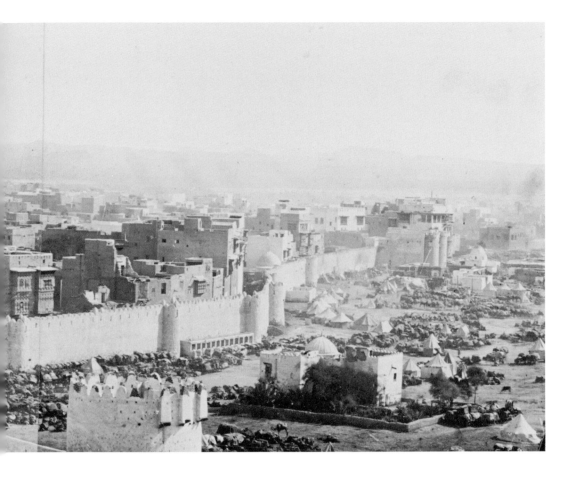

Fig. 47
View of Medina
Photo: Sadiq Bey, *c.*1880
Albumen print
24.2 x 46.5 cm
Victoria and Albert Museum, London

View of Medina from the north-west. In the background at the left of the photo can be seen the Prophet's mosque and tomb, with its four minarets. Beneath the coloured dome, situated underneath the third minaret from the left, is where the Prophet Muhammad is buried, along with the tombs of the first two of the 'Rightly guided caliphs', Abu Bakr (632–4) and Umar (634–44). Outside the walls of the city at the right are the camels, luggage and tents of pilgrims.[6]

tradition which was to be carried on by their successors: the beautification of the two holy cities and the construction of mosques and other facilities for the pilgrims. Umar made alterations to the *haram* and Uthman enlarged the mosques in both Mecca and Medina.

The regular personal involvement of the caliph with the Hajj came to an end with the accession of Ali in 656. This is not because it was thought to be unimportant but was a consequence of the fact that the centre of political power had shifted decisively away from Medina and the Hijaz, first to Iraq under Ali and then, under his rival and successor, the Umayyad Mu'awiya ibn Abi Sufyan (661–80), to Damascus. This meant that the caliph seldom led the Hajj in person, but the organization and protection of the pilgrims, as well as the appointment of their leader, remained an important function of rulership and expression of sovereignty.

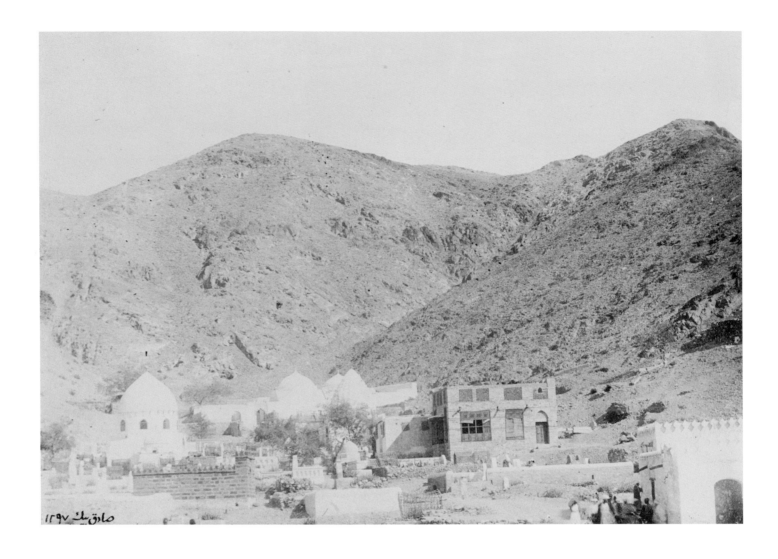

منيق شطا ١٢٩٧

Fig. 48
The Ma'la cemetery at Mecca
Photo: Sadiq Bey, *c.*1880
Albumen print
24.2 x 61.5 cm
Victoria and Albert Museum, London

*The cemetery contains tombs such as those
of the Prophet's mother, Amna, his first
wife Khadija, her great-grandfather Abd
al-Manaf and the Prophet's grandfather Abd
al-Muttalib. Pilgrims often went on ziyara
to these tombs while they were in Mecca
for Hajj.*[7]

Ali appointed cousins of his, all of course members of the Family of the Prophet,[8] to be his deputies as leaders of the Hajj, a tradition which was to be continued in one form or another until 1926. The first Umayyad caliph Mu'awiya also used the Hajj to emphasize his authority over the Muslim *umma*. He began the tradition that the caliph or other ruler should provide the *kiswa*, the embroidered covering of the Ka'ba, another way of demonstrating his leadership. He himself only made the Hajj twice – going every year from his base in Syria was hardly practical – but he always appointed members of his immediate family, brothers, cousins and nephews, to lead the pilgrims. In 671 he set a new precedent by appointing his son Yazid to lead the Hajj. This was an

openly political move. At this time the caliph was lobbying to have Yazid acknowledged as his heir, in the face of considerable opposition from those who were against what they saw as a drift to hereditary monarchy. In an attempt to overcome this opposition, Mu'awiya built up Yazid's status as a true Muslim leader of the *umma*, appointing him to lead the *sa'ifa*, the annual summer raid, and then to lead the Hajj, to publicize his position.

The political nature of the Hajj became more explicit in the decade that followed Mu'awiya's death in 680, as his son tried to maintain his authority. The major open challenge to his rule came in the form of a struggle to control the Hajj and with it public opinion in the wider Muslim world. With Yazid far away in Syria, a number of his opponents sought to attract the loyalty of the pilgrims and the Hajj became the theatre in which the high drama of Muslim politics was played out. The historian al-Ya'qubi makes the importance of this explicit: 'People say', he writes, 'that the caliphate rightly belongs to whoever controls the Haramayn [Mecca and Medina] and leads the Hajj for the people'.[9] Among these were a Kharijite[10] leader called Najda and the Prophet's grandson al-Husayn ibn Ali, soon to be martyred by Yazid's troops at Karbala in Iraq, but the most powerful and threatening of these opponents was Abdallah ibn al-Zubayr. Abdallah's father, one of Muhammad's earliest and staunchest supporters, had been killed fighting against Ali at the Battle of the Camel (656) in southern Iraq, but his son had inherited much of his Islamic status (*sabiqa*). On hearing of Yazid's accession, he left the comparative comfort of Medina where, like many of the early Muslim elite, he had been living, and went to Mecca to establish himself in the *haram*, determined to use the Hajj to challenge and undermine Umayyad power. He was supported by many of the old families of the *muhajirun*, those who had accompanied Muhammad on his *hijra* from Mecca to Medina in 622. He stood for the return of the caliphate from distant, and still largely non-Muslim, Syria to its homeland in Mecca and Medina and getting back to the pious simplicity of early Islam. Possession of the Ka'ba and leadership of the Hajj were central to his vision.

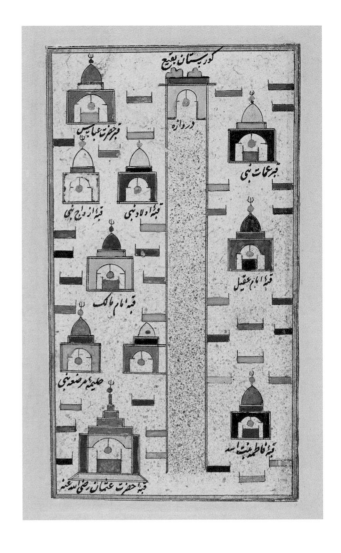

Fig. 49
The Guristan Cemetery of Baqi in Medina, fol. 51a of the Futuh al-Haramayn
22.7 x 14.2 cm
Chester Beatty Library, Dublin

Near the upper edge of the illustration is an arched gate at the top of a road running through the cemetery, and either side are a series of domed tombs described as qubbas, which include those of the Prophet Muhammad's wives, his children and Halima, his wet-nurse, all on the left. The tomb of Fatima is shown on the bottom left.

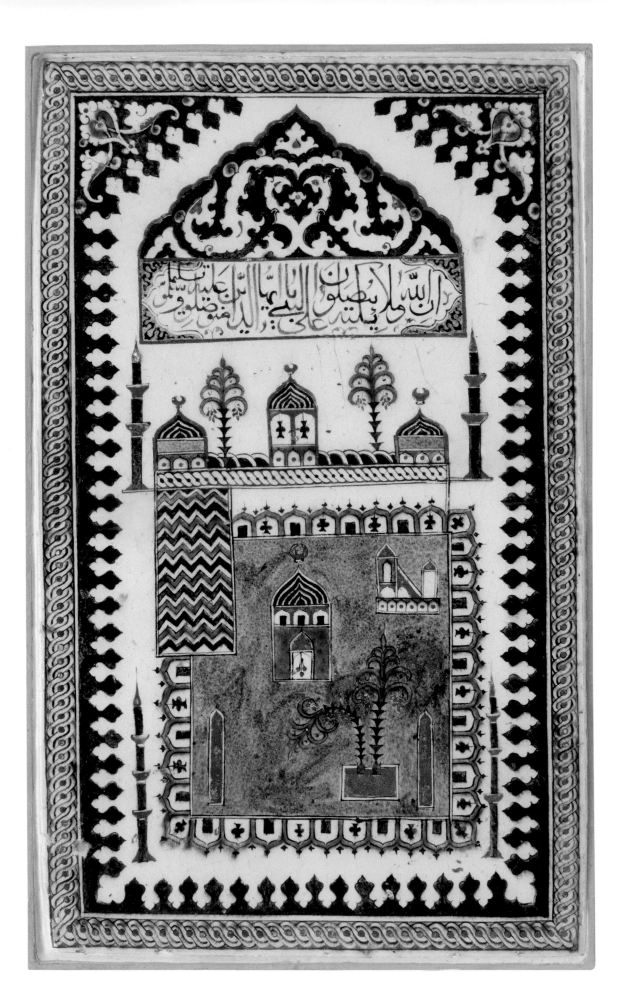

Fig. 51 Left
Plan of the mosque of the Prophet
at Medina

Fig. 50 Opposite page
Medina tile
Iznik or Kutahya, Turkey, c.1640
59.8 x 36 cm
Musée du Louvre, Paris

*The sanctuary at Medina is depicted as a
large courtyard open to the sky, surrounded
by arcades and with four minarets. As can
be seen from the plan, this is not an exact
representation. Clearly identifiable within
the courtyard are the pulpit (minbar) of the
Prophet and his tomb, which is decorated
with a chevron pattern characteristic of the
actual textiles designed to cover his tomb.
Two other domes may imply the presence of
other mihrabs. To the left of the pulpit is a
domed structure where the oil for the lamps
was kept. Below is Fatima's garden in which
are two palm trees planted at the time of
the Prophet. The two rectangles on either
side may represent lamp stands for lighting
the courtyard. At the top of the panel is a
verse from surat Ahzab (33:56), 'God and
His angels send blessings on the Prophet. O
you who believe send blessings to him and
salute him with all respect.'*

In-plan labels:

Store rooms · Qur'an School · Bab al-Majidi · Qur'an School
Majidiyya Minaret · Suleymaniyya Minaret
Open Court
Women's Prayer Section
Fatima's Garden · Well
N
Mihrab
Bab al-Rahma
Minaret
Platform
Bab al-Nisa
Storeroom
Mihrab al-Tahajjud
Bab Jibril
Fatima's Tomb
Platform
The Rowdha Garden of Paradise
Tombs of the Prophet Muhammad, Abu Bakr and 'Umar
Bab al-Salam
The Prophet's Minbar
Mihrab of the Prophet
Minaret · Mihrab of Suleyman · Mihrab of 'Uthman · Minaret

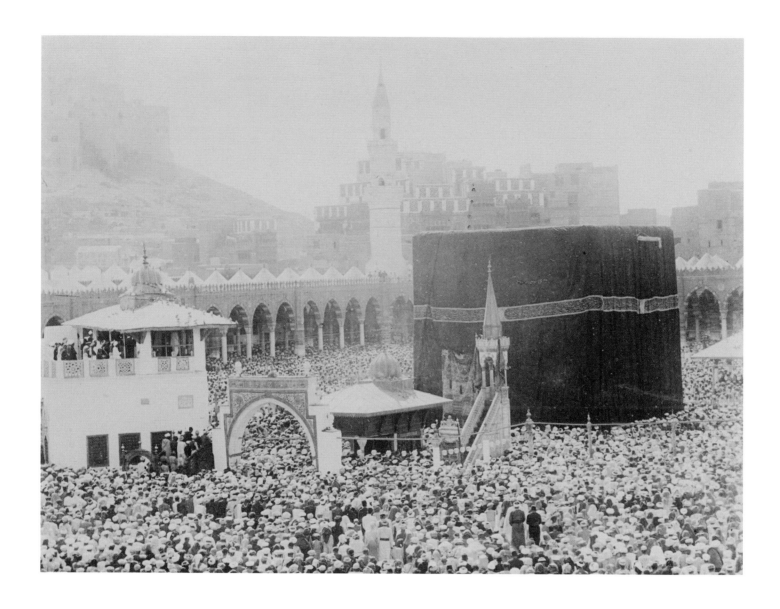

In 680, the first Hajj of Yazid's reign, Ibn al-Zubayr refused to acknowledge the caliph's representative and led his own supporters in separate prayers. In the Hajj of 682 there were no less than three separate assemblies at Arafat, one led by the Umayyad representative, another by the Kharijite Najda and a third by Ibn al-Zubayr: the three groups returned from Arafat quite separately, following their own leaders. Finally Yazid sent a military force to the Hijaz to re-establish Umayyad control. Mecca was besieged and the Ka'ba itself bombarded with catapults and largely destroyed, but the Umayyad attempt

came to nothing when news arrived of Yazid's death (from natural causes) and his forces returned to Syria.

Ibn al-Zubayr was now unchallenged ruler of Mecca and leader of the Hajj. While the Umayyads quarrelled among themselves in distant Syria, he set about rebuilding the Ka'ba. The structural history of the Ka'ba is not entirely clear and it has never, for obvious reasons, been the subject of any archaeological investigation,[11] but there are a number of early Arabic accounts which describe the work. The reconstruction of the Ka'ba was remembered in Mecca and the traditions about what happened were later recorded by the first historian of the city, al-Azraqi (d. *c.*864). Al-Azraqi himself was said to have been descended from a Greek slave (the surname Azraqi referring to his blue eyes) who had been an early convert to Islam and whose family had thus entered the exclusive ranks of the Meccan aristocracy. It was from these circles that he acquired his historical information.

It is clear from al-Azraqi's account that the reconstruction of the damaged Ka'ba was fraught with difficulties.[12] There were many in the city who felt that it should not be tampered with and was better left as a ruin, but Ibn al-Zubayr was not having any of this. He set out to reconstruct the Ka'ba as he believed Abraham had first built it.

'Ibn al-Zubayr called upon the elite of the people and questioned them on whether he should tear down and rebuild the Ka'ba. Many of them advised him against tearing it down. It was Abdallah ibn Abbas who said he should leave it as was, as the Prophet had, because he feared that destroying it would set a precedent for future generations to tear it down and rebuild it. So he advised him to merely renovate it.' It was the classic dilemma facing conservationists and restorers through the ages.

'Ibn al-Zubayr answered: "By God, is there no one among you who would not mend the house of his parents, so how would you wish me to do otherwise with God's House, when I watch it falling apart piece by piece? When even the pigeons sit on its walls, and the stones fall down."

'Ibn al-Zubayr asked around for advice for days, and he finally decided to tear down the building. He wished to be the one to rebuild it, according to what the Prophet had described to Aisha [i.e. the form of Abraham's Ka'ba].' The idea was not to create a new structure but rather to reconstruct an older and more authentic, but now vanished, original.

Fig. 52
The *haram* during Hajj
Photo: Sadiq Bey, *c.*1880
Albumen print
21.2 x 61.5 cm
Victoria and Albert Museum, London

View of the Ka'ba from the north-west. From left to right can be seen the building erected over the Zamzam spring, Bab Bani Shayba, Maqam Ibrahim, the holy mosque's main minbar, *and behind it the Ka'ba itself. The photograph shows the holy mosque full of pilgrims, during one of the five daily prayers.*

Not everyone was convinced. 'When he had collected the stones and he was ready to begin the demolition, the Meccans evacuated the city and went to Mina because they were afraid that [divine] punishment would befall them for demolishing it. When Ibn al-Zubayr ordered the work of demolition to begin, no one dared to do it. When he saw this, he climbed it himself, took up the pick and started dismantling it himself. When the rest saw that nothing had happened to him, they got up to assist him. They demolished it with the help of the people, and by the time the sun was descending the walls of the building were leveled to the ground on all sides. This took place on Saturday 15 Jumada in the year 64 AH [8 February 684].' But how could the Muslims pray in the (temporary) absence of their *qibla*, the Ka'ba? Ibn al-Zubayr had the answer: 'He put up around the Ka'ba a wooden frame to which he attached cloth curtains so that the people could circumambulate outside it and pray.'

A further cause of contention was the new design. Based on his understanding of the Abrahamic Ka'ba, Ibn al-Zubayr made two doors in his new building so that people could go through it. He also attached the small semi-circular enclosure known as the *hijr*. Both these innovations were regarded as suspect by the traditionalists.

Stone came from quarries around Mecca, gypsum for the mortar from Yemen. 'He started building on that foundation and put the threshold of the door of the Ka'ba on top of one layer of marble close to the ground level and he located the back door in the same manner – the threshold consisted of a long green marble stone – in the back of the Ka'ba, close to the Yemeni corner. And the building went on behind the curtains at the same time as the people were circumambulating outside it.'

Naturally, the placing of the Black Stone was of major importance. When the old Ka'ba was demolished, Ibn al-Zubayr had wrapped the stone in brocade, taken it to his own house and put it in a chest for safekeeping. When the walls of the new Ka'ba reached the appropriate height, he 'ordered that it be placed between two courses of stone . . . carved to match its size. When the place was prepared, Ibn al-Zubayr ordered his son Abbad ibn Abdallah along with Jubayr ibn Shayba[13] to put the stone in a cloth. Ibn al-Zubayr instructed them, "When I begin praying the noon prayer, carry it out and put it in its place". When the prayer was begun and Ibn al-Zubayr had made his first prostration, Abbad came out of the door of the Dar al-Nadwa [Ibn al-Zubayr's house] carrying the

stone, and Jubayr ibn Shayba was with him. They passed through the rows of people praying and entered the curtain surrounding the building. Abbad ibn Abdallah put the stone in its place, assisted by Jubayr ibn Shayba.'

The stone itself was not in good shape. 'It had been cracked by the fire into three parts. A splinter had chipped off it and it was preserved by some of the Banu Shayba for a long time after that. Ibn al-Zubayr held it together with silver nails, except for the splinter from its top, whose position is clear. The length of the stone is two cubits[14] and it occupies the thickness of the Ka'ba wall. The rear face inside the wall is carved something like a molar tooth with three roots.

Fig. 53
A stone from Heaven
Shadia Alem, 2009

Born in Mecca, Alem's family have been involved with the care of the sanctuary and the Hajj for generations. She herself has inherited the title mutawwif. *She describes the black stone as follows: 'A stone touched and kissed by millions through the ages, believed to enhance memory and learning ability. And thus is transformed into a sculpture, sculpted by human wishes and desires' (pers. com. 2011).*

Ibn Jurayj[15] said, "I heard someone who described the colour of its rear face inside the wall. Some said it was rosy, others said it was white".'

'He built the Ka'ba twenty-seven cubits in height[16] and it consisted of twenty-seven courses of stone, and the thickness of the wall is two cubits. Inside he put three pillars . . . Ibn al-Zubayr sent to Yemen for the marble known as *balaq*[17] and he put it on the apertures that are in the ceiling for light. The entry to the Ka'ba used to be a single panel door but he made it a double door with the height of eleven cubits from the ground to the top and he made the back door

Fig. 54
Black Cube II
Kader Attia, 2005
Oil on canvas
200 x 200 cm
Galerie Christian Nagel, Berlin

This painting is one of a series that Attia has created, inspired by the form of the Ka'ba. For the artist, the Ka'ba is what links man and God as the centre of all things, drawing Muslims everywhere to want to touch it. Kader Attia was born in 1970 into an Algerian family in Paris. He studied at the École Supérieure des Arts Décoratifs in Paris and at Barcelona's Escola de Artes Applicades. He held his first solo exhibition in 1996 in the Democratic Republic of Congo, and since then has exhibited regularly throughout the world.

the same size. Inside he made a wooden ladder at the Syrian corner whereby to ascend to the roof. When Ibn al-Zubayr had finished building it, he perfumed it inside and out, top to bottom and draped it with the Egyptian linen cloth known as *qubbati*.'

There can be little doubt that the Ka'ba as it exists today is essentially the building designed and constructed by Ibn al-Zubayr as described by al-Azraqi. The dimensions are broadly comparable, the building stands on a marble foundation and is constructed from courses of grey-blue stones from the hills around Mecca. It has three wooden pillars to hold up the ceiling with a ladder leading to the roof. Given the reverence with which the structure is regarded, we can be certain that any substantial changes would have been the subject of much discussion which would have left traces in the evidence. Some alterations were made when it was repaired after a second bombardment in 693; in particular, one of the two doors Ibn al-Zubayr had inserted into the walls was blocked up. There were also extensive renovations in 1630 after flood damage, but the old materials were used as much as possible and the general form of the ancient building was retained.[18]

Ibn al-Zubayr may have been rightly proud of his achievement in rebuilding the Ka'ba, but he was not to enjoy it for long. In 693 the young and determined Umayyad caliph Abd al-Malik (685–705) sent his most trusted military commander, al-Hajjaj ibn Yusuf, supported by another commander, Tariq ibn Amr, to the Hijaz to establish Umayyad control over the holy places. The caliph is said to have wanted to avoid the use of force, but al-Hajjaj had no such scruples. He ordered his men to prepare to make the Hajj. When they reached Mina they found that a catapult had already been set up on the hill of Abu Qubays overlooking the city. The siege and bombardment of Mecca began at the end of March. When the Hajj formally began on the first of May, both sides attempted to perform the rites as far as possible. Al-Hajjaj claimed to be leading the Hajj but he did not perform the *tawaf*, nor did he wear the *ihram* clothing. Instead he led the pilgrims at Arafat, mounted on a horse and wearing a coat of mail. Meanwhile Ibn al-Zubayr, who was confined to Mecca, sacrificed camels on the Day

Fig. 55
Gold dinar struck by the caliph
Abd al-Malik, probably at Damascus,
79 AH/AD 698
Diameter 2 cm
British Museum, London

of Sacrifice but was unable to go to Arafat. During this temporary truce, ordinary pilgrims were allowed to perform all the rituals of the Hajj, visiting the Ka'ba to perform the *tawaf* and going to Arafat for the *wuquf*.

As soon as the Hajj was over, the fighting began again. By now Ibn al-Zubayr and his men were running short of supplies and the bombardment was taking its toll. One eyewitness[19] is said to have recalled, 'The stones of the catapult were thrown at the Ka'ba until the *kiswa* became rent like the bosom of a woman's blouse. A dog was hurled by the mangonel at the Ka'ba and it fell into a pot in which we were cooking bulgar. We took the dog and found it was fleshy and it was more filling for us than the bulgar.'[20] Despite the fact that he was considered a rebel by many, the Arab historians present Ibn al-Zubayr's final hours in unmistakably sympathetic terms. On 4 October, six months after the siege had begun, the Syrian soldiers forced their way into the *haram*. Ibn al-Zubayr had spent most of the night praying. Then he sat with his legs braced against his belly with the shoulder belts of his sword around him and slept lightly. At dawn he awoke and ordered that the call to prayer be sounded. Then he attacked the enemy once more, having, according to some accounts, taken off his armour to achieve martyrdom more swiftly. He was hit in the face by a brick and began bleeding. The enemy were soon on him and he was slain. As the Umayyad commanders stood over his dead body, Tariq said, 'Women have borne none manlier than he'. Al-Hajjaj said, 'Will you praise one who disobeys the Commander of the Faithful?' 'Yes', said Tariq, 'He has freed us from blame. Were it not for his courage we would have no excuse. We have been besieging him for seven months. He had no defensive trench, no fortress, no stronghold; yet he held his own against us as an equal and even got the better of us whenever we met with him.' These words were reported to the caliph 'Abd al-Malik, who declared that Tariq was right.[21]

Ibn al-Zubayr had effectively controlled Mecca and the Hajj for a decade, in defiance of the Umayyads, and this period may have had an important artistic legacy. Some Arab historians[22] say that the caliph Abd al-Malik was very reluctant for his Syrian subjects and supporters to make the Hajj to Mecca and perhaps be influenced by his arch-enemy. He decided to encourage them to make their Hajj to a Syrian shrine instead, and he ordered the construction of the Dome of the Rock in Jerusalem. There are good reasons for thinking that there may be some truth in this suggestion. Jerusalem was, after all, a holy city

in Islam and the *qibla* to which the earliest Muslims had prayed before they had been turned towards Mecca. The form of the building, with its centre plan and wide aisles, looks very much as if it was designed for making the *tawaf*: it is certainly very different from congregational mosques of the same period, including the nearby Aqsa. The objection that no Muslim ruler would want, or be able, to challenge the sanctity of the Ka'ba and the *haram* at Mecca essentially misses the point: the Jerusalem shrine was an alternative which the pious could choose while Mecca was in hostile hands.

After the dramas of Ibn al-Zubayr's time, the rest of the Umayyad period was comparatively peaceful in the Haramayn, and the Hajj was led each year from Syria, sometimes by the caliph himself but more often by one of his relatives. In 695 Abd al-Malik decided to make the pilgrimage in person to make it clear both to the pilgrims and to the people of the holy cities that he was now in charge. The additions Ibn al-Zubayr had made to the Ka'ba, the extra door and the link with the *hijr* enclosure, were swept away, as though to erase all memory of him.

Fig. 56
Figurine of camel and rider
Iraq or Syria, probably 8th–9th century
Ivory
25.5 x 24.5 cm
Nasser D. Khalili Collection of Islamic Art

The figurine represents an Arabian dromedary with an elaborate fringed harness and saddle blanket. The rider wears a long tunic decorated with herring-bone designs and is represented side-saddle. It is carved from four large pieces of ivory, with an additional nine small pieces held together with ivory and metal pegs and decorative studs.

It was the first and last Hajj that Abd al-Malik made. His son and successor al-Walid (705–15) made the Hajj just once, in 710, but he encouraged the pilgrimage in other important ways. When the leaders of the Muslim community lived in Medina, as did the first three caliphs, or even in Mecca like Ibn al-Zubayr, the question of travelling to the holy places hardly arose. But with the government now firmly based in Syria, the Hajj caravan began for the first time to be an important part of the performance of the Hajj. The Umayyad who was leading the pilgrims now set out from Syria accompanied by those Syrians who wanted to perform the rites. An early papyrus shows the caliph writing to Egypt to order those Egyptians who wanted to go on pilgrimage to meet him at Aqaba. We know little about the organization of the Hajj caravan at this stage, which would certainly have been a simpler affair than the great parades organized by their Abbasid successors. Nonetheless the caliph al-Walid took measures for the first time to make the road easier for the pilgrims. He ordered the governor of Medina to dig new wells in the Hijaz, he cleared the roads through mountain passes and improved the provision of drinking water in Mecca itself. The Umayyad caliphs wanted to show themselves as true leaders of the Muslim community, encouraging the faithful to perform the Hajj and making it safer and more comfortable for them to do so.

The last of the great Umayyad caliphs, Hisham ibn Abd al-Malik (723–43), made a point of leading the Hajj in the second year of his reign. A careful and methodical man, he had aqueducts and water tanks built along the road from Syria. He travelled in some style, reportedly bringing six hundred camels to carry his baggage, and took care to familiarize himself in advance with the rituals so that he could perform them in the proper manner.

THE HAJJ UNDER THE ABBASID CALIPHS

In 750 the Umayyads were overthrown by the supporters of the Abbasid family in a complex political and military upheaval known to modern scholars as the Abbasid Revolution. The coming of the new regime changed the nature of the Hajj very significantly and the first half-century of Abbasid rule, from 750 to the death of the caliph Harun al-Rashid in 809, can be seen as something of a golden age for the Hajj. The pilgrimage and its rituals formed a central part of Abbasid policy for the caliphate and the projection of its power in the wider Muslim community.

Fig. 57
Map showing Hajj routes across Arabia

This map illustrates the main Hajj routes across Arabia from the early Islamic period to the mid-twentieth century. In many cases the pilgrim routes followed the ancient trade routes, although there were many more trade routes than are shown on this map. The Darb Zubayda (Zubayda's road), marked in red, was the most significant of the early routes and was extensively developed during the era of the early Abbasid caliphs (750–1258), whose capital was Baghdad. The Darb Zubayda included twenty-eight stops and its official point of departure was Kufa.

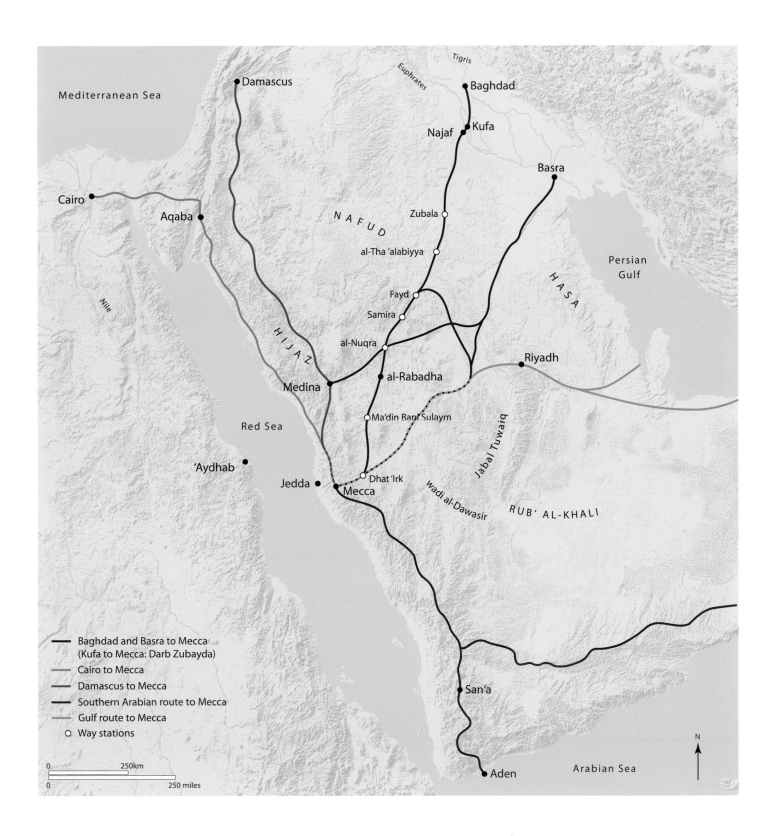

Mediterranean Sea

Damascus

Baghdad

Tigris

Euphrates

Najaf
Kufa

Basra

Cairo

Aqaba

N A F U D

Zubala

H A S A

Persian
Gulf

al-Tha'alabiyya

Nile

Fayd

Samira

al-Nuqra

Riyadh

H I J A Z

Medina

al-Rabadha

Ma'din Bani Sulaym

Red Sea

Jabal Tuwaiq

'Aydhab

Jedda

Dhat 'Irk

Mecca

wadi al-Dawasir

RUB' AL-KHALI

San'a

Baghdad and Basra to Mecca
(Kufa to Mecca: Darb Zubayda)
Cairo to Mecca
Damascus to Mecca
Southern Arabian route to Mecca
Gulf route to Mecca
○ Way stations

N

0 250km
0 250 miles

Aden

Arabian Sea

Fig. 58
Milestone from the Darb Zubayda
Late 8th century
Granite or basalt
50 x 42 cm
National Museum of Saudi Arabia, Riyadh

This milestone was found on the Darb
Zubayda, a route used by the pilgrims as
well as for the postal and communications
*system (*barid*) that had been established by*
the Umayyad caliph Mu'awiya (661–80).
The text reads: 'mil min/al-barid wa huwa
ala i/thnayn wa sittin/barid min/al-kufa':
'one of the barid *milestones 62* barid *from*
Kufa'.[23] Surviving Abbasid period milestones
use two kinds of measurements: the distance
in miles and in postal stages. The caliph
al-Mahdi is recorded in 777 as placing
milestones along the Kufa to Mecca route.[24]

The most obvious change was the result of the transfer of power from Syria to Iraq, first to a variety of capitals in the area of Kufa and then, in 762, to Baghdad. This meant that the official, caliph-sponsored pilgrimage caravan now came from Iraq across the deserts of what is present-day northern Saudi Arabia to the holy places. While the journey from Syria had certainly been arduous, especially when the Hajj fell in summer, the journey from Iraq was more difficult and there were long stretches without natural water supplies. The Abbasids made considerable efforts to ease the paths of the faithful by

constructing a series of cisterns and way stations collectively known as the Darb Zubayda, which far surpassed any of the road improvements of the Umayyad period.

The Abbasid caliphs proclaimed themselves members of the House of the Prophet who would restore a genuinely Islamic system of government. There could be no more important role for the caliphs than to safeguard the Hajj, not just from human enemies but from the perils of hunger and thirst. Most of all they should be able to look after the poorer pilgrims, who could not afford their own camel trains or the high prices often charged for water and supplies en route. More than their Umayyad predecessors, the early Abbasids took it upon themselves to organize the Hajj caravans.

The result was the most important and impressive civil engineering project undertaken in the entire early Islamic world, the so-called Darb (path or road) Zubayda.[25] The Darb Zubayda project aimed to provide water supplies, food and camping places in easy day's journeys along the entire route between Iraq (from Kufa initially but after 762 from the new capital at Baghdad) to the holy cities. It was an immense undertaking. There were only one or two natural oases along the route, notably Fayd about halfway through, where there were regular supplies of water. Furthermore, much of the route ran across flat, stony plains, without any natural features to guide the traveller and very hard going on sandalled feet. The Abbasid authorities set out to provide solutions for all these problems. At its height the caliphate had the capacity for organization and construction on a scale not seen since the Roman empire.

The works are conventionally ascribed to Zubayda bint Ja'far (d. 831), granddaughter of the caliph al-Mansur and wife and companion of Harun al-Rashid (786–809). She was a woman of enormous wealth with her own estates, secretaries and administrators and, in early Islamic society, she could use this wealth as she wished. There was almost a sense of competition in pious generosity and display between her and her husband, and later generations remembered her, not him, as the great benefactor of the Muslims. She was not the first woman from the ruling family to spend her wealth on improving the lot of the pilgrims.[26] Al-Khayzuran (d. 789), the favourite of the caliph al-Mahdi (775–85) and Harun's mother, made the pilgrimage at least twice in 776 and 788, and on her second visit purchased the House of the Prophet in Mecca and converted it into a mosque. Later Shaghab, mother of the caliph al-Muqtadir

Fig. 59
Way marker (reconstructed)
Photo: John Herbert, 1983

*One of a number of way markers and fire signals (*manar*) that would have been placed on the route to guide the pilgrims, this is situated close to al-Rabadha.*

(908–32), made many charitable donations to the holy cities and donated a million dinars a year from her estates for the support of the pilgrims.

In fact, the creation of this infrastructure began before Zubayda's involvement, attracting the patronage of many other rich and influential people in the elite of the caliphate, but there can be no doubt that her contribution was the most important. As early as 751, the first Hajj after the coming of the Abbasids, we are told that the caliph al-Saffah (750–4) ordered that fire signals (*manar*) and milestones (*amyal*) should be set up on the route between Kufa in Iraq and Mecca.[27] Many pilgrims chose to travel during the hours of darkness when it was much cooler, and fire signals to point the way would have been very helpful. Milestones (in Greek) were a feature of the Roman road network in the Middle East, and many early Muslims would have been familiar with them. The Umayyad caliph Abd al-Malik (685–705) had erected Arabic-language milestones along routes in Syria, and the Abbasids followed his example. Just two of these milestones have been preserved and discovered in the present day, but they show that the route was well marked. One gives distances in (Roman) miles, the other in stages (days' journeys).[28]

The provision of water was the most fundamental aspect of looking after the pilgrims. The most important features of the infrastructure, the *birak*, were basically tanks or small reservoirs for collecting rainwater and runoff from the shallow wadis (intermittent watercourses) of northern and north-eastern Arabia. Water from the spasmodic and occasional rains would be channelled into these tanks and, when the system was working at its best, would be stored there until the time of the Hajj when the pilgrims could make use of it. Numerous well-spaced *birak* were built along the trail in a sophisticated feat of engineering. For a start they had to be carefully positioned at the intersection of a number of wadis so that the water would flow into them naturally; without mechanical pumps, all movement depended on gravity. Then the water had to be held so that it did not leak away and yet be made accessible to those who needed it. The classic Abbasid-period *birak* on the Darb Zubayda were square or rectangular tanks, 30–50 m (100–165 ft) along the sides and about 5 m (16 ft) deep. They were built of stone, usually coursed rubble, and some were lined with plaster to prevent leakage. There were often semi-circular or, less commonly, rectangular buttresses, but since the *birak* were dug down below ground level, the buttresses were on the inside so that the weight of the surrounding sand

and rock did not collapse the sides. Many were provided with well-built steps so that the pilgrims could walk down to the water level. The technology was effective but obviously required regular maintenance: sand blew in, entrance channels became clogged up, and even the best-built walls needed attention. If the patronage that supported them, whether private or state, disappeared, then it would not be long before the system fell into decay.

Wells seem to have been less important than *birak* for the provision of water, perhaps because the water tables were very deep, but they still played a part. Some of these wells, unlike the *birak*, have continued in use down to the present day, and many are superb pieces of small-scale engineering, beautifully lined with cut stone. There were also fortifications and various houses, caravanserais (*khans*) and other kinds of accommodation, but time and the elements have

Fig. 60
Birkat al-Aqiq
Photo: Alex Sykes, 2008

Birkat al-Aqiq was one of several water reservoirs on the Darb Zubayda. While most have dried up, Birkat al-Aqiq still fills with water periodically, depending on the weather conditions.

Fig. 61
Circular reservoir at al-Rabadha
Photo: John Herbert, 1983

*Built of cut limestone and plastered with
gypsum, the reservoir (one of two discovered
at al-Rabadha) is 64.5 m in diameter and
4.7 m in height. Next to it is a rectangular
filter tank. Flood water was taken in by
means of two inlets which slope into the
filter. When the filter was full the water
drained through an overflow channel
into the reservoir. On the southern side
two staircases led from a podium into the
reservoir. At capacity the reservoir would
have contained about 14,250 cu m, which
would have sustained the inhabitants of
Rabadha, pilgrims and other travellers and
their animals.[29]*

been hard on them; the surviving examples are not very impressive and none has yet been excavated. Most of the pilgrims either stayed in tents they brought with them or simply slept in the open, wrapped up in their cloaks.

Finally there was the road surface itself. The tradition of paved Roman roads had died out in the Middle East long before the Muslim conquests of the 630s. Pack animals had replaced carts and paved roads were no longer necessary. But stones in the road were still an obstacle for men and beasts, and even today we can see where care has been taken to remove stones to create a flat pathway and there are stretches, especially where the sand was thick and soft, that have been carefully paved. The surviving remains of the works on Darb Zubayda are testimony to the importance of the Hajj and the commitment of the early Abbasid government to safeguarding and making it as easy as possible, asserting their position as leaders of the Muslim *umma*.

Umayyad caliphs had only led the Hajj once or twice during their reigns, but the Abbasids participated in person more often. Al-Mansur made the Hajj three times in the twenty years of his reign. In 775 he had intended to lead it for a fourth time but died of a stomach complaint just as he was entering the sacred area. His body was wrapped in a shroud but his head was left exposed because he was in a state of *ihram*, preparing for the pilgrimage he never completed. It was taken to Mecca and buried on the heights overlooking the city. Immediately after his death it was imperative to administer the oath of allegiance to his son and successor, who was not with his father at the time, and the pilgrims took the oath between the corner of the Ka'ba and the Maqam Ibrahim.

The new caliph al-Mahdi (775–185) pursued a more clearly Islamic agenda in his politics, and for him the Hajj was a perfect theatre for demonstrating his piety, wealth and generosity. In 777 he made his first Hajj as caliph, which was a magnificent occasion.[30] He distributed immense largesse among the people of the holy cities. It is said that he brought with him thirty million silver dirhams from Iraq as well as three hundred thousand gold dinars from Egypt and two hundred thousand from Yemen.[31] All of this was given away. In addition to the cash, he also handed out large numbers of garments. High-quality textiles, often made by the *tiraz*, the state-owned textile factories, were frequently used as gifts and marks of honour and respect. The caliph is said to have distributed a hundred thousand robes of one sort and fifty thousand of another. The numbers may be exaggerated but the impression is quite clear:

the caliph used the occasion of the Hajj to mount a spectacular display of his wealth and generosity. The beneficiaries were the people of the Haramayn, including many members of the different branches of the Family of the Prophet and Companions of the Prophet. This certainly helped to win them over to the Abbasid cause, and the returning pilgrims would take reports of this great display all over the Muslim world. When Ibn Jubayr went on pilgrimage four centuries later, he found numerous monumental inscriptions in the name of al-Mahdi, testifying to his generosity and the publicity that accompanied it.

One small detail is worth noting. We are told that while al-Mahdi was in Mecca, Muhammad ibn Sulayman brought ice to him and that this was the first time that ice, for cooling drinks, had been brought to a caliph on the Hajj. Let us pause for a moment to think what this means. We know a great deal

Fig. 62
Aerial view of Darb Zubayda
Photo: John Herbert, 1983

The Darb Zubayda crossed lava fields (harra) south of Mahd al-Dhahab. This part of the route was inhospitable and devoid of vegetation, and the remarkable feature was that the volcanic stones had been cleared and heaped to one side. The width of the road varied between 2 and 20 m. The Abbasid prince Isa ibn Musa (d. 783) is said to have first established this part of the road.

Al-Rabadha on the Darb Zubayda

Al-Rabadha was one of the principal cities on the Darb Zubayda. Its soil was fertile and as a *hima* (protected area) its excellent pastures were reserved for the grazing of camels and horses to be used for the Muslim armies. The caliph Umar annually drew 40,000 camels from al-Rabadha for the purposes of *jihad*. It was famed for the nutritious plant *hamd* and camels who ate their fill of it were reputed to be able to travel for long distances without further food. Prominent historical figures including grammarians and reciters of Hadith resided in the city and princes and caliphs often spent periods of time there. Al-Rabadha suffered in the mid-tenth century at the hands of the Carmathians, who attacked the city and caused its inhabitants to flee. When the geographer Muqadasi passed by there a few years later he found it a desolated ruin. Excavations begun by King Saud University in 1979 recovered houses, mosques, wells, cisterns and a cemetery and a remarkable range of objects (shown here) dateable between the seventh and tenth centuries, some traded from Iraq and elsewhere, which give a remarkable insight into the daily life of this vibrant community.

Fig. 63
Bone figurine with painted decoration
8th–10th century
Height 5.3 cm
King Saud University Museum, Riyadh

Fig. 65
Earthenware cup, glazed and painted in
blue and green
9th–10th century
7 x 8 cm
National Museum of Saudi Arabia, Riyadh

*The ceramic finds include typical pottery
produced in Iraq and unearthed at major
archaeological sites such as Samarra.*

Fig. 66
Earthenware bowl decorated
in lustre
9th–10th century
4 x 12 cm
King Saud University Museum, Riyadh

Fig. 64
Fragment of painted wall decoration
48 x 185 cm
National Museum of Saudi Arabia, Riyadh

*This fragment is probably from one of the
houses of al-Rabadha. It is inscribed in kufic
script with the phrase 'In the name of God
the Merciful the Compassionate there is no
God but He'.*

Fig. 67
Steatite incense burner
7th–10th century
5.6 x 23 cm
King Saud University Museum, Riyadh

Fig. 68 Above
Blown glass bottle
Excavated at al-Rabadha, 8th–10th
century
Height 11.5 cm
National Museum of Saudi Arabia, Riyadh

Fig. 69 Opposite
View of the sanctuary at Medina, from
a Hajj certificate
Mecca, 17th–18th century
Opaque watercolour, gold, silver and ink
on paper
65 x 46.6 cm
Nasser D. Khalili Collection of Islamic Art

*The tomb of the Prophet Muhammad is
under a green dome, his cenotaph covered
with a green and white textile (also seen
on the Medina tile, see fig. 50). Below is
the tomb of the Prophet's daughter Fatima
with the characteristic palm trees that she
planted in her garden.*

about Muhammad ibn Sulayman. He was a cousin of the caliph and governor of the southern port city of Basra, where his family had extensive properties and commercial interests. (He also had a reputation for never throwing anything away: when they cleared out his house after his death, they found the clothes he had worn as a schoolboy still with ink stains on them and, rather less attractively, huge amounts of rich and luxurious food, completely rotten, inedible and very smelly.) He was in short very rich and very well connected.

But even for a man with his resources, bringing ice to Mecca was something of a tour de force. The pilgrimage this year fell in September, at the end of a long hot summer. The ice must have been collected in the high Zagros mountains of western Iran during the winter and packed in icehouses where it was kept cool enough not to melt. How it was then transported across the Arabian desert in the summer we cannot tell, though the containers must have been very well insulated. It was a spectacular offering, almost a miracle, which demonstrated the wealth and organizing power of the caliphate. And we must imagine that pilgrims from all over the Muslim world would have returned to their homelands to tell of what they had seen.

Al-Mahdi also embarked on a job creation project. The *ansar* (helpers), the people of Medina, had been very poorly represented in the military elite of the early caliphate, which was dominated by Quraysh and other, Bedouin, tribes and increasingly, in the early Abbasid period, by men of Iranian origin. He now recruited five hundred of the *ansar* as a special guard, with enhanced salaries, and when they reached Baghdad with him, they were given plots on which to build houses.

He also set about beautifying the holy places. The mosque of the Prophet in Medina, which had already been enlarged by the Umayyad caliph al-Walid, was again extended. When al-Mahdi reached Mecca the guardians of the Ka'ba told him that they were afraid that the weight of the *kiswas*, which had been placed one on top of another over the building, was in danger of causing it to collapse. He ordered that all the old coverings should be removed until the building was completely uncovered and then a new one put on. They found that the covers from as far back as the time of the Umayyad caliph Hisham were all made of fine thick silk brocades, but that earlier they were made of thinner fabrics from Yemen.

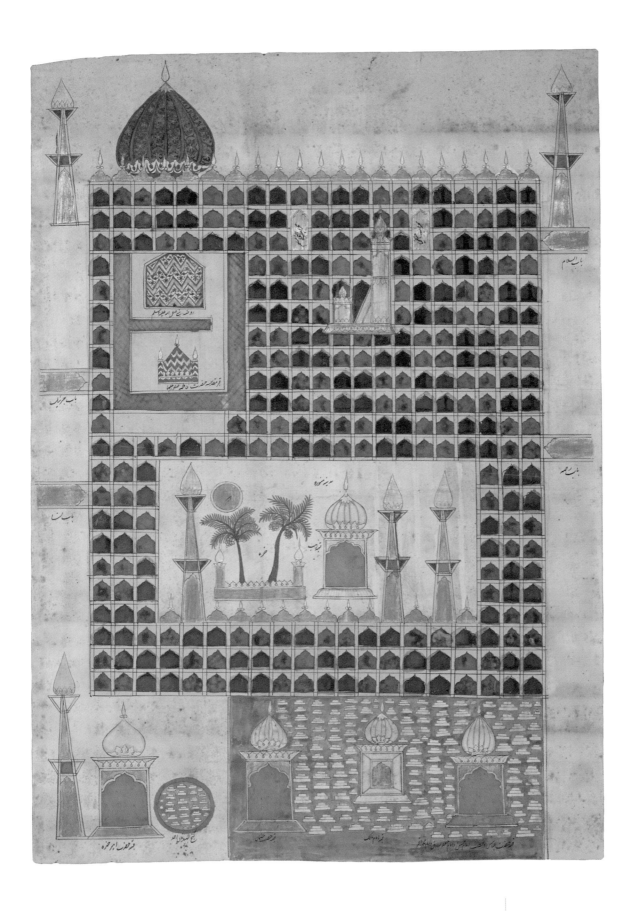

The reign of Harun al-Rashid (786–809) was the high point of the early Islamic Hajj. The caliph himself led his courtiers and officers to Mecca no fewer than nine times. The most important of these was the Hajj of December 802. Harun came with two of his sons, al-Amin and al-Ma'mun, and many of his most important courtiers. For the period of the Hajj, Mecca became, in effect, the capital of the Muslim world. There was a great display of generosity. Not only did the caliph disburse large sums to the people of the holy cities but his two sons did as well, so that it was said that a million and a half gold dinars were given away. But the caliph had a serious and weighty matter on his mind. He had already appointed al-Amin to be his heir and al-Ma'mun to succeed to the caliphate afterwards. He now wanted to make sure that his careful arrangements were witnessed and publicized throughout the Muslim world. When he was in Mecca, he ordered documents to be written in which both of his sons acknowledged their obligation to the other so that there should be no cause for dispute and civil war after his death. The documents were signed and entrusted to the Keeper of the Ka'ba and were then, for safekeeping, hung up inside the Ka'ba itself.

Solemn and terrible conditions were laid on the sons and all the Muslims lest they break their oaths that they would not break their promises: 'If you should change any part of it, or alter it or break it, or contradict what the Commander of the Faithful [the caliph] has commanded and proscribed for you in this document, you are outside the protection of God and His Prophet and of the believers and the Muslims. Though the wealth you now own or may dispose of for the next fifty years is given to the poor as alms, though every man among you take an obligatory oath to walk on foot to the House of God which is in Mecca for fifty pilgrimages, God will not accept anything except the fulfillment of this oath. If this oath is broken, every slave that a man now possesses or may possess for the next fifty years is set free, every wife he may have is absolutely and finally divorced without possibility of revocation or exception. God is the surety and overseer of this, and God suffices as a reckoner.' Surely, he must have told himself, no one would violate the oaths signed, sealed and deposited in so holy a place with such strict conditions. But even at the time people had their doubts and poets wrote odes about it, heavy with anxiety. And within three years of Harun's death, the binding promises had been cast aside, open warfare had broken out between the two sons and the formal documents, drawn up in such style, were taken down and destroyed on the orders of al-Amin.

Harun went on the Hajj more often than any other reigning Abbasid caliph, but he was also the last to do it. If the eighth century had witnessed the high point of the Hajj, the ninth and early tenth saw its nadir. There were a number of reasons for this. Caliphs no longer came in person, though some said they would. At first the Hajj caravan still set out from Baghdad, led by important men of state and escorted by the caliph's troops. But all was not well. The caliphate was facing increasingly severe economic problems and growing unrest. The vast sums that al-Mahdi and al-Rashid had been able to spend were no longer available. The relationship between the Bedouin tribes of Arabia and the Hajj began to break down as the tribes no longer received their subsidies.

At first the disturbances were no more than raids by tribes like the Banu Sulaym of the Hijaz and, until the assassination of the caliph al-Mutawwakil in 861, the Abbasid government was strong enough to send out punitive raids conducted by the Turkish soldiers who formed the military elite of the regime. But in the last decades of the ninth century, the position changed. After 861 the caliphate was beset by internal challenges, notably the great rebellion of the Zanj, the black slaves who were employed in the back-breaking work of clearing salt deposits off the agricultural lands of southern Iraq, in the very heartlands of the caliphate. The same years saw the emergence of the Qaramita (Carmathians), a religious movement seeking to establish a caliphate in the name of Isma'il, the seventh imam in line of descent from Ali. They recruited most of their followers among the Bedouin of north-eastern Arabia and the Syrian desert. Whereas the previous Bedouin raiders of the Hajj caravans were simply after money and could be punished or bought off, the Qaramita rejected the Abbasid caliphate entirely and regarded the majority Muslim community as unbelievers whose lives were worthless. They were well organized, fast moving, brutal and merciless. From 916 they blocked the Hajj route along the Darb Zubayda, massacring the male pilgrims and taking the women into captivity. In 930 they went still further and raided Mecca itself, slaughtering those pilgrims who had reached the *haram* and tossing their bodies into the sacred well of Zamzam. To cap it all, they then wrenched the Black Stone out of the wall of the Ka'ba and carried it off to their stronghold in remote Hajar in eastern Arabia. The Abbasid caliphs were powerless to protect the Hajj caravan or safeguard the holy places against the marauders.

Fig. 70 Opposite page
The dream of the wife of Harun al-Rashid
1614
Opaque watercolour and gold leaf on paper
National Museum of New Delhi

This painting is from the Tarikh-i Alfi, a compendium of world history commissioned by the Mughal emperor Akbar in the second half of the 16th century. It contains a section on the Abbasids and here Harun's wife Zubayda wakes from a bad dream.

Fig. 71 Below
Moulded bronze cup with spout and stamped decoration
Excavated at al-Rabadha, 8th–10th century
Length 11 cm
National Museum of Saudi Arabia, Riyadh

Fig. 72
Copper coin, minted in Mecca for the
Sharif of Mecca, Yahya bin Surour, during
the reign of the Ottoman Sultan Mahmud
II (1808–39)
1223 AH/AD 1808
Diameter 2.3 cm
British Museum, London

The tenth century also saw a change in the political position of Mecca. Until the mid-tenth century Mecca and Medina had been, in theory at least, part of the great Muslim caliphate ruled by the Umayyads and their Abbasid successors. The governors were usually imperial officials appointed from Damascus or Baghdad, but all this changed with the collapse of Abbasid power. In around 966 Mecca was controlled by the Musawis, a family who claimed descent from Ali ibn Abi Talib through his son al-Hasan. They took the title of Sharif, meaning, by this stage, descendants of Ali. Through the centuries different families of Sharifs succeeded each other, but all were, or claimed to be, direct descendants of Ali. This tradition only came to an end with the conquest of the holy city by the Saudis from the last of the Sharifs in December 1924. Mecca thus enjoyed a measure of autonomy, and the management of the Hajj within the *haram* was the business of the local rulers rather than some distant potentate. At the same time, the city became much poorer. In Abbasid times, pious Muslims had sent gifts and pensions to the inhabitants of the Haramayn as a mark of respect for the holy cities. Now this largesse virtually dried up and the inhabitants were forced to depend on the *hajjis*, rich and poor alike, for their uncertain prosperity. Both the Sharifs and the ordinary people of Mecca began to acquire a reputation for greed and dishonesty in the treatment of the pilgrims. The Sharifs were proud of their ancestry and jealous of their status, but they could not play as monarchs on the wider Islamic stage.

In 969 the Shi'ite Fatimids conquered Egypt and established their new capital in Cairo. They claimed to be caliphs of the whole Islamic world and, naturally, sought to establish themselves as patrons of the Hajj, as the Abbasids had been. From this time on, the main Hajj caravans were to leave from Egypt and Syria, rather than Iraq. There were two possible routes. One ran from Cairo across the Sinai peninsula to Aqaba and then down through the Hijaz to Medina and on to Mecca. The other went from Cairo up the Nile to Upper Egypt and then across the eastern desert to the Red Sea port of Aydhab and thence to Jedda, the port of Mecca. The new caliphs never patronized the Hajj in the way the Abbasids had done and no reigning Fatimid left the comforts of Cairo to endure the rigours of the pilgrimage road. The Fatimids also claimed overlordship of Mecca and when this was challenged by the Sharif in 976, he was soon brought to heel by the Fatimid caliph, who cut off the food supply from Egypt. With the coming of the Sunni Saljuks in the 1050s, the Abbasid

caliphs were once again able to challenge the Fatimids for leadership of the Muslim world and the Sharifs offered the right to be mentioned in the *khutba*[32] in Mecca to the highest bidder, changing back and forth between the two rivals. This caused great hardships for the pilgrims, especially those from Iraq.

The situation changed again when the Sunni Ayyubids replaced the Fatimids in 1171. They now took charge of the Hajj. The brother of the great Saladin (1169–93) tried at one stage to abolish the rule of the Sharifs altogether, but in the end he contented himself with ensuring that Saladin was mentioned in the *khutba*, along with the Abbasid caliph and the Sharif, and he was temporarily successful in putting an end to some of the worst abuses. In the later twelfth century, however, the Hajj was threatened from another quarter when the European Crusaders established a network of castles in present-day Jordan which effectively blocked off the pilgrim route from Damascus and made the route from Egypt through Sinai and round the head of the Gulf of Aqaba very dangerous. Pilgrims from Egypt and the West had either to go up the Nile and across the Red Sea or to make the long journey round by Baghdad.

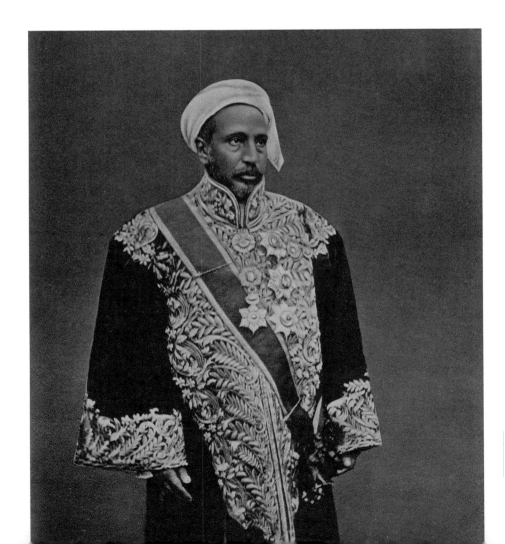

Fig. 73
Sharif of Mecca Awn al-Rafiq
(882–1905)
Photo: Snouck Hurgronje, 1885
Leiden University Library, Leiden

In the mid-eleventh century Nasir-i Khusraw, a Persian pilgrim, made the Hajj to Mecca no less than four times. He recorded his experience in his Safarnameh or Book of Travels,[34] and this is the earliest first-hand account of what it was like to be on the Hajj that has come down to us. Nasir came from what is now Tajikistan on the north bank of the River Oxus in the far north-east of the Muslim world. His family were landowners and he received an excellent education in Persian literature and the Muslim sciences. As a young man he was heavily involved in the political and social life of Khurasan but in 1045 he resigned his positions and set out to go on the Hajj. In the end he was away for seven years. Nasir was an Isma'ili and one of his purposes in travelling was to go to the court of the chief of the Isma'ilis, the Fatimid caliph of Cairo, and after his travels he returned to remote Badakhshan where he devoted himself to Isma'ili learning. His tomb there is still a place of pilgrimage to this day.

Nasir's account of his travels is written in a simple, lively style of Persian. He was certainly pious and wanted to describe the Hajj to people who might never have the chance to go on it but, at the same time, he had an eye for the bizarre and comic which enlivens his narrative. He left Khurasan in 1046 and

Fig. 74 Below
Qibla indicator and compass, *c*.1800
Wood
8 x 12.5 cm
Benaki Museum, Athens

This instrument enabled the user to find the qibla (the direction of Mecca) from wherever they were. The first step was to locate north–south by placing the instrument on a flat surface and allowing the needle to find magnetic north. The board was then rotated. The inscriptions on the wood form a rough map. Standing in Baghdad, for example, a line towards Mecca could be drawn and this was the direction in which to pray. (See also p. 64.)

Fig. 75 Opposite page
A treatise on the sacred direction by al-Dimyati, fol. 88v
Egypt, 12th century
19 x 12.5 cm
Bodleian Library, Oxford

Al-Dimyati was a 12th-century Egyptian legal scholar who wrote a treatise on the qibla in Egypt. At this time each sector of the world was believed to be connected to a particular part of the perimeter of the Ka'ba, the qibla from Egypt reaching 'the part between the western corner and the water-pipe'.[33] In the drawing, the four points of the compass mark each corner. The Hajj routes are shown as wavy lines. Cairo is at the centre right, and Jerusalem, Damascus and Aleppo are on the left. The road from Jerusalem goes through Ayla (near Aqaba) and Medina.

Fig. 76 Following pages
Map illustrating the journeys of four pilgrim travellers during the medieval period: Nasir-i Khusraw (1046–52), Ibn Jubayr (1183–4), Ibn Battuta (1325–6), and the Emperor of Mali, Mansa Musa (1324)

travelled through northern Iran and what is now eastern Turkey before entering Syria, passing through Aleppo and taking the coast road to Jerusalem. He gives an elaborate description of the Dome of the Rock and other holy sites in the city. He also explains that it was a centre of pilgrimage for those who could not make the Hajj to Mecca.[35] Twenty thousand people gathered there at the time of the Hajj, probably more than actually made it to Mecca at this period. Jerusalem was the third holiest city in Islam: each prayer here was worth twenty-five thousand prayers said elsewhere, while those said in Medina were worth fifty thousand and those in Mecca a hundred thousand.[36]

Nasir then went on to make his first Hajj to Mecca. He says something about all four of his visits to the holy city but only gives a full description of the last one. His first Hajj was made from Jerusalem on foot. Led by their guide (dalil), Abu Bakr, the party set out on 13 May 1047 and took the inland route through the Hijaz via Wadi'l-Qura. They found the holy city in a very depressed condition. No caravans had come from anywhere and there was no food to be had. When the pilgrims went to Arafat, they were in danger of attack by the Bedouin. They seem to have stayed the minimum time necessary to perform the rites before returning safely to Jerusalem on 2 July 1047. The whole expedition had lasted just over seven weeks, during which they walked over a thousand miles (1,600 km), or around twenty miles (32 km) a day: impressive stamina indeed.

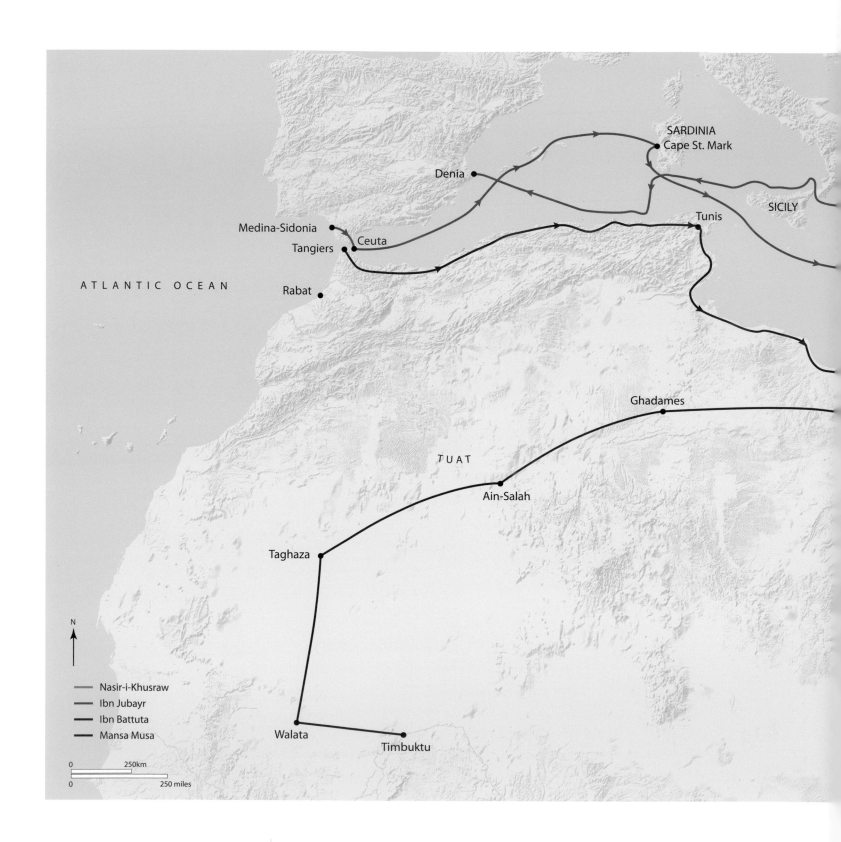

SARDINIA
Cape St. Mark

Denia

SICILY

Tunis

Medina-Sidonia
Tangiers
Ceuta

ATLANTIC OCEAN

Rabat

Ghadames

TUAT

Ain-Salah

Taghaza

N

Nasir-i-Khusraw
Ibn Jubayr
Ibn Battuta
Mansa Musa

Walata
Timbuktu

0 250km
0 250 miles

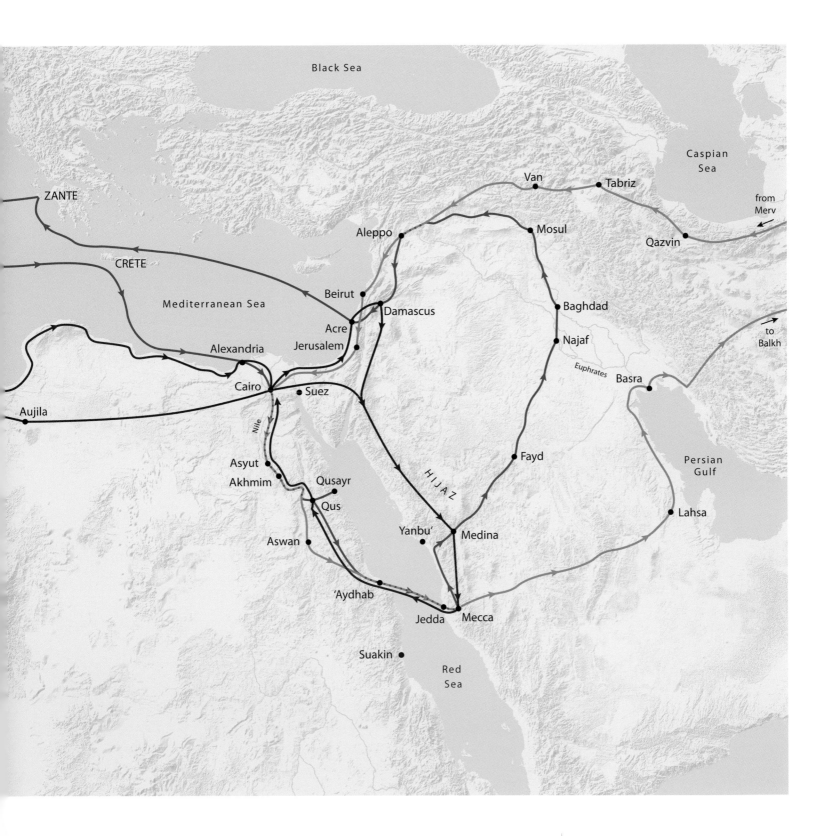

Black Sea

Caspian
Sea

ZANTE

CRETE

Mediterranean Sea

Van · Tabriz

from
Merv

Qazvin

Aleppo · Mosul

Beirut · Baghdad

Damascus

Acre · Najaf

Jerusalem · Euphrates · Basra

Alexandria

Cairo · Suez · to
Balkh

Aujila

Nile

Asyut · Fayd

Akhmim · Qusayr

Qus · HIJAZ

Persian
Gulf

Aswan

Yanbu' · Medina · Lahsa

'Aydhab

Jedda · Mecca

Suakin ·

Red
Sea

The next year Nasir went on the Hajj again. This time he left by sea, presumably from Suez, on 18 April 1048. It took fifteen days to reach the port of Jar, south of modern Yanbu, which was the port of Medina during the Middle Ages. It then took four days to reach Medina. Here the pilgrims visited the mosque of the Prophet, but they only stayed two days because time was short if they were going to reach Mecca in time for the main celebrations. The journey to Mecca took them eight days, a journey which Nasir describes as 'easy' (*sabuk*).[37] The situation had not improved much since the previous year. A drought had resulted in a shortage of food and 'because of hunger and misery, people were fleeing the Hijaz in every direction'. Even the *mujawirun*, pious people from all over the Muslim world who had settled near the *haram*, were abandoning Mecca. They completed the rites, including the visit to Arafat, but only stayed two more days before setting off back to Egypt. The whole journey took seventy-five days.

The next year (1049), the authorities in Egypt announced that there was famine in the Hijaz and 'since it was unwise to go on the pilgrimage, the people should excuse themselves from this obligation and adhere to God's commandment'.[38] Despite this, an official delegation was sent by the Fatimid caliph to take the *kiswa* for the Ka'ba and a 'gift' to the Amir of Mecca of three thousand dinars per month, a horse and a robe of honour.

A famine and the danger of sudden death were not enough to discourage a man like Nasir, so he joined the official party at Suez and they sailed down to Jar, arriving on 1 May. They hired camels at the inflated price of five dinars and it took them two weeks to reach Mecca. The official party seems to have been safe, but others were not so lucky. A caravan had come from the Maghreb, perhaps unaware of the famine, but when it reached Medina the Bedouin demanded protection money (*khifara*). A fight ensued which, according to Nasir, left some two thousand of the unfortunate Maghrebis dead.[39]

Tragedy on a smaller scale affected a group from Nasir's native Khurasan. They had come on the Hajj by way of Syria and Egypt, then by boat to Medina. Unfortunately they were running late and unless they moved very fast, they would miss the *wuquf* at Arafat and hence the whole point of their journey. They still had 104 *farsakhs*[40] to go and offered forty dinars to anyone who could get them to Arafat in the three days remaining. 'Some Arabs undertook to take them to Arafat in two and a half days: they took their money, tied them each to a fast camel and drove

them from Medina. When they arrived at Arafat, two of them had died still tied to the camels: the other four were more dead than alive. As we were standing there at the afternoon prayer they arrived, unable to stand up or speak. They finally told us that they had pleaded with the Bedouin to keep the money they had given but to release them as they had no more strength to continue. The Bedouin however, heedless of their entreaties, kept driving the camels forward. In the end the four of them made the pilgrimage and returned via Syria'.

Nasir's fourth and final pilgrimage was the one he describes most fully. His narrative provides all sorts of interesting information about the Hajj in the mid-eleventh century. It is also one of the most detailed and realistic accounts of the hazards and hardships of desert travel in medieval Islamic literature.

He left Cairo on 9 May 1050. This time he chose a new route. Though he gives no reason for this, it is clear that this route was becoming more popular. He sailed up the Nile, past Asyut ('an opium producing area'), Akhmim with its ancient buildings made of vast stone, and bustling commercial Qus, until they finally reached Aswan. Above this was the First Cataract and navigation was impossible, so at this point they had to abandon the comparative comfort of river navigation and cross the two hundred *farsakhs* of virtually waterless desert which lay between them and the Red Sea port of Aydhab.

With the help of a 'pious and righteous' local man called Muhammad Falij, 'who knew something of bargaining (*mantiq*)', Nasir hired a camel for the journey for a dinar and a half. The road across the desert was hard, even for such an experienced traveller. There were stretches of five days and more with no water, and the members of the group had to fill their water skins whenever they could. They travelled almost continuously. They would pause for a rest in the heat of the day until afternoon prayer and then went on all night. He was amazed by the camels, which did not need to be driven and seemed to know the way by instinct even though there was no trace of a road. Finally, after fifteen days of this punishing routine, they reached the Red Sea port of Aydhab on 12 August. It was high summer and must have been almost unbearably hot.

Aydhab was a small port which had developed since the ninth century as a place where goods from the Red Sea and Indian Ocean areas were landed and taken across to the Nile to be carried down to Cairo and Alexandria. From Nasir's description it was clearly more of a shanty town than a developed Islamic city, although it did boast a Friday mosque. He estimated the population

Fig. 77 Opposite left
Mecca tile
Iznik, Turkey, mid-17th century
Stonepaste underglaze painted
61 x 38 cm
Victoria and Albert Museum, London

*The sanctuary and the sites within it are
depicted in diagrammatic style and labelled
as with Hajj certificates (see p. 39). The
upper third includes a panel in* naskh *script
which contains verses from the Qur'an
(3:96–7), encouraging all Muslims to
undertake the pilgrimage to Mecca at least
once in their lifetime. The lunette above is
filled with Chinese-style cloud scrolls. It is
similar in style to the Medina tile (see fig.
50) and as such may have been part of a
group made to go together.*

Fig. 78 Opposite right
Mecca tile panel
Iznik, Turkey, 17th century
Stonepaste underglaze painted
73 x 49.5 cm
Benaki Museum, Athens
(acquired in Egypt)

*This panel made up of six square tiles is
inscribed with a poem by the Ottoman
poet Suleyman Nahfi (d. 1739). 'Whoever
has the fortune to visit the Ka'ba, God
forgives him and the one who is invited to
the house is for certain the beloved.' Above
the sanctuary is the Profession of Faith:
'There is no God but God Muhammad
is the messenger of God.' Unlike the tile
illustrated on the left (fig. 77), the structures
and the minarets are depicted in a more
topographical style.*[41]

at about five hundred men, so perhaps two thousand people in all, and notes
that there were no wells. The people relied on collecting rainwater, some of
which they bought from the pagan Beja people of the lands to the south. He
had to pay a dirham or two for each container of water. Nasir was stuck in this
desolate spot for three months, waiting for a favourable wind. The local people
asked him to preach in their mosque, so he became their *khatib* for the duration
of his stay.

By this time Nasir was running out of money. He remembered that
Muhammad Falij, the man who had helped him hire the camel in Aswan, had
said that he had a friend in Aydhab, presumably a commercial partner, who
was keeping a great deal of his money. He had given Nasir a letter to this man,
saying that Nasir could ask him for anything he needed. Nasir now went to this
Aydhab merchant, who said that he did indeed have his friend's money and was
willing to help. He gave Nasir a quantity of flour, very expensive in Aydhab,
which Nasir presumably sold. When Muhammad Falij in Aswan was told about
this, he wrote back to the Aydhab merchant saying that Nasir could have had
more if he needed it; there was no question of repayment.

Nasir was amazed by this generosity because he hardly knew Falij, who
was simply someone he had met in Aswan. 'I have included this little anecdote',
he says, 'so that my readers may know that people can rely on others, that
generosity exists everywhere, and that there have been, and still are, noble
men.' It shows how unofficial networks of commerce and friendship made this
sort of travel possible, at least for someone like Nasir, who was a learned man
of a certain social status as well as a likeable person who made friends easily.
What is not clear is how a poor and uneducated pilgrim would have managed
in these circumstances.

As ever, Nasir could not resist a good story, especially a fishy one. 'In the
town of Aydhab, a man whose word I trust told me that once a ship set out
from that town for the Hijaz carrying camels for the Amir of Mecca. One of the
camels died so it was thrown overboard. Immediately a fish swallowed it whole
except for one leg which stuck a bit out of the fish's mouth. Then another fish
came and swallowed whole the fish that had swallowed the camel.'[42]

Eventually the wind changed and they could sail across the Red Sea. Nasir
must have felt he was back in civilization when he reached Jedda, then as now
the port of Mecca. He describes it as a large city with a strong wall and good

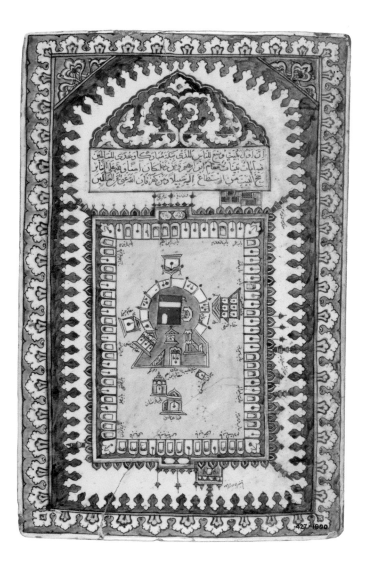
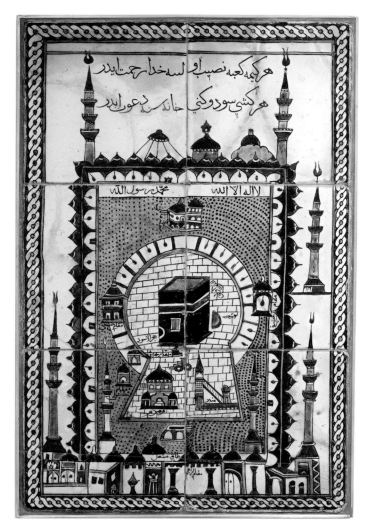

markets and puts the population at five thousand men. His academic credentials
came in handy here. He went to the governor, appointed by the Sharif of Mecca
to collect taxes, who exempted him from the customs duties that he would have
had to pay as he passed though the city gate and wrote to Mecca, saying that
Nasir was a scholar (*danishmand*) and that nothing should be taken from him.[43]
Again, one wonders how an ordinary pilgrim would have fared.

Nasir stayed in Mecca for nearly six months, from 19 November 1050 to
5 May 1051, and gives a full description of the city, the *haram*, the Ka'ba and the
rituals associated with them, all virtually unchanged through the centuries.
But he also gives us more individual insights, including an interesting account
of the interior of the Ka'ba. The doors were made of teak (*saj*) and decorated
with silver circles and gold inscriptions, including the verse from the Qur'an:
'Verily the first house appointed unto men to worship in was that which was

Tiles

Tiles depicting the holy sanctuaries of Mecca and Medina were made between the mid-17th and early 18th centuries at Turkish ceramic centres at Kutahya, Iznik and Tekfur Saray in Istanbul. They were generally made of stonepaste and glazed in vibrant colours. Occasionally dated and signed, such topographical renderings follow the same style as the depictions of the sanctuaries in manuscripts and Hajj certificates. The structures within the sanctuary are often marked and labelled, and calligraphic inscriptions, most of them Qur'anic, often appear in panels at the top of the tiles. On the Mecca tiles these refer to the creation of the Ka'ba and the sacredness of the sanctuary.

The tiles were made in various forms, from small portable individual tiles to large panels. The earliest surviving example of a tiled depiction of Mecca is on the eastern wall of the Aya Sofia in Istanbul, dated 1642 and with an inscription bearing the name Tabaqzade Mehmed Beg.[44] Depictions developed in style until the 18th century, the latest dated example of which is the tile from the mosque *mihrab*, dated 1724, from Cezerli Kasim Pasha Camii, Istanbul, which is also signed.[45] The Medina tiles are rarer. The tiles may initially have been wall decorations in houses and palaces, perhaps acquired by people who had been on Hajj themselves to remind themselves of Mecca. Sometimes these were placed in mosques on the *qibla* wall to draw the faithful in the direction of prayer. (See figs 50, 77–9.)

Fig. 79
Mecca tile, dated 1074 AH/AD 1663
Stonepaste underglaze painted
38 x 35 cm
Museum of Islamic Art, Cairo

At the base of the tile is the signature of the maker 'Ahmad' and the date. The name of the owner is inscribed top left, 'Sahib Muhammad Agha'. Although similar in its topographical representation to the Benaki Museum tile (fig. 78), it has a new feature of clusters of jugs. These probably represent the containers for Zamzam water.

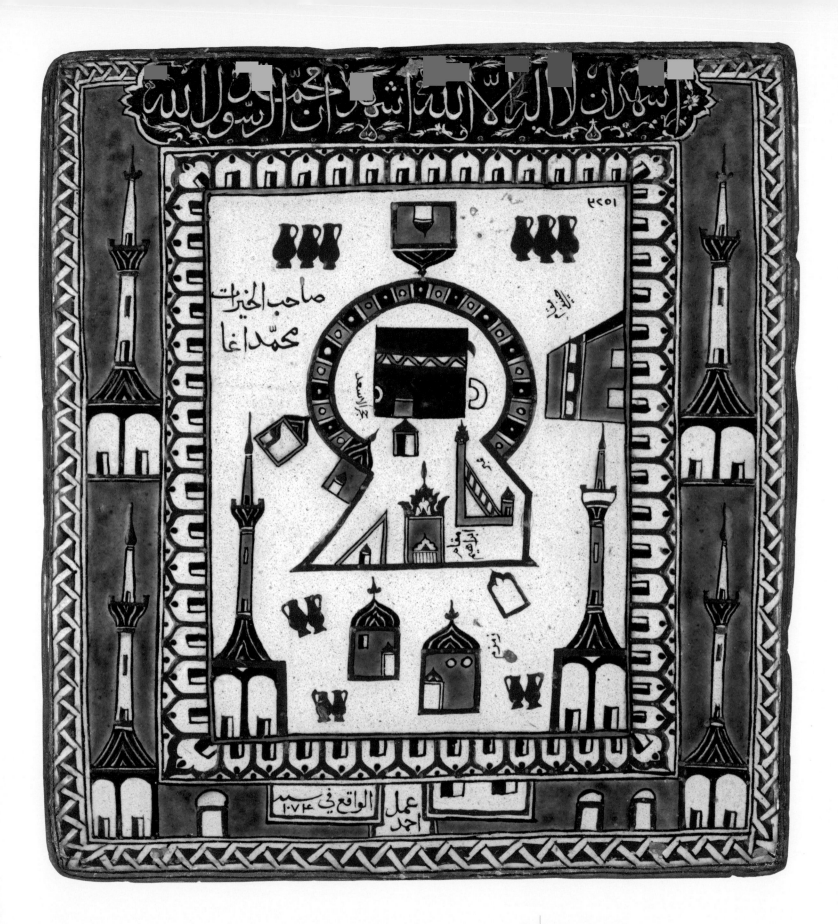

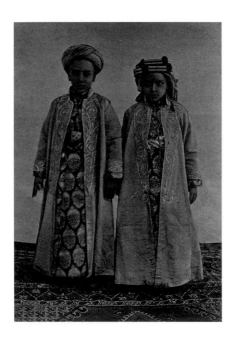

Fig. 80
Children of the Bani Shayba
Photo: Snouck Hurgronje, 1885

*The Banu Shayba are a family from the
Hijaz who hold the keys to the Ka'ba.
During the annual cleaning ceremony of the
interior of the Ka'ba, members of the family
greet visitors who are permitted to go inside
the Ka'ba to participate with the Banu
Shayba in the cleaning. The Banu Shayba
also assist in the annual changing of the
kiswa, the richly decorated cloth that covers
the Ka'ba. The Prophet Muhammad gave
the keys of the Ka'ba to the Banu Shayba
in 8 AH/AD 630 when he and his followers
occupied Mecca: 'Take it, O Bani Shayba,
eternally up to the Day of Resurrection, and
it will not be taken from you unless by an
unjust, oppressive tyrant.'[46]*

At Bakka'.[47] There were two large silver rings sent from Ghazna, presumably by the Ghaznavid rulers,[48] whom Nasir may not have wanted to mention because of their championship of Sunni Islam. The lock was attached to two smaller rings. The floor of the interior was paved with white marble and the columns were made of teak; one was round, the others four-sided. Set into the floor was a large red marble slab on which the Prophet was said to have prayed. The walls were of marble, plain up to the height of four cubits – about 2 m (6½ ft) – from the floor but richly decorated above and mostly plated with gold. Affixed to the west wall were six silver niches and on another wall were two large planks from Noah's ark. On one wall was a gold inscription commemorating the Fatimid takeover of the Haramayn from the Abbasids by the caliph al-Mu'izz (953–75). The ceiling was wooden but covered with brocade so that no wood was visible, and a silver door led to the roof. The roof was covered with Yemeni marble, which let in the light but not the rain, and there was a waterspout covered with gold writing. The Ka'ba was unlocked on certain specified days by the chief of the ancient family of the Banu Shayba, who was given a salary and a robe of honour by the Fatimid caliph. When it was opened, the pilgrims were allowed in to pray, and Nasir reckoned that there were 720 of them at one time. A potential problem was the direction of prayer, since the Ka'ba itself is, of course, the *qibla* to which all Muslims pray, but it had been decided that, while most people prayed in the direction of the door, any direction was permissible.

In some ways Mecca seemed to be flourishing. Nasir was amazed, for example, by the variety of fruits and vegetables available in late November. Used to the harsh winters of the Iranian plateau, he was astonished to find cucumbers, aubergines and melons for sale. The Suq al-Attarin to the east of the mosque was well built and thriving, there were twenty barbers' shops where the pilgrims had their heads shaved and two baths.

In other ways, however, the city was clearly in decline. The male population was no more than two thousand natives and about five hundred visitors: many people had moved away because of food shortages and high prices. Nasir comments on the decay of the infrastructure which had been developed by the Abbasid caliphs. There had been sarais, hospices for pilgrims from Iraq and Iran, but most of these were now ruined. 'The Baghdad [Abbasid] caliphs had built many beautiful structures but when we came some had fallen into ruin and others had been appropriated for private use'.[49] As ever, water was a major

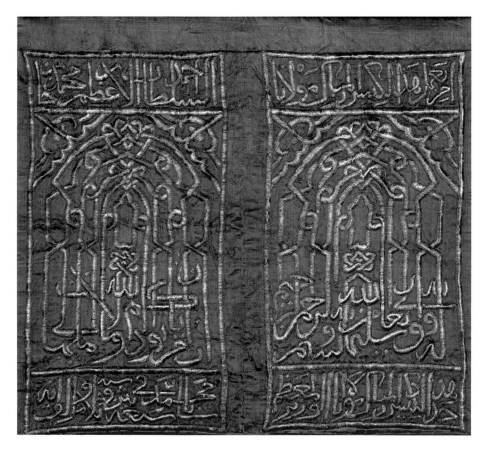

Fig. 81 Top
Key for the Ka'ba, dated 765 AH/AD 1364
Copper alloy inlaid with silver
Length 34 cm
Museum of Islamic Art, Cairo

Keys were made as gifts by the rulers who had overlordship of the holy places. This key bears the name and titles of the Mamluk sultan Sha'ban II (d. 1377), who donated it. Sha'ban also restored the pavement in the haram. The other inscriptions are from Qur'an Surat al-Fath (48:1–4) and Al Imram (3:96–7).

Fig. 82 Centre
Key for the Ka'ba, mid-14th century
Steel inlaid with silver
Length 29 cm
Museum of Islamic Art, Doha

This key works on a spring lock system and it is suggested that it may have been made in Mecca. It bears neither date nor patron's name. The inscription consists of verses from the Qur'an as above.[50]

Fig. 83 Left
Key bag, dated 1737 AH/AD 1724–5
Silk with embroidery in silver-gilt thread and lined with silk lampas (shown both sides)
47 x 50 cm
Nasser D. Khalili Collection of Islamic Art

The keys to the Ka'ba were traditionally kept in embroidered bags. The dedication inscription, which starts at the top on the right, indicates that this was ordered by the sultan Ahmed III (1703–30) and presented by the grand vizier Muhammad Pasha. In the centre are Qur'anic inscriptions: on the left from Surat al-Nisa (4:58), and on the right from Surat al-Naml (27:30).

problem. The well water in the city was brackish and bitter. Many large pools and cisterns had been constructed to collect rainwater but, even though it was winter, these were all empty and water had to be brought from outside and it was sold to the pilgrims.

His Hajj completed, it was time for Nasir to return home. For reasons he does not explain, he decided to cross the Arabian desert to Basra and make his way through Iran from there. It seems as if the Darb Zubayda route was not used at this time and he headed straight across the desert to al-Hasa near Bahrayn. It was a horrible journey. The local Bedouin tribes lived in great poverty, fighting their neighbours and preying on anyone unwise enough to travel through their territory. This meant waiting to secure safe-conduct agreements and even these were very fragile. Nasir's situation was made much more difficult by the fact that he was running out of money. He only had a bag with a few books in it, but none of these ignorant people were interested in buying them. One day he was sitting in a mosque and painted a line of poetry on the wall and 'a branch with leaves going up through the writing'. The local people had never seen anything like it and paid him a vast quantity of dates to paint the whole of their *mihrab*. But he still needed money to rent transport to take him to Basra and by this time he did not have a single dirham left. Eventually some merchants said they would take him to Basra on condition that he paid them a huge sum when he got there. He readily agreed, even though he had never been to Basra before and did not know a soul there.

His arrival in Basra was not easy. His first thought was to go to the bath-house, so he sold his book bag for a few rusty dirhams. But the bath attendant would not let him in because he was so dirty and tattered, and the small children threw stones at him in the streets. But a man of learning like Nasir was never entirely without resources. He found a Persian living in the city who introduced him to the vizier of a local potentate. Money was supplied to pay for a new set of clothes and when he appeared at court and demonstrated his culture and learning, his problems were over: the caravan that had brought him across the desert was paid off and he was given enough money to send him on his way. He even had the satisfaction of going back to the bath-house and shaming the attendants. And so he returned through civilized Iran to his native land, welcomed by a brother who had longed to see him: a happy ending to a long and sometimes dangerous pilgrimage.

Our second traveller made the Hajj more than two centuries after Nasir-i Khusraw. Ibn Jubayr was a well-off young man from al-Andalus, Muslim Spain. He received a good education in the skills required of a government secretary and secured a position in the service of the Almohad governor of Granada. One day, according to his own account, his master persuaded him to accept a glass of wine. Overcome with remorse at this breach of Islamic law, he decided to make the Hajj and, on 3 February 1183, he and a friend left the city and began their long journey to the holy places. He decided at this stage to keep a travel diary.[57] It is clear from the text that he wrote it as he went along, although he may have revised it on his return to his native country. As might be expected

Fig. 84
The travels of Ibn Jubayr, fols 2–3
Mecca, dated 875 AH/AD 1470
28.4 x 19.6 cm
Leiden University Library, Leiden

This is the earliest known copy of Ibn Jubayr's Rihla. *It was copied in Mecca in 1470 by Abd al-Qadir al-Qurashi in Maghribi script.*

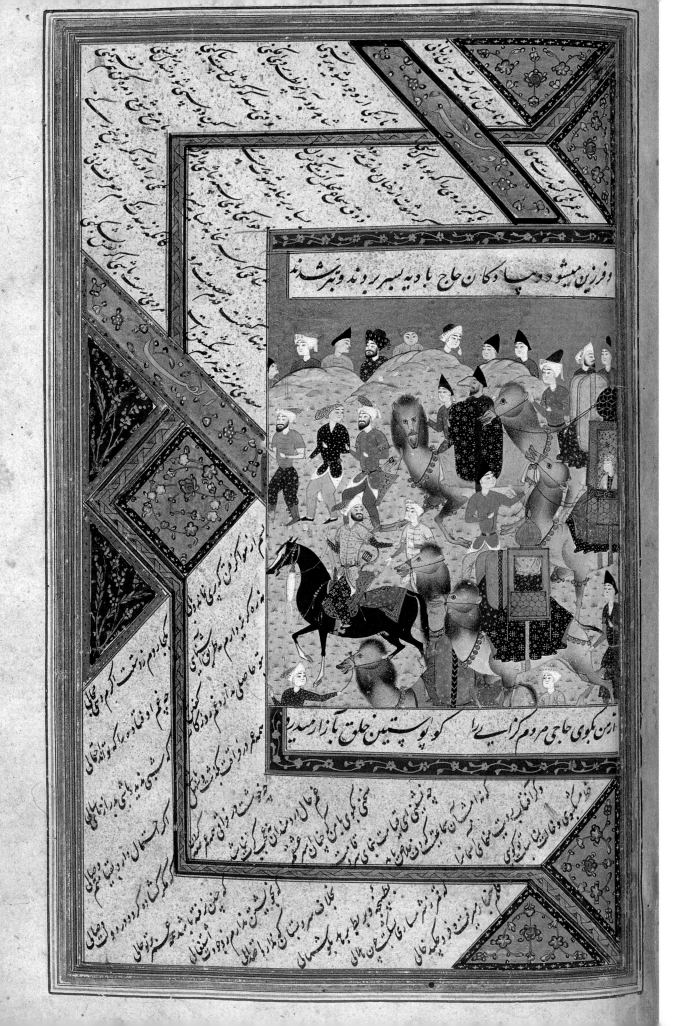

وفزين ميشود دسپادكان حاج باد يه بسهر رو بند وبهرشاند

ازمن بكوى حاجى مردم كزاسرى را كوبوستين حلق باكزار مسيد

from a man of his class and education, the Arabic is at times mannered and literary. But this is also one of the fullest and most detailed travel narratives to come down to us from the Middle Ages and the most important first-hand account we have of the Hajj experience before the nineteenth century.

Ibn Jubayr went first to Ceuta, where he found a Genoese ship bound for Alexandria. It may seem strange that so devout a Muslim should travel in a Christian-owned ship when the Crusades were at their height, but by the late twelfth century virtually all the long-distance shipping in the Mediterranean was run by the Italian cities of Venice, Pisa and Genoa, and the transport of Muslim pilgrims may have been a valuable part of their business. Ibn Jubayr provides the most vivid surviving description of sailing in the medieval Mediterranean. As might be imagined, the voyage was long and perilous; it took a month and the ship was often battered by spring storms. The ship island-hopped, calling at Sardinia, Sicily and Crete, all islands in Christian hands, before arriving at Alexandria. Since 1171 Egypt had been part of the domains of the great Saladin, who was then fully engaged in his campaigns against the Crusaders which were to culminate in the Muslim reconquest of Jerusalem four years later in 1187. Ibn Jubayr admired Saladin enormously, but his initial

experience of Egyptian government officials was not a good one. On coming ashore their names and countries of origin were recorded. Then their bags were taken to the *diwan* (customs house)[54] and thoroughly searched, and taxes were demanded even though most of them were pilgrims who only had what they needed for their journey. The customs house was packed; their possessions were taken out and thrown together in great confusion and, worst of all, 'hands were thrust into their waistbands in search of what might be within'. Not surprisingly, 'because of the confusion of hands and the overcrowding, many possessions disappeared'.[55] It was a low point. Ibn Jubayr was outraged that pious Muslims should be treated in this way by Muslim officials. He was sure that the great Saladin did not know what his subordinates were doing, and he later wrote a poem to the sultan to make his feelings clear.

After this humiliation, they were eventually allowed to go and set off to explore the sites of Alexandria. They decided to follow the same route as Nasir-i Khusraw had done on his last Hajj, going up the Nile as far as Qus and then striking out across the desert to Aydhab on the Red Sea, partly at least because of the threat from the Crusaders. They passed through Cairo, where they visited the tombs of holy men and women and admired the mosques and *madrasas*, and then pressed on to Qus, pausing, like all good tourists, to admire the ruins of ancient Egyptian temples en route.

On 6 June Ibn Jubayr and his party set out across the desert on camels. This must have been a new experience for him, coming as he did from the well-watered lands of Granada, and he gives some fascinating details about how more affluent pilgrims could make the journey more comfortable and while away the tedium of the long, hot stages. He notes that some people travelled in considerable comfort in camel litters called *shaqadif*, which were tied on the camel one on each side. They were roomy and the seats were made of leather. A canopy on poles was set up above them to provide shade from the sun. 'With his traveling companion [the pilgrim] may partake of what he needs of food and the like, or read, if he wants to from the Qur'an or some other book. If he thinks it is lawful, he may play chess with his companion, for diversion and to relieve the spirit. In short, it eases the hardship of travel.' But this was for the privileged few. 'Most travelers ride their camels on top of their luggage so painfully endure the rigours of the burning heat'. Ibn Jubayr, discreetly, does not say how he travelled.

At a later point in his narrative, he describes the luxurious conditions in which rich Iraqi pilgrims made the desert crossing. Shaded by canopies, they rode in wooden litters 'like cradles to infants, being filled with soft mattresses on which the traveler may sit in comfort as though he were in a soft and commodious bed ... Thus all unconscious of the movement, they journey on slumbering and doing as they will. When they arrive at the stopping place, screens are immediately set up for them if they are people of easy and luxurious means, and they enter still riding. Steps are then brought to them and they descend, passing from the shade of the litter's canopy to that of their resting place without feeling a breath of wind or being touched by a ray of sun'. But again, this was not for all: 'As for the man who cannot afford these conveniences of travel, he must bear the fatigues of the way which are but a part of the chastisements [of God]'. Are we catching here the envious voice of the economy-class passenger, eight hundred years ago?

Aydhab, the port on the Red Sea, seems to have been nobody's favourite place; all food and water was imported and very expensive and 'we lived between the air which melts the body and the water which turns the stomach from appetite for food'. Ibn Jubayr is scathing about the greed of the owners who hired out their boats, called *jilab*, to take the pilgrims across to Jedda. Their motto was 'We produce the ships: it is up to the pilgrims to protect their lives', and the pilgrims were crammed 'like chickens in a coop'. The ships were very different from the Mediterranean ships Ibn Jubayr would have been used to: no nails were used and the planks were sewn together with cords made from the fibre of coconuts, caulked with palm shavings and smeared with shark oil to keep the water out. The winds were uncertain and navigation could be haphazard, sometimes stranding pilgrims on wild and inhospitable coasts further down the African shore. Ibn Jubayr and his party were lucky: they set sail on Monday 18 July and were safely anchored in Jedda by Tuesday 26 July.

Jedda was ruled by the representative of Mukthir, the Sharif of Mecca. The illustrious descent of the Sharifs from Muhammad himself did not ensure that their behaviour was saintly. Mukthir looms large in Ibn Jubayr's account. At times he seems an impressive figure, leading processions in the *haram* and maintaining some sense of order, but on other occasions he appears venal and grasping. Mukthir explained that Saladin had been sending a subsidy of some two thousand dirhams a year and a quantity of wheat, so that he did

not have to extort dues from the pilgrims. This year, however, the sultan was engaged in wars against the Crusaders, and the governor made it clear that if the subvention did not come, he would extract it from the pilgrims. Ibn Jubayr was outraged that anyone should treat the Hajj like a piece of property.

Ibn Jubayr's impressions of Mecca are quite varied. On the positive side, he was deeply and genuinely moved by being in the holy sanctuary and by many of the religious celebrations he witnessed, especially the candle-lit prayer vigils and Qur'an recitations, not only during Ramadan but at other times as well. He also noted the wealth of fruit and vegetables that were available in this barren land, mostly brought from other areas of the Hijaz and Yemen, but also from Iraq and India. Nasir-i Khusraw had witnessed starvation so bad that many of the citizens had left, but Ibn Jubayr describes a plenty which he admits surprised him, coming as he did from the richness of al-Andalus. 'We thought that Spain was especially favoured above all other regions until we came to this blessed land and found it overflowing with good things and fruits such as

figs, grapes, pomegranates, quince, peaches, lemons, walnuts, water melons, cucumbers, and vegetables like aubergines, pumpkins, carrots, cauliflower and other aromatic and sweet-smelling plants'.[56] Furthermore, much of this bounty was available all the year round.

The inhabitants, on the other hand, were less admirable. Shortly after his arrival, Ibn Jubayr penned a furious diatribe against the local people and the ways they defrauded the pilgrims: 'The lands of God that most deserved to be purified by the sword', he wrote, 'and cleansed of their sins and impurities by blood shed in holy war are those Hijaz lands for what they are about in loosening the ties of Islam, stealing the pilgrims' property and shedding their blood'. He added that there were religious scholars in his native al-Andalus who believed that the Muslims there should be relieved of their obligation to make the Hajj because they were so badly treated by the people of the holy places. After more in a similar vein, he concludes: 'Let it be absolutely certain and beyond doubt established that there is no [true] Islam except in the lands of the Maghreb' (i.e. Spain and north-west Africa).[57]

Fig. 87
Pilgrims on Hajj
Photo: Abbas Hilmi II, 1909
Durham University Library, Durham

Although the exact location of this photograph is unknown, it is a good representation of how pilgrims travelled between Jedda, Mecca and Medina before cars and lorries were introduced into the Hijaz from the late 1920s. Because of the recurrent threat of robbery by bandits and Bedouin tribesmen, pilgrims tended to travel in long camel processions. At the rear of the procession are camels equipped with shaqadif, a litter placed on the camel which provided the rider with some comfort and protection from the sun. Poorer pilgrims, however, had to make their journeys on foot.

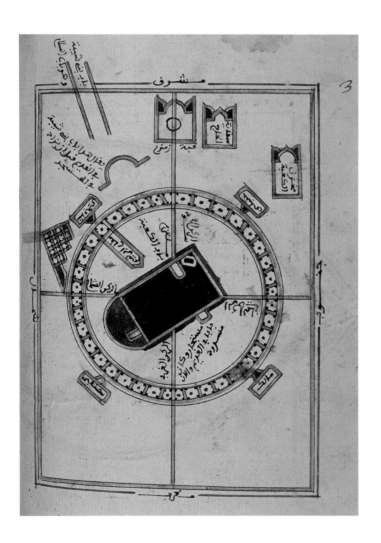

Ibn Jubayr arrived in Mecca on 4 August. It was a moment of unalloyed joy. They had walked all night from Qurayn, where the pilgrims put on their *ihram* garments. 'As we marched that night, the full moon had thrown its rays upon the earth, the night had lifted its veil, voices struck the ears with cries of "Here I am O God, here I am" from all sides and tongues were loud in invocation, humbly beseeching God to grant them their requests. . . . Oh night most happy, the bride of all nights of life, the virgin of the maidens of time!'[58] The party immediately performed the *tawaf* of new arrivals, clung to the *kiswa* and the place of Multazam, 'the place where prayers are answered' between the Black Stone and the door of the Ka'ba, drank from the well of Zamzam, and performed the *sa'i* between Safa and Marwa. They also found lodgings in a house which not only had 'many domestic conveniences' but which also overlooked the *haram* and the sacred Ka'ba.[59]

It was now August 1183 and the month of Dhu'l Hijja did not begin until 16 March 1184, so the author and his companions had a seven-month wait. They did not find time hanging heavily on their hands and there were always things to do. The holy month of Ramadan was especially lively, with candles everywhere in the *haram* as the imams of the four main law schools led their followers in the *tarawih* prayers traditional during Ramadan. Candles were displayed on wooden frames known as *hatim*, and each group hoped to make the best display in a spirit of pious competition. None of the candle-lit displays could rival that of the Malikis, the school to which Ibn Jubayr, like almost all Andalusis, belonged. In the last nights of the month there were frequent recitations of the entire Qur'an through the night and Ibn Jubayr was keenly appreciative of the qualities of the various reciters.

The climax, of course, was the Hajj itself. It started in a spirit of apprehension, as many of the pilgrims passionately wanted the standing at Arafat to take place on a Friday. In order for this to happen, the new moon

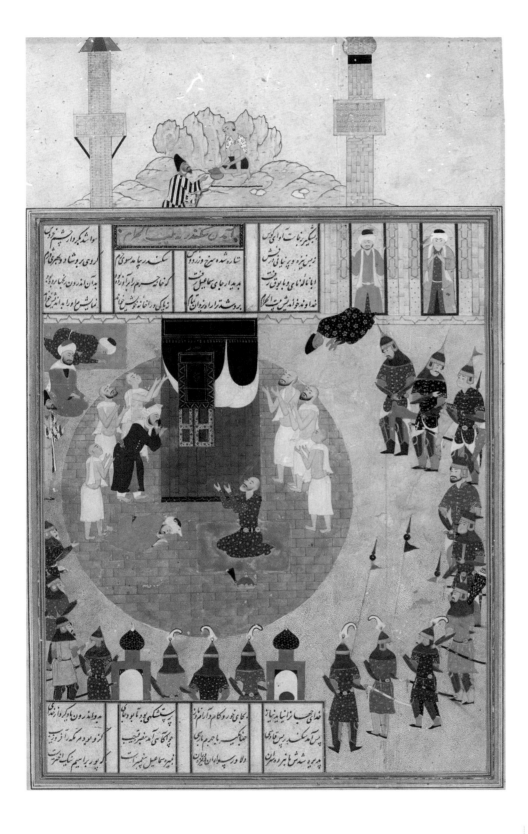

Fig. 89
Alexander visits the Ka'ba, from the
Shahnama of Firdausi
Shiraz, mid-16th century
Ink, opaque watercolour and gold
on paper
36 x 21.5 cm
Nasser D. Khalili Collection of Islamic Art

*Alexander was associated with the Prophet
in the Qur'an Dhu'l Qarnayn, whose mission
it was to impose the prophetic mission of
Abraham. In Firdausi's account, Alexander's
visit to the Ka'ba is the first of his world
journeys. Here he is seated to the right of
the door in the* mataf *area, his hands in
prayer. Worshippers in their* ihram *garments
are on either side. His companions, armed
and helmeted, stand to the edges.*

had to be sighted on the previous Thursday, but Thursday was cloudy. In their enthusiasm many went to the Qadi, whose decision it was, to claim that they had indeed seen the first sliver of the new moon. But he was made of stern stuff and refused to believe them. Everyone was in suspense until the arrival of a messenger from the Amir of the Hajj, appointed by the Abbasid caliph in Baghdad.

In Ibn Jubayr's time, the leadership of the Hajj caravan had once again been assumed by the Abbasid caliphs of Baghdad, now enjoying a significant revival of their power and prestige. At this stage the caliph himself did not lead the Hajj in person but entrusted an amir to lead the pilgrims from Iraq and Iran along the old route of the Darb Zubayda to Mecca. The Amir's messenger now arrived to say that his master could confirm that the new moon had indeed appeared on Thursday, so the *wuquf* could take place on Friday. Even so, anxieties remained: the pilgrims were still threatened by the Banu Shu'ba, a tribe of local Bedouin, and only when a military escort was provided could they go in peace. The Amir of the Iraqi caravan arrived late on Thursday night and the *wuquf* on Friday was as magnificent as anyone could remember. Some people said that so great a number had not assembled at Arafat since the days of Harun al-Rashid – the last caliph, as Ibn Jubayr notes, to make the pilgrimage.

Ibn Jubayr made his return journey via Medina to Baghdad along the route of the Darb Zubayda, where he still found many traces of the Abbasid works. From there he travelled west to Damascus before sailing in an Italian boat from the Crusader port of Acre to Sicily, where the ship was wrecked, and finally to Spain. His account is full of interest and keenly observed detail, but there can be no doubt that, for him, the Hajj in Mecca was the great climax of his remarkable trip.

Fig. 91
Al-Harith joins a caravan to Mecca and meets Abu Zayd along the way, fols 94v–95r from the Maqamat of al-Hariri, written and illustrated by Yahya al-Wasiti
Iraq, 634 AH/AD 1237
Opaque watercolour and gold on paper
39 x 34 x 5.5 cm
Bibliothèque Nationale de France, Paris

This painting illustrates the 31st Maqama, the encounter at Ramla. The narrator, the merchant al-Harith, happens on a Hajj-bound caravan and joins it. At one of the stops he hears the voice of Abu Zayd, the rogue and hero of the Maqamat, haranguing the pilgrims, seen on the left standing on a hillock. The two tented structures are thought to be early examples of mahmals *(palanquins). The one on the right, on top of the camel, is yellow, the colour of Mamluk mahmals.*[61]

'Oh you company of pilgrims ... do you comprehend what you are about to face ... and what you are undertaking so boldly? Do you imagine that the Hajj is the choosing of saddle beasts, the traversing of stations ... that piety is the tucking up of sleeves, the emaciating of bodies, the separation of children, the getting far from your native place? No, by Allah ... it is the sincerity of purpose for making for that building there, and the purity of submission along with the fervour of devotion, the mending of dealings, before working the doughty camels.'[62]

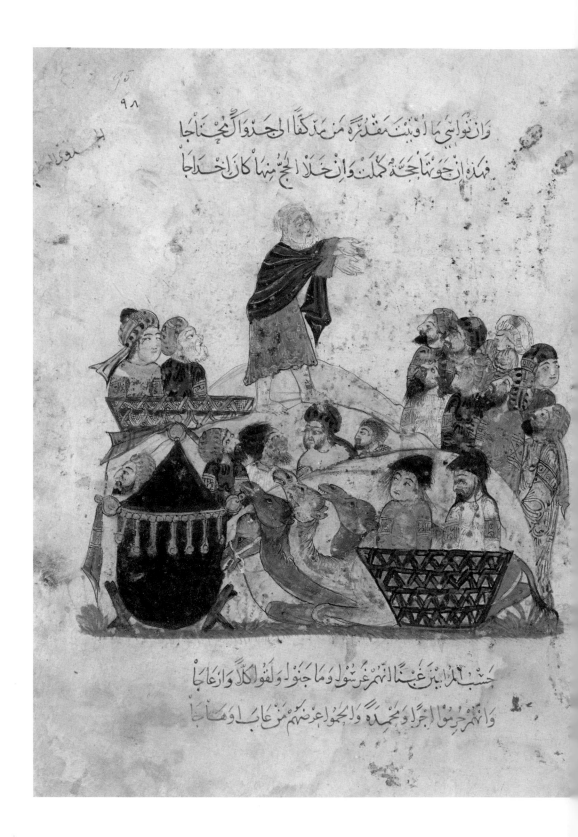

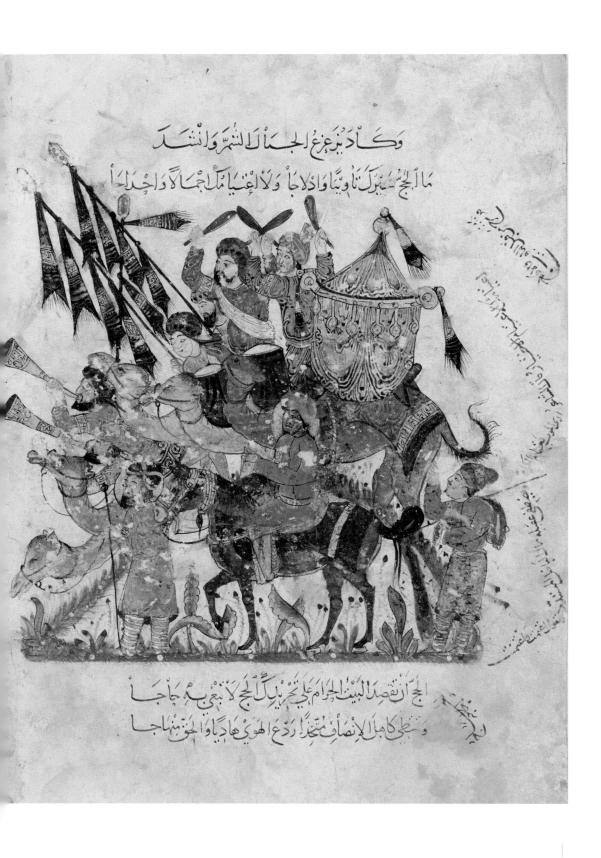

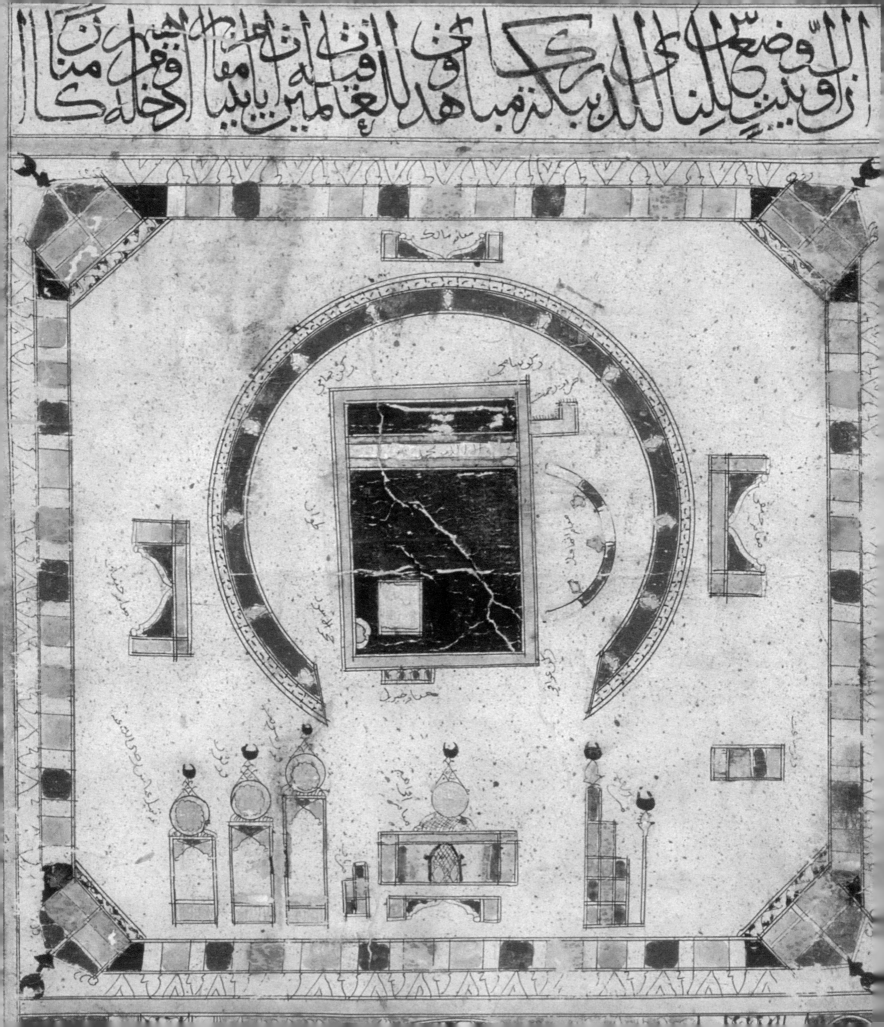

Journey to Mecca:
A History
(Part 2)

Fig. 92
Pilgrimage certificate
(detail; see also p. 5),
dated 836 AH/AD 1433
Coloured inks and gold on paper
212 x 28 cm
British Library, London

This certificate testifies to the Hajj of Maymuna, daughter of Abdallah al-Zardali, in the year 836 AH/AD 1433. She went on from Mecca to Medina. It is not clear where Maymuna came from, possibly North Africa. This section of the scroll depicts the sanctuary, the Ka'ba with the four corners denoted, and the principal elements of the sanctuary. At the top in thuluth script are verses from the Qur'an (3:96–7) in reference to the Ka'ba: 'The first House [of worship] to be established for people was the one at Bakka. It is a blessed place, a source of guidance for all people.'

In 1964 Malcolm X, a leading figure among the Black Muslims in America, went on the Hajj. When asked what had impressed him most about the experience, he replied, 'The *brotherhood*! The people of all races, colors, from all over the world coming together as *one*! It has proved to me the power of the One God.'[1] Throughout the centuries the rights and duties of the Hajj, transcending political divisions and religious schisms within Islam, have constituted a force for unity and orthopraxy (correct practice in religion).

THE THIRTEENTH TO FIFTEENTH CENTURIES

In the early thirteenth century the political divisions within the Islamic world and the threats posed to it by the Mongols and Crusaders were exceptionally severe. This made performance of the Hajj difficult, and the economy and culture of the holy cities suffered accordingly. The Crusaders based in the coastal cities and fortresses of Palestine and Syria were in a position to launch damaging raids into the Syrian interior and, after the Mongols occupied Iran and Iraq in the 1250s, the Euphrates frontier between Iraq and Syria was closed. In the last years of Ayyubid rule no Hajj caravans from Egypt or Syria arrived in Mecca. In 1256 an earthquake in Medina destroyed the Great Mosque. For

several decades after 1258, in the wake of the Mongol occupation of Baghdad and the execution of the Abbasid caliph, there were no caravans from Iraq. In the early thirteenth century the Abbasids in Baghdad, the Ayyubids in Egypt and the Rasulids in the Yemen had contested for suzerainty, however nominal, over the holy cities, though the Banu Qatada, a local dynasty of Sharifs based in Mecca, had usually been successful in playing off the claims of their more powerful neighbours.

The situation in the Hijaz changed in the 1260s as a result of the establishment of the Mamluk sultanate in Egypt and Syria. Most of the Mamluk ruling elite were slaves of Kipchak Turkish or Circassian origin. The Mamluks were largely successful in bringing a degree of security to Egypt and Syria that was without precedent in the immediately preceding centuries. In 1266 the Hajj caravan with a Mamluk escort was able to set out once more from Egypt via Aqaba. This was also the year in which the practice began of sending out with the caravan the *kiswa*, an embroidered black cloth destined to

cover the Ka'ba, together with an elaborate palanquin known as the *mahmal*.[3] The fifteenth-century encyclopaedist al-Qalqashandi described the *mahmal* as 'a tent made of embroidered yellow silk and topped by a spherical finial'[4] (yellow was the regnal colour of the Mamluks). There was nothing inside the palanquin except a copy of the Qur'an. Once it had delivered its heavy burden to Mecca, the camel that had carried the *mahmal* was excused from carrying anything else for the rest of its life. Although the precise origin and significance of the despatch of the *mahmal* remain unclear, it seems that it was viewed as a symbolic assertion of the Egyptian sultan's hegemony over the holy cities (and later that of the Ottoman sultan). This hegemony was contested by the Rasulid sultans of Yemen who periodically sent the *mahmal*. This was first recorded in 1296 during the reign of the sultan al-Mu'ayyad; they continued to send it intermittently later as a matter of tradition.[5]

In 1269 Mamluk hegemony over Mecca and Medina was confirmed when the Mamluk Sultan Baybars (1260–77) went on the Hajj. His pilgrimage combined politics with piety: he confirmed Abu Numay of the Banu Qatada tribe as Sharif of Mecca, and the long-lived Abu Numay (d. 1301) was to serve Mamluk interests in the region. Baybars and his successors were proud to add the title Protector of the Holy Cities (*khadim al-haramayn*) to their protocols.[6]

Although the pilgrimage is accomplished in Dhu'l Hijja, the twelfth month of the year, it became the custom to parade the *mahmal* through Cairo during Rajab, the seventh month, when it could serve as an advertisement of the Hajj to come and as the proclamation of the identity of the Amir of the Hajj. The North African pilgrim Ibn Battuta witnessed the procession in 1325. All the grandees of the city rode out to greet the *mahmal* and the Amir of the Hajj and then they all processed around the city with 'the camel drivers singing to their camels in the lead'.[7] Towards the end of the Mamluk period the ceremonies that accompanied the procession of the *mahmal* through Cairo became increasingly elaborate. Precious textiles and objects of Chinese manufacture were displayed on the backs of camels.[8] The great dervish orders marched behind the palanquin. Shopkeepers on the route of the *mahmal* would paint their houses and hang out carpets. The carnival also acquired a somewhat scandalous character and the pious denounced the mingling of women with men in the crowds. Lance games were performed by young Mamluks dressed in red and they were accompanied by mounted ruffians wearing bizarre costumes and demonic masks who were

The *Mahmal*

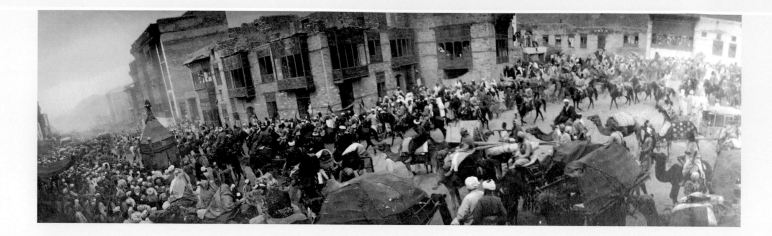

The *mahmal* was the ceremonial palanquin carried on a camel which was the centrepiece of the pilgrim caravan. It was the symbol of the authority of the sultan over the holy places. The origin is unclear: it may go back to the ancient Arab tradition of having a litter with a high-ranking lady accompanying military campaigns for encouragement. The Prophet's wife Aisha is said to have had such a role. The first sultan to be firmly associated with the sending of the *mahmal* was Baybars (1260–77). Following the Ottoman conquest of Egypt in 1517, the Ottomans too sent a *mahmal* from Damascus and on occasion so did the Yemenis.

The oldest surviving *mahmal*, in Topkapi Palace, Istanbul, made for the Mamluk sultan al-Ghawri (d. 1516), is yellow, the dynastic colour of the Mamluks.[9] Later examples are in the Azem palace in Damascus, and a *mahmal* in the name of Fou'ad I, sultan (1917–22) and then king (1922–36) of Egypt, is in the Geographical Society in Cairo.[10] These later examples are generally red or green. The *mahmal* had both processional and day-to-day coverings. It did not remain in Mecca but was brought back to Cairo by the returning caravan.

Fig. 94 Above
Mahmal procession
Photo: Abbas Hilmi II, 1909
Mohamed Ali Foundation and
Durham University Library, Durham

Panoramic view of the procession of the Egyptian delegation following the mahmal *on a street in Mecca, taken in 1909. The arrival of the* mahmal *in Mecca was a major event during the pilgrimage season. Pilgrims from across the Muslim world and the inhabitants of Mecca flocked to see the progress of this splendid procession, vividly captured in this photograph.*

Fig. 95 Opposite
Mahmal
Cairo, c.1867–76
Red silk with silver and gold thread
on a wooden frame
Height 390 cm
Nasser D. Khalili Collection of Islamic Art

This mahmal *bears the* tughra *of the Ottoman sultan Abd al-Aziz (1861–76) in the roundel at the top. On the sides is the name of the Khedive Ismail (1863–79) who received his title from Sultan Abd al-Aziz in 1867 and who ordered this to be made. In a band around the lower portion is the 'throne verse' from the Qur'an (2:255).*

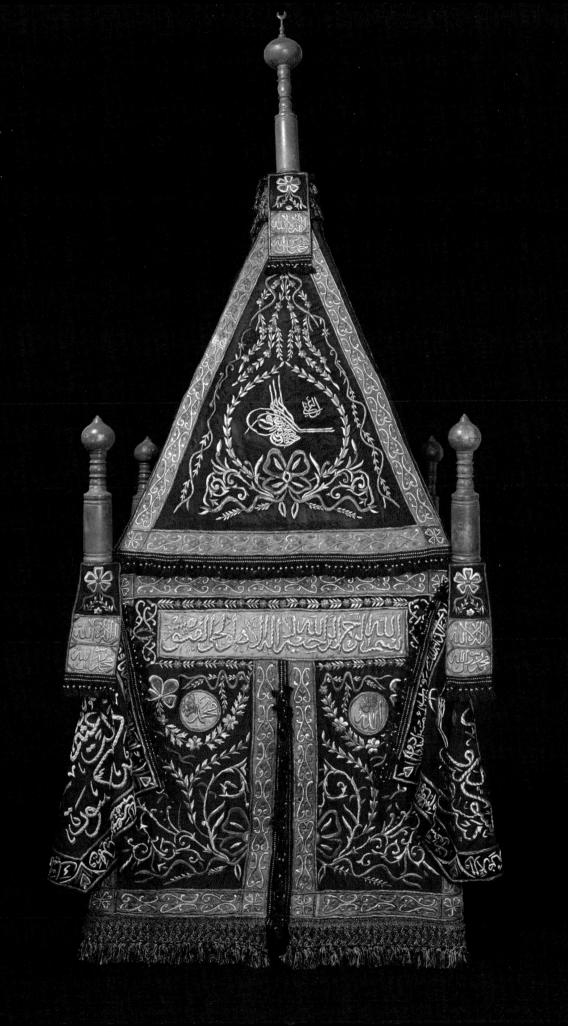

Fig. 96
Pilgrims returning from Mecca
From an album of watercolour paintings,
Ottoman, 18th century
14.7 x 10 cm
British Museum, London

The text in French reads: 'These are the pilgrims who go to Mecca with their sight and return blind.' The pilgrim guiding the other carries prayer beads in his hand and a banner over his shoulder. A similar image was drawn by the French 16th-century traveller Nicolas de Nicolay who describes the pilgrims as follows: 'And thus they go about in troupes carrying great banners with a pyke and half a moone in the top of their staffs, going about towns and villages, singing the praises of their Prophet Mahomet, and asking of almes for the honor of God.'

called *ifrits* (demons). They performed tricks to amuse the crowds, but they extorted money with menaces from shops on the route.[11] Under the Ottomans the lance games and rough behaviour were suppressed and instead the great dervish orders took a leading role in the procession of the *mahmal*. In Damascus dervishes, especially the Mevlevis, had a similarly important role in the various processions that preceded and advertised the Hajj. Three months after the Rajab parade, the Cairo caravan and with it the *mahmal* actually set out.

Under the Mamluk and Ottoman sultans the great Hajj caravans from Cairo and Damascus did not differ much from those in earlier centuries, but they were perhaps more tightly organized and certainly we are better informed about them.[12] In particular Abd al-Qadir al-Ansari al-Jazari, a sixteenth-century Egyptian bureaucrat who was employed in the organization of the Hajj, produced a detailed manual on the subject.[13] The Hajj caravans coming from Cairo and Damascus were like small towns on the move. (In this period not so much is known about the Iraqi caravans which were less regular.) Professional Bedouin guides who were familiar with the desert routes rode at the head of the caravan, followed by the water carriers, then the notables, then the *kiswa*, the *mahmal* and the treasury, which were escorted by archers and torchmen. (Under the Ottomans artillery was also part of the escort.) Wealthy merchants followed the treasury and behind them came the main body of pilgrims, with the indigent towards the rear and struggling to keep up.

Though the pilgrims were expected to carry enough foodstuffs to support themselves for the round trip, there were always mendicant pilgrims who depended entirely on the charity of others. Bedouin outriders were hired to chivvy and guide stragglers, as well as pick up lost property. Yet other Bedouin followed behind in order to feast on the dead camels that were invariably left in the wake of the caravan's progress.

The providers of camels, known as *muqawwim*, were under contract to provide replacements for those camels that died. Customarily the camels travelled four abreast and the cameleers walked in front of them, singing the songs that were traditionally used to urge camels on. The lead camels wore big bells, and ropes linked the lines of camels that followed. Since the Hijaz could not possibly offer adequate grazing for so many camels, they were fed on cakes compounded from mash of bitter vetch and barley meal. The best dromedaries were known as the *namiyya*, the soporific ones, because their padding pace was

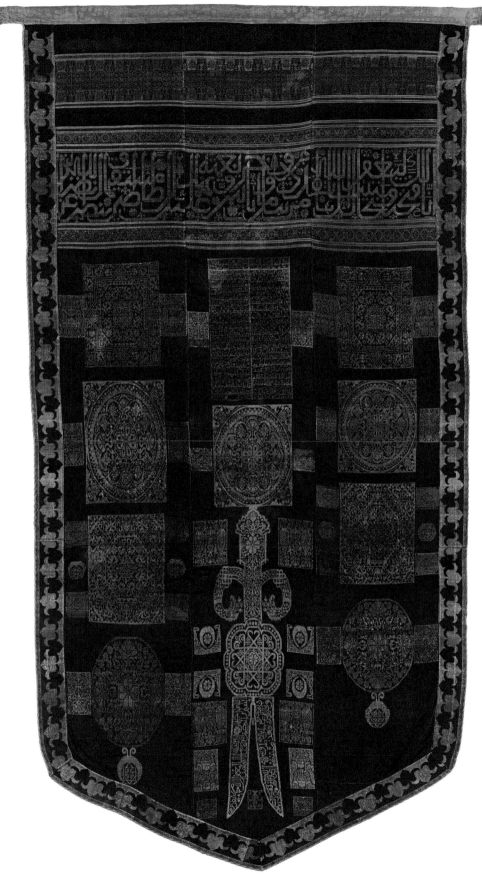

Fig. 97
Ottoman Hajj banner
North Africa, dated 1094 AH/AD 1683
Red silk
369.5 x 190.5 cm
Harvard Art Museums, Cambridge, MA

In form this banner is a traditional Ottoman war banner, with the inscriptions on the two-bladed sword asking for victory. The inscriptions in the rectangular panel, a poem in Arabic in Maghribi script, contain references to the rituals of Hajj and indicate that the banner was carried on Hajj by members of the Sufi order, the Qadiriyya (founded by the 12th-century mystic Abd al-Qader al-Jilani): 'Were it not for him [the Prophet] there would be no pilgrimage and no place of pebbles; were it not for him there would be no circumambulation; neither man nor jinn would have come to Safa to drink from Zamzam.'

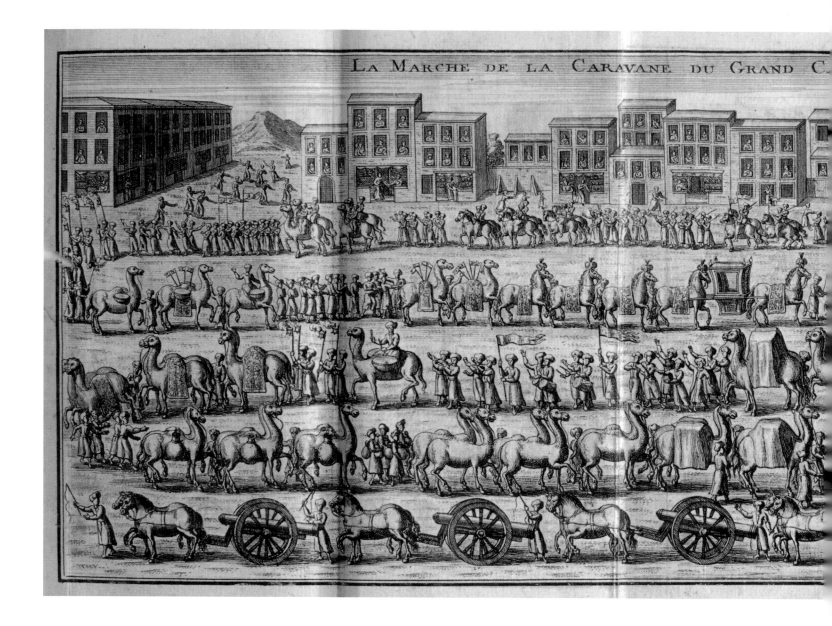

so smooth that one could easily go to sleep while riding on such beasts. In the summer caravans travelled in the coolness of the night guided by lanterns on tall poles. As Ibn Battuta put it, 'You saw the countryside glowing with light'.[14]

The Amir of the Hajj held the power of life and death over the pilgrims. These amirs frequently became wealthy through trading on their own account in the Hijaz and consequently this post was much sought after. The troops under the Amir's command did the same on a smaller scale. The Hajj had its own imam, muezzin and qadi. There were also officers in charge of water, firewood collection and fireworks, a bakery, an orchestra, executioners, occulists, a carpenter to repair camel saddles and poets with rebecs to entertain the Amir

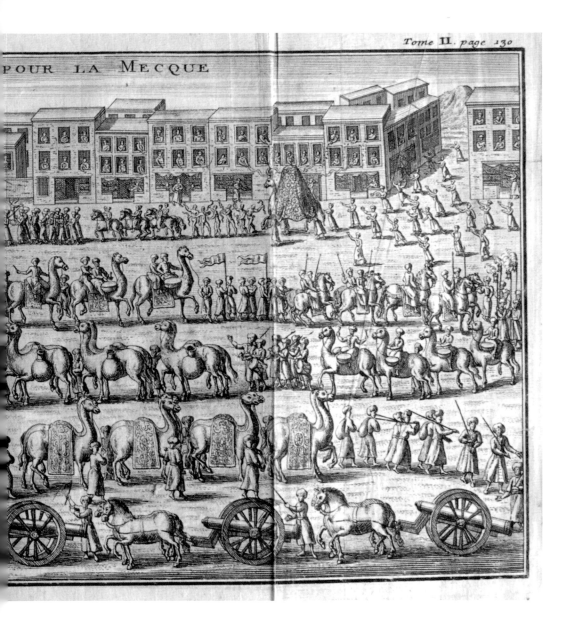

POUR LA MECQUE

Tome II. page 130

of the Hajj. The firework officer's job was not restricted to mere entertainment, for in the Mamluk period fireworks together with trumpets were used to signal the departure and stopping times of the caravan. (From the fourteenth century onwards cannons were employed for the same purpose.) Fireworks were also employed as flares to guide errant pilgrims and in the Mamluk period a sort of Bengal fire was used to show up potential thieves.

The journey from Cairo to Mecca via Ajrud, Aqaba and then along the eastern shore of the Red Sea usually took between forty-five and fifty days, including some lengthy stops. The Damascus caravan, which took about the same length of time, would pause for about a week at Muzayrib, two nights

The Hajj Route from Cairo

There were several routes from Cairo. The main one was across Sinai and had 34 stages, each about 45–48 km (28–30 miles) in length. The first stop was Birkat al-Hajj, 18 km (11 miles) from the Citadel at Cairo, where there was a large reservoir. It was here that the final preparations were made. In order to be in Mecca at the beginning of Dhu'l Hijja, a timetable established in the 14th century had pilgrims arriving at Birkat al-Hajj about the 24th of the previous month of Shawwal.[16] From here they could travel south to Suez and go by sea, or carry on east to Aqaba. This journey could take 45–50 days: 'the custom is to travel much and rest little … they travel from 2 o'clock in the morning until the sun rising, then having rested until noon they set forward and so continue till night and then rest again … till 2 o'clock.'[17]

During a period between 1116 and 1187 the Crusader kingdoms controlled the land routes from Egypt to Syria, so pilgrims such as Ibn Jubayr had to go down the western coast of the Red Sea to Aydhab and cross from there to Jedda (see p. 126). The Sinai route was reinstated in 1266 by Sultan Baybars.

Fig. 99
Al-Qibab
Photo: Sami Abd al-Malik

Along the route succeeding Mamluk sultans dug wells and built caravanserais and other structures to help the pilgrims. At al-Qibab, 35 km (22 miles) east of Suez, there is a pilgrim stop next to a narrow wadi cut through limestone hills. Remains at the site comprise a series of wells, a dam and two rectangular cisterns which, according to a rock-cut inscription at the site, were built under the orders of Sultan al-Malik Nasir Hasan in 1358. The dam, which is 24 m (80 ft) long, is made of limestone blocks quarried from the sides of the wadi. In 1387 the pilgrims' camp was destroyed by a flash flood which killed 107 men, women and children, despite the dam and the extensive drainage system which had been installed three decades earlier. In addition to the water system the site also contains a domed mausoleum known as the Qubba of Shams al-Din, which may date to the Mamluk period or earlier.[18]

Fig. 100 Opposite
Map illustrating the main Hajj routes from Egypt to Mecca and Medina that were in use from the medieval period to the mid-twentieth century.

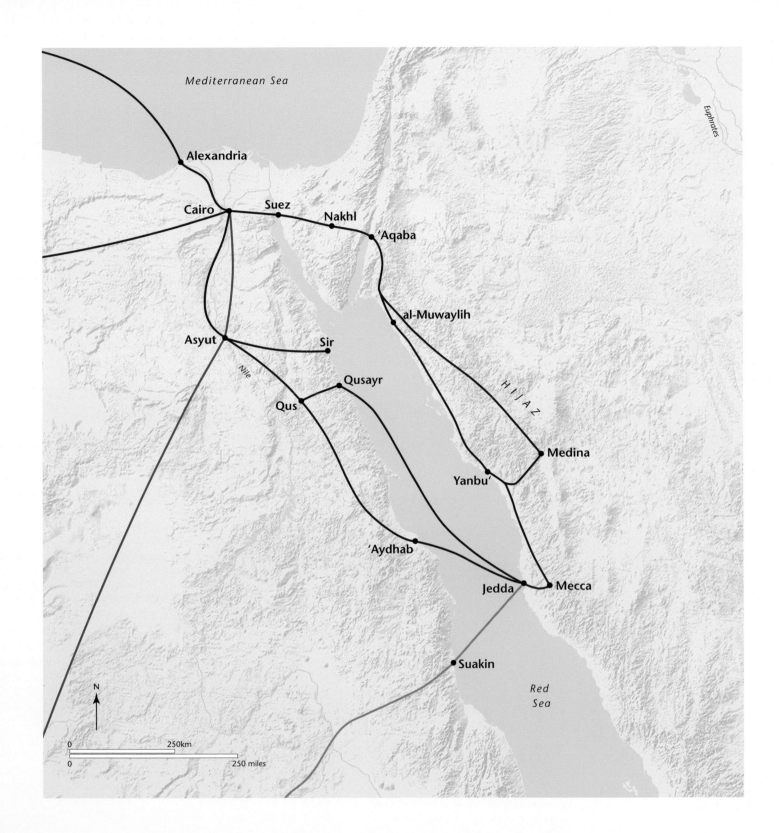

Mediterranean Sea

Euphrates

Alexandria

Cairo Suez

Nakhl

'Aqaba

al-Muwaylih

Asyut Sir

Nile

Qusayr

Qus

H I J A Z

Medina

Yanbu'

'Aydhab

Jedda Mecca

Suakin

Red
Sea

N

0 250km

0 250 miles

The Syrian Hajj Route

The Hajj route from Syria was an ancient trade route which flourished under the Nabataeans and linked Arabia with the Mediterranean. Under the rule of the Umayyad caliphs (661–750), with their capital at Damascus, this route was used for the purposes of Hajj. Following the takeover by the Abbasids, however, the focus of the Muslim empire changed to Baghdad and it was the route from Kufa – the Darb Zubayda in particular – that took precedence. The Ottoman conquest of Syria in 1516, and of Egypt and the Hijaz soon after, was to radically change the importance of the Syrian Hajj route, and it became the main artery that linked the Ottoman capital Istanbul with Mecca.[19] The route between Istanbul and Damascus began at Üskudar (on the Asian side), which the Ottoman traveller Evliya Çelebi described as 'in the territory of the Holy Land'.[20] The 18th-century traveller Mehmed Edib wrote that between Üskudar and Damascus, which cut through central Anatolia, took thirty-seven travelling days. Including an extra six rest days on the journey gave a total time of forty-three days before arriving at Damascus, the great gathering point bringing pilgrims from all over the Ottoman empire.[21] At Damascus next to the Hajj camping ground the Ottoman Sultan Suleyman constructed between 1554 and 1560 a large pilgrimage centre. This was known as the Suleymaniyya or Takiyya and included a mosque, soup kitchen, hospice and *madrasa*. All along the route, starting from the Farewell Fountain at Üskudar down to Mecca, the Ottomans constructed a wide range of facilities for pilgrims, such as a network of Hajj forts.

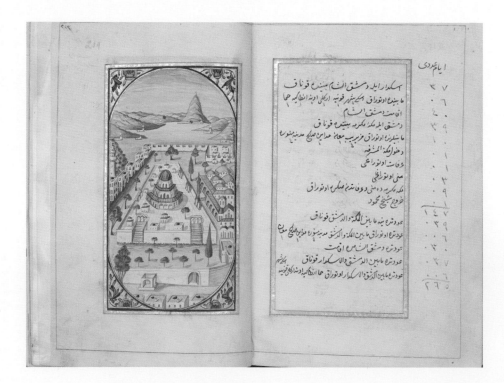

Fig. 101
Bahjat al-manazil (The joy of stages, fols 218b–219a), autographed by Mehmed Edib and dated Dhu'l Qa'da 1240 (31 August 1790)
19.9 x 13 cm
Chester Beatty Library, Dublin

Mehmed Edib (al-Hajj Muhammad Adib-efendi ibn Muhammad Darvish), an Ottoman judge from Candia in Crete, travelled from Istanbul to Mecca in 1779. His text contains a detailed description of the journey and is particularly significant because of the details he provides of the construction of forts and other buildings and facilities all along the Hajj route. This book was evidently valued as an important practical guide and it is notable that it was one of only a very few books printed in the Ottoman empire in the early 19th century.

Fig. 102 Opposite
Map illustrating the Hajj route from Damascus to Mecca, showing the principal Hajj forts built by the Ottoman empire during the 16th and 17th centuries.

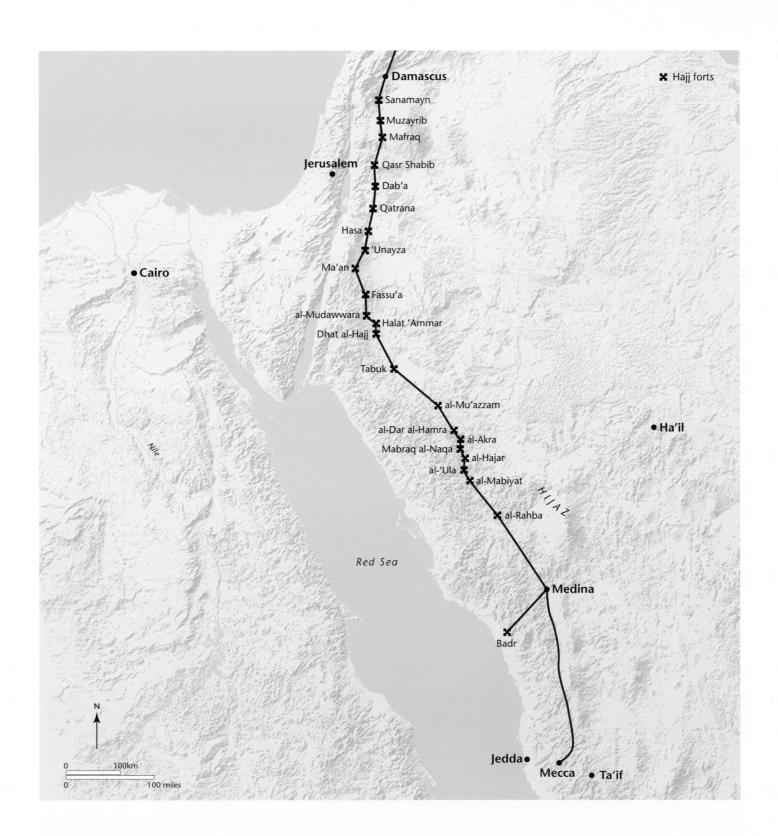

Damascus

Sanamayn

Muzayrib

Mafraq

Qasr Shabib

Jerusalem

Dab'a

Qatrana

Hasa

'Unayza

Ma'an

Fassu'a

al-Mudawwara

Halat 'Ammar

Dhat al-Hajj

Cairo

Tabuk

al-Mu'azzam

al-Dar al-Hamra

al-Akra

Mabraq al-Naqa

al-Hajar

al-'Ula

al-Mabiyat

Ha'il

HIJAZ

al-Rahba

Nile

Red Sea

Medina

Badr

N

0 100km

0 100 miles

Jedda

Mecca

Ta'if

✖ Hajj forts

Hajj Forts

The northern section of the road between Istanbul and Damascus was provided with bath houses, covered markets, caravanserais and mosques while the desert route to the south had a series of forts protecting cisterns and wells. The system continued to be improved and enhanced into the nineteenth century. The advent of steamships in the Red Sea during the 1840s followed by the opening of the Suez Canal in 1869 led to the decline of the overland route, though pilgrims continued to travel on foot and by camel until the opening of the Hijaz Railway in 1908. The Ottomans repaired forts that had been built by the Mamluks and also constructed their own along the Hajj route. The best surviving examples are along the 1,500 km (930 miles) from Damascus to Mecca and many have been extensively documented.[22] The characteristic form of the forts was square,

arranged around a central courtyard. In the centre was a cistern and staircases at the sides led to upper floors and the roof. The forts housed the troops that accompanied the pilgrims. Evliya Çelebi described Qatrana (right) as being 'in the middle of the desert and is a square building made of small stones [foundations]. In the direction of the *qibla* [south] there is a gate. Outside measures three hundred paces but there is no moat. Inside there are seven rooms as well as storerooms and a *masjid* [mosque]. The fort has a commander and seventy troops.'[23] The role of the troops was to guard the water facilities and the pilgrims camped outside. A number of the cisterns attached to forts are huge and rectangular and probably Roman in origin as with Qatrana, which had a capacity of 2,100 sq cu (about 1,050 sq m).

Fig. 103 Left
The fort at Aqaba
Photo: Dudley Hubbard, 2010

The large fort at Aqaba is strategically placed at the head of the Gulf of Aqaba. Its main period of construction was under the Mamluk sultan Qansuh al-Ghawri in 1514.[24] It was the terminus for the Egyptian route across Sinai but pilgrims coming through Jordan sometimes passed that way if the desert route was dangerous.

Fig. 104 Opposite
The fort at Qatrana
Photo: Philip Kennedy

The fort at Qatrana was built on the orders of Sultan Suleyman in 1559 as part of a building programme along the Hajj route. The large reservoir, which has now dried up, is 69.5 m (230 ft) on each side and 4 m (13 ft) deep, and the smaller one is 35.5 x 9.1 m (118 x 30 ft) and 3 m (10 ft) deep. The two tanks are connected by a shallow channel 3 m (10 ft) wide and 70 cm (2 ft) deep which slopes down into the larger tank.

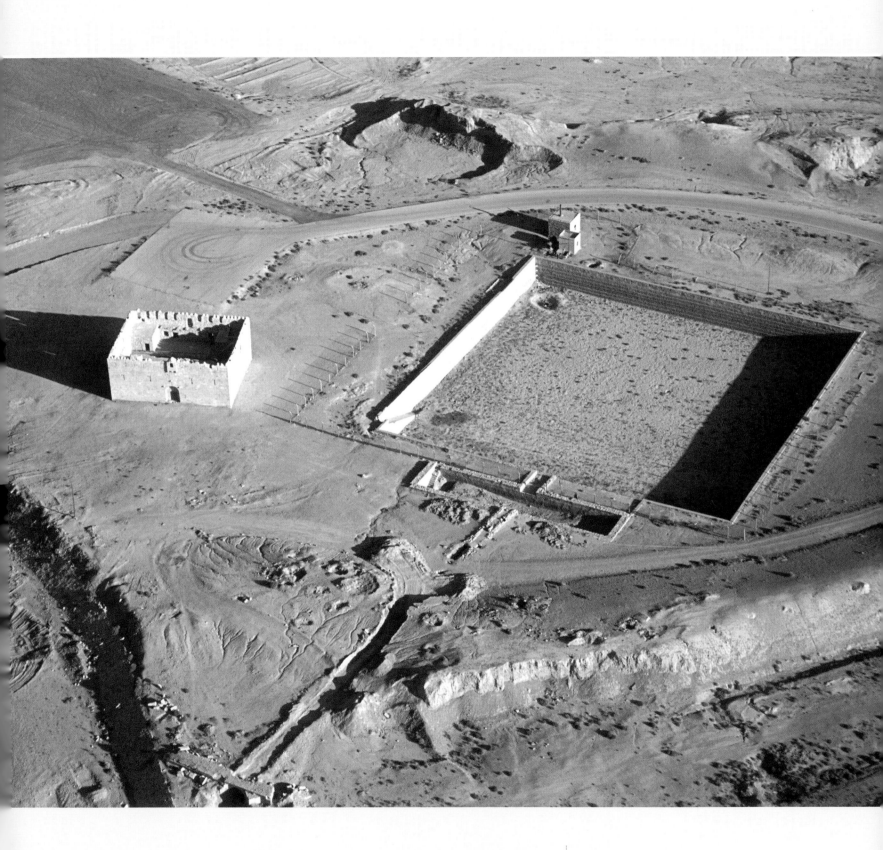

away from Damascus. This allowed latecomers to catch up with the caravan. It was also the place where camels were hired and much general trading was done, as pilgrims sought to equip themselves for the arduous journey ahead.

To die while on the Hajj was judged to be meritorious. Many of the pilgrims were old or sick people who were determined to reach Mecca or die in the attempt, and quite often they did die. The weather in deepest winter or high summer was brutal, the heat of the *samoom*, the 'hot, sandy wind', could be lethal and there was the danger of flash flooding. Banditry and plague also took their toll. As Evliya Çelebi put it, 'Travel is a fragment of Hell, though it be but a single parsang.'[25] Mortality on the Hajj was high, so the washers of the dead had an essential role to play. There was also an official to deal with the estates of pilgrims who died. Since the possessions of deceased pilgrims were deemed to be forfeit, it was common for a dead man's companions to bury him in secret in his tent.

Many North African pilgrims travelled by sea to Alexandria and from there made their way down to join the Cairo caravan. But from the thirteenth century onwards in most years there were also two overland caravans that started out from Fez and Sijilmasa.[26] A Moroccan pilgrim was liable to spend fifteen to eighteen months away from home. The *rihla* texts, accounts of their pilgrimages produced by *hajjis* from Morocco or Andalusia, sometimes doubled as market guides for the many pilgrims who had to finance their journeying through trade.

Hajjis setting out from sub-Saharan Africa faced formidable obstacles. In pre-colonial times a pilgrimage from the Songhai empire of Gao or from Mali took no less than two years and sometimes as many as eight.[27] Most West Africans who went on the Hajj did not expect to return and consequently they

Fig. 105
Qibla compass
Turkey, *c*.1800
Painted wood
Diameter 13.2 cm
Benaki Museum, Athens

This instrument is described as 'Mihrab Afaqi', 'universal prayer niche', the words inscribed within a niche with a mosque lamp hanging from the top. It gives the direction of Mecca for 28 cities which are largely within the Ottoman empire. A depiction of the sanctuary at Mecca is above. The magnetic compass is in the centre. This type of instrument displaced the more complicated methods used to work out the direction of Mecca.

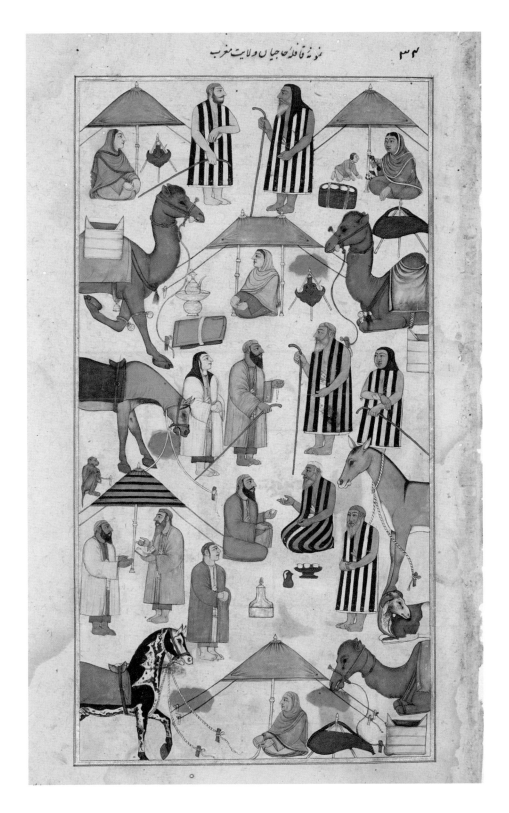

مونه قافلهٔ حاجیان ولایت مغرب ۳۴

Fig. 106
The caravan of pilgrims, fol. 15a from the Maghreb Anis al-Hujjaj (The Pilgrim's Companion) by Safi ibn Vali (see also figs 120, 121)
India, possibly Gujarat, c.1677–80
Ink, watercolour and gold on paper
33 x 23.2 cm
Nasser D. Khalili Collection of Islamic Art

The striped garb of some of the pilgrims serves to emphasize that this is the caravan from North Africa. The lively composition shows pilgrims with their animals at an encampment greeting each other.

might sell all their property before setting out and would sometimes divorce their wives. Often the pilgrims were old men who expected to die either in Mecca or while journeying towards it. Not only were black African pilgrims liable to be attacked by bandits, but they also risked being enslaved or conscripted into a foreign army. Since the Hajj was so dangerous, some religious scholars in the Sudan and elsewhere argued that the Hajj was no longer obligatory. Nevertheless, despite the risks, *ulama* who returned to Timbuktu or to places further to the south or west found their prestige as religious scholars greatly enhanced by having been to Mecca. Though little is known about the medieval African pilgrimages, occasionally the Mamluk chronicles record royal pilgrimages, such as the one made by Mansa Musa of Mali in 1324–5 to atone for the accidental killing of his mother.[29] He set off with a retinue of 8,000 and 500 slaves walked in front, each of whom was carrying a staff of gold weighing 500 *mithqals*.[30] Mansa Musa's dispensation of largesse was so extravagant that the price of gold fell in Egypt. Another celebrity pilgrimage was that of Askia Mahmud of Songhai (1492–1527), who made his Hajj in 1496–7.[31]

Once the border between Mamluk Syria and the Mongol Ilkhanate opened in the 1320s, Iranian pilgrims either arrived in Damascus early and then

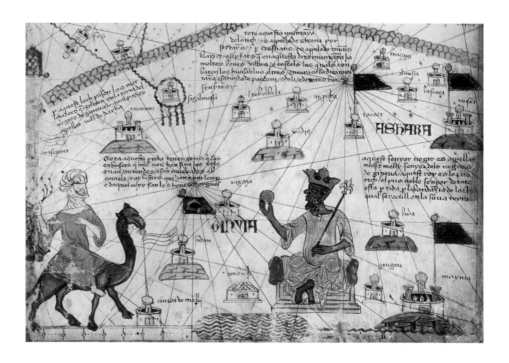

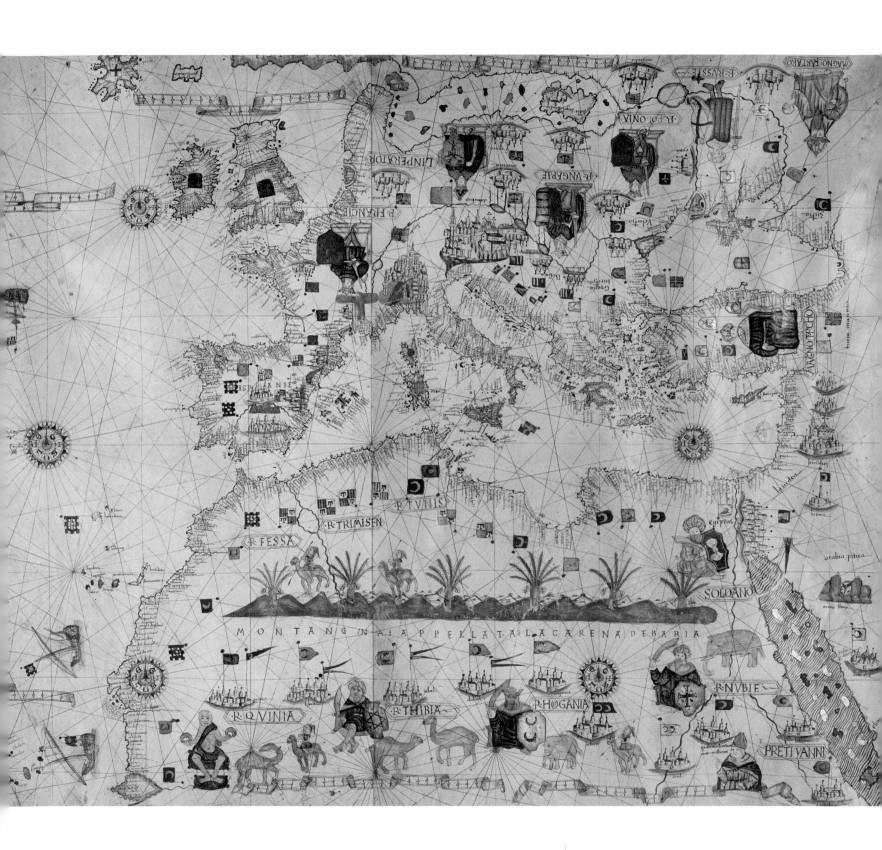

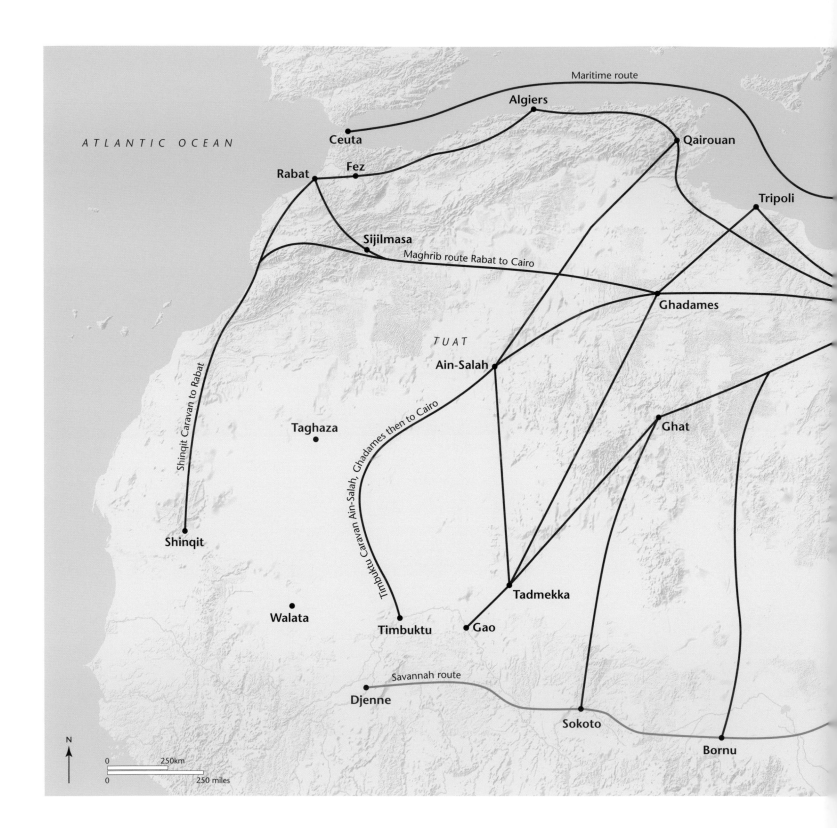

ATLANTIC OCEAN

Maritime route

Algiers

Ceuta

Qairouan

Fez

Rabat

Tripoli

Sijilmasa

Maghrib route Rabat to Cairo

Ghadames

TUAT

Ain-Salah

Shinqit Caravan to Rabat

Ghat

Timbuktu Caravan Ain-Salah, Ghadames then to Cairo

Taghaza

Shinqit

Tadmekka

Walata

Gao

Timbuktu

Savannah route

Djenne

Sokoto

N

0 250km

Bornu

0 250 miles

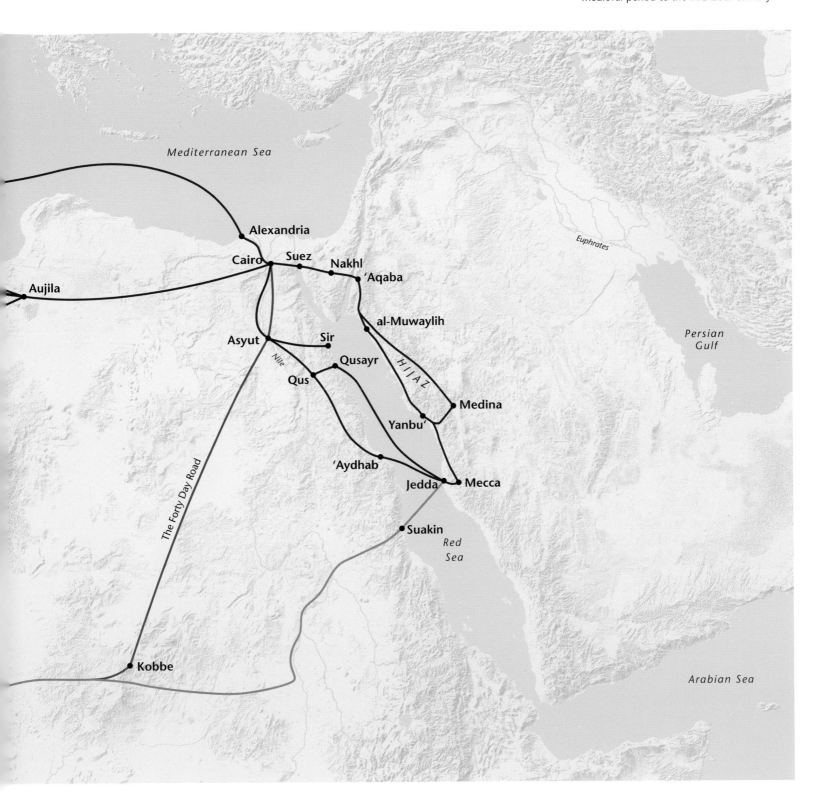

Mediterranean Sea

Alexandria

Cairo Suez Nakhl

'Aqaba

Aujila

al-Muwaylih

Asyut Sir

Nile

Qusayr

H I J A Z

Qus

Medina

Yanbu'

Euphrates

Persian Gulf

The Forty Day Road

'Aydhab

Jedda Mecca

Suakin

Red Sea

Kobbe

Arabian Sea

The Hajj from West Africa

Hajj has been central in Mali since at least the tenth century when significant conversion to Islam began. Trade across the Sahara from cities such as Gao and Timbuktu served to connect with North Africa and on to Arabia and ultimately Mecca and Medina. Saharan towns such as Tadmekka, modern Essouk in Mali, were important stopping points for pilgrims and traders. Tadmekka's very name draws upon links with and evokes images of Mecca.

Mansa Musa in the early fourteenth century and the later Songhai emperor Askia Muhammad, who also went on pilgrimage following his assumption of power in 1492, were rich because they controlled the West African gold sources. At Tadmekka gold coin moulds dating to the ninth–tenth centuries have been found, as well as a piece of silk textile. In Gao, numerous archaeological finds have been made testifying to the riches of medieval trans-Saharan trade including imported glazed pottery and glass from North Africa and Egypt.

Hajj also enriched Islamic scholarship in Mali. At Timbuktu there existed a university and a tradition of recording on manuscripts in Arabic script, including science, law, medicine, history and religious texts. Returning pilgrims contributed both ideas and travel accounts.[32]

The Hausa are numerically one of the largest of the peoples of West Central Africa, living predominantly in northern Nigeria but also southern Niger. Hausaland comprised seven original city-states of Daura, Zaria, Biram, Kano, Katsina, Rano and Gobir, where Islamization started from the fourteenth century.

Prior to 1800 Hajj was the preserve of religious scholars and the elite. Following religious reform and the growth in literacy in the nineteenth century, the numbers of Hausa pilgrims increased. Pilgrims travelled to Mecca on foot or horseback across the savannas of central Africa, which could take several years. Many pilgrims died while travelling or in the holy cities. Some settled permanently at some point along their route, and substantial communities of Hausa origin are found across Saharan Africa and the Middle East, including Saudi Arabia, reflecting the routes earlier pilgrims took and the places they sold slaves to finance their Hajj.[33]

Fig. 110 Top
Gold coin mould from Tadmekka, Mali
9th–10th century
8 x 5 cm
Institut des Sciences Humaines, Bamako

In 2005, excavations at Tadmekka found fragments of ceramic coin moulds with minute traces of highly pure gold on their surface – the only known evidence of Tadmekka's famous gold coinage. Gold dust or nuggets were melted in these moulds to produce discs of gold which could then be worked into a finished coin form. The very pure, unstamped Tadmekka gold 'coins' would have been a highly prized commodity for early pilgrims making their way across the Sahara.[34]

Fig. 111 Above
Fatimid coins
Gold dinars, minted in al-Mansuriya and al-Mahdiya, 392–411 AH/AD 1001–1020
Diameter 2.1–2.3 cm
British Museum, London

Fatimid coins circulated throughout West Africa as well as in Fatimid-ruled Egypt.

Fig. 112
Tadmekka, Mali
Photo: Sam Nixon, 2005

This photograph looks northwards along the Essouk valley in northern Mali, the location of the ruins of Tadmekka, which date from the 8th to the 14th century. Tadmekka was one of the most important West African towns involved in trade across the Sahara, and pilgrims bound for Mecca congregated there to join the Saharan trade caravans. The meaning of its name – 'resemblance of Mecca' – testifies to its importance as both a locality on the pilgrimage route and its role as a centre of early Islam in West Africa.[35]

Fig. 113
A Hajj journey by Umar ibn Sa'id al-Futi
al-Turi (d. 1864)
Red and black inks on paper
12 loose leaf pages, 18 x 22 cm
Mamma Haidara Library, Timbuktu

*Al-Futi was a renowned scholar, social
activist and sheikh in the Tijani Sufi order
commonly known as al-Hajj Umar Tal.
Written in Sudani script, this is an account
of his Hajj which he undertook with his
family in 1827. On his return from Mecca
he visited Jerusalem, Syria and Egypt, where
his reputation for piety and learning were
recognized. He is said to have led the prayer
in the Dome of the Rock in Jerusalem, cured
the son of a sultan from madness in Syria,
and astonished scholars in Cairo by his vast
erudition.[36] On his return he went through
Fazan and at a village called Tijra his wife
Maryam and brother fell ill and died. During
this time he heard that the conflict between
the kingdoms of Bornu and Satku was
continuing and he succeeded in mediating
between them. This is one of a number of
manuscripts relating to Hajj in the renowned
libraries of Timbuktu.*

Fig. 114 Left
Blue and white porcelain dish made in Jingdezhen
Ming dynasty, 1403–24
Diameter 38 cm
British Museum, London

Made during the period when Admiral Zheng He was undertaking his voyages across the Indian Ocean and beyond (1403–33), this was the type of dish that was widely exported to the Middle East – eleven similar dishes are in the Ardebil shrine in Iran – and copied by potters at Iznik in Turkey. That it had a Middle Eastern owner is known from the drilled mark on the back.

Fig. 115 Overleaf
Chao Jin Tu Ji, pp. 18–19 of the travelogue of Ma Fuchu, dated 1861
Woodblock on rice paper
15 x 26.5 cm
Aga Khan Collection, Geneva

Ma Fuchu (Ma Dexin, 1794–1863) was an eminent scholar of Islam and Sino-Muslim philosophy and the author of some thirty-five books written in Arabic and Chinese ranging from metaphysics to history. He also translated the Qur'an. This text is a travelogue of his journey from China to Mecca travelling with a group of Muslim merchants. They started by going overland and by riverboat to Rangoon and then went by steamship to Jedda. Ma Fuchu (probably a rendering of Yusuf) wrote the text in Arabic and it was translated into Chinese by his student Ma Anli.

joined the Syrian Hajj or they travelled from Baghdad to Mecca via Kufa and Ha'il. Indian and South-east Asian pilgrims usually arrived by sea, though not in great numbers until the nineteenth century. The same was true of Chinese pilgrims, many of whom were involved in maritime trade.[37] In the early fifteenth century the Chinese admiral Zheng He commanded a series of exploratory trading fleets which visited South-east Asia, India, East Africa and the Middle East. On the seventh and last of these expeditions some of his sailors joined a ship which sailed up the Red Sea and they went on to Mecca where, reportedly, they purchased 'strange gems and rare treasures, as well as giraffes'.[38] The Ka'ba was known in Chinese as *Tianfag*, 'the Heavenly Cube'. Although Zheng

شكل المسجد الحرام والكعبة

凱爾白圖式

He was a Buddhist, he did know Arabic, and both his father and grandfather seem to have been Muslims who had performed the Hajj.

The economy of Mecca was entirely dependent on the pilgrim traffic, income from *awqaf* (religious endowments, singular *waqf*) and subsidies from pious Muslim rulers, while the economy of Medina, notwithstanding its groves of date palms, was hardly less dependent. For instance, large *awqaf* in Egypt financed the supply of grain to the holy cities. However, it is in the nature of *awqaf* that, over the years, the income supplied by such pious endowments tended to diminish due to inflation and maladministration.[39]

The Haram enclosure in Mecca, the Prophet's mosque in Medina and various other religious colleges and Sufi centres were expensive to maintain as their structures suffered repeatedly from fires, flash floods and earthquakes. The erection of new foundations and the restoration of old ones in the Hijaz was exceptionally expensive, as all the necessary building materials – marble, stone, wood, tiles, nails, etc. – had to be imported. The skilled labour also had to be imported and the work carefully planned in advance in Istanbul or Cairo.[40] However, the prestige accruing from having commissioned or restored religious foundations in Mecca or Medina was immense. The Mamluk Sultan Qaytbay (1468–96) commissioned the construction of a madrasa (religious teaching college) and a hospice on the side of the Mosque of the *haram*. The mosque of the Prophet was restored by Qaytbay's architect, Shams al-Zaman. Suleyman the Magnificent (1520–66) commissioned the restoration of the aqueduct that supplied Mecca with water and put a new roof on the Ka'ba. Several sultans restored the famous drainpipes (*mizab*) of the Ka'ba (see fig. 117).[41] The Mosque of the Haram was reconstructed on the orders of the Ottoman Sultan Selim II (1566–74).[42]

Apart from their associations with the life of the Prophet, Mecca and Medina were also famous as centres of religious scholarship and for many pilgrims, especially those coming from the most distant territories, performance of the religious duty doubled as a quest for knowledge. In particular they sought out reliable transmitters of the Hadith, orally transmitted traditions concerning the deeds and sayings of the Prophet and his Companions. The holy cities served the Islamic world as theological and legal finishing schools, and if a religious scholar wanted to publicize his writings throughout the Islamic world, he sent his books to Medina.

Fig. 116
Candlestick
Egypt, dated 887 AH/AD 1482–3
Brass inlaid with silver
46 x 37 cm
Benaki Museum, Athens

This is one of five candlesticks[43] whose inscriptions state that they were offered by the Mamluk Sultan Qaytbay (1468–96) to the mosque of Medina. Qaytbay was an outstanding patron of the arts and architecture; he renovated and built monuments in the key cities of his domain and is said to have sent teams of craftsmen to work on the mosque at Medina. The inscription band on the socket states: 'This was endowed to the shrine of the Prophet by our master, the Sultan al-Malik al-Ashraf Abu'l Nasr Qaytbay' and the date 887.

Fig. 117 Above
Presentation drawing of a restoration inscription for the drainpipe (*mizab al-rahma*) of the Ka'ba, in the name of the Sultan Abdülmejid I, Istanbul
c.1856–7
Ink and gold on paper
20.5 x 155 cm
Nasser D. Khalili Collection of Islamic Art

The drainpipe of the Ka'ba, decorated with beautiful inscriptions, was replaced by different Ottoman sultans.[44] This drawing is the first of three sections for the mizab *which is now located in the museum in Mecca. The area below the* mizab *was believed to be the location of the tomb of Ishmael.*

Fig. 118 Opposite
Astrolabe with rete for 60 stars, dated 728 AH/AD 1327–8, made by Ali ibn Ibrahim al-Harrar the muezzin, in Taza, Morocco
Brass
Diameter 22 cm
Museum of the History of Science, Oxford

This astrolabe uses the concept of the 'Universal Lamina' in which the rete rotates above a horizontal projection of the celestial sphere. This invention meant that astrolabes (in contrast to the planispheric astrolabes which required a specific tympanum for each latitude) were now lighter and more portable. Someone such as Ibn Battuta, travelling alone, may have had such a one in his possession.

For some scholarly pilgrims, particularly those coming from Spain and Morocco, their *rihla* narratives served to establish their religious credentials, since they included accounts of their meetings with religious scholars in Mecca, Cairo, Jerusalem and elsewhere and listed the *ijazas*, or licences to transmit what they had learned from those scholars. One such was the famous *hajji* Ibn Battuta who travelled in search of knowledge. When he left Tangiers in 1325 he was only twenty-one and needed to complete his education. Perhaps because of this, he did not proceed directly to Mecca, but travelled on from Cairo to Damascus. He devoted a section of his *rihla* to 'What lectures I attended at Damascus, and those of its scholars who gave me licence to teach'. After studies in Damascus he went on to Mecca and subsequently, having acquired a taste for travel, he spent decades on a series of journeys that took him to India, Central Asia, tropical Africa, South-east Asia and perhaps China.[45]

Although Ibn Battuta visited many Sufi lodges and reported many Sufi miracles, his narrative of his travels, like those of most pilgrims who have left a record, is quite prosaic and decorous. But other *hajji*s wrote of their pilgrimages in terms that were mystical and rapturous. Muhyi al-Din Ibn al-Arabi (1165-1240), one of the most famous medieval Sufis, set out from Andalusia on the Hajj in 1201. He was never to return. His pilgrimage inspired a series of obscurely couched mystical works, including *al-Futuhat al-Makkiya* (The Makkan Revelations), *Ruh al-Quds* (The Holy Spirit of Jerusalem) and *Tarjuman al-Ashwaq* (The Interpreter of Desires).

Once the rituals of the Hajj were formally concluded after the standing at

Arafat, the *ihram* was no longer worn and there were celebrations at Mina. Fireworks were let off, guns were fired and a trade fair was held there from the 11th to the 13th Dhu'l Hijja. Some pilgrims merely replenished their supplies for the return journey, but the fair was also the main setting for the international trade in luxury goods including silks, spices, coffee, pearls from Bahrayn and Chinese porcelain. The annual systole and diastole of the Hajj played a major role in disseminating craft designs and techniques during the Mamluk and Ottoman periods.

The Hajj features in various stories in the *Arabian Nights*, most of which were composed or given their final revision in the late Mamluk period, including, for example, 'The Story of Ali Khawaja, a Merchant of Baghdad'. In this story, after the merchant happened 'to dream for three nights together, that a venerable old man came to him, and, with a severe look, reprimanded him for not having made a pilgrimage to Mecca, he was very much troubled'. On the one hand, he did not want to leave his house and business in jeopardy; on the other, he was conscience-stricken at not having fulfilled this basic religious duty. In the end he sold the house and business and, having a thousand pieces of gold more than he wished to carry with him on the pilgrimage, he concealed this money at the bottom of a jar of olives which he gave to a neighbour to look after. Then he set off to Mecca with the residue of his

money and merchandise to trade with 'and when he had acquitted himself of the duties of his pilgrimage, he exposed the merchandise he had brought with him, to sell or exchange them'. At this point he heard from passing merchants that he would make a bigger profit with these goods in Cairo, so he travelled on and spent years trading profitably throughout the Middle East. There is no need to follow this story any further here, with the details of how he lost and regained that jar of olives.[48] But, in depicting the mixture of piety and commercial entrepreneurship, the fiction reflects the reality of the times.

Though the coming together of people from all over the Islamic world with things to buy and sell made the Hajj somewhat resemble an international trade fair, there were certain obstacles that prevented Mecca becoming a really

Fig. 119 Below
Bengali trade cloth
19th century
Embroidered silk,
121 x 119 cm
British Museum, London

This textile is made from a wild silk known as tussar *which is characteristically beige in colour, embroidered in yellow gold thread. It is of a type made in Bengal and taken by pilgrims to be traded in Mecca. The style was particular popular with Indonesian pilgrims who returned home with them.[46]*

Fig. 120 Opposite
Crossing the sea of Oman (left) and View of Surat oriented south (right), folios 3b and 2b from the Anis al-Hujjaj (The Pilgrim's Companion) by Safi ibn Vali (see also figs 106, 121)
India, possibly Gujarat, c.1677–80
Ink, watercolour and gold on paper
33 x 23.2 cm
Nasser D. Khalili Collection of Islamic Art

Safi ibn Vali advises pilgrims to be careful as to their choice of ships and to make sure that the captain does not overload them. He himself sailed from Surat in Gujarat, known as the gateway to Mecca, on the Salamat Ras *in 1669 and noted that there were more than forty who had not registered. He advises on all manner of details from where the luggage should be placed to how to avoid sea sickness and suggests pilgrims carry their own medicines. He also asks that they assist the crew in fighting off enemies, carrying out repairs to the ship and bailing out water.[47]*

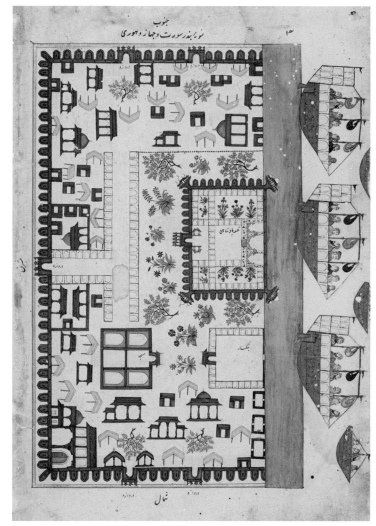

grand international trading centre on an annual basis. Because the Hajj was
governed by the lunar year, commencing eleven days earlier each solar year,
travel by sea to the Red Sea ports was often difficult for traders and pilgrims.
Until the appearance of steamships from the 1830s onwards, navigation in
both the Indian Ocean and the Red Sea was dependent on the seasonal winds.
For pilgrims coming from India, Malaysia, Java and other eastern regions, the
timing of their journey was dependent on the monsoon winds.[49] Since the
west coast of India was not navigable between roughly June and September
when the south-west monsoons prevailed (and there were also a dangerous few

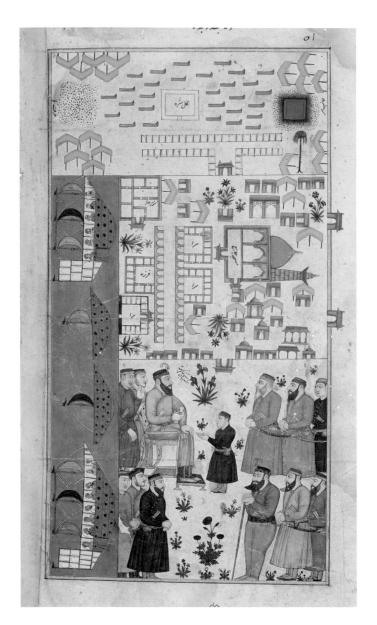

weeks in mid-winter), ships from India generally sailed in convoys in spring and autumn. Therefore it was not always worth a great Indian merchant's time to set out for the markets of the Hijaz.[50]

The Red Sea presented other problems to seafarers. The prevailing winds between May and September were northerly or north-westerly, but during the rest of the year the prevailing wind south of Jedda was south-easterly. Thus

tacking up to Jedda was difficult during most of the year. Additionally, shoals and coral reefs as well as sandstorms blowing across the waters made sailing dangerous. Navigation was so problematic that the dhows would have a man at the prow to shout back directions to the man at the stern. Consequently ships coming from India usually ended their journey in Aden, where their passengers and cargo were transhipped on to smaller vessels. Jedda's harbour was sheltered, but it was foolhardy to attempt to enter it at night, and large ships never entered it at all.[51]

Returning now to the camel caravans, while the Egyptian caravan took approximately forty-five to fifty days to make its way back to Cairo, a sequence of greeting parties rode out from the city with provisions and celebratory gifts. The first of the greeting parties would meet the caravan fifteen days out from Cairo. As well as relatives and friends, there were opportunistic traders in the party. Similarly the returning Damascus caravan was greeted by the *cerde* (or *jirda*), a heavily armed relief escort for the last part of their journey. The *cerde* brought supplies and extra security. The Bedouin were most likely to attack the Hajj on the return journey, because by then it might have become clear that they were not going to be paid off by the Amir of the Hajj. Moreover, there would be rich pickings from the luxury items purchased by pilgrims in Mecca.[52] The Burgundian Bertrandon de la Brocquière was in Damascus at the time of the return of the Hajj caravan in 1432. 'It was said to be composed of three thousand camels; and in fact it was two days and as many nights before they had all entered the town. The event was, according to custom, a great festival'.[53] The *Na'ib* (Governor) of Damascus came out to greet the camel which carried a Qur'an wrapped in precious silks. This camel was escorted by soldiers bearing swords, crossbows and muskets. It was followed by eight old men on camels (who had probably been the guides on the pilgrim route) and then by the wealthy and distinguished personages. Bertrandon tried to find out more about the Hajj from a Bulgarian renegade who proved to be a rich source of misinformation, for he told him that the Prophet's tomb was in Mecca and that some of the pilgrims 'having seen it, had their eyes thrust out, because they said, after what they had just seen, the world could no longer offer them anything worth looking at'.[54]

Fig. 121
The port of Jedda (left) and the port of Mocha in Yemen (right), fols 22b and 21a from the Anis al-Hujjaj (The Pilgrim's Companion) by Safi ibn Vali (see also figs 106, 120)
India, possibly Gujarat, c.1677–80
Ink, watercolour and gold on paper
33 x 23.2 cm
Nasser D. Khalili Collection of Islamic Art

Jedda was the principal port on the Red Sea on account of its proximity to Mecca. It is said to have been founded by the caliph Uthman in 647. During the Mughal period it is probable that some 15,000 pilgrims came annually. Mocha was an important port on the Red Sea coast of Yemen, but by the time the Malay traveller Abdallah Munshi (see pp. 194–5) visited in 1854 it was a shade of its former glory: 'I was absolutely astonished by the architecture of the large houses which were beautifully constructed. Each had windows which were all carved and adorned with fine and intricate floral patterns ... the atmosphere of the place gave the impression of being a deserted city'[55]

In 1503 Ludovico Varthema saw unicorns in the 'Temple' at Mecca (well, if not unicorns, then they may have been oryxes). Varthema had arrived in Alexandria 'longing for novelty as a thirsty man longs for fresh water'.[56] Subsequently he attached himself to a group of Mamluks who were escorting the Hajj caravan from Damascus. He reported that the Bedouin who sought to attack the caravan were easily repelled by the Mamluks, for they were skilled and well-equipped warriors, whereas the Bedouin rode about naked on horses without saddles. In Medina he inspected the Prophet's tomb and consequently was able to declare that the medieval European legend that it was suspended in the air in Mecca was false. In Mecca he noted the commodities coming there from India and Ethiopia, including silk, cotton, spices, incense and wax. He described the Ka'ba as a tower which Abraham had built.[57]

If not the first European to find his way to Mecca, he was perhaps first to write down what he had seen. In subsequent centuries his account was followed by those of Joseph Pitts, Richard Burton, Lady Evelyn Cobbold, A.J.B. Wavell and others. Some had travelled to Mecca as sincere Muslims, some came as slaves in the retinues of Muslims, but others were explorers and spies who contrived to reach the forbidden city in disguise. Europeans first became aware of the importance of the Hajj in the sixteenth century and thereafter they strove to exercise some sort of control over it.

Until the sixteenth century the Indian Ocean and the Bay of Bengal could be described as Muslim lakes. To such an extent was maritime commerce dominated by Muslim traders that those Chinese who wanted to facilitate their participation in this commerce tended to convert to Islam. But, soon after the Portuguese rounded the Cape of Good Hope in 1497, this changed. The primary Portuguese aim in eastern waters was to prevent ships carrying spices from reaching Red Sea ports from where their cargoes would be transhipped and transported on to Cairo. Although the Portuguese were only partially successful in establishing a blockade of the Red Sea, they did manage to reroute much of the spice trade around the Cape to Lisbon. They dreamed of seizing the Prophet's tomb, which they had heard was suspended in the air by magnets in Mecca, but with such poor intelligence it is not surprising that they did not succeed. Inevitably the seaborne Hajj was adversely affected by the

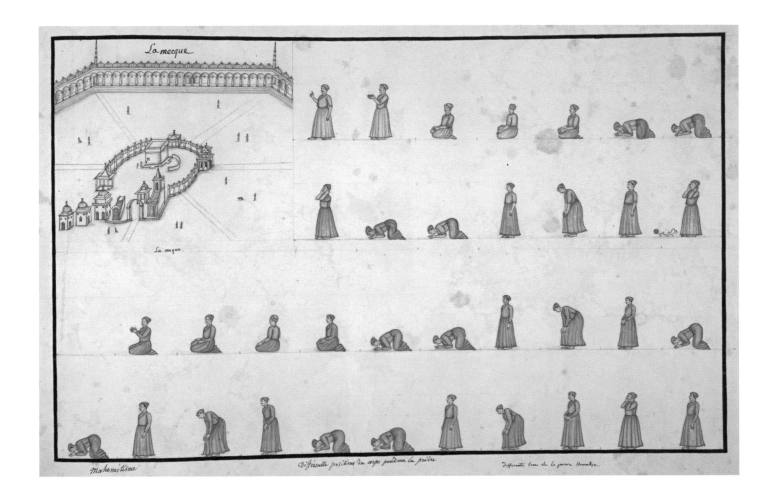

Fig. 122
People at prayer, fol. 25 from the
Gentil Album
India, Faizabad, c.1774
Watercolour on paper
37 x 53.5 cm
Victoria and Albert Museum, London

*This painting is intended to demonstrate
the different positions taken by Muslims
in their prayers. They are dressed in
Mughal costume and face the sanctuary
at Mecca. It is part of an album of 58
'Company' paintings commissioned by
French infantry colonel Jean-Baptiste-Joseph
Gentil (1726–99), who served under Shuja'
al-Daula of Awadh between 1774 and
1786. Company paintings were produced
by Indian artists for Europeans living in
the Indian subcontinent.*

Portuguese presence in the Indian Ocean, for the Portuguese first attacked and
sank pilgrim ships and later levied a special tax on the pilgrim passengers.[58]
(Their maritime supremacy in the region was subsequently challenged in the
seventeenth century by Dutch and British ships.)

As the Portuguese exerted their influence over the sea routes taken by
pilgrims in the Indian Ocean, the Mughal empire conquered the province of
Gujarat in 1573, which included Surat, the main port used by South Asian
pilgrims. Surat's capture led to an increased interest in the Hajj among the
Mughal ruling class. An imperial edict proclaimed that 'the travelling expenses
of anybody, who might intend to perform the pilgrimage to the Sacred Places,
should be paid'. The first Mughal Hajj caravan left the imperial capital
Fatehpur Sikri in 1576, with a 600,000-rupee donation for the holy places.

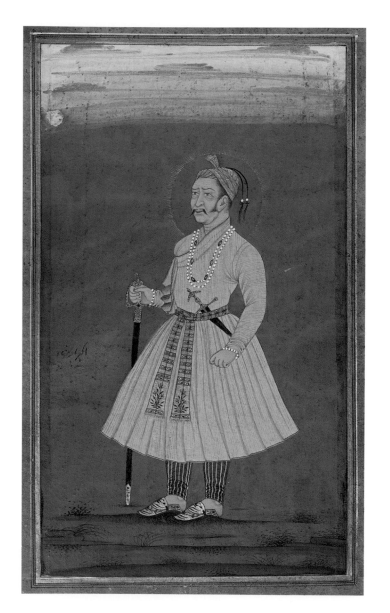

Emperor Akbar (1542–1605) wanted to perform Hajj, but was dissuaded by his officials. However, Akbar's aunt, Gulbadan Begum, and a large retinue of ladies from the royal household left Fatehpur Sikri in October 1575, bound for Mecca. In October 1576 the royal party set sail and reached Jedda in early 1577. They stayed in the Hijaz for four years, and performed the Hajj four times. Reports reached the sultan in Istanbul that the party's long stay was causing a scarcity of provisions in Mecca. The sultan ordered the governor of Mecca to expel the royal party. The ladies of the royal household returned to Fatehpur Sikri in April 1582. Their expulsion by the Ottomans angered Akbar. In retaliation, the emperor suspended relations with the Ottomans, halted the lavish charitable donations he had annually sent to the holy cities, and suspended the Mughal-sponsored Hajj caravan.[59] Akbar's successors Jahangir (1605–27) and Shah Jahan (1627–58) resumed Mughal patronage of the Hajj. Emperor Aurangzeb (1658–1707) paid for 'professional' pilgrims who went on Hajj on his behalf.[60]

The Portuguese threat to Jedda and to Mamluk hegemony in the Hijaz more generally was part of the background to the downfall of the Mamluk sultanate in 1516–17, as Mamluk musketeers and other military forces were diverted to the Red Sea and therefore not available for the defence of Syria from the Ottomans. The Ottoman occupation of Egypt and Syria, and the subsequent allocation of large sums for paying off the Bedouin, increased the security and economic importance of the caravans from Cairo and Damascus. Each year the Ottomans spent a sum on financing the Hajj that would have been sufficient to fund a major war in early modern Europe.[61]

The Ottomans confirmed the Sharifs as the rulers of Mecca and Medina, but they also installed a Pasha and a Janissary garrison in Jedda as a counter-balance to the authority of the Sharifs. The Ottoman sultans placed great

importance on their role as overlords and defenders of the holy cities, and they treated their inhabitants generously, exempting them from taxation and military service.[62] The Hijaz became an attractive place to retire to, though non-Ottoman subjects who settled there were not exempt from taxation. It also became a place of exile. Previously, under the Mamluks, disgraced amirs were sometimes sent into exile in Mecca and Medina.[63] Occasionally the Ottomans also used the Hijaz as a place of exile – and possibly even worse. Ali Bey al-Abbasi, who went on the Hajj in 1806, reported that the Sharif employed a charming young man, known privately as 'the Poisoner', whose job it was to hand out water that he claimed to be from the well of Zamzam to out-of-favour Ottoman officials who had been despatched from Istanbul to Mecca, and this was how they met their end. Exile to the Hijaz was also used by the Mughals: notables who had fallen out of favour were quite often instructed to go on the Hajj and given to understand that they should not return to India unless they received authorization to do so.[64]

During the heyday of the Ottoman empire in the sixteenth century and later, the Hajj caravans and the holy cities were well protected. In 1554–60 Sultan Suleyman the Magnificent commissioned the famous architect Sinan to build the Suleymaniyya mosque complex in Damascus. In large part the Suleymaniyya was designed to act as an assembly point for pilgrims and, for this reason, it included a hospice and an *imaret* (soup kitchen). In addition to the mosque and its dependent buildings, Sinan also enclosed a large area which was set aside for the pilgrim tents.[65]

From the time of the Ottoman Sultan Selim I (1512–20) onwards, the amir of the Damascus Hajj had a *sürre* or 'purse' from which he was supposed to pay off the dangerous Bedouin tribes as well as distribute largesse among the dignitaries of Mecca and Medina and give alms to the poor. From 1708 onwards the Pasha of Damascus was usually also the Amir of the Hajj, and he spent months before its departure on the *dawra*, a tour of the *sanjak*s, Syrian sub-provinces. The sole purpose of this tour was to raise funds to cover the expenses of the forthcoming pilgrimage.[66] Doubtless there had been a similar arrangement under the Mamluks, but it was perhaps less formal and certainly we are less well informed about it. Though there was always enough money to pay some tribes to work for and supply the Hajj, there was rarely enough to pay off all the tribes along the route. Consequently the allocation of that part of the budget dedicated to paying

Fig. 123
Portrait of the Emperor Akbar (1556–1605), from an album belonging to Sir Hans Sloane
17th century
34.5 x 22.7 cm
British Museum, London

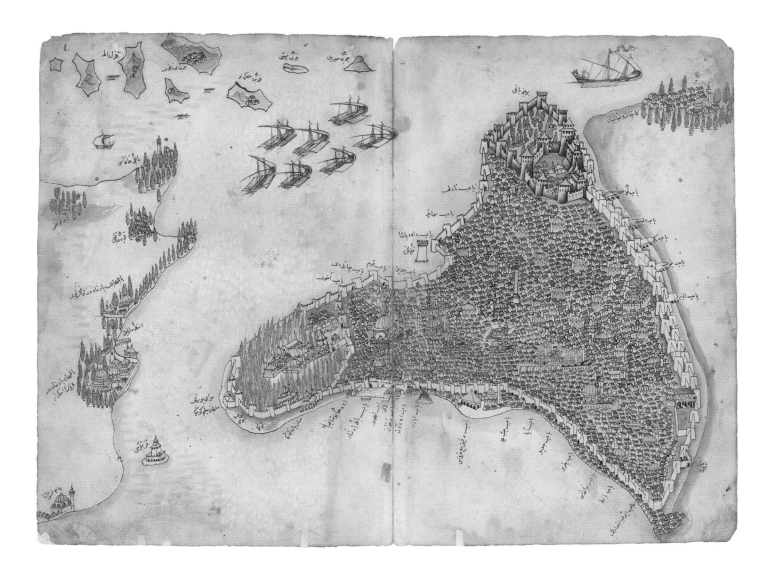

Fig. 124
View of Istanbul, fols 3b–4a from the Kitab-i
Bahriye (Book of Navigation) of Piri Reis
Ottoman Turkey, c.1670
Ink, watercolour and gold on European
paper
24 x 34 cm
Nasser D. Khalili Collection of Islamic Art

*Piri Reis (d. c.1555) was an Ottoman
cartographer whose work survives in several
versions, the earliest made in 1521 as a
sailor's manual. This view of Istanbul and
the islands is topographically exact. Pilgrims
leaving Beşiktaş below Topkapi Palace would
go by boat to Üskudar, shown here with
a landing station projecting out into the
Bosphorus. The Iskele mosque is also marked.*

off the Bedouin required some delicate political calculations. If the amir or pasha
got his sums wrong and misjudged the relative strengths of the tribes along the
route, then the consequences could be catastrophic.

Even in the Ottoman period, the leader of the Egyptian caravan took
precedence over his Syrian counterpart. The numbers in these two caravans
varied greatly from year to year – depending on economic circumstances, the
weather and the likelihood of Bedouin attacks, among other factors – and
ranged from 10,000 to 60,000 pilgrims in each.

The most vivid account of Hajj during the Ottoman era comes from Evliya
Çelebi who made the Hajj in 1672. On his twentieth birthday in 1631 he had
had a dream in which he was instructed by the Prophet to travel. For the next
fifty years or so he travelled throughout the Ottoman empire and beyond.

'Evliya' was actually a name derived from the Arabic 'awliyya', meaning 'friends of God' or 'saints', and Çelebi acquired this nickname through his habit of visiting saints' tombs and recording their miracles. His Hajj, which came quite late in life (he died in 1685), was thus the fulfilment of a lifetime's pious travelling. He wrote of his Hajj, 'To put on the pilgrim's robe is to separate oneself from all but God'.[67]

Evliya Çelebi's account of the preparations made by Husayn Pasha, the governor of Damascus for the Hajj of 1672, shows that they were, if anything, even more elaborate and expensive than in Mamluk times:

ALAIH ou MARCHE DU SURRE-ÉMINY,
avec les Chameaux chargés de Trésor destiné pour la Mecque.

A. Graf van Mahomet. B. plaedts van waffinge. C. moskea d...
Gaspar Huberti excudit ooge laëte voor senge. D. Caraua...

Hoca Bekir Agha bought forty purses each from Kara Mehmed Pasha in Syrian Tripoli and Haci İshak Pasha, governor of Sidon. When Husayn Pasha received these sums he disbursed them among his retinue. First he gave each of his twenty chief doorkeepers 300 guruş, five camels, one muleteer, one water carrier, and one torchbearer. The 100 individuals deserving of esteem, each 50 guruş; 100 müteferrikas, each 40 guruş, 100 delis 100 gönüllüs, 20 regiments of Segban and Sarica troops, a total of 2,000 levend horsemen, each 100 guruş; those mounted

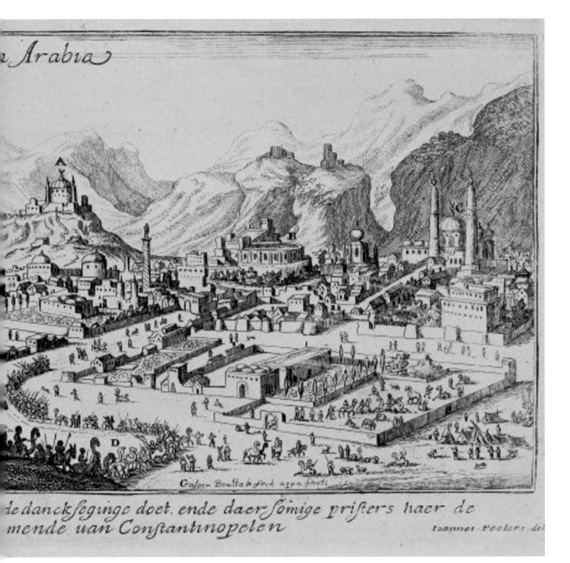

Within the image:
Arabia

le danck ſeginge doet. ende daer ſomige priſters haer de
mende van Conſtantinopelen

Ioannes Peeters del

Goſpar Boutta ſ culp

Fig. 126
'Mecha in Arabia', from a collection of
fourteen etchings (Views from Arabia,
Judea, Chaldea, Syria, Jerusalem,
Antiochia, Aleppo, Mecca etc.)
Engraving by Gaspar Bouttats after Jan
Peeters, 1672
12 x 26.5 cm
British Museum, London

*The scene is an imagined one of a Hajj
caravan from Istanbul proceeding towards
Mecca. The principal locations are marked
A–D. These, translated from the Dutch,[69]
denote:*

A. The burial place of Muhammad
B. The place of ritual cleansing (washing)
*C. Mosque where one performs the prayer of
thankfulness and where some of the priests
[rest of phrase unknown]*
D. Caravan coming from Constantinople

on camel-litters, each 50 guruş; two regiments of Tatars, including
200 fully armed warriors, each 100 guruş; 50 each of saddlers, cooks,
tasters, panters and tent pitchers each 50 guruş; 30 players of the
military band, five purses; 1,000 water carriers, 300 torchbearers,
300 muleteers, 1,000 camel drivers, each 10 Venetian guruş; and
100 of his personal retinue each 100 guruş. In short, a total of 5,120
men were given 270 purses. And 300 more purses were spent on
provisions and other expenses.[68]

Fig. 127
Single volume Qur'an copied by
Mehmed Shakir probably in the Hijaz
Ottoman Turkey, dated 1224 AH/
AD 1809–10
16.1 x 10.5 cm
Nasser D. Khalili Collection of Islamic Art

*Mehmed Shakir was a calligrapher pupil of
Ismail Zuhdi and is known to have copied
nine other Qur'ans. He was also responsible
for the illumination. He died in the Hijaz.*

Although Evliya was provided with camels in Damascus, most people purchased or hired their camels at the traditional stopping place of Muzayrib. Evliya again:

It is a *kanun* of the Sultan Suleyman that the sheikhs of the seventy-seven tribes come annually to this plain of Muzayrib with their followers to serve the pilgrims with 40,000 or 50,000 camels for which service they receive sultanic gifts from the Damascus treasury . . . The pashas get

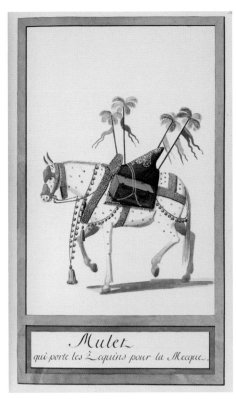

Mulet
qui porte d'autres présents à la Mecque.

Mulet
qui porte l'alcoran à la Mecque.

Mulet
qui porte les Zequins pour la Mecque.

3,000 free-ranging camels from these sheikhs, 2,000 of which are for carrying water – four goatskins of water per camel – and 1,000 for barley and beans. In addition, the Pasha has two hundred camel-trains for his other supplies and fifty mule-trains loaded with his own provisions. Mules actually bear up quite well between Damascus and Mecca. His personal retinue and some of his troops use thoroughbred mares as their mounts. But stallions do not bear up very well.[70]

But the halt at Muzayrib also functioned as a grander and more general trade fair. As Evliya reported, 'It was a sea of men, all jostling shoulders. Everything was for sale, except the elixir of life, including silks and brocades and satins and other precious stuffs'.[71] Under the Ottomans selected Bedouin tribes were put under contract to bring camels for hire to Muzayrib, and here pilgrims coming from Turkey exchanged their Bactrians for dromedaries. For water, Muzayrib had a lake and further along the route Bosra had a large cistern.

The Syrian route ran via Ma'an and Mada'in Salih along the edge of the desert in order to avoid areas of settled agriculture. In the sixteenth century the security of this route was greatly improved by the establishment of a chain of small fortresses which were garrisoned by Janissaries (see p. 150). Besides

Fig. 128 Mules carrying gifts for Mecca, fols 125, 123 and 124 from *Costumes Turcs*, vol. I, *c.*1790
37 x 22 cm
British Museum, London

These three watercolour drawings appear as engravings in d'Hosson's Tableau Général de l'Empire Ottoman, *Paris, 1787 (see fig. 125).[72] They are the mules bearing gifts. As noted in the captions, one is carrying a Qur'an (centre), money (right) and other unspecified gifts (left), which would have included objects such as keys for the Ka'ba and candlesticks.*

Fig. 129 Opposite
Chamfron and cheek pieces
Ottoman Turkey or Egypt, 18th century
Forged iron or steel, leather, silver gilt
appliqués and semi-precious stones
54.5 x 74 cm (max.)
Nasser D. Khalili Collection of Islamic Art

*This highly decorated chamfron is likely
to have been used for parade rather than
battle. It is suggested that it may have been
worn by a horse that took part in the Sürre
parade as illustrated by d'Hosson (p. 175).
Both the gold-encrusted jade plaque and the
chamfron itself might have been re-used.*

Fig. 130 Below
The fort at Mudawwara
Photo: Dudley Hubbard, 2010

*Mudawwara in Jordan, close to the border
with Saudi Arabia, is mentioned as a stop
on the Hajj route from as early as the 9th
century. Built by the Ottomans, it consists
of a fort and a reservoir with a section of
paved road still surviving. Evliya Çelebi,
who saw it in 1672, noted that it contained
a castle built out of rock without any sign
of an entrance. This mountain formation
is directly above the fort. Mehmed Edib in
1790 (p. 148) noted that water was scarce
at this site and was only found around the
fortress. He also observed that 'the sand
around the fort appears to be impassable
giving the impression of a vast ocean.'[73]*

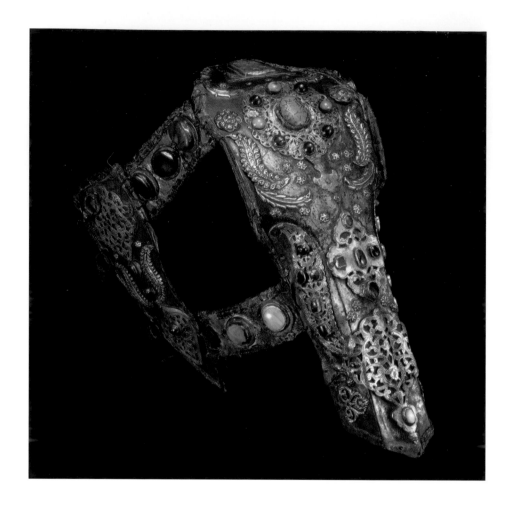

offering security, these fortresses served as storehouses for provisions for the Hajj.[74] Medina was situated in the midst of agricultural land, but the final approach to Mecca took the pilgrims through bleak territory. A twentieth-century *hajja* described the landscape: 'It was a frightening land we travelled through – stark, bare, inhospitable with its collars of dead volcanoes and naked mountains dotted with black basalt boulders, a land of hunger and fear . . .'[75]

In the seventeenth century the security situation in Syria and the Hijaz deteriorated. The Janissary regiments had previously been recruited from the *devshirme*, a compulsory levy on Christian children who were then converted and trained to become officials and soldiers. But from the seventeenth century onwards they were infiltrated by civilians, and in cities such as Aleppo and Damascus the Janissaries came to resemble urban factional interest groups

more than elite fighting forces. Inflation due to the influx of silver from Spain's South American possessions fostered corruption and diminished the value of older *waqf* endowments. In the course of the seventeenth century the powerful Anaza Bedouin confederation began a slow migration from the Najd into Syria.

From 1708 onwards the amirate of the Hajj was usually held jointly with the governorship of Damascus, while around the same time the command of the *jirda*, the relief escort, came to be regularly assigned to one of the *sanjak* governors. The Arab Azm dynasty first gained prestige from its tenure of the leadership of the *jirda* before going on to become pashas of Damascus and amirs of the Hajj. The Azms dominated Syria for much of the eighteenth century, holding both those offices in the years 1725–30, 1734–8, 1741–57 and 1771–83.

Bedouin attacks on the Hajj increased in the eighteenth century. In 1700, 1703 and 1757 the Hajj caravan was sacked by the Banu Sakhr. In the major disaster of 1757, 20,000 died from a combination of Bedouin aggression, thirst and heat exhaustion. The Banu Sakhr had first attacked the *jirda*, defeating and destroying the escort as it came out from Damascus to greet the returning Hajj caravan. They then turned on the returning Hajj caravan itself. A sister of the sultan was killed and the consequent blow to Ottoman prestige was immense. Esat Pasha al-Azm, the recently deposed Pasha of Damascus, was executed. The Bedouin attack was motivated by economic desperation: the Banu Sakhr had suffered from the drought of 1756, and then in 1757 the Amir of the Hajj had offered them nothing, preferring to use members of the Anaza confederacy as protectors and providers for the pilgrimage. The spread of the Anaza and Shammar confederacies from Najd into Syria continued throughout the eighteenth century. The Anaza, who pastured their herds on the edge of the desert in summer and in the interior in winter, took over the trade routes and the provision of camels for the Hajj.

As a result of these attacks by Bedouin tribes on the Hajj caravans, the Ottomans viewed these nomadic peoples in a fairly negative light. It is important, however, to understand the Bedouin point of view. The passage of a Hajj caravan was likely to monopolize crucial and irreplaceable resources of water and pasturage. The problem was exacerbated when the pilgrimage season fell in the summer or in a year of drought, and the years 1725–9 were both. Of course, Bedouin attacks also served as advertisement for their services, drawing attention to the consequences of not paying them off.[76]

Fig. 131
Coins of Sultan Abd al-Hamid I (1774–89)
Ottoman Turkey, 1187 AH/AD 1774
Gold
Diameter 2.2–3.7 cm
British Museum, London

Carrying coins as part of the Sürre *was an essential part of the duties of the Amir al-Hajj of the Damascus caravan. They would be used to pay off Bedouin tribes so they did not attack the caravan and to give to the Sharif of Mecca. These coins were all struck in Istanbul in 1187 AH/AD 1774 and bear Sultan Abd al-Hamid's* tughra.

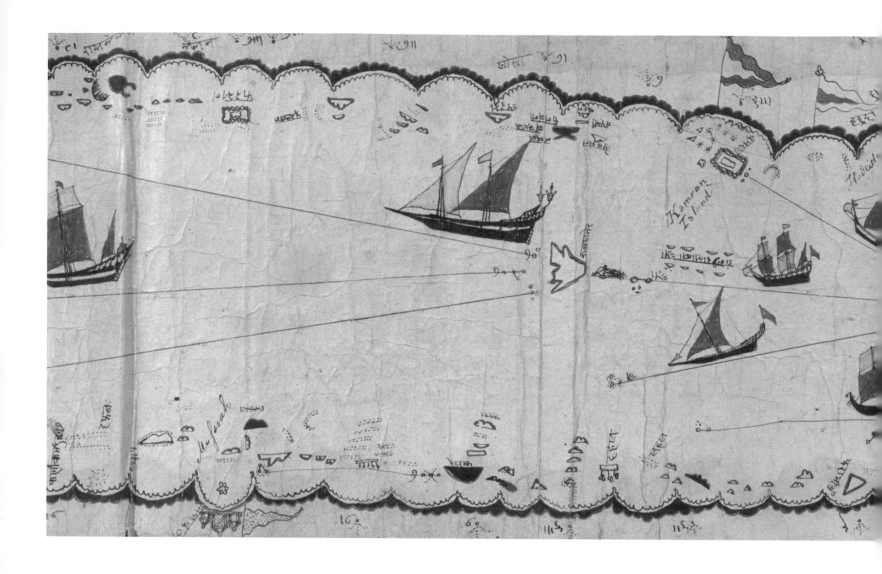

While the rulers of the so-called jihadist states that arose in the Sahel region of Africa in the late eighteenth century emphasized the importance of performing the Hajj, the ensuing wars actually made this more difficult, and before the nineteenth century Hajj caravans from West Africa were only intermittent. From the fourteenth century onwards Tuat, an oasis in what is today southern Algeria, became an important staging post on the Hajj. But it was not unknown for entire caravans to perish from thirst and those few pilgrims who could afford it travelled by sea.

During the seventeenth and eighteenth centuries the pulses of reformist Islam beat out from Mecca and Medina. In particular, Naqshabandi Sufis from Central Asia and India travelled to the Hijaz in order to study and then preach a purer form of Islam (though there were also numerous Naqshabandi centres in Turkey, Syria, Egypt and elsewhere). Unlike some Sufi orders, the Naqshabandis advocated

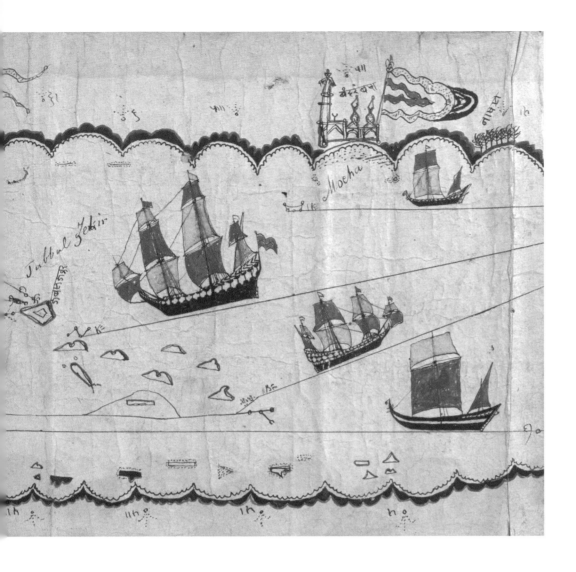

Fig. 132
Chart of the Red Sea and Gulf
of Aden (detail)
Gujarat, c.1835
24.1 x 195.6 cm
Royal Geographical Society,
London

*This chart was presented to Sir
Alexander Burnes in 1835 by a pilot
from Kutch in Gujarat. Its Gujarati
maker is unknown. The map shows
the Gulf of Aden and the Strait of Bab
al-Mandab, with Jedda on the far left,
suggesting that this map was used by
ships transporting pilgrims to Mecca
on Hajj. Different types of ships are
depicted on marked directional lines.
Also marked in Gujarati and Hindi are
land features and the flags of local
rulers that the pilot would need to know
as well as the location of reefs and
other dangerous hazards. On account
of the changing seasons of Hajj, which
might fall outside the October–March
sailing season, Jedda had sometimes to
be reached by local rather than ocean-
going dhows using land breezes, and
the inner channel up the Arabian coast
was notoriously difficult to navigate.[78]*

a strict adherence to the Shari'a and Sunna. In the case of Indian Naqshabandis, they were reacting to the excessively tolerant and syncretistic form of Islam favoured by the Mughals in the seventeenth century. There was a Naqshabandi colony in Mecca and in the early seventeenth century Mawlana Abd al-Haqq and Sheikh Ahmad Sirhindi were prominent among those who, having been on the Hajj, returned to India with their puritanical prestige enhanced. Sirhindi founded the Mujaddidi branch of the Naqshabandis. When Ahmad Sirhindi's son Khwajah Muhammad Ma'sum was in Mecca, he meditated on the mystical status of the Ka'ba which he felt was 'superior to all realities'.[77] He came to believe that he was a *qayyum*, 'a lasting figure of the age', and as such he had special responsibility for the reform of contemporary society. Later Naqshabandis in India declared all the territory occupied by the British to be a war zone (*Dar al-Harb*) and Naqshabandis were to play a leading part in the Mutiny Rebellion in India in 1857.

THE NINETEENTH CENTURY

Towards the end of the eighteenth century a different kind of reform movement was getting under way in Najd in central Arabia. Muhammad ibn Abd al-Wahhab (1703–92) was an *alim* who had studied in Medina and been strongly influenced by the rigourist teachings of the theologian and jurist Ibn Taymiyya (1263–1328) who had lived in Mamluk Damascus. Following Ibn Taymiyya's teachings, Ibn Abd al-Wahhab preached against the survival of *jahili* (pagan) practices among the Bedouin tribes, such as the cult of sacred trees or springs. He also condemned all forms of *bid'a* (unacceptable innovation), such as smoking. Though Sufism was acceptable, the unorthodox and innovatory practices that some Sufi orders had embraced were not. His Wahhabi following placed great stress on the Hajj, but they denounced the cult of certain tombs of the Prophet's Companions and later saints. While it was held to be permissible to visit the Prophet's tomb, this was not part of the pilgrimage.

The expulsion of the Turks from Arabia was another of the goals of the first Saudi state (1803–13). One of Ibn Abd al-Wahhab's teachers in Medina had shown him the weapons that he had prepared for the liberation of the heartland of Arabia: a room full of books. But Ibn Abd al-Wahhab was not content to spread his faith through study and preaching. He formed an alliance with a local tribal leader, Muhammad ibn Sa'ud, and they went on to recruit a force of devoted Bedouin known as the *Ikhwan* (Brothers). The early wars were with local tribes in Najd. Muhammad ibn Sa'ud died in 1765, but his son Abd al-Aziz I occupied Riyad in 1773. By the 1790s the Wahhabi-Sa'udi alliance posed a threat to the Hashemite Sharif's hold over Mecca and Medina, and Ottoman Syria and Iraq were also raided. In 1803, during the pilgrimage season, Abd al-Aziz's son Sa'ud occupied Mecca and in 1805 Medina fell to him.

In 1807 Sa'ud's tribal forces in Medina prevented the Syrian caravan under the leadership of Yusuf Pasha from reaching Mecca. Sa'ud declared it improper that there should be soldiers, artillery and women in the caravan. In truth his fear was that Yusuf Pasha would use the soldiers and artillery to drive him out of the Hijaz. The embargo on the Syrian pilgrimage, which continued for three years, was disastrous for the economy of Damascus and for Ottoman prestige. In the long run, the Ottoman sultan was driven to seek the assistance

of Muhammad Ali, the Khedive of Egypt (1805–48). He sent a well-equipped force under the command of his son Tusun. Medina fell to him in 1812 and Mecca in 1813. In a second round of campaigning, Egyptian forces invaded Najd and occupied the Sa'udi capital of Dar'iyya in 1818.[79]

THE IMPACT OF COLONIALISM

As nineteenth-century pilgrims made their way to Mecca from Java, India, Central Asia, Morocco, sub-Saharan Africa and other remote regions, it was inevitable that they should become aware of the growing wealth and imperial ambitions of the European powers as well as their control over most of the routes to Mecca. Sometime in the 1830s Ahmad ibn Tuwayr set out on the Hajj from Marrakesh. From Tangier he travelled onwards on a European ship which involved a forty-day period of quarantine in Livorno which he strongly resented: 'The reason for that is their false belief that death only comes through infection and not by divine decree as is the belief of the people of the Sunna'. He was bitter about the power and wealth of the 'infidel' and wrote that, when he contemplated the fine buildings in Livorno, he understood the Hadith, 'This world is the prison of the believer and the paradise of the infidel'. In general, he saw and feared the growing power of the European nations and he believed that the recent occupation of Algiers by the French (1830) might presage the Last Days.[80]

To take another example, in 1885 the Persian Shi'i pilgrim Mirza Mohamed Hosayn Farahani travelled from Tehran to the shore of the Caspian and there took a steamer to Istanbul, from where he boarded another steamer to Alexandria and from Alexandria a train down to Suez, before taking a boat to Jedda. Since he had travelled on a Russian ship and later encountered British officials in Egypt and at the quarantine stations, his journey was an education in, among other things, how horrible non-Muslim foreigners could be: 'Generally, the middle and lower [classes] of Russians, in so far as I have seen, are very impolite, wicked, devious, coarse, rude, unjust, haughty to the peasants and careless. The institution of marriage does not have much sanctity among these people'.[81] Faced with this sort of competition, the English fared relatively well: 'Although they too are very deceitful, cunning, time-serving, hypocritical, and don't understand about friendship and camaraderie at all,

Fig. 133 Following pages

Map illustrating the major maritime routes used by pilgrims across the Indian Ocean from the medieval period to the mid-20th century. The main ports used by pilgrims in the colonial period were Singapore, which served as a hub for those travelling from China and South–East Asia, and Bombay, which attracted pilgrims from South and Central Asia. Steamships stopped at Aden to re-coal before proceeding to Jedda. From 1882, ships had to spend several days in quarantine at Qamaran island off the coast of Yemen.

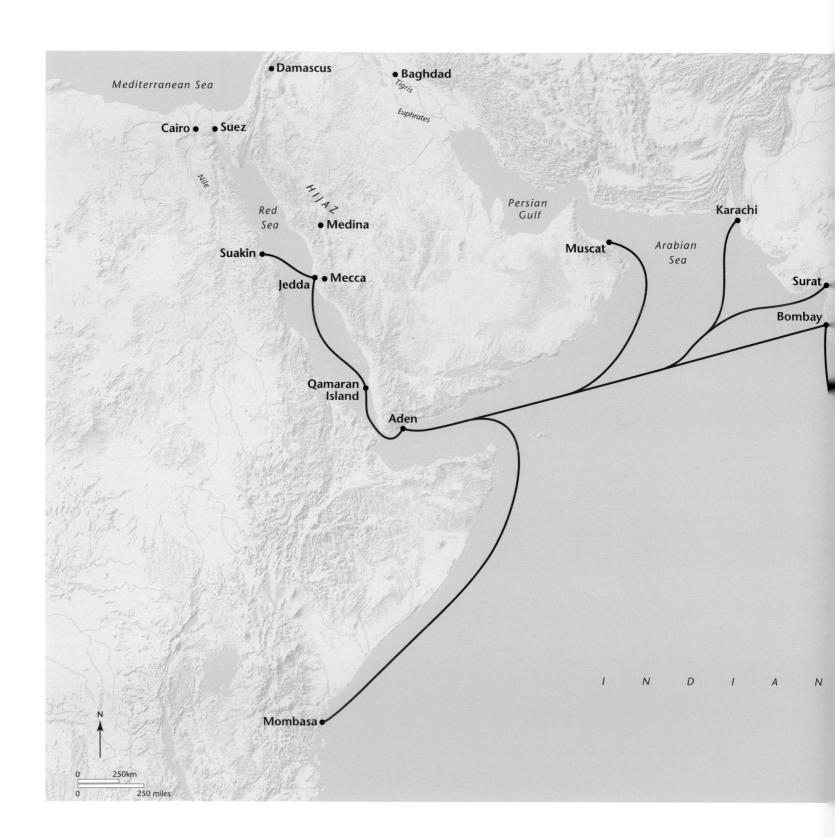

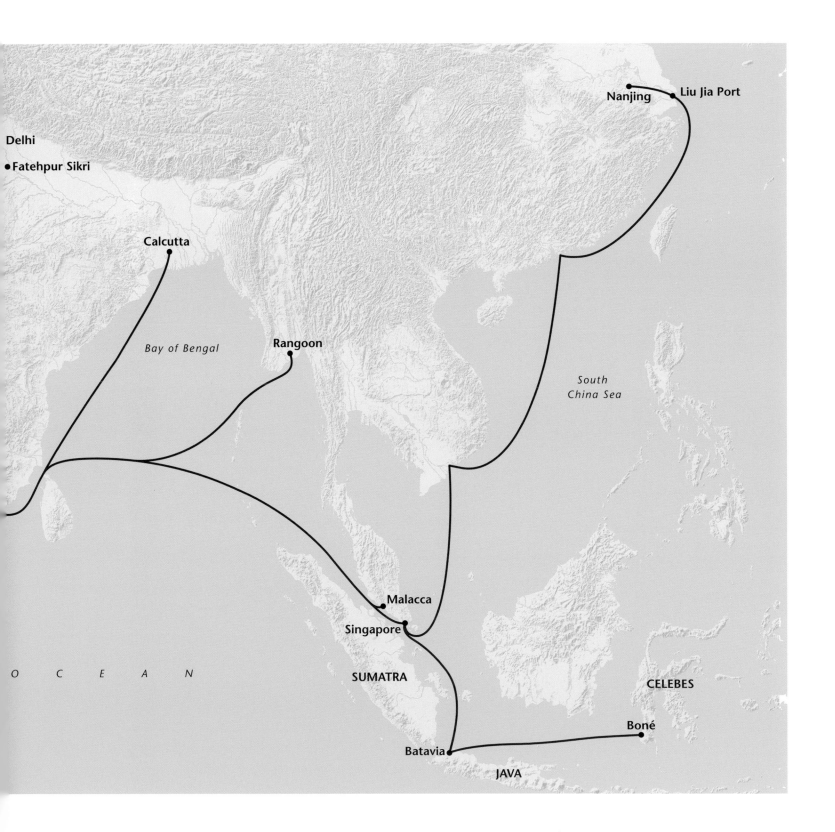

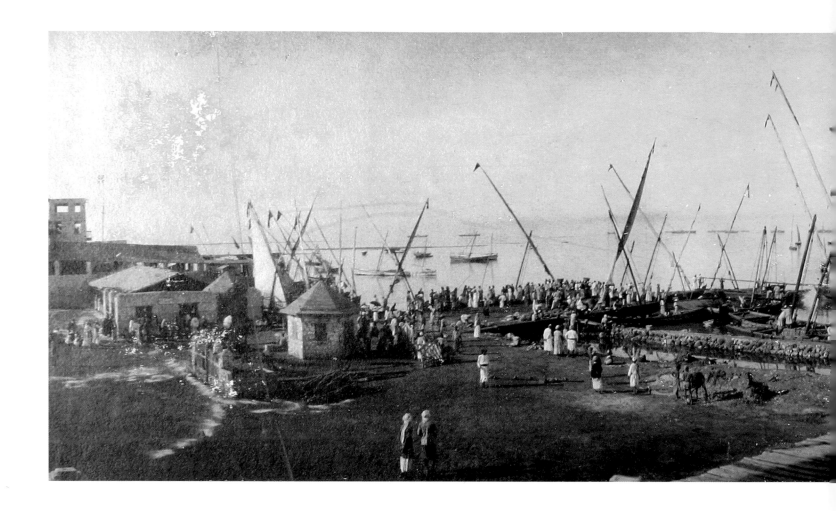

Fig. 134
Jedda
Photo: Khedive Abbas Hilmi II, 1909
Mohamed Ali Foundation and
Durham University Library, Dublin

Hossein Kazemzadeh wrote in 1912 about the arrival of the ships as follows: 'When a boat enters the port of Jidda its arrival is publicly announced by a crier who goes around the various quarters announcing the arrival or departure of such and such a ship at such and such an hour. Then the guides' agents and their landlords gather at the port. One man who is called the Iranian deputy has the task of asking the pilgrims the name of their guide. When he has learnt who they are he points each one to guide's wakil and directs him to follow where he leads.'[82]

still in outward behaviour they do act justly and humanely and have a mildness, dignity and orderliness'.[83]

Like Peking's Forbidden City and Lhasa in Tibet, Mecca was seen to offer a challenge for European adventurers seeking to make a name for themselves. The risk was considerable, since infidels discovered in or near the holy cities faced lynching or execution. The explorer Jean Louis Burkhardt joined the Damascus caravan in 1814–15. Under the name Ibrahim, he spent a week in Mecca and then three further months in the Hijaz. Though it was very dangerous to be seen taking notes, he did so and his 1829 *Travels in Arabia* was the first systematic account of the holy cities to be produced by a European.[84]

In 1853 the explorer Richard Francis Burton, disguised as an Afghan doctor, took part in the Hajj and published the account of his adventure in

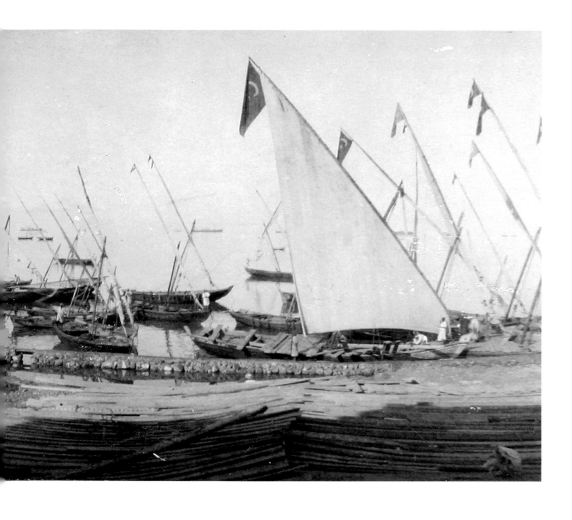

Fig. 135 Below
Richard F. Burton's *A Pilgrimage to Meccah and Medinah*, London, 1855
19.8 x 13.8 cm
Arcadian Library, London

Burton's travels to the Hijaz were sponsored by the Royal Geographical Society. His journey was fraught with danger. On the way to Mecca his caravan was attacked by bandits. He had to be on guard at all times to ensure his true identity was not discovered because non-Muslims were prohibited from entering Mecca and Medina. During his journey to and from Mecca, he made careful notes about the conditions of travel, his companions, the terrain they went through and the ceremonies of Hajj, which moved him greatly. He also gave detailed descriptions of the holy sites. Burton's audacious venture made him famous in Britain, and his book was a best-seller, going through several editions.

two volumes as *A Personal Narrative of a Pilgrimage to El-Medinah and Meccah* in 1855–6.[85] Much of his detailed description of Mecca drew on Burkhardt's earlier account, but Burton's account of Medina is fuller, as Burkhardt had been too ill there to take many notes. It is also noteworthy that Burton wrote his account in what was generally a plain and workmanlike style, in marked contrast to the contorted syntax and bizarre use of obscure vocabulary that marked his later translation of the *Arabian Nights*. But just occasionally the prose of *A Personal Narrative* turned lyrical, as when he described his feelings on entering the enclosure of the Ka'ba: 'I truly may say that, of all the worshippers who clung weeping to the curtain, or who pressed their beating hearts to the stone, none felt for the moment a deeper emotion than did the hajji from the far-north. It was as if the poetical legends of the Arab spoke the truth, and that

the waving wings of angels, not the sweet breeze of morning, were agitating and swelling the black covering of the shrine. But, to confess the humbling truth, theirs was the high feeling of religious enthusiasm, mine was the ecstasy of gratified pride.'[86]

The Dutch orientalist Christiaan Snouck Hurgronje (1857–1936) also managed to spend time in Mecca in 1885. In 1880 he had presented a thesis at Leiden on the pre-Islamic origins of the Hajj. However, he was not content only to study the subject through books and he was inspired by reading Edward William Lane's *Manners and Customs of the Modern Egyptians* (1836) to plan an ethnographic study of Mecca and the Hajj. Having learnt the techniques of photography he brought with him substantial amounts of equipment and while in Jedda he spent a great deal of time photographing pilgrims from

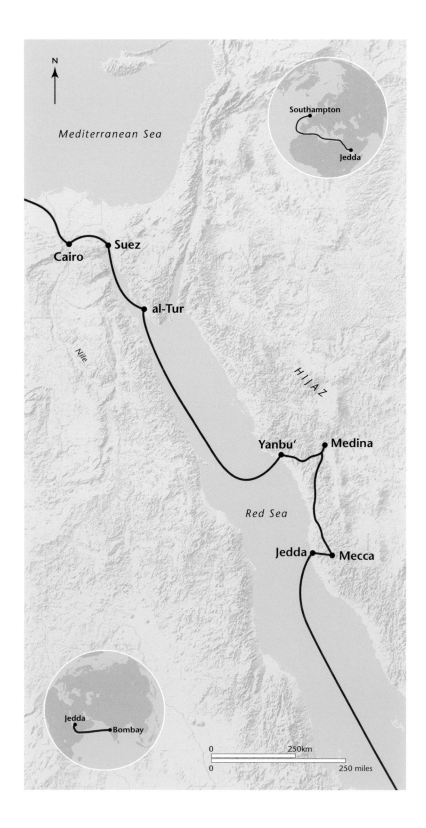

Fig. 136 Opposite above
The *Takhtrawan* or Grandee's Litter,
London, 1853–4
Royal Geographical Society, London

This image, drawn by Richard Burton, appears
opposite Chapter XI, 'To Yambu', in his book
about his journey to Mecca. Takhtrawan is a
Persian word meaning litter or sedan chair,
which was a common mode of transport for
well-off pilgrims during this period.

Fig. 137 Opposite below
Metal pilgrim flask
Diameter 9 cm
British Museum, London

This receptacle for Zamzam water was
brought back by Burton from his journey to
Mecca in 1853 and was donated by his wife,
Isobel Burton, after his death in 1890.

Fig. 138 Left
Map of Richard Burton's travels to and
from the holy cities, 1853

Burton sailed from Southampton to Cairo,
travelled down the Red Sea to Yanbu', and
then on to Medina and Mecca. After he had
completed the Hajj, he sailed to Bombay,
where he began to write up his account of
the journey.

South-East Asia in the Dutch consulate. It was in Jedda that he may have converted to Islam[88] and he took on the Muslim name of Abd al-Ghaffar. After being examined by the governor of Jedda and a body of Islamic scholars and discussing his forthcoming sojourn in Mecca with them, he was allowed to proceed. Since his Arabic was good and he was well versed in Muslim theology and law, he managed to stay there from February to August 1885. Although his survey of Mecca was comprehensive, two topics in particular interested him. The first was Meccan religious scholarship and its impressive vitality. The second was the welfare and ideology of pilgrims and settlers in Mecca who had come from the Dutch East Indies, and the last section of volume two of his *Bilder Aus Mekka* (1889) is devoted to the Jawah, as he called them. In general, Jawah pilgrims were relatively prosperous, especially by comparison with pilgrims

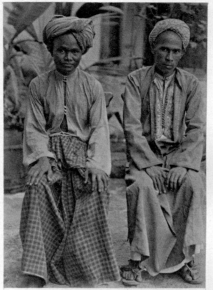

Pilger aus Sukapura (Java)

Buginesische Pilger (Celebes)

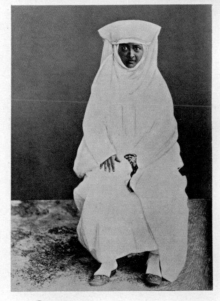

Pilger aus Solok (Sumatra)

Pilgerinn aus Banten (Java)

Fig. 140
Portraits of pilgrims
Plate XIX from Hurgronje's *Bilder Aus Mekka*, 1888
36.2 x 27 cm
Leiden University Library, Leiden

This is a proof copy annotated by Hurgronje himself. He took these photos of pilgrims in the inner courtyard of the Dutch Consulate in Jedda, which enjoyed plenty of natural light. Hurgronje used these sessions to learn about the pilgrims' religious life in Indonesia, and pilgrims took the opportunity to voice their complaints about the restrictive policies of the Dutch colonial government regarding the Hajj and Islamic practices.

Top left: pilgrims from Sukapura, Java.
Top right: pilgrims from Celebes.
Bottom left: pilgrims from Solok, Sumatra. Both pilgrim are holding Dutch Hajj permits (see fig. 143).
Bottom right: pilgrim from Java.[89]

coming from British India. Because of this, the Jawah were a particular target of touts and beggars, according to Hurgronje and other observers.

In making a close study of the Jawah, he was responding to the concerns of the Dutch colonial authorities, who feared the spread of pan-Islamism and were worried about its possible role in stimulating resistance against Dutch colonialism in Aceh, the northernmost tip of Sumatra. It was becoming evident

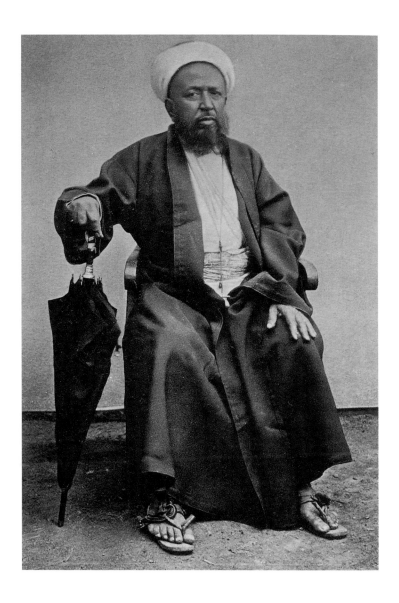

Fig. 141
The Meccan doctor, Abd al-Ghaffar
Photo: Snouck Hurgronje, c. April 1885
Detail of Plate XIV from *Bilder Aus Mekka*,
1888
36.2 x 27 cm
Leiden University Library, Leiden

*Hurgronje enthusiastically collaborated with
the doctor. He wrote that 'no one will object
to the hakim [doctor] doing what some
could take amiss in me'.[90] (See fig. 159.)*

that the version of Islam mixed with older pagan beliefs that had prevailed in the Dutch East Indies was giving way to a stricter and more orthodox version of Islam, brought back by *hajjis* who had studied in Mecca.[91] Imam Bonjol (d. 1864) was one such rebel against Dutch rule in Western Sumatra and, as a result of these mounting concerns, the Dutch monitored the pilgrims closely, issuing permits and requiring that they check into the consulates on arrival and departure.[92]

Besides taking copious notes and photographs, Hurgronje also trained a Meccan doctor, coincidentally also known as Abd al-Ghaffar, to take photographs. Although Hurgronje had planned to stay in Mecca to take photographs of the Hajj, before he could do so he fell out with the French vice-consul in Jedda, who denounced him to the authorities in Istanbul, and the order came from there for Hurgronje's expulsion from the Hijaz. So he was cheated of his ambition to witness and record the pilgrimage, which he thought of as 'a medieval dream', but the doctor he had trained took photographs of the Hajj for him. Back in Holland, Hurgronje published a two-volume account of Mecca: the first volume was on the history of the city and the second dealt with the 1880s.[93] He published this work in German, the dominant language of orientalism in the nineteenth century. A third volume of photographs appeared a little later. (Although the photographs of Hurgronje and Abd al-Ghaffar are among the earliest ever taken in the holy city, they are not the first: an Egyptian colonel, Sadiq Bey, had taken photographs of the Ka'ba and the Hajj in 1880; see pp. 49 and 208.)[94]

The journey by sea from South-East Asia was fraught with danger and many pilgrims embarking on this voyage feared it would be their last. This is movingly evoked by Munshi Abdullah in his travelogue written in 1854, in which he chronicles his tempestuous journey from Singapore on his way to

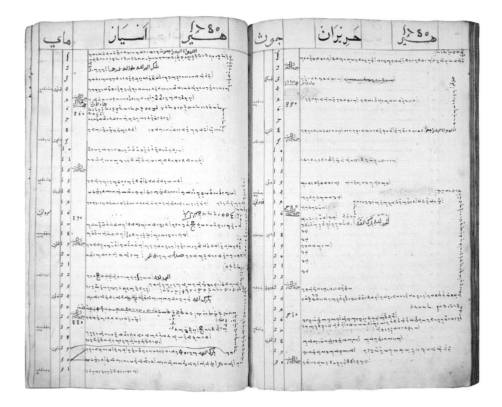

Fig. 142 Above left and right
Diary of the King of Boné, fols 43b–44a
Ink on Dutch paper
42.5 x 26.5 cm
British Library, London

Written in Bugis language and script with occasional words in Arabic, this is the personal diary of Arumpone Ahmed al-Salih with (right) designs of his personal seal, one of which is dated 1194 AH/AD 1780. Pilgrims wishing to go on Hajj needed to obtain the permission of both the Arumpone and the Dutch. On their return many would call on the Arumpone and bring him gifts from Mecca[95] The diary is open at the page for May 1780, and the Arumpone notes that on 18 May he gave a prospective pilgrim, La Panuq, a sealed permit, and on 22 May La Panuq took his leave to depart for Mecca.

perform Hajj. He left Singapore on 29 January 1854, eight months before the Hajj. His ship ran into a storm as it tried to cross Cape Comorin at the southern tip of India. Abdullah recounts:

> Oh God! Oh God! Oh God! I can't even begin to describe how horrendous it was and how tremendous the waves were, only God would know how it felt, it was as if I had wanted to crawl back into my mother's womb in fright! Waves from the left thrashed to the right and those from the right thrashed to the left. All the goods, chests, sleeping-mats and pillows were flung about. Water spewed into the hold and drenched everything completely. Everyone was lost in their own thoughts, thinking nothing else but that death was close at hand. We even had to sit down and grasp something firm while performing our prayers.

Fig. 143
Permit in Dutch and Malay from East Java
(Timur), dated 8 August 1906
47 x 57 cm
Tropenmuseum, Amsterdam

This Hajj permit is for a male (whose name is unclear), thought to be aged 23, height 1.61 m, with oval face and big eyes. It is noted that if he dies on the journey his belongings are to be transferred to his fellow traveller Yusuf. All pilgrims from the Dutch colonies needed a permit to go on Hajj. They had to prove they had the means and that their families were taken care of, and on their return they were examined to prove they had actually undertaken the Hajj.[96]

During this fearful storm, Abdullah recounted, 'various voices shouted and besought the names of God and the Prophet'. The ship's captain said that 'it would be best for all of you to pray to God, for every year many ships disappear here without leaving either a trace or any survivors! Ah! Ah! Ah!'[97] Fortunately, the storm abated, but tragically, Abdullah died of cholera shortly after he reached Mecca in May 1854.

The appearance of steamships in the Mediterranean and the Indian Ocean from the 1830s onwards had massive repercussions for the Hajj. The monsoon season and the prevailing direction of winds presented few problems and sailing times were drastically shortened. Consequently the numbers of pilgrims arriving from India, Malaysia and the Dutch East Indies increased enormously.

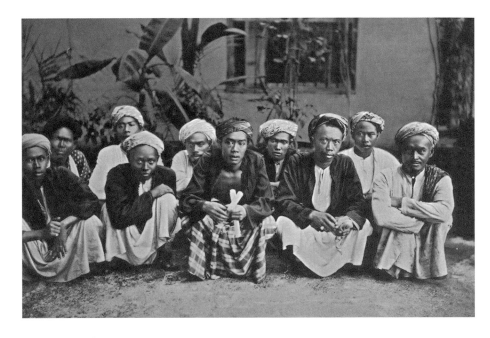

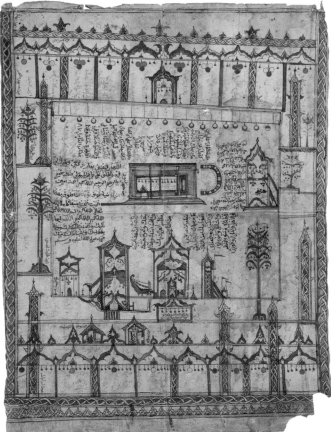

Fig. 144 Above left
Hajj certificate
Mecca, 1331 AH/AD 1912–13
28.6 x 20 cm
Tropenmuseum, Amsterdam

This document was printed in Mecca and testifies that a certain Abd al-Ghani, probably from Jambiin, Sumatra, undertook the Hajj in this year.

Fig. 145 Above
Pilgrims from Martapura (South Borneo)
Photo: Snouck Hurgronje, Jedda, 1884
Published in *Bilder Aus Mekka*
Leiden University Library, Leiden

The pilgrim in the centre of the picture is holding a Dutch Hajj permit.

Fig. 146 Left
Ink drawing representing the Masjid al-Haram in Mecca
Aceh, late 19th century
Coloured inks on paper
42.5 x 32.5 cm
Tropenmuseum, Amsterdam

This is an unusual depiction of the sanctuary and the Ka'ba, which is shown as rectangular in shape. Texts in Malay and Arabic state what each location is and what prayers should be recited there. A text on the back mentions the rites of Hajj and states that it was written by 'the humble mendicant for its owner Teungku Imam Beutong'.[98]

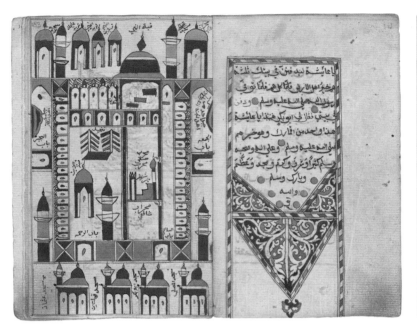

Fig. 147 Above left
The Mosque of the Prophet Muhammad in
Medina, fol. 183a from the prayer book of
Tuanku Imam Bonjol (1772–1864)
Bandar Natar (West Sumatra), dated
1229 AH/AD 1814
Coloured inks on paper
15.9 x 9.8 cm
Leiden University Library, Leiden

*Bonjol is a small fortress town (*benteng *in
Malay) in central Sumatra (Indonesia). It
was here, in 1837, that Tuanku Imam Bonjol,
the leader of the Padri-wars, took his last
stand against a Dutch colonial army. It is not
known if the Imam performed Hajj. This tiny
volume, which apparently was confiscated
after the Imam's surrender, contains some
25 shorter and longer devotional and
magical texts in Arabic and Malay. The
images of Mecca and Medina accompany
a copy of al-Jazuli's Dala'il al-Khayrat.*

Additionally, the opening of the Suez Canal in 1869 led to an increase in the numbers arriving in Jedda or Yanbu from North Africa, Turkey and elsewhere by steamship. (It also led to a strengthening of Ottoman control over the Hijaz.)[99]

The pilgrim ships from India were packed and customarily carried some passengers who were too poor to pay their own way but depended entirely on the charity of other pilgrims. The Sharifs in Mecca and the British government in London pressed the government of India to take steps to impose quarantine controls, enforce minimum standards of accommodation on the ships and deter the indigent from going on the Hajj, but the Indian government was extremely reluctant to do any of these things, correctly fearing that any such measures would be fiercely resented by the Muslims of the subcontinent who were suspicious of infidel control of any aspect of their religious obligations. Not until the 1880s did the government of India bring in various regulations to control the number of pilgrims and their conditions, and Thomas Cook was briefly appointed sole agent for their transport. Before this, reaching the Hijaz by sea was for most Indians a dangerous and unpleasant ordeal.[100]

Until the 1870s, when the Dutch started to compete, the transportation of pilgrims by steamship was practically a British monopoly. Joseph Conrad's

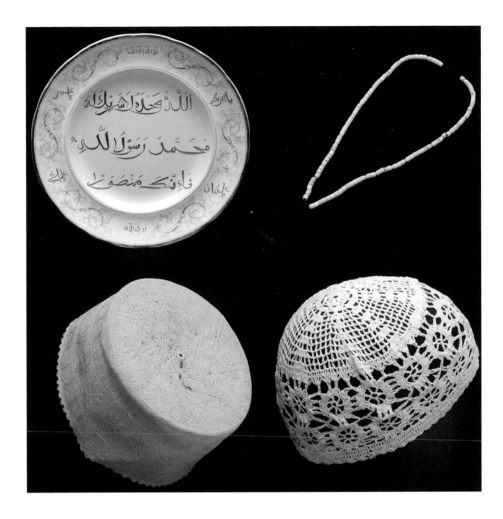

novel *Lord Jim* (1900) and its account of the abandonment by its eponymous protagonist of a pilgrim ship called the *Patna* was based on a similar real-life incident in the Bay of Bengal in August 1880 in which the cowardly white officers of the pilgrim ship *Jeddah*, believing that it was about to sink, abandoned the vessel and its 953 closely packed pilgrim passengers. But the ship did not sink and was found and towed into the port of Aden a few days after its captain had reported that it had foundered. The *Daily Chronicle*, reporting on the scandal, declared that 'It is to be feared that pilgrim ships are officered by unprincipled and cowardly men'.[101]

Conrad made the reported cowardice and hypothetical subsequent shame of an officer the subject of his novel. As a merchant seaman, he had actually seen the *Jeddah* and other pilgrim ships while he was in Singapore in the 1880s,

Figs 153–5 Opposite
Mecca pilgrimage ticket issued by Thomas
Cook and Sons, 1886, 6.7 x 15.2 cm
Front page of report of information
obtained in Jedda on the pilgrimage
by agents of Thomas Cook and Sons,
October 1886, 20.5 x 33.5 cm
Mecca pilgrimage booklet detailing
Thomas Cook and Sons' involvement with
the Hajj, 1886, 13.8 x 21.5 cm
Thomas Cook Archive, Peterborough

*After several scandals involving
overcrowding on pilgrim ships, the
government of India appointed Thomas
Cook and Sons as the official travel agent
for the Hajj from 1886 to 1893. John
Mason Cook, son of Thomas Cook, upon
learning of the appointment, is said to
have commented: 'I know this business
is surrounded with more difficulties and
prejudices than anything I have hitherto
undertaken.'[103] Although Thomas Cook and
Sons did not own the steamships that took
pilgrims to the Hijaz, the company issued
tickets for the Bombay–Jedda voyage, liaised
with railway and steamship companies for
the conveyance of pilgrims, and provided
quotes for pilgrims' journeys. The company's
association with the pilgrim traffic ended
because it was not profitable, and Indian
pilgrims went back to using a variety of
British and Indian brokers and agents to
arrange their travels for Hajj.*

so he was writing about what he knew. He described the pilgrims boarding the *Patna*: 'Eight hundred men and women with faith and hopes, with affection and memories, they had collected there, coming from north and south and from the outskirts of the East, after treading the jungle paths, descending the rivers, coasting in *praus* along the shallows, crossing in small canoes from island to island, passing through suffering, meeting strange sights, beset by strange fears, upheld by one desire. They came from solitary huts in the wilderness, from populous campongs, from villages by the sea. At the call of an idea they had left their forests, their clearings, the protection of their rulers, their prosperity, their poverty, the surroundings of their youth and the graves of their fathers'.[104]

Even after the imposition of some regulation, the maritime passage could be uncomfortable, for the steamships never left until they were full. Winifred Stegar (Muslim name Zatoun) made the Hajj from Karachi in 1927. She recalled that passengers had to make their wills before being allowed to board ship and then: 'Every inch of the third deck round my hatch was filled with passengers, both male and female. To reach the stairs you had to hurdle over the sleeping or lounging bodies. Each pilgrim had seized himself just room to lie down and pack his gear at his feet'.[105] Disembarking was also a problem as steamships could not get closer than a mile from the Jedda shore, and the lighters that were used for transhipping pilgrims and their luggage were customarily overloaded.

The growth of mass transport to the Hijaz made the Hajj increasingly vulnerable to the spread of epidemic diseases. Prior to the nineteenth century, cholera had been largely restricted to India. In the nineteenth century Bombay regularly had cholera outbreaks from May to August. From the 1830s onwards Indian and other *hajjis* often brought cholera with them to Mecca and from there the disease was re-exported by returning *hajjis* to the rest of the Islamic world, as well as to Europe. Of course, the overcrowding on ships exacerbated the health problem.[106]

Cholera reached the Hijaz for the first time in 1831. But in 1865 there was an exceptionally severe outbreak in which the 'the yellow wind' of cholera was spread by pilgrims coming from Java and Singapore among the rest of the 90,000 pilgrims, of whom 15,000 died. The disease was then spread worldwide and 200,000 died, 60,000 in Egypt alone. The epidemic spread as far as New York and only abated in 1874. In Europe the French Mediterranean ports were

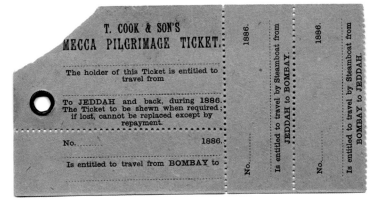

**T. COOK & SON'S
MECCA PILGRIMAGE TICKET.**

The holder of this Ticket is entitled to travel from

To JEDDAH and back, during 1886. The Ticket to be shewn when required; if lost, cannot be replaced except by repayment.

No. 1886.

Is entitled to travel from BOMBAY to

1886. Is entitled to travel by Steamboat from JEDDAH to BOMBAY.

No.

1886. Is entitled to travel by Steamboat from BOMBAY to JEDDAH.

No.

1886. Is entitled to travel by Railway from to BOMBAY.

No.

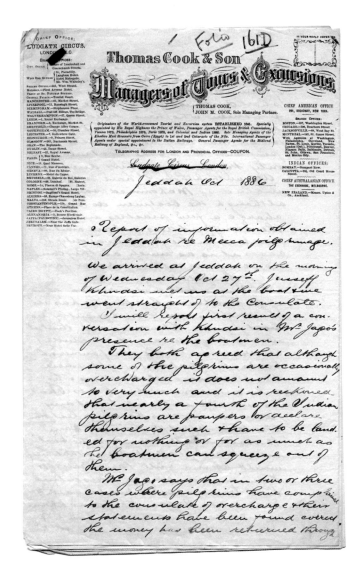

Folio 161D

Thomas Cook & Son

Managers of Tours & Excursions

THOMAS COOK,
JOHN M. COOK, Sole Managing Partner.

Ludgate Circus London

Jeddah Oct 1886

Report of information obtained in Jeddah re Mecca pilgrimage.

We arrived at Jeddah on the morning of Wednesday Oct 27th. Jussuff Khudsi met us at the boat & we went straight off to the Consulate.

I will report first result of a conversation with Khudsi in Mr Jago's presence re the boatmen.

They both agreed that although some of the pilgrims are occasionally overcharged it does not amount to very much and it is reckoned that nearly a fourth of the Indian pilgrims are paupers or declare themselves such & have to be landed for nothing or for as much as the boatmen can squeeze out of them.

Mr Jago says that in two or three cases where pilgrims have complained to the consulate of overcharge & their statements have been found correct the money has been returned though

'MUSEUM' ITEM 163 F

THE MECCA PILGRIMAGE.

APPOINTMENT

BY THE GOVERNMENT OF INDIA

OF

THOS. COOK & SON

AS

Agents for the Control of the movements of Mahomedan Pilgrims from all parts of India to Jeddah for Mecca, Medina, &c., and Back.

London

PRINTED FOR PRIVATE CIRCULATION.

From the 1850s, the majority of pilgrims' journeys by sea were undertaken on steamships, a trade dominated by European shipping companies such as Alfred Holt & Co. However, many Muslim-owned firms also participated, such as Nemazee and Sons in Bombay.[107] This photograph gives a good idea of a crowded steamship as pilgrims flocked to the deck to catch their first view of the Hijaz and prepared to disembark to begin the final leg of their journey to Mecca.

particularly badly affected. This was the background to the Cholera Conference of 1866–7 which was convened in Istanbul. Though the French pressed for quarantine controls and other restrictions, Britain had been dragging its feet for fear of upsetting its Indian Muslim subjects. So the debate was stormy, particularly as there was still no consensus on how cholera was spread. Eventually, quarantine stations were set up at al-Tur in Sinai, Wajh in the Hijaz and eventually in 1882 on the island of Qamaran at the southern end of the Red Sea. Ships whose passengers had not passed through quarantine would be turned away from Mecca and Yanbuʻ. Quarantine might last up to fifteen days, depending on whether there were sick pilgrims among the passengers, and baggage was routinely disinfected.[108]

However, the way the quarantine stations were run and the perfunctory way pilgrims were inspected as well as the fees levied attracted widespread criticism. The Persian pilgrim Farahani (1885–6) wrote that the quarantine stations were really just rackets for raising money and most of the pilgrims were not even looked at.[109] Hurgronje similarly came to the conclusion that the Ottomans used quarantine regulations as way of raising money.[110] The island of Qamaran, in particular, was unhealthy, expensive and under provisioned. The pilgrims regarded the quarantine stations with great suspicion as the product of an imperialist conspiracy and hence the doctors stationed there needed to be guarded by Egyptian troops. In 1895 *mutawwifs* (pilgrim guides) led an attack on one of the quarantine stations. Indian Muslims campaigned against what they declared to be illegitimate British interference with their fulfilment of Islamic religious duties. Though the quarantine restrictions were moderately effective in keeping cholera away from Egypt and Europe, there were nevertheless major outbreaks during the pilgrimages of 1893–4 and 1902.[111] In the first over 30,000 out of 200,000 pilgrims died and many of their corpses were thrown overboard.

Death rates were high in the nineteenth century. The pilgrimage account of Nawab Sikandar, Begum of Bhopal, gives us a snapshot of the tragedies faced by her retinue in 1864: 'Nine people in my suite were attacked with various complaints, such as dysentery, fever, and tumours in the leg. On the pilgrimage I lost eight altogether, four of whom died on board ship and four at Mecca and Jeddah... Two persons also disappeared out of my suite, and were never found again... I do not know what became of them.'[112] Disease, banditry and all kinds of hardship were certainly part of the reason, but it was also the case that

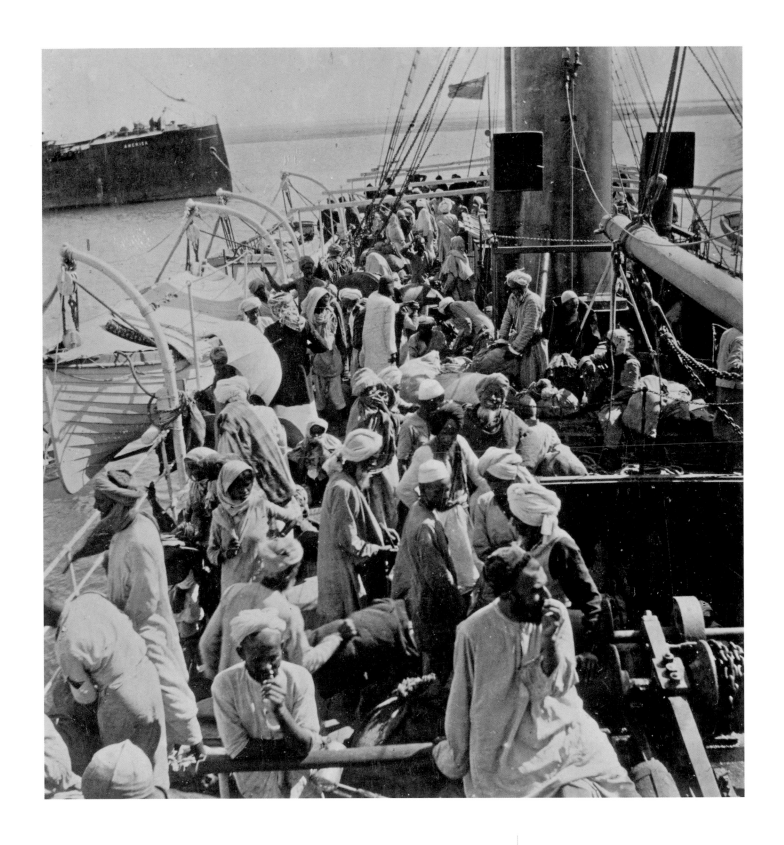

Fig. 157 Right
Document from officials at the Sanctuary of the Prophet in Medina to Begum Shah Jahan, Medina, dated 21 Dhu'l-Qa'da 1296 AH/AD 6 November 1879
Ottoman chancery script (Diwani) in alternating gold and black ink
38.5 x 22.7 cm
British Library, London

This illuminated document was written and confirmed by officials at the Prophet's Sanctuary in Medina to Begum Shah Jahan (1868–1901), the ruler of Bhopal, informing her that the official in charge of pilgrims from her territory had been replaced by a certain Ahmad Abu'l-Jud al-Madani. The document is headed by the three tughras *of the Treasurer to the Sanctuary, Muhammad Salim Agha, the Deputy Keeper of the Sanctuary, Tahsin Agha, and the Sheikh al-Islam of the Sanctuary, Sheikh Husayn Akhtar, each with their seal impression.[113]*

Fig. 158 Far right
Nawab Sikander, Begum of Bhopal
Photo: Colonel James Waterhouse, 1862
British Library, London

Nawab Sikander was the ruler of the Indian princely state of Bhopal from 1844 to 1868, and performed the Hajj in 1864. She travelled to Bombay by train and went by steamship to Jedda with a vast quantity of luggage and gifts. The Begum's pilgrimage account, which she dedicated to Queen Victoria, reflected her forceful character and intelligence. The royal party faced several difficulties. Chests of money destined for the holy cities were broken into at the docks in Jedda. When the Begum was performing the Hajj rituals, many pilgrims asked her for gifts, as news of her generosity had spread throughout Mecca. At a dinner hosted by the Sharif of Mecca, the Begum criticized the corruption of the Ottoman Hajj administration and the unsafe roads, where bandits attacked pilgrims. Despite her experiences, the Begum remained deeply committed to the Hajj. She sponsored her subjects to go on Hajj and funded mosques and hostels for her subjects in the holy cities.[114] Her daughter Shah Jahan also performed the Hajj and wrote a book about her pilgrimage experience in 1909.

a high proportion of the pilgrims were very old. Some waited until they had accumulated enough money to support themselves on the Hajj, while others delayed until it became clear that unless they went to Mecca death would come for them first. Edward Lane, who witnessed the return of the Hajj to Cairo in 1834, noted that the sounds of lamentation mingled with those of rejoicing, for the death rate had been high that year. Moreover, a thousand of the returning pilgrims had been seized and press-ganged into the Egyptian army.[115]

By the late nineteenth century so many *hajjis* came from British imperial possessions, and British officials in the Foreign Office and India were so heavily involved in administering and monitoring the Hajj, that it is only a slight exaggeration to describe the Hajj as it was then as a ritual of the British empire, comparable to durbars and receptions at the British embassies on the Queen's birthday. More pilgrims came from the British empire and specifically from India than from anywhere else. From the 1830s onwards there were British consuls in Cairo and Damascus and from 1852 consuls were posted to Jedda on a regular basis, from where they closely monitored and reported on the

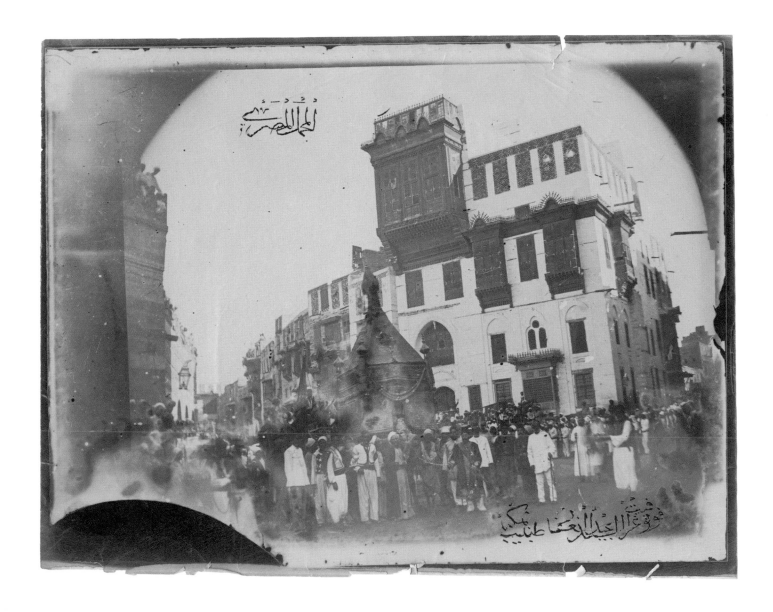

فوتوغراف العبد الفقير عبد الغفار طبيب مكة

المحمل المصري

progress of each Hajj. Most of their contacts were with people who had come to complain about thefts, high fees, incompetence and other problems. Jedda's small expatriate community was usually confined within the town walls, and the place was very hot and damp, unhealthy and often short of water, which had to be imported, so it was an uncomfortable consular posting. In the nineteenth century a *punkah wallah* kept the British consul cool. For the various consuls – British, Dutch, French, Italian and Russian – the Hajj was an annual crisis that they had to weather.[116]

Fig. 159
The arrival of the Egyptian *mahmal* in Mecca
Photo: Abd al-Ghaffar, 1880s
Leiden University Library, Leiden

The Ottoman governor of the Hijaz stands at the front. A lithograph from this photograph appears in Hurgronje's Bilder-Atlas zu Mekka *(plate V). Abd al-Ghaffar's signature is at the base of the photograph.*

The India Office was nervous of being seen to be too interventionist in Muslim affairs. Nevertheless, it did eventually assign a pilgrimage officer, a Muslim soldier, to accompany the Indian *hajjis* and to represent them in cases of difficulty, as well as to report back on conditions in the Hijaz. They also brought in the Hajj passport, the chief aim of which was to prevent people with insufficient resources from going on the pilgrimage.[117] (In 1882 the Ottoman authorities introduced their own Hajj passport in an unsuccessful attempt to deal with destitute pilgrims.) While some Muslims resented the Raj having anything to do with their Hajj, others took the opposite view. Mirza Irfan Ali Beg, the deputy collector in Manipuri, who did the Hajj in 1894, complained about the uselessness of the Indian Hajj passport and thought that the Raj should ban the old, the sick and the dying from going on the Hajj. It should also intervene more decisively to stop overcrowding on the ships. He judged that Britain was not fulfilling its imperial responsibilities.[118] Indian issues apart, the extreme poverty of most of the sub-Saharan African *hajjis* coming from Nigeria and elsewhere raised consular concerns. In addition, the British harboured dark suspicions about Russian and Afghan pilgrims, fearing that these might be spies or anti-British agitators.[119]

Throughout the nineteenth century there was a broad consensus among British observers that the Hajj was in decline and that it was costing the Ottoman authorities a fortune to keep it going. Lane in Egypt noted how year by year the ceremony and festivity associated with

The following is my table :—

TABLE OF THE MECCA PILGRIMAGE OF 1880.

Nationality of Pilgrims.	Arriving by Sea.	Arriving by Land.	Total of Mussulman population represented.
Ottoman subjects including pilgrims from Syria and Irak, but not from Egypt or Arabia proper	8,500	1,000	22,000,000
Egyptians	5,000	1,000	5,000,000
Mogrebbins (" people of the West "), that is to say Arabic-speaking Mussulmans from the Barbary States, Tripoli, Tunis, Algiers, and Morocco. These are always classed together and are not easily distinguishable from each other	6,000	...	18,000,000
Arabs from Yemen	3,000	...	2,500,000
,, ,, Oman and Hadramaut	3,000	...	3,000,000
,, ,, Nejd, Assir, and Hasa, most of them Wahhabites	...	5,000	4,000,000
,, ,, Hejaz, of these perhaps 10,000 Meccans	...	22,000	2,000,000
Negroes from Soudan	2,000	...	10,000,000(?)
,, ,, Zanzibar	1,000	...	1,500,000
Malabari from the Cape of Good Hope	150	...	
Persians	6,000	2,500	8,000,000
Indians (British subjects)	15,000	...	40,000,000
Malays, chiefly from Java and Dutch subjects	12,000	...	30,000,000
Chinese	100	...	15,000,000
Mongols from the Khanates, included in the Ottoman Haj	6,000,000
Lazis, Circassians, Tartars, etc. (Russian subjects), included in the Ottoman Haj	5,000,000
Independent Afghans and Beluchis, included in the Indian and Persian Hajs	3,000,000
Total of Pilgrims present at Arafat	93,250		
Total Census of Islam	175,000,000		

the despatch of the *mahmal* from Cairo was being reduced.[120] Charles Doughty, who travelled with the Syrian Hajj caravan as far as Mada'in Salih in 1876, observed that the Ottoman government was spending less on the Hajj and that consequently most of the cisterns were no longer functional and the camp at Ma'an had been abandoned.[121] Burton, as consul in Damascus, remarked on the low numbers leaving for the Hajj. Apart from the growing popularity of sea travel, he ascribed it to a depression in the wake of the Franco-Prussian War and fighting in the Arabian peninsula.[122] Certainly the numbers travelling overland to Mecca were declining steeply, as pilgrims preferred to go by steamship. By the late 1870s the overland Hajj from Damascus had declined from tens of thousands to eight hundred. The last great camel caravan left Cairo in 1883: it numbered 1,170 pilgrims.[123]

The Hajj acquired a romantic, medieval image and became a fit subject for orientalist painting. Léon Belly's grand *Pilgrims Going to Mecca* was the most successful and spectacular painting on this subject, winning a First Class medal when it was exhibited at the Paris Salon of 1861. It shows a camel caravan proceeding through the furnace-like heat of the desert. The Sheikh of the Hajj, stripped to the waist, is followed by the poorer pilgrims' camel litters, with the most beautiful camel bearing the Khedive's gift. The sun has bleached most of the colour from the procession. Belly had wanted to follow Courbet in reproducing 'the truly beautiful and interesting features of the everyday life of our fellow men', and yet his rendering of everyday life has acquired an epic quality. Much later, Etienne Dinet, an orientalist painter who had converted to Islam and who actually went on the Hajj in 1929, painted a series of canvases of the various stages of the pilgrimage which are more accurate in a documentary sense, but lack the compelling quality of Belly's work.

Fig. 160 Opposite
Table of the Mecca Pilgrimage of 1880
Reproduced from Wilfrid Scawen Blunt's
The Future of Islam, London, 1882[124]

The poet, Arabist and political agitator Wilfrid Scawen Blunt's book The Future of Islam *was based on his sojourn in Jedda the previous year. He attempted a census of the Hajj and, from his observation post on the route to Mecca, he tried to give a broader account of what was happening in the Islamic world, such as Ottoman Sultan Abd al-Hamid's pan-Islamic propaganda to Muslims outside his empire and the growth of Islam in sub-Saharan Africa. Blunt thought that Mecca or Medina was destined to become the capital of a revived caliphate and that the Sharif of Mecca was the most plausible future candidate. Yet Blunt also believed that it was Britain's destiny to assume leadership of the Muslim world because it ruled over millions of Muslims.*

Early Photographers of the Hajj

General Muhammad Sadiq Bey was the first photographer of the holy cities of Mecca and Medina and the Hajj which he first visited in 1861. In 1880 Sadiq Bey returned to the Hijaz and took many photographs of buildings and interiors in Mecca and Medina, as well as important Meccan officials. He was also able to take panoramic pictures of the holy mosque at Mecca from multiple angles. Bey's pioneering achievement was noted with great interest in Arabic and European magazines and he won a gold medal at the Venice geographical exhibition in 1881. Later publications on the holy cities often used Sadiq Bey's photographs, including Muhammad Batanuni's *The Journey to Hijaz* and Subhi Saleh's *Pèlerinage à la Mecque et à Medine*.

General Ibrahim Rif'at Pasha, Amir al-Hajj for the Egyptian *mahmal* procession in 1903, taught himself photography and recorded various aspects of the Hajj. He repeated this feat in 1904 and 1908, and over 400 of these photographs were reproduced in his *Mir'at al-Haramayn* (Cairo, 1925). Rif'at's photographs are noted for vividly capturing the intricate details of Islamic architecture and enjoyed a wide commercial circulation. During the 1908 Hajj, Rif'at Pasha was accompanied by Muhammad Ali Effendi Sa'udi, who took the first 3-D views of the Hajj. Another notable early photographer was Muhammad Husayn, Britain's Indian Muslim Vice-Consul at Jedda, who recorded the Hajj in 1909. A further collection of photographs of the holy cities from the early years of the twentieth century, which are inscribed 'H.A. Mirza and Sons, Delhi', are famed for their sharp focus. Scholars believe they are by a professional Indian photographer who owned a studio and took them while on Hajj.

The first European photographer of Mecca was Dutch orientalist Snouck Hurgronje, who took photographs there in 1885. Hurgronje trained the Meccan doctor Abd al-Ghaffar, whose photographs of the Hajj were published by Hurgronje in 1889. Hurgronje's and Ghaffar's pictures are a wide-ranging and unique archive of Mecca and the Hajj in the late nineteenth century.[125] The advent of photography is of seminal importance to the history of the Hajj – for the first time, the pilgrimage and the holy cities were accurately and realistically documented.

Fig.161
Photo portrait of Muhammad Sadiq Bey (1822–1903)
From Sadiq Bey's *Dalil al-Hagg li-al-warid ila Makka wa-al-Madina min kull fagg*, published in Cairo 1313 AH/AD 1896
Leiden University Library, Leiden

Fig. 162 Opposite
Photography equipment and some of the photographs of Muhammad Ali Effendi Sa'udi, including stereoviews on glass of varying sizes; stereoscopes for viewing the stereoviews in 3-D, comprising stereoscope by Verascope Richard of Paris (early 1900s) with adjustable focus for small slides, stereoscope (early 1900s) for medium slides, and stereoscope (late 19th century) with walnut veneer for large slides. Selection of original photographs by Sa'udi, laid on card and window mounted in two folding black cloth boxes
Private collection

Sa'udi's collection of photographs, taken on pilgrimages to Mecca and Medina in 1904, 1907 and 1908 when he accompanied the Egyptian Amir al-Hajj and the pilgrimage caravan, are the earliest 3-D photographic views of the holy cities.[126]

The coming of the steamship had radically changed the nature of the Hajj in the nineteenth century. The construction of the Hijaz Railway in the first decade of the twentieth century had a similarly great impact, at least for a few years. At the beginning of the century the journey to Mecca was as hazardous as it had ever been. The Bedouin of southern Syria and the Hijaz had become increasingly aggressive and rapacious, while piracy flourished in the Red Sea. In 1900 work began on the Hijaz Railway at the behest of the Ottoman Sultan Abdul Hamid II (1876–1909). It was funded by the subscriptions of pious Muslims and was built mainly by Turkish soldiers with assistance from German advisors (though these advisors were not permitted to enter the Hijaz). At the same time the Turks and Germans were cooperating on building a railway that was designed to link Berlin with Baghdad. The ostensible reason for building the Hijaz Railway was to make the journey swifter and easier for pilgrims, but there was also a politico-military agenda. The railway, when completed, would bring the Hijaz under tighter Ottoman control. It would facilitate troop movements and assist in the defence of southern Syria and the Hijaz from attacks by the British in Egypt in the war which the Ottomans and Germans anticipated was coming. Moreover, it might help defend the Hijaz from the resurgent power of the Wahhabis in Najd.[127]

Fig. 163
Hijaz railway watch
Diameter 5 cm
Private collection

Watch made to commemorate the opening of the Hijaz Railway in 1908. The watchface is adorned by the Ottoman imperial coat of arms and a train.

The narrow-gauge track, which ran from Damascus along the pilgrim route via Ma'an, Mada'in Salih and Tabuk, reached Medina in 1908 and the Ottomans felt able to stop paying off the Bedouin in southern Syria. From the first, Sharif Husayn in Mecca had been hostile to the construction of the railway, for he realized that he would become increasingly subject to Ottoman supervision and political pressure, but at first the Bedouin tribes did not realize its significance. 'Can this thing', they asked, 'carry as much as a camel?'[128] In the event, the continuation of the line to Mecca was never built, in part because of Bedouin hostility.[129]

Local hostility to the railway is part of the background to Muhammad Arif's manuscript treatise on the potential benefits of the railway project, *al-Sa'ada al-namiya al-abadiyya fi'l – sikka al-hadidiyya al-Hijaziyya* (The Increasing and Eternal Happiness – the Hijaz Railway).[130] He was scathing about the Bedouin and their exactions on the pilgrim caravans, particularly the Mutary and Juhayna Bedouin of the Hijaz: 'Savagery, ignorance, aggressiveness, plundering and raiding are prevalent among them. Sometimes they lay siege to Medina, which thus remains invested for a month or two, or more . . .'[131] Even in relatively peaceful years the Ottoman official with the caravan had to present 'gifts' to the tribesmen. Moreover, the Syrian economy had been losing out because so many pilgrims preferred to travel by sea.

The completion of the railway would cut the journey time to four days and the tickets would be cheap. (Arif's promise was borne out: A.J.B. Wavell travelled on the Hijaz Railway in 1908 and paid £3 10 shillings for the four-day journey.) Besides vaunting the benefits of the railway, Arif extolled the Hajj more generally: 'Among the benefits of the pilgrimage for this world are the following: Muslims get in touch with each other and get better acquainted with conditions, news and affairs from near and far; they conclude agreements and assist one another in their worldly and religious matters; they cooperate, reciprocally, until they become as one'.[132] The coming together of so many people with things to exchange in Mecca during the Hajj boosted commerce, the transfer of craft and industrial know-how, and the diffusion of different kinds of foodstuffs and seeds throughout the world.

Arif's treatise also gave a detailed account of how the Syrian Hajj was managed prior to the completion of the railway. One of the contributory factors to the fall in numbers in the Damascus caravan was that the official in charge of the *sürre* no longer travelled overland from Turkey to Damascus. 'When the custom of bringing the *sürre* by land was changed, the number of pilgrims decreased and the overland trade between Scutari and Damascus suffered'.[133] Many pilgrims had followed the custodian of the purse on foot, as he dispensed money en route to the various people serving the caravan. But in recent years the official had travelled by steamship from Scutari to Beirut and thence to Damascus.

However, the Muzayrib halt and market south of Damascus flourished much as it had in earlier centuries:

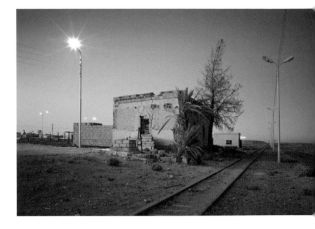

Fig. 164
Station at Unaiza, one of the smaller stations on the Hijaz Railway
Photo: Dudley Hubbard, 2010

The remains of this station shows its similarity in style to the Ottoman Hajj forts of the 16th and 17th centuries. This architectural style was not merely decorative, however. Bedouin hostility to the railway meant stations also had to be structures that could be defended from Bedouin attacks.

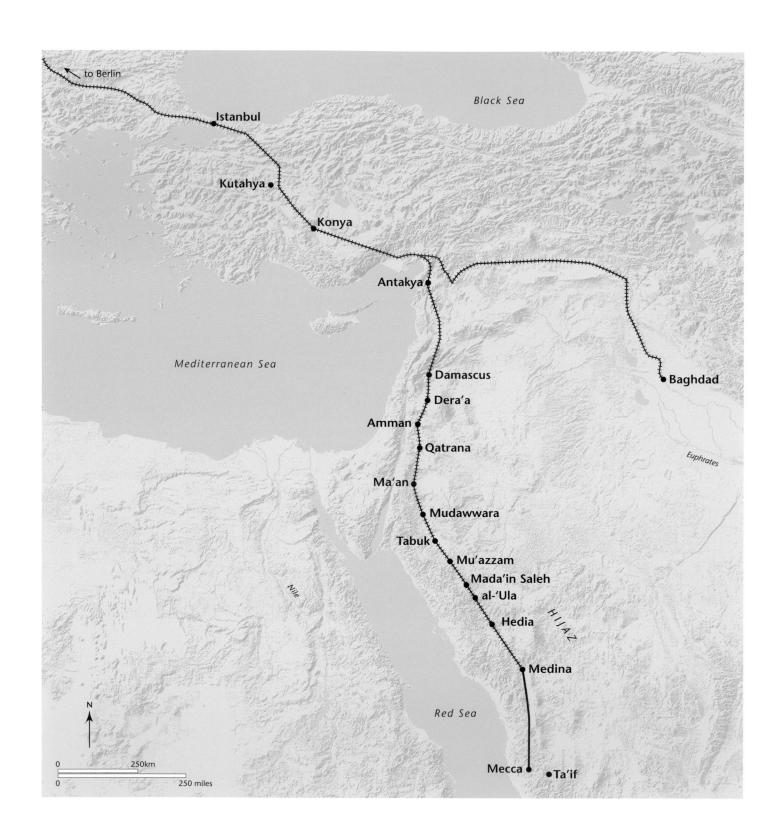

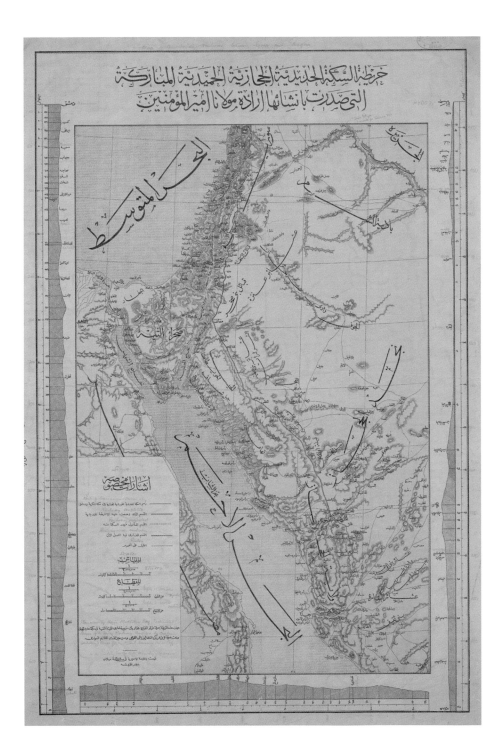

Fig. 165 Opposite page
Map illustrating the Berlin to Baghdad railway, the branch line to Damascus, and the Hijaz Railway from Damascus to Medina, showing the principal stations on the route.

Fig. 166 Left
Map of the Hijaz Railway, compiled Istanbul, 1904
57.5 x 84.5 cm
Royal Geographical Society, London

A plan of the Hijaz Railway made by Hajji Mukhtar Bey during his pilgrimage to Mecca following the old Damascus–Mecca route. It was compiled by Captain of the Artillery Umar Zaki and Lieutenant Hasan Mu'ayyin in the Printing Works of the Ministry of Marine in Istanbul, 1904. This copy of the map was printed in Egypt in 1905.[134]

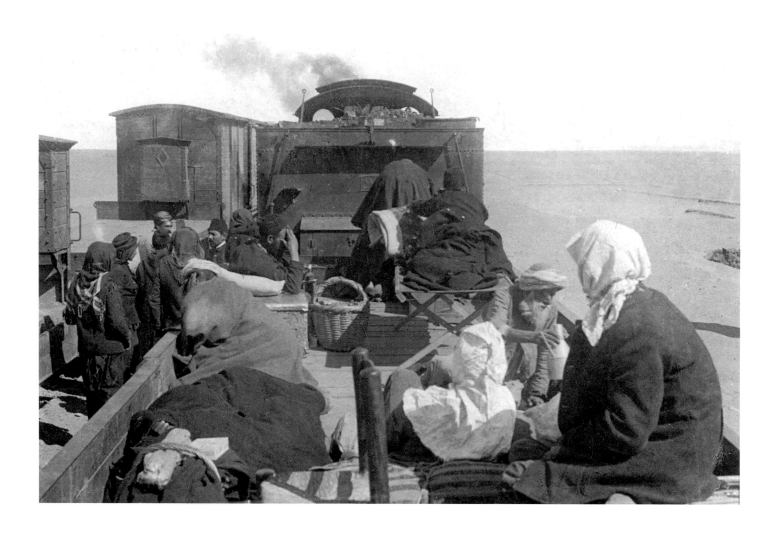

Fig. 167
Pilgrims travelling on the Hijaz Railway
Photo: Lieutenant Colonel F.R. Maunsell,
1907
Royal Geographical Society, London

*Maunsell was a British officer who travelled
on the Hijaz Railway to gather intelligence
on its military potential for the Ottoman
empire, in terms of the possible threat it
posed to Britain's military position in Egypt,
especially in relation to the Suez Canal.*[135]

The Syrian pilgrimage caravan reaches Muzayrib on 7 or 8 Shawwal. Then, there is a large market for trading, to which anyone who desires comes. Merchants put up their tents in this market, as do the traders in the Syrian caravan. The latter carry special wares for this market, as well as for others along the way, and sell them there. The people of Hawran, Jaydur, Lijja and Salt, as well as Arabs [Bedouins] near these places, up to a distance of three or four days, come. They bring camels, wool and other things with them; they buy from the merchants, and sell what they have brought along to them. In this Market one may find whatever one desires, whether edibles, clothes, or other merchandise. This market functions for 18 days.[136]

Merchants then left the caravan and headed back to their homes. Towards the end of the fair the Banu Sakhr and other Bedouins arrived to hire out beasts of burden. The *jirda* relief convoy continued to meet the returning Syrian caravan at Mada'in Salih.

In the years between the completion of the railway and the outbreak of the First World War the Bedouin launched ineffective attacks on the trains. (They were also prone to remove the wooden sleepers and use them for firewood.) A.J.B. Wavell, who travelled by train with the pilgrims in 1908, reported that all the stations south of Mada'in Salih were fortified with trenches and barbed wire and that Medina was being reinforced with Turkish troops as it was under siege by the Bedouin.[137]

Fig. 168
Photograph taken approximately halfway between Medina and al-Ula, a maintenance base for the Hijaz Railway
Photo: John Herbert, 2002

During the 'Arab Revolt' T.E. Lawrence operated on the more northerly part of the railway, near the present Jordanian border. Sabotaging the southern section was delegated to Colonel Newcombe. The guerilla actions against the railway were as a result of Lawrence's plans, but not always directly so. It is difficult to ascertain which trains left in the desert today were attacked by Lawrence and his men; some trains show signs of explosion damage but this is not always obvious.

Fig. 169 Above, left and right
Portrait of T.E. Lawrence and Camel March
Illustrations from T.E. Lawrence, *Seven
Pillars of Wisdom*, London, 1926
26.7 x 20.4 x 7.6 cm
Arcadian Library, London

*During the First World War Lawrence
was posted to the Military Intelligence
Department in Cairo. His reports from
the Hijaz from October 1916 led to his
appointment as a liaison officer to the
Amir Faisal's forces in the Arab Revolt.
From 1917, Lawrence was instrumental in
developing and implementing the strategy
of guerrilla raids against the Hijaz Railway,
which neutralized the Ottoman garrison at
Medina. He played a key role in the capture
of Aqaba in July 1917, and in subsequent
raids on the Hijaz Railway to support
General Allenby's advance through Palestine
to Damascus. These exploits are recounted
in* Seven Pillars of Wisdom, *written between
1919 and 1922, which was a huge critical
and commercial success. His fame as
Lawrence of Arabia was due to the efforts
of Lowell Thomas, who put on a lavish
travelling production of Lawrence's exploits
which became massively successful. He died
after a road accident where he was thrown
from his motorbike.*[138]

In the early stages of the Great War the Ottoman army was able at first to take the offensive in the Sinai and its commanders hoped to take control of the Suez Canal. However, troops from across the British empire were eventually able to take the offensive under Allenby's command. Apart from Bedouin hostility to the Turks and their railway, the holy cities were almost wholly dependent on food imported from India and Egypt, and therefore in 1916 Sharif Husayn declared himself King of the Arabs and in so doing inaugurated the Arab Revolt against Turkish rule. The Turkish garrison in Mecca was massacred, though those in Medina held out until the end of the war. In the desert T.E. Lawrence, with the enthusiastic cooperation of the local Bedouin, set about blowing up sections of the Hijaz Railway. [139]

At the end of the war Sharif Husayn was recognized as the King of the Hijaz. He had grander ambitions than that and in 1924 he was to declare himself Caliph of all Muslims, but very few Muslims took his pretensions seriously.[140] During the war the Hajj had been briefly suspended and after the war it went through difficult times. Part of the problem was that since the break-up of the Ottoman empire the holy cities had lost many of their *waqf* endowments. The various European consuls in Jedda were inundated with complaints about the extortionate dues levied at the port, the seizure of gold from departing pilgrims and Sharif Husayn's failure to pay the Bedouin tribes enough to allow the passage of pilgrim caravans between Mecca and Medina. Sharif Husayn also insisted that pilgrims, who had already been subjected to quarantine at Qamaran, should be subjected to quarantine again at Jedda.[141]

Figs 170–1 Left and above
Letter from Lady Evelyn Cobbold to her grandson, Toby Sladen, 14 March 1933, written in H. St John Philby's house in Jedda, the Beit al Bagdadi
26 x 20 cm
Photo of Lady Evelyn Cobbold, 1915
25 x 17.5 cm
Private collection

Lady Cobbold (1867–1963), who owned an estate in the Scottish Highlands, was the first British woman to perform the Hajj, at the age of 65, in 1933. During her childhood she spent winters in North Africa where she became interested in Islam. While she never formally converted, she later wrote that she did 'not know the precise moment when the truth of Islam dawned on me. It seems that I have always been a Moslem'.[142] Lady Cobbold travelled to Cairo and sailed to Jedda from Suez. Once King Abd al-Aziz Ibn Sa'ud granted his permission, Lady Cobbold travelled to Medina to visit the Prophet's tomb and then arrived in Mecca to perform Hajj on 26 March 1933. Her pilgrimage account, published in 1934, received favourable reviews in most British newspapers and periodicals. Unlike other authors of Hajj accounts, she was able to describe women's life in the holy cities.[143]

As Laurence Grafftey-Smith of the British Consular Service in Jedda recalled from the early 1920s: 'In those days, there was no alternative transport, and caravans of a thousand camels filed through the Mecca gate in the sunset, lurching under their *shugduf* or camel litter, in which two pilgrims balanced each other right and left... It was good to see the pilgrimage as it was in the Prophet's time, and indeed in pre-Islamic times; the soft snarling shuffle of an

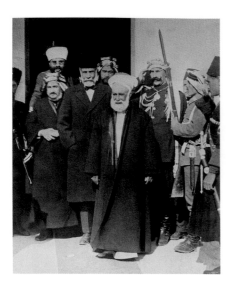

Fig. 172
Husayn, Sharif of Mecca (1908–24) and
King of the Hijaz (1917–24), leaving his
palace in Amman on 3 April 1924

*Born in Mecca, Sharif Husayn was brought
up in Istanbul. After the Turkish National
Assembly abolished the caliphate on 3
March 1924, Husayn declared himself
caliph. Following his abdication he retired to
Cyprus. He died in Amman in 1931 and is
buried in Jerusalem.*

endless caravan, carrying weary and ecstatic men and women along the road to Paradise'.[144] But he was among the last to behold such a vision.

Sharif Husayn clashed repeatedly with the leaders of the Egyptian Hajj over such matters as their wish to bring medical facilities with them and the provision of the *kiswa* by the Egyptian king. Since Husayn was also concerned about spies, it was all but impossible for European converts to proceed to Mecca. However, the arrival of real or *soi-disant* Muslim would-be pilgrims from Europe and America did present both the consuls and the Hashemite authorities with problems. Most of these would-be pilgrims seem however to have been genuine converts. One such was Lord Headley who went on Hajj in 1923 and 1927 and was highly regarded for his services to Islam.[145]

Sharif Husayn also had to contend with the rising power of the Al Sa'ud in Arabia. The army of the Hashemites proved to be no match for the forces of the Al Sa'ud and the warriors of the *Ikhwan*. When they captured Taif in the autumn of 1924 Sharif Husayn abdicated in favour of his eldest son Ali who briefly became King of the Hijaz. This was short lived and when Abd al-Aziz Ibn Sa'ud captured Mecca in October Sharif Husayn fled into exile. This spelt the end of Hashemite rule in the Hijaz.[146] In 1932 the now unified country was proclaimed the Kingdom of Saudi Arabia.

Following the imposition of Sa'udi rule in the Hijaz, there was an immediate improvement in the circumstances of pilgrims. In part, this was due to the ending of the war between the Saudi and the Hashemites. But Ibn Sa'ud also purged the administration of the Hajj and forced the pilgrim guides to lower their prices. Untrustworthy guides were discharged and Bedouin tribes who had been attacking pilgrim caravans were either properly paid for their services as cameleers or became the victims of efficiently conducted military campaigns. In 1926 Ibn Sa'ud issued comprehensive Hajj regulations in forty articles and fixed the prices of the various services to pilgrims. He also encouraged the use of cars. However, in the same year the age-old tradition of bringing the *mahmal* and the *kiswa* to Mecca from Egypt ended due to a disagreement between the Saudi and Egyptian authorities.[147]

Nevertheless, despite increased security in the Hijaz, economic problems persisted for over a decade. The destruction of the Hijaz Railway had been ruinous for the economy of Medina. Prior to the discovery of oil, pilgrims were almost the only source of income in Saudi Arabia necessitating the levying of an entry tax on them. For much of this period, pilgrim numbers remained low,

in large part because of the worldwide economic depression. In 1931 they fell to 40,000 and by 1934 to as low as 20,500.

In the long run the situation improved. In 1938 oil was struck in Arabia and thereafter a large part of the oil revenue was devoted to lifting the pilgrim tax and to improving the facilities for pilgrims. The end of the Depression and the increased use of cars and coaches led to a vast increase in the numbers of pilgrims and, from the 1950s onwards, those numbers increased yet further as pilgrims started to arrive by air.

The temptation for a historian to analyse the history of the Hajj in terms of its politics, economics and logistics is all but overwhelming, but that is to miss everything that is important about this pillar of Islam. Although the Hajj is a pious duty, it has sometimes also been a passport to scholarship, a wild and romantic adventure, or a mystical journey. While it is inevitably difficult to communicate the lived experience of the Muslim pilgrimage, some writers have tried their best.

The fourteenth-century *hajji* Ibn Battuta was rarely moved to rhapsodic prose, but he was nevertheless emotionally stirred by the climax of the Hajj and reported that God 'has created the hearts of men with an instinctive desire to seek these sublime sanctuaries, and yearning to present themselves at their illustrious sites, and has given love of them such power over men's hearts that none alights in them but they seize his whole heart'.[148]

Joseph Pitts, who was a convert to Islam and came as a slave with his master, reported on the standing at Arafat in 1680: 'It was a sight indeed to pierce one's heart to behold so many thousands in their garments of humility and mortification, with their naked heads, and cheeks watered with tears; and hear their grievous sighs and sobs, begging earnestly for the remission of their sins, promising newness of life, using a form of penitential expression and thus continuing for the space of four or five hours.'[149]

In 1807 Ali Bey was similarly overwhelmed by the spectacle of the standing at Arafat: 'No, there is not any religion that presents a spectacle more simple, affecting and majestic'.[150] In more modern times, Winifred Stegar wrote, 'If I have seemed to speak lightly of this pilgrimage, it is not that I felt so, but deeper feelings choke human utterance. I am honoured and proud to have been one of the pilgrims. Their living faith shattered my callousness towards religious attitudes. I learnt there that God is a reality. I learnt too love for my fellow pilgrims, and in the hereafter I hope to mingle with those dear ones again'.[151]

Fig. 173
King Abd al-Aziz Ibn Sa'ud (1876–1953) in the desert in 1922, during the conflict with Sharif Husayn

Ibn Sa'ud and his supporters captured Riyadh in central Arabia from their rivals the Al Rashids in 1902, marking the beginning of the modern Saudi state. In 1912 Ibn Sa'ud consolidated his control over the Najd region in central Arabia and founded the Ikhwan. Ibn Sa'ud was allied to Britain during the First World War, and eventually defeated the Ottoman-supporting Al Rashids in 1920–2. Sharif Husayn's hostility to the Saudi state led to conflict between the two. Ibn Sa'ud's forces steadily occupied the Hijaz, and he declared himself King of the Hijaz in the holy mosque at Mecca on 10 January 1926.

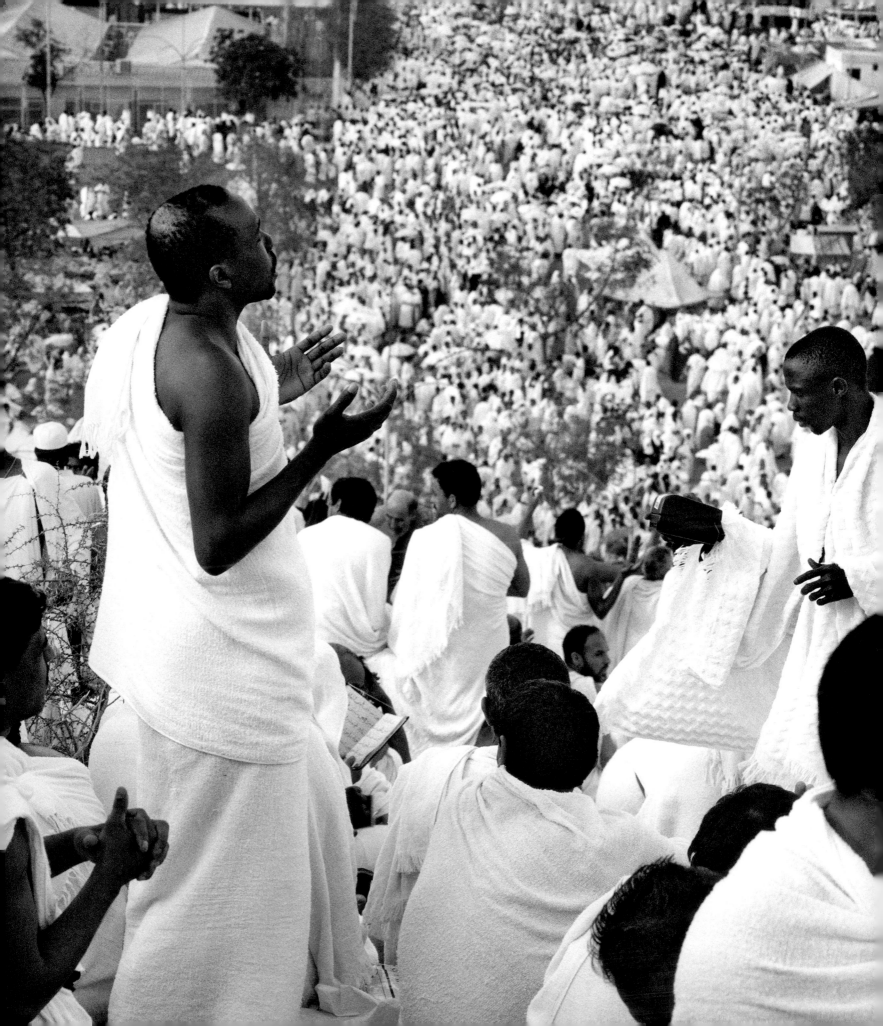

Hajj After 1950

Fig. 174
A view from Jabal al-Rahma
Photo: Reem Al Faisal, 2000–3

Reem Al Faisal was born in Jedda. Her photographic document of the Hajj, from which this image comes, was published in 2009.[2]

'It is difficult to capture the Hajj in text or visually since the Hajj is larger than any possible description. No book or photograph can ever give the Hajj its due. Even those who perform the Hajj can never fully comprehend it. From the first day of the Hajj one is swept away by the sheer motion and size of it and you find yourself moving at another level of your consciousness. As you perform one ritual after the other you slowly discover the rhythm of the universe.'[3]

For the majority of people who perform the Hajj these days, taking a flight to Jedda is quite simply the natural thing to do. But when Abdul Ghafur Sheikh performed the Hajj in 1953, coming 'From America to Mecca on Airborne Pilgrimage',[4] he achieved a rare distinction. In an age when air travel was not a common form of transport, Sheikh was among the first to arrive in the holy city aboard a propeller-powered aircraft.

Sheikh's historic journey was a clear indication that traditional patterns of travel for pilgrimage to Mecca were about to change radically. The pilgrim camel caravans from Damascus, Baghdad and Cairo, the standard mode of travel for centuries, were now being replaced by buses and cars, steamships and in 1908 the arrival of the Hijaz Railway, from Damascus to Medina. But the biggest changes came with air travel.

During the 1950s plane trips were bumpy and noisy, aircraft could not fly at very high altitudes and they had to make frequent stops to refuel. Air travel was limited to the few who could afford it. But in the 1960s, when the Middle East Airline (MEA) of Lebanon decided to convert Second World War bombers into passenger planes and charter them to groups of pilgrims, air travel opened the doors to many who would otherwise not have been able to perform the Hajj.[5] MEA started to charter special Hajj flights to and from Jedda, the main gateway

Fig. 175
Pilgrims disembarking from a plane
Photo: Abdul Ghafur Sheikh, 1953[6]

Pilgrims disembark from a plane at Jedda. Sheikh was a Harvard Business School student when he went on Hajj and published his account and striking colour photos in the National Geographic Magazine. *His photos are some of the first to document the growing role air travel played in pilgrims' travels.*

to Mecca, for national airlines in India, Turkey, Iran and Nigeria. The airline assigned up to five Boeing 707s to a particular country for six to eight weeks during the Hajj season. The planes made up to 300 flights and carried around 1,900 pilgrims per day. In 1969, chartered flights from Nigeria alone brought 22,500 pilgrims to Mecca. The idea caught on quickly, and by the early 1970s all the major Arab airlines were competing with each other for special Hajj flights.

Air travel totally transformed the Hajj. It was now not only quicker to get to Mecca, it was cheaper, too. More and more Muslims throughout the Islamic world could now fulfil their lifelong ambition to perform the Hajj, and travelled by plane.[7] In 1974, for example, all of the 5,000 pilgrims from Bangladesh, 98 per cent of pilgrims from Iran, and more than half the pilgrims from Indonesia came by air instead of sea. Not surprisingly, the number of pilgrims coming to Mecca increased dramatically. In 1974, airborne pilgrims poured into Jedda at the rate of 120 flights a day. Within a decade pilgrim numbers had increased from approximately 290,000 in 1961 to 450,000 in 1972.[8]

HAJJ LOGISTICS

Technology did not just change the experience of getting to Hajj, it also began to change the experience of the pilgrimage itself. Logistically, the Hajj is a very complex affair. It involves constant movement and numerous rituals that have to be performed according to a fixed schedule. The Hajj takes place during Dhu'l Hijja, the twelfth month in the Islamic calendar. The pilgrims begin to arrive in Mecca two or three weeks before the actual Hajj. In Mecca, they visit the sacred mosque (the Masjid al-Haram or Haram), where they are required to walk round the Ka'ba seven times, and run, seven times, between the hills of Safa and Marwa, a ritual known as the *sa'i*.

On the morning of 7th Dhu'l Hijja, the simultaneous rituals begin when pilgrims move from Mecca to the nearby town of Mina, where they spend two nights in prayer. On the 9th, they move again – this time to the plain of Arafat, a few kilometres from Mina, where they must arrive before noon. The supreme rite of the Hajj, the vigil, known as *wuquf* (standing), takes place here at Arafat. The congregational prayer on Arafat is the one all pilgrims offer together and in unison. The pilgrims remain in Arafat until sunset; immediately after dusk begins the *nafra*, the great exodus to Muzdalifa, an area between Arafat and Mina, where the pilgrims spend the night under the sky in prayer. The following

morning they return to Mina. During the next three days, the pilgrims perform the rite of *Ramy al-Jamarat*, which requires them to throw small pebbles at three pillars – a symbolic gesture to cast out 'the evil within'. In Mina, the pilgrims also sacrifice an animal and distribute its meat.

It is not just a question of transport – of moving hundreds of thousands of pilgrims from one ritual site to another, on a six-day, 195-km (120-mile) round trip from Jedda, where most pilgrims enter Saudi Arabia, to Mecca and all the other holy places, and back to Jedda. They have to be supplied with accommodation, food and drink at every stop. Basic information must be provided so they know where to go and what to do – not an easy task when we consider that pilgrims come from different countries and backgrounds and most do not speak Arabic, or indeed any language other than their own.[9] Their safety must be ensured and their health and medical needs attended to – a serious problem when many are old, and some may be ill – and sanitary facilities have to be provided for all. Animals must be available for them to purchase and sacrifice. Even the millions of pebbles that are thrown at the *Jamarat* have to come from somewhere. All this makes the organization and management of Hajj an extremely intricate and complicated affair.

> *Everyone performing hajj has turned away from himself to face God. He has been endowed with the spirit of God. You have gone from an exile to the Hereafter. You have been exposed to the absolute facts. You have overcome ignorance and oppression and have been enlightened by consciousness and justice.*
>
> ALI SHARIATI 2003, *THE HAJJ*[10]

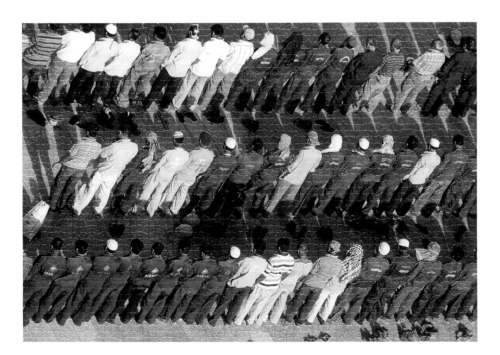

Fig. 176
People mosaics under my window
Photo: Shadia Alem, 2010

Shadia Alem was born in Mecca and her family have been involved with the care of the sanctuary and the Hajj for generations. She is a painter, installation artist and photographer and with her sister Raja represented Saudi Arabia at the Venice Biennale in 2011. From her window overlooking the Masjid al-Haram, she has photographed some of the many workers (here dressed in particular uniforms) on the site during the feast of Eid al-Adha following the wuquf *at Arafat.*

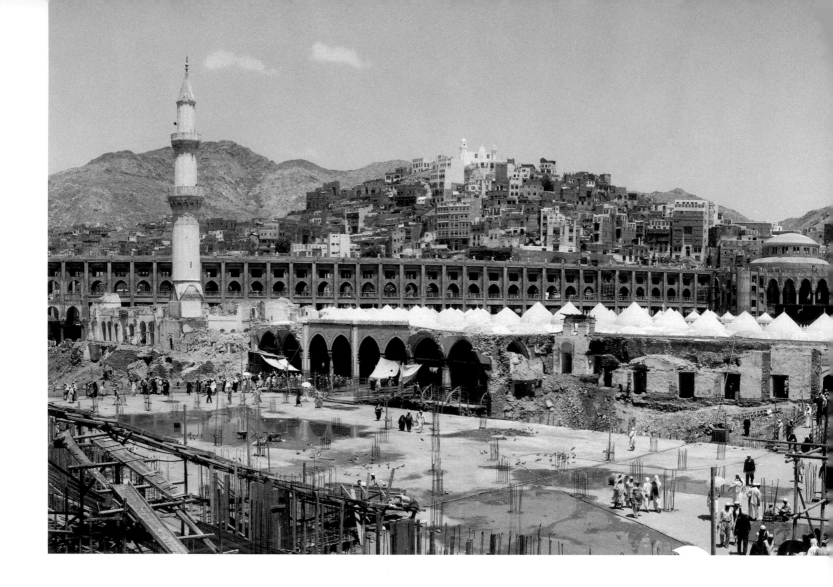

THE SACRED MOSQUE GETS ITS FIRST EXTENSION

Even in the 1950s, when pilgrim numbers hovered around 200,000, it was obvious that the sacred mosque could not accommodate all pilgrims. The founder of the modern Kingdom of Saudi Arabia, King Abd al-Aziz ibn Sa'ud, decided during the 1940s that the sanctuary had to be extended as a matter of urgency. After writing a letter to Muslims throughout the world signalling his intentions, King Abd al-Aziz ibn Sa'ud asked his son, the late (then Prince) King Faisal, to supervise the extension. Work began in 1956 and was carried out in four phases.[11]

The first phase, which took place between 1955 and 1961, involved re-routing the main road which crossed through the area between the hills of Safa and Marwa, where *sa'i* is performed. Houses on both sides were knocked down.

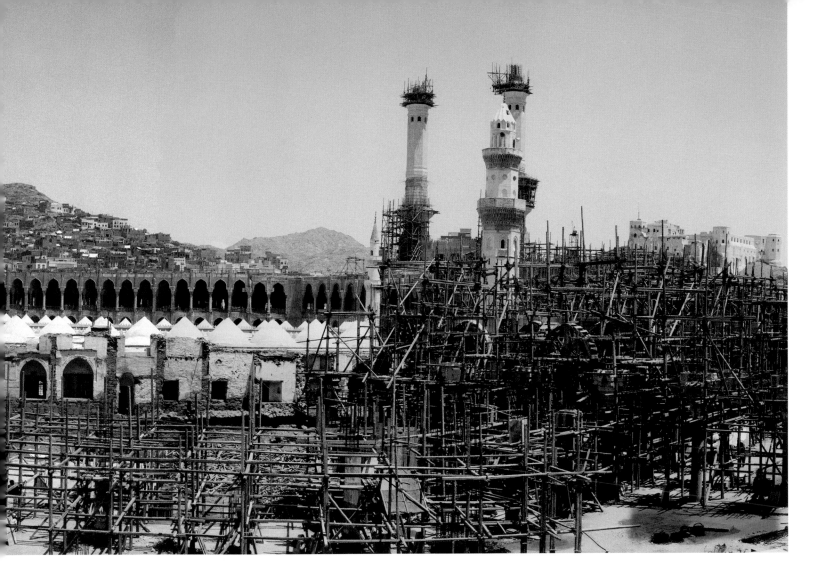

Fig. 177
The Haram
Photo: Safouh Naamani, 1963

This photograph shows construction works that formed part of the second phase of the Saudi extension of the sanctuary at Mecca (1961–9). Photographs of the restorations of this period are extremely rare.

The *mas'a* (place of hurrying) already had a roof, first built in 1920 by the then Amir of Mecca, Sharif Husayn ibn Ali. The roof was renewed and the whole area paved. A barrier was added to separate the people travelling in opposite directions, from Safa to Marwa and coming back from Marwa to Safa. A second storey was added, making it possible for pilgrims to perform the *sa'i* on two levels. Moreover, eight doorways on the ground floor on the eastern façade overlooking the main road, and two entrances to the first floor on the side of the mosque, one each at Safa and Marwa, were added. The river bed that passed in front was also altered. The mosque itself was paved with white marble and the walls and roof of the Ka'ba, which had fallen into disrepair, were rebuilt.[12]

The second phase began in 1961 and lasted until 1969. Attention now shifted to the southern side of the mosque. The basement and the ground and first floor of the mosque were repaired, with walls faced in marble and the arches

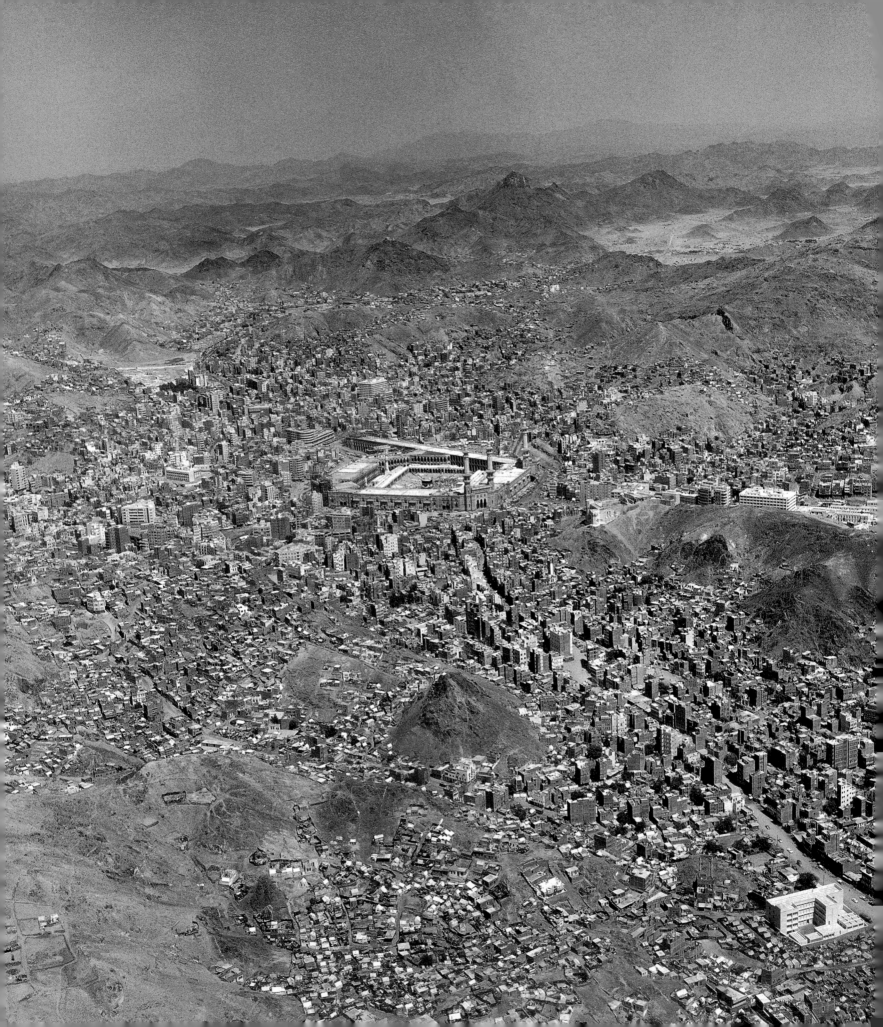

in artificial stone. A wide entrance gateway was introduced, incorporating three existing smaller doors. The new door was named after the monarch, the successor to King Abd al-Aziz: King Sa'ud Gate.

During the third phase, beginning in 1969, all the buildings that stood on the site where the western arcade was to be constructed, many of historical significance, were demolished. The construction of the western arcade began with the basement and was followed by the ground and first floors. The northern side of the sacred mosque was extended during the fourth phase, which began in 1973. Two new minarets were added; and all the gates were renovated in a similar style to give visual coherence to the building.

Before the extension, the area of the sacred mosque was 29,127 sq m (313,520 sq ft). After the extension, seven minarets – each 89 m (292 ft) high, standing on a square base adjoining the mosque's wall, and two balconies with parapets – defined the borders of the extended mosque. It now covered 160,168 sq m (1,724,035 sq ft), almost a six-fold increase in the total area.[13]

In addition, road networks taking pilgrims from Jedda to Mecca, and within the Hajj environment, were improved. A four-lane highway was completed between Jedda and Mecca, and a road from Mecca directly to Medina, bypassing Jedda, was built to alleviate traffic congestion during the Hajj season. Flyovers and spaghetti junctions were constructed to improve the flow of traffic between Mecca, Mina and Arafat. A two-level system was introduced in the *Jamarat* area to enable more pilgrims to perform the ritual of stoning at a given time. High-mast floodlighting was introduced at every ritual site. Most of this work was undertaken according to a 'Master Plan for the Holy City of Mecca' which was completed and submitted to the Saudi Arabian government in 1973.[14]

By the early 1970s it had also become obvious that the Jedda airport, then located in the Sharafia district in the middle of the city, was totally inadequate to cater for the increasing number of pilgrims. A new airport, some 30 km (18½ miles) outside the city, was therefore commissioned, with a separate, exclusive terminal for the pilgrims. Opened in 1981 by the late King Khalid, the Hajj terminal of the new King Abd al-Aziz International Airport in Jedda has a tent-like structure made of fibreglass and special facilities for processing pilgrim visas. Even though the new airport had a massive land area of 105 sq km (40.5 sq miles), it was obvious from early on that it would have to be expanded and upgraded within a decade.

Fig. 178
Aerial view of Mecca
Photo: Safouh Naamani, 1967

This photograph shows the Haram at the centre of Mecca, and the Jabal al-Nur (Mountain of Light) in the upper centre above it. The Jabal al-Nur is the location of the Cave of Hira where the Prophet Muhammad received the first revelations. This is one of the first aerial photographs taken of Mecca.

Fig. 179
Road to Makkah, 2011
Abd al-Nasser Gharem
Ink and industrial lacquer paint on rubber
stamps on 9-mm Indonesian plywood
70 x 330 cm

*Gharem was born and lives in Khamis
Mushait in Saudi Arabia. He studied at the
al-Meftaha Arts Village in Abha and joined
the army, reaching the rank of Lieutenant
Colonel. He is an installation artist and has
also developed a series of stamp paintings
of which this is a recent example, created
especially for the exhibition* Hajj: journey
to the heart of Islam. *The road sign on
the way to Mecca indicates the alternative
route for non-Muslims, who have not been
allowed into Mecca or Medina since the
beginning of the Islamic era.*

ADMINISTRATION AND ORGANIZATION

Managing the redevelopment of Mecca, the extension to the sanctuary and
developments in Mina and Arafat required a sophisticated system of planning
and coordination across several institutions of the Saudi government. Overall
responsibility for the administration of Hajj and improvements in the Hajj
environment was given to the Ministry of Hajj. The Ministry was first established
in 1930 as the Directorate-General of Hajj Affairs under the supervision of the
Ministry of Finance, as the Hajj was, during the first half of the twentieth century
and before the discovery of oil, the main source of revenue for Saudi Arabia. The
Ministry of Finance also supervised the semi-autonomous Directorate-General
for Waqfs, a body that managed a string of pious foundations and charitable
trusts throughout the Kingdom. With the rapid rise in the number of pilgrims, an
independent Ministry of Hajj became a necessity. Thus in 1962 the Directorate-
General of Hajj Affairs and Directorate-General for Waqfs were combined to
create the Ministry of Hajj and Waqfs and given the principal responsibility for
overseeing and regulating the Hajj service industries.[15] The Hajj departments of
the cities of Mecca and Medina, and the reception centres where the pilgrims
are processed on their arrival in Jedda, were now under the direct control of the
Ministry of Hajj and Waqfs. The Ministry also took charge of the entire transport
system of Hajj, as well as the guild of pilgrim guides and other professions and
industries that provide services for the pilgrims.

But that still left a number of other requirements associated with the Hajj – from providing accommodation to medical facilities, security and sanitary services. So in 1966 a Supreme Hajj committee was established to oversee the overall coordination and planning of the Hajj.[16] The members of the committee include senior officials from the ministries of Hajj, Health and Interior, the mayors of Mecca and Jedda, and representatives of the police, customs, quarantine, national guard and volunteer organizations as well as pious foundations. Virtually all the regulations concerning the Hajj, from traffic routes to parking, the employment of closed-circuit television, rules of conduct for pilgrim guides, licensing of food outlets and fixing the price of basic provisions, are under the control of this committee. It also oversees the erection of tents in Mina and Arafat – which are laid out on a grid system and put up and taken down each year – and assigns welfare workers, national guardsmen and Boy Scouts (who are recruited in their thousands each year) to look after blocks of pilgrims, including those who get lost or become ill. The individuals in charge of each grid block can summon a helicopter, which hovers overhead to indicate the precise spot from where the pilgrim needs to be rescued and guides the ambulance or police van. The committee meets several months before the Hajj to plan for the arrival of the pilgrims, provide guidelines and make recommendations.

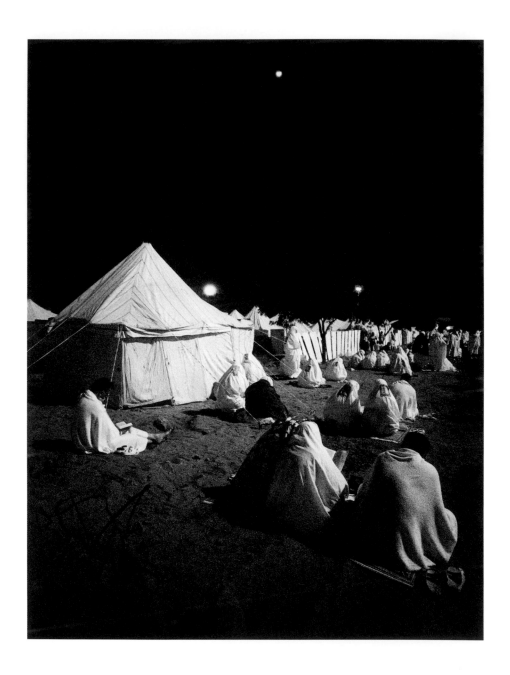

Fig. 180
A view of Muzdalifa at night
Photo: Reem Al Faisal, 2000–3

'Pilgrims camp at Muzdalifa and pick up stones from there to be able to stone the devil. It's a time of meditation and prayer … Even though the Hajj is a collective event it is also a very personal one, for each of us finds the Hajj he came looking for.'[18]

THE PROFESSIONAL GUIDES

An important part of the administration of Hajj is the regulation and supervision of the historic institution of the *mutawwifs*. Conventionally described as 'pilgrim guides', *mutawwifs* do much more than simply 'guide' pilgrims through various

rituals, although this is an important part of their job. The *mutawwifs* arrange transport and accommodation in Mecca, Mina and Arafat and are responsible for providing basic provisions such as food and drink. It is the responsibility of the *mutawwifs* to ensure that pilgrims get to various ritual points at the prescribed time and place. Without a *mutawwif*, a pilgrim would be totally lost. This is why every single pilgrim has to register with a *mutawwif* before he or she can come to Saudi Arabia to perform the Hajj – indeed, every movement of the pilgrims, from arrival to departure, is controlled by the *mutawwifs*. The costs of their services are included in the overall Hajj package that the pilgrims buy or are provided by their respective countries.

Most *mutawwifs* belong to Meccan families who have guided pilgrims for generations – it is, after all, one of the oldest professions in Islam.[19] It has provided seasonal employment and business for the inhabitants of 'the Barren Valley', as the area around Mecca was described in the Qur'an (14:37). Being a *mutawwif* was always considered to be a privilege and *mutawwifs* themselves have taken great pride and care in looking after the pilgrims. Many of the *mutawwif* families originally came from elsewhere in the Muslim world. People from Yemen, India, Java, Egypt, Turkey and North America would come to perform the pilgrimage, and some stayed and settled in Mecca. Their descendants eventually integrated with the local inhabitants, making Mecca one of the most cosmopolitan cities of the Muslim world. Some became *mutawwifs* catering almost exclusively to pilgrims from their own cultural and national backgrounds. But many traditional pilgrim guides found it difficult to adjust to the rapid rise in pilgrim numbers. It was not always possible to provide the same personal attention to their responsibilities, given the number of pilgrims that the Ministry of Hajj and Waqfs was assigning to them. It became necessary to modernize.

The *mutawwifs* were thus reorganized as modern firms, and new codes of conduct were issued to regulate them. There are now over eighty *mutawwif* firms, of various sizes, providing different standards of service and catering to pilgrims from different backgrounds, rich and poor, urban and rural. Depending on the price the pilgrims are willing to pay, they can have five-star accommodation and service throughout the Hajj or they can perform

Fig. 181
The office of one of the *mutawwifs* in Mecca
Photo: Qaisra Khan, 2010

the pilgrimage on a much lower budget. There are even provisions to pay the fees of the *mutawwif* on an instalment basis.

CONTROLLING THE NUMBER OF PILGRIMS

However, all this restricting, planning and coordination, and rapid development of the Hajj environment, would have been futile if the number of pilgrims continued to increase. In the 1970s it was generally believed that pilgrim numbers would quickly rise beyond a million. Turkey alone sent 100,000 pilgrims in 1974, 1975 and 1976, and Pakistani pilgrims exceeded 100,000 in 1973. Whereas the conventional description was 'streams of pilgrims', officials now started to talk about 'flash floods' of pilgrims. There was an urgent need to control the flow of pilgrims coming for Hajj.

That the new ease of travel, combined with cheap 'coach-class' air fares, would drastically increase the number of pilgrims was recognized even in the 1960s, when the late King Faisal made a number of attempts to persuade other Muslim leaders to control the number of pilgrims coming from their respective countries.[20] He regularly used the occasion of Hajj to take forward his project to launch the Organization of the Islamic Conference (OIC), a United Nations of the Islamic world, to serve the common political, economic, social and cultural interests of Muslim states. The OIC was finally established in September 1969,[21] with headquarters in Jedda. It developed into the leading organization of the Muslim world, with fifty-seven 'member states'. But King Faisal's attempt to persuade the OIC to introduce a regime to control the number of pilgrims was not immediately successful.

The pilgrim numbers continued to rise, passing the million mark in 1972. During the late 1970s Saudi officials started to talk about a 'two-million Hajj', and congestion during the Hajj became a serious problem. It could take up to nine hours to travel from Mecca to Arafat on the multi-lane highway, a distance of a little over 14 km (9 miles). There was also the constant danger of accidents and disasters from overcrowding and surging crowds. Faced with these realities, the OIC eventually adopted a system of national quotas in 1988.

The quota system is pegged to the population of Muslim countries. Each participating country is allowed to send one person per 100,000 of population in any given year.[22] Growth in pilgrim numbers began to level off almost

immediately. But the quota system also had another equally important effect. During the 1960s and 1970s, the bulk of the pilgrims came from Egypt, Yemen, Jordan, Morocco, Libya, the Sudan and the Gulf – the countries nearest to Saudi Arabia. But given their populations, the quota system reduced the number of pilgrims who could come from these countries. In contrast, Indonesia, with a population of over 220 million, now provided the highest number of pilgrims for Hajj. Indonesia was closely followed by Pakistan (170 million), Nigeria (158 million), Bangladesh (154 million), Turkey (70 million) and, we must not forget, India, which has a special status in the OIC and a Muslim population of 160 million. An overwhelming majority of pilgrims now came from outside the Arab world. One in ten pilgrims is from Indonesia, and one in four from the Indian subcontinent. The shift towards the non-Arab Muslim world changed the overall social and cultural make-up of the Hajj.

SCIENCE MEETS TRADITION IN THE HAJJ RESEARCH CENTRE

The problems and challenges of the modern Hajj were met in Saudi Arabia by the redevelopment of Mecca and the holy areas and the reorganization of its administration and management. But there were concerns, primarily that while a great amount of time, money and massive financial resources were devoted to planning and execution, no one was actually collecting basic data on which much of the planning depended. For example, while the Saudi authorities knew the total number of pilgrims performing Hajj during a given year, and the number that came from each country, there were no statistics on their age, work status, urban/rural distribution or level of education. Moreover, there were hardly any statistics about the substantial number of internal pilgrims – that is, pilgrims, native and resident, from within Saudi Arabia itself. The residents included Muslim expatriates from Egypt, Palestine, Syria, India, Pakistan and, most numerous of all, immigrants from Yemen who worked as guards and attendants throughout the Kingdom. Unlike foreign pilgrims, the internal pilgrims were not attached to *mutawwifs* and made their own arrangements. When and how did they arrive in Mecca? Where and how long did they stay? How did they travel to Mina and Arafat – by cars, local taxis or buses, or on designated Hajj vehicles? All this information was essential in the planning and organization of Hajj.

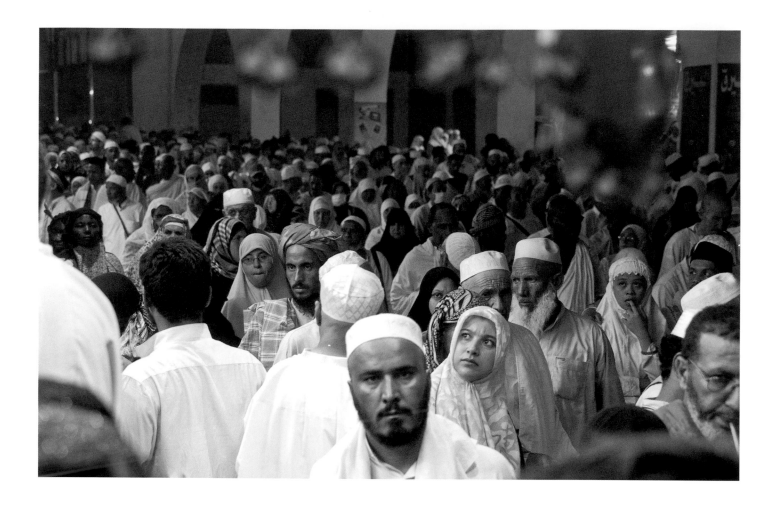

It was to undertake just this type of work that the Hajj Research Centre (HRC) was established in September 1974. This was initiated by Sami Angawi, an architect from Mecca. Angawi felt that the developments in Mecca and the changes in the Hajj environment tended to overlook the basic social and cultural backgrounds of the pilgrims as well as the importance of preserving properties of cultural and historical significance, and sacred sites, according to Islamic principles of conservation, town planning and design. 'The main challenge of the hajj', he declared, was 'how to fit the variables into the constants'.[23]

For the first few years, the HRC, now established at the University of Jedda, functioned as a semi-autonomous unit within King Abd al-Aziz University. Its fundamental aim was 'to contribute, by means of objective and thorough

research, towards appropriate solutions of all problems connected with pilgrimage and with the Sacred Cities and Sites'.[24] Much of the work of the Centre focused on establishing a wide-ranging databank on the Hajj and on providing extensive (documentary, aerial and infra-red) film and photographic records of every Hajj. An interdisciplinary team was assembled which consisted of architects, planners, economists, sociologists, information scientists, statisticians, transport engineers, computer scientists, geographers, health professionals and experts on Islam and the history of Hajj.

The HRC team developed a critique of the Master Plan for the Holy City of Mecca.[25] It undertook extensive studies on the movement of vehicles within the Hajj environment including traffic jams and bottlenecks, documented the destruction of cultural and religious property, and made numerous recommendations to the Ministry of Hajj. But by far the most important contribution of the Centre was in the development of computer simulation models, based on the research work on global dynamics at the Massachusetts Institute of Technology which was the basis of the 1972 *Limits to Growth*, the famous first report to the Club of Rome.[26] The Centre developed a set of interrelated models of the various elements of Hajj. These models could predict, for example, what would happen to transport and pollution if the number of pilgrims increased to two million, and identify risks, such as at the *Jamarat*, where crowd pressures could lead to serious accidents. On the basis of these models, the Centre argued for reduction in the number of vehicles in the Hajj environment and the construction of shaded pedestrian walkways. Instead of insisting that pilgrims travel by cars and buses, which then generated some 80 tons of exhaust fumes per day during the peak period, the Centre suggested that most pilgrims, with the exception of the old and infirm, should be encouraged to walk to Mina, Arafat and Muzdalifa. Because people walk at different speeds, there would be a more even flow of pilgrims through the various ritual points, easing the dangerous bottlenecks.

The pioneering work of the HRC led to its formal recognition by the late King Fahd. In 1981 the HRC was established as a consultative authority to the Hajj Supreme Committee and other institutions concerned with Hajj affairs. In 1993 the centre was transferred from King Abd al-Aziz University in Jedda to Umm al-Qura University in Mecca. In 1998 its name was changed to The Custodian of the Two Holy Mosques Institute for Hajj Research. In 2002 a

Fig. 182
Pilgrims in Mecca after evening prayers during Hajj
Photo: Qaisra Khan, 2010

'The many and varied nationalities of pilgrims was one of the most fascinating facets of Hajj. Especially where people are relaxed, they have time to chat and are all dressed in national costume. The Uzbeks in blue, the Turks in pink and the Africans in their multicoloured Hajj dresses. Many pilgrims wore their national costumes, Kazakhs with tall furry hats, the Malians in vibrant indigo, Indians in shalwar qamis and the orderly South-East Asians with matching flowers in their hijabs *(the women of course!). ... The faces, stories (one Indian man told us he gave up his job to go on Hajj) and the parts of the earth these people had travelled from – was quite inspirational and captivating!'[27]*

branch was opened in Medina, and in 2007 a fund was established to focus specifically on transport and crowd management during Umra and Hajj.

FURTHER EXTENSIONS TO THE SANCTUARY

Some of the recommendations of the Hajj Research Centre were accepted during the second extension of the sanctuary and further development of the

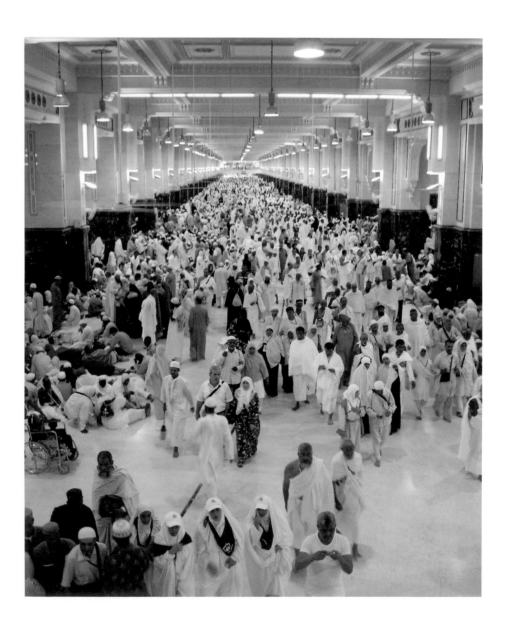

Fig. 183
Pilgrims doing *sa'i*
Photo: Qaisra Khan, 2010

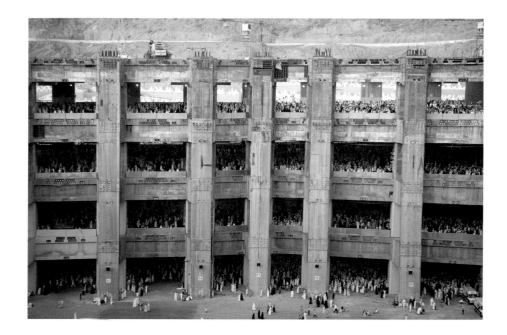

Fig. 184
The new *Jamarat* building
Photo: Newsha Tavakolian, 2008

Each level of this multi-storey structure serves north, south, east and west, with twelve entrances and thirteen or fourteen exits. The building contains the Jamarat pillars which can be accessed on all floors.

Newsha Tavakolian, who was born and lives in Iran, is a self-taught photographer who started working for the Iranian press at the age of sixteen. She went on Hajj in 2008 and was one of only a handful of photographers permitted to photograph during that year's Hajj, which fell in November.[29] Her work moves between reportage and art photography.

holy areas. Legislation was introduced banning private vehicles from the Hajj areas. Pedestrian walkways were built between Mina and Arafat, making this area one of the safest and most pleasant parts of the Hajj environment.

The second expansion took place from 1982 to 1988, when King Fahd was on the throne.[28] A new wing on the western side of the mosque was built, supplemented by a new gate, King Fahd Gate, in addition to fourteen minor gates and entrances to the basement of the mosque. The mosque also acquired three new domes and two new minarets, and the entire roof was modified to allow worshippers to pray on top. To enable pilgrims to get to the roof and the first floor, five escalators were distributed around the mosque and the new extension. Four lifts, two of which served the minarets, were also added. Moreover, an outdoor prayer area known as the Eastern Courtyard was built next to the mosque on the western side, located at the bottom of the famous Abu Qubays mountain. The mosque now had four principal gates and fifty-four minor entrances, as well as six entrances to the basements and upper entrances to the second level. It could hold 820,000 worshippers on ordinary days and a million during the Hajj season. Roads and tunnels were available to take worshippers direct from Mecca to Mina.

Additional development in Mecca and the holy areas took place from 1988

to 2005. This period saw further expansion of the Haram, adding more prayer space within and outside the mosque. More minarets and gates were built, as well as a palace for the King, overlooking the mosque and the Ka'ba. The mosque was provided with air conditioning and heated floors for the chilly nights. Mina, Arafat and Muzdalifa were also extensively developed.

THE RISKS OF HAJJ

While much of the development in Mecca and the holy areas was aimed at accommodating increasing numbers of pilgrims, improving and easing their movement between ritual sites, and generally making the Hajj easier, there were also unforeseen consequences. We can get an idea of the magnitude of the problem the Hajj presents by thinking in terms of a crowd of 60,000 people leaving a large football stadium. Imagine over thirty such stadiums, all located in one place. Now imagine the crowds leaving these stadiums after a game: all at once, heading for the same place, which they have to reach at the same time. But in the case of the Hajj, the crowd consists of numerous nationalities, speaking a multitude of languages, and not everyone knows where they are going. When a crowd of that magnitude moves in unison and religious fervour, accidents are bound to happen.

It is not unusual for crowds to surge and pilgrims to be crushed, or for ramps to collapse under their overwhelming weight. The black spot was the *Jamarat* area, where the pilgrims stone the devil. It was first built as a two-storey structure. Later, during the third expansion, it was transformed into a five-storey permanent structure, 950 m (3,117 ft) long, with eleven entry and twelve exit points and the capacity to handle 300,000 pilgrims per hour.

The first major accident at the *Jamarat* occurred in 1994, when 270 pilgrims were trampled to death, and serious accidents have occurred in subsequent years. The *Jamarat* area has been redesigned and redeveloped after each incident, but the dangers presented by surging crowds persist and are constantly being re-evaluated. After 1,426 pilgrims died during a stampede inside a tunnel in 1990, the tunnels were closed and the whole project was abandoned.[30]

There are other hazards, too. With millions of pilgrims from over a hundred different countries and numerous cultures intermingling, the danger of infectious diseases and epidemics is always present. In fact, it is unusual for

pilgrims to return home after Hajj without taking cold, flu or an even more serious infection back with them. To prevent an epidemic of meningitis during the 1987 Hajj, the Saudi government made immunization against meningitis compulsory for visiting pilgrims. During 2009 there were fears about swine flu spreading rapidly among the pilgrims, but the Saudi authorities refrained from introducing a wide-ranging travel ban. Fortunately, only three or four cases of swine flu were reported. Indeed, every year the Supreme Hajj Committee publishes a list of required vaccines. In 2010 the list included polio, yellow fever and influenza. Many pilgrims insist on cooking their own food over open fires, so the careless use of fire is always a present danger. In 1975 a fire in Mina killed 200 pilgrims; again, in 1997, fire destroyed 70,000 tents in Mina, causing 343 fatalities. After the second incident, fireproof tents were introduced in Mina and Arafat. During the 2006 Hajj the al-Ghaza Hotel, located near the Haram, collapsed. An estimated 76 pilgrims, who were staying in the hotel, eating at its restaurant or shopping at its convenience store, were killed. Building regulations were tightened after the incident.

There are also deaths caused by sheer physical exhaustion. Many pilgrims, particularly from rural, poor backgrounds, tend to be elderly and frail. Gruelling treks to the *Jamarat*, sleeping rough during a chilly night in Muzdalifa, running in a state of panic between Safa and Marwa, circumambulating the Ka'ba where crowd pressure is often unbearable, and the oppressive summer heat of Mecca – all take their toll. As a consequence, hundreds of people die of natural causes every year. And a handful, like the ageing father who persuades his son to drive him from Paris to Mecca in Ismael Ferroukhi's film, *Le Grand Voyage* (2004), come specifically to die on the holy soil.

MANAGEMENT OF HAJJ IN MUSLIM COUNTRIES

To reduce the risks associated with the Hajj, some Muslim countries actually train their pilgrims before sending them to the holy cities. In Malaysia and Indonesia, for example, pilgrims train over a number of days, even learning to perform the circumambulation around a mock Ka'ba, and attend classes that equip them not just with religious knowledge but also health and safety information. In Singapore, weekly study groups are held in advance for all those performing the Hajj; once in Mecca, the pilgrims are taken on a tour of

> *I stepped outside and waded into the traffic, but the street was a surging slough of heads and shoulders. The current of the hajj flowed away from the mosque now. Turning downhill proved impossible. I tried to cross the median strip, thinking to turn downhill from there, but it was hopeless. Looking back, the hotel lay behind me. I was being carried up, not down, the street.*
>
> MICHAEL WOLFE 1993, *THE HADJ: AN AMERICAN'S PILGRIMAGE TO MECCA* [31]

ritual sites and the rites are explained, so that they know where they have to go and what they must do during the actual Hajj. Many foreign embassies in Jedda have dedicated 'Hajj affairs officers' who look after the needs of the pilgrims from their own countries and provide them with safety information. Most countries have their own medical missions to accompany the pilgrims during Hajj. British Hajj delegations, for example, normally take doctors with them. And the poor of the Muslim world are not totally forgotten. There are numerous organizations in Saudi Arabia devoted to bringing pilgrims from poorer Muslim countries and covering their expenses partially or totally.[32] The biggest is the Custodian of the Two Holy Mosques Hajj Sponsorship Programme, which brings up to 1,500 pilgrims to Mecca from Kosovo, Afghanistan, Syria, Iraq, Palestine and Central Asian states at the expense of the King. Similar schemes are run by the Ministry of Hajj, the Ministry of Islamic Affairs and the Saudi Cabinet ministries as well as the National Guard, the World Muslim League and other charitable organizations.

The organization of Hajj is not simply a challenge for Saudi Arabia. The modern Hajj requires advance administration and management at the point of departure, in the countries from which the pilgrims begin their journey, and

almost all Muslims countries now have some form of pilgrim management. Malaysia and Pakistan were the first to establish centralized and well-funded Hajj administration systems. Throughout the 1960s and 1970s these two countries set the international standards in pilgrim education, medical services and subsidized air travel. Indonesia and Turkey have also led the way along slightly different lines.

MALAYSIA

Malaysia was the first to produce an innovative system of Hajj management.[33] During the early 1960s Malaysian economists noticed that Malay pilgrims, who came largely from rural backgrounds, often sold their property, livestock or land to pay for the Hajj. They would then return, with no means of livelihood, to a life of abject poverty. To help Malay pilgrims avoid being trapped in this cycle of poverty, the concept of Tabang Haji, or 'the Hajj fund', was developed. The fund provided a savings infrastructure, allowing poorer Malays and would-be pilgrims to save gradually in advance for the Hajj. The rural Malay thus benefited from the advantages of prior planning, received a return on their savings, and avoided the situation where their property had to be sold at a low price to generate immediate cash for the performance of Hajj. Established by an act of Parliament in 1962, in 1969 the fund was given the official title of the Muslim Pilgrimage Control and Savings Corporation and became an independent body with a Director General.

But Tabang Haji is not just a Hajj bank devoted to savings and investments. It also provides Hajj services, including transport to Mecca and within the Hajj environment, accommodation, medical and health care, and information and training on Hajj. Over 90 per cent of all Malaysian pilgrims perform Hajj through Tabang Haji, and over five million Malaysians now save with the fund, which in 2010 had deposits of $8 billion. Apart from providing subsidized Hajj packages and paying dividends to savers, Tabang Haji also pays out the obligatory *zakat* (the religious tax for the poor that is one of the Five Pillars of Islam) from each saver to recognized charities. As an Islamic bank, Tabang Haji only invests in ethical (Sharia-compliant) businesses and institutions.

Fig. 185
Pilgrim receipt, AH 1375/AD 1955–6
Saudi Arabia Monetary Agency
7.1 x 12.8 cm
British Museum, London

Saudi Arabian pilgrim receipts were introduced in 1953. As currency exchange throughout the world became more competitive, monetary options became more varied for pilgrims. Pilgrim receipts were purchased by pilgrims through banks in their home countries and were exchanged for Saudi riyals in Saudi Arabia, so that pilgrims were not disadvantaged by poor exchange rates on their arrival in Saudi Arabia. Over time the use of traveller's cheques and receipts increased and it became more common for pilgrims to exchange money in this way.

PAKISTAN

Pakistan runs a national Government Hajj Scheme, which receives applications from potential pilgrims through designated banks.[35] The successful applicants are chosen by a ballot. Those who have already performed the Hajj during the previous five years are automatically excluded, and applicants who remain unsuccessful for two consecutive ballots are declared successful without ballot. The entire process, from submitting an application for Hajj to processing travel documents and booking flights, is computerized. Indeed, Pakistan was the first country to introduce an online system dedicated to Hajj, which takes the potential pilgrim from registration, application, payment and airline booking all the way to Mecca.

Through the scheme, buildings are hired to accommodate Pakistani pilgrims in Mecca, arrangements are made for the provision of tents in Mina and Arafat, and Hajj flights are organized and booked. Pilgrims also have the option of travelling with licensed Hajj group organizers and making their own bookings. A medical team – one doctor or paramedic, usually from the armed forces, per 500 people – travels with the pilgrims. Also included in the Pakistani Hajj delegation is a contingent of around 500 people known as *khuddam-al-hujjaj*: drawn from the army, civil armed forces and Boy Scouts, their sole function is to attend to the needs of the pilgrims and to ensure that

Fig. 186
10-rupee Hajj note made for the collectors' market, 1950
8.2 x 14.5 cm

In 1949 Pakistan placed restrictions on the export and import of Pakistani currency to deal with the illegal importation of gold. The only exception was currency taken to Saudi Arabia for Hajj. In an attempt to reduce the exploitation of this exception during pilgrimage, in May 1950 the Pakistan government issued the first Hajj note, a 100-rupee note which could be used only in Saudi Arabia. In 1951 a 10-rupee note was introduced, and both continued in use until 1994. This note is not genuine but was made specifically for the collectors' market.[34]

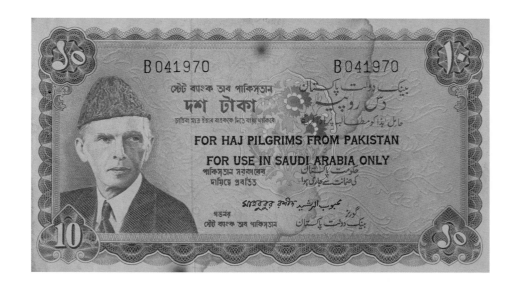

Fig. 187
Indonesian kindergarten students practise
the annual Hajj pilgrimage in Jakarta
Photo: Crack Palinggi, 2004

all the arrangements, such as the preparation of buildings and tents, have
been properly made. Maximum and minimum air fares and charges for services
during the Hajj are fixed months in advance and announced publicly. The
entire process is overseen by a number of committees consisting of ministers,
senators and members of the National Assembly.

Each pilgrim is required to undergo training in the performance of the basic
rituals of the Hajj. This is carried out at the district level throughout Pakistan
by 'master trainers', usually from Islamic studies departments of universities,
as well as volunteers. Training programmes are also broadcast on television
and radio, and pilgrims are given interactive CDs to improve their knowledge of
Hajj and inform them of all possible risks.

INDONESIA

Traditionally Hajj management in Indonesia was in the hands of a plethora
of merchants and travel agents, most of whom were linked to one of the big
religious parties.[36] The agents worked with the Ministry of Religious Affairs to
arrange subsidized fares and exchange rates. On the whole, pilgrim numbers
from Indonesia were low: in 1972, for example, fewer than 23,000 Indonesian
pilgrims performed the Hajj.

But all this changed after 1988, when the quota system was introduced. The number of pilgrims from Indonesia shot up tenfold. In 1991 a much-publicized Hajj by President Suharto – presented locally as a grand spectacle – increased the popularity of the Hajj. The pilgrimage was transformed into a major business, and the government took the organization out of the hands of private business and effectively nationalized it. State agencies replaced small private firms as the main providers of transport, lodging, medical care and information. The country also developed a complex system of international leases, assembling the world's largest fleet of rented aircraft for each Hajj season and then disbanding it for the rest of the year. A Hajj Directorate was established to oversee the management and train the potential pilgrims. Each person receives a package of guidebooks covering accommodation, transportation and health issues as well as prayers and the spiritual significance of the Hajj.

Indonesia adopted a lottery system similar to Pakistan's. But whereas in Pakistan a pilgrim only has to wait for a maximum of three years before going on Hajj, in Indonesia pilgrims can wait for as long as six years. In Pakistan, the deposit for the Hajj is paid when the pilgrim is ready to go to Mecca, whereas in Indonesia the deposit – $2,500 in 2010 – is paid upon registration. In 2010 the Indonesian government was holding nearly $2.4 billion on deposit from prospective pilgrims, with 2.1 million people on the waiting list. And this list is growing: according to official figures, between 15,000 and 20,000 people register every month.

TURKEY

The main Turkish body responsible for the organization of Hajj is the Presidency of Religious Affairs, more popularly known as the Diyanet. It was established in 1924, after the abolition of the caliphate, and is the highest religious authority in the country. But initially the Diyanet did not play any role in the management of Hajj, which was organized on an ad hoc basis by travel agents and other established businesses catering to pilgrims.

Moreover, the Hajj was highly politicized. Pilgrim numbers from Turkey would increase under a civil government and decrease when the military assumed power. Political leaders also used the Hajj to increase their popularity.[37] It was Prime Minister Erbakan who first established a centralized Hajj management

system; the Diyanet emerged as a de facto coordinator and undeclared national body responsible for all Hajj issues.[38]

Recently Turkey has also adopted a computerized lottery system. Each year around 800,000 people enter their names, but only 75,000 are chosen; the 'winners' are announced nationally in a ceremony. The unlucky ones have to enter their names again and again until they are chosen. While the Diyanet manages every aspect of the Hajj, a substantial number of Turkish pilgrims still use the services of designated Hajj operators, and there is no formal pilgrim training.

The organization and management of Hajj is not as developed in other Muslim countries as it is in Malaysia, Pakistan, Indonesia and Turkey. In Iran, the management of Hajj is under the control of the Hajj and Pilgrimage Organization, which is located between the Pilgrimage and Foreign Ministries but supervised directly by the 'Supreme Leader'. In 2010 over a million people had registered with the Hajj and Pilgrimage Organization; the number of pilgrims from Iran hovers around a million, although numbers can vary depending on the relationship between the two countries.[39] Nigeria administers its Hajj via a Hajj Pilgrims' Board in the Ministry of External Affairs. The Hajj Committee of India, an autonomous body constituted under an act of Parliament, looks after the affairs of Indian pilgrims, with the Hajj Section of the Consulate General of India in Jedda functioning as a central processing agency for visa and other requirements. In Britain, Hajj is organized through Saudi-approved operators, who secure visas and provide facilities in Mecca in conjunction with *mutawwifs*. Around 25,000 British Muslims go on Hajj every year; there is also a formal delegation, which includes doctors and social workers, usually led by a peer or junior minister.[40]

However, things have not always gone well for pilgrims. Even from early Islam they suffered from being preyed upon by the unscrupulous and this unfortunately can still take place today. Given the complexity and amounts of money involved in Hajj, allegations of corruption are not surprising. Regular accusations of 'Hajj scams' have been made in a number of countries. For example, in Indonesia, government officials have been charged with exploiting the numerous requirements of the state-run Hajj for personal gain. Even in a respected institution such as Tabang Haji individuals have been similarly indicted, and pilgrims from Nigeria have frequently complained about poor

Fig. 188
The Road to Mecca, 2010
Maha Malluh
Photogram
75 x 95 cm
British Museum, London

'My inspiration for art comes from my country, a land of contrasting images and ideas.' [41] *This work is from a series entitled* Tradition & Modernity. *Malluh's intention is that this work 'exposes the contrasting experiences that traditional vehicles such as camels provide from today's modern method of airplanes. The modern man no longer enjoys the freedom of traversing expansive desert dunes, relatively unobstructed and unoccupied by the ugly machinery of screening equipment of surveying.' Maha Malluh has lived much of her life in Riyadh. She received a certificate in design and photography from De Anza College in California in 2000 and the photogram has been her preferred form of expression for some time.*

accommodation and being left stranded at Hajj terminals. Even in Britain tour operators have been accused of fleecing pilgrims. In the past a few have gone into liquidation, leaving their clients stranded. Hajj organization is, after all, a very human affair and thus potentially prey to greed and exploitation.

AFTER THE HAJJ

As soon as the rituals of the Hajj are complete, there is a frenzied rush to buy souvenirs.[42] Most of the shopping is done along streets that radiate from the Haram into the conurbation of Mecca. Shops on the ground floor of high-rise buildings and hotels overlooking the mosque are open twenty-four hours a day. The most popular items include prayer beads and rugs, T-shirts emblazoned with 'Hajj Mabruk' (Congratulations on your Hajj), Saudi-style caftans, alcohol-free perfume, incense, dates, henna, tea sets, pens and postcards. There are cheap Chinese beads for the poor, but the rich prefer prayer beads with expensive gemstones as a mark of prestige, or opt for precision-cut miniature crystal models of the Ka'ba and the Grand Mosque. And everyone takes bottles of Zamzam water (in plastic replicas of traditional jars) back with them. Such is the increasing demand for Zamzam water that in 2010 the King Abdallah Zamzam water project was opened – an enormous project to filter and store 10 million litres of Zamzam water, part of which feeds directly to the Masjid al-Haram and which also goes into the containers that the pilgrims take home.

But not all the shopping is done in expensive shops. Pilgrims from Afghanistan, Iran and Central Asia have traditionally brought carpets to sell in Mecca to pay for their living expenses. There are also countless hawkers from different countries, who colonize various street corners to display their wares. Hats and sunglasses go fast, but they also sell prayer rugs with pictures of Mecca, prayer beads, *oud* (a local perfume), honey, fake stones embedded in silver rings, cameras, digital media players and bric-a-brac.

The pilgrims now have the right to the honorific title of *hajji* for men and *hajja* for women, indicating that they have performed the Hajj. In the days of old, when performing the Hajj was a serious and highly hazardous affair and few undertook the great journey, being a *hajji* was a high honour. Although nowadays the title is less used, the sense of achievement remains. Returning pilgrims from the Middle East and Africa, particularly in rural areas, still

paint images of their Hajj experiences on the walls of their houses. In Egypt, for example, Hajj painting is a well-established tradition: the usual symbolic elements (the Ka'ba, the Haram mosque, the sacrifice) and images of the journey (aeroplanes, boats) are painted on the walls of the pilgrim's house, inside and out, by inspired rather than experienced artists (see pp. 60-1).[43]

THE HAJJ IN THE TWENTY-FIRST CENTURY

The Hajj has now passed the much-feared figure of 2 million. In 2010, around 1.8 million foreign pilgrims performed the Hajj. When we add 800,000 local pilgrims – Saudis plus expatriates from all over the world who live and work in the Kingdom – we can see how close it is getting to 3 million. When the day of Arafat, the 9th Dhu'l Hijja, falls on a Friday – known as *Hajj al-Akbar*, 'the Great

Fig. 189
A personal diary, 2006–7
20 x 16 cm
Private collection

The diary of Saleena Nurmohamed, who undertook the Hajj in 2006 at the age of 10, is a personal account of Hajj during the Christmas break of 2006, when the Hajj fell on a Friday – known as Hajj al-Akbar *('the Great Hajj'). She was inspired to write the journal by a school teacher. Illustrated with photographs taken during her trip, the diary is a touching and genuine account of the physical and spiritual effort undertaken by a young Shi'a pilgrim.*

The Holy Ka'ba as seen from the top floor.

Mosque, and I made my way inside cautiously, not wanting to set my eyes on the Ka'ba (house of God) until I was able to get a clear and unobstructed view, in order to properly savour the moment. I also wanted to pray for three things dear to me as prayers get granted when you first cast your eyes on the Ka'ba.

Words cannot describe the emotions that are created when one looks at the Ka'ba, such a simple object structurally yet so majestic and awe-inspiring that it is difficult to take your eyes off it. After emotionally gathering myself, I started my pilgrimage which included Tawaf (walking round the Ka'ba seven times). Praying near the pillar of Prophet Abraham and then walking

Fig. 190 Opposite
Souvenirs of Hajj purchased in Mecca
and Medina, 2010
British Museum, London

*Mecca was for centuries an important
commercial centre and still today going
to the holy cities is combined with the
purchase of mementos and souvenirs.
Mecca is full of bazaars and scattered
shops filled with goods. It is part of the
Hajj experience that pilgrims spare time to
purchase gifts for friends and family and by
virtue of being sold in Mecca they have a
special significance for the pilgrim. For those
receiving gifts, the objects brought back will
often take a place of honour and respect in
the house, souvenirs from Mecca counting
among the most precious ever bought.*

Hajj' – the number of local participants can double. But even these numbers could be dwarfed in the coming decades. The number of pilgrims is expected to rise to 20 million by 2030.

The organization and management of Hajj has thus become an even more complex and formidable enterprise. To appreciate just what is involved today, consider the following basic statistics:[44]

- 6,000 flights arrive at the Hajj Terminal at Jedda's King Abd al-Aziz International Airport during the two weeks of the Hajj.
- 15,000 buses are needed to transport the pilgrims from Jedda to Mecca and within the Hajj environment (2,000 more than serve New Delhi, 8,000 more than all the buses in London, and five times as many as New York).
- 27,000 men are employed for crowd control and to provide water to thirsty pilgrims.
- 14,000 men are employed to keep the area clean.
- 300,000 pilgrims have to be given medical treatment in an average year; 50,000 receive emergency treatment, and around 10,000 are admitted to hospital.
- 2,100 *mutawwif* guides work during the Hajj.
- 60,000 public telephones and 415 postboxes are located in the holy areas.
- 1,500 barbers are licensed to shave the heads of pilgrims, with another 2–3,000 unlicensed helping to relieve the congestion.
- 850 families of Zamazines, a consortium of Meccans who have traditionally looked after the well of Zamzam, distribute bottled Zamzam water.
- 49 pebbles – the size of a hazelnut – are thrown by each pilgrim at 'the Satans' in the *Jamarat* area during three days (do the sums!).

The Hajj pushes to the limit every system of organization known to man. To keep pace with continuous growth, the Hajj environment is constantly extended, redeveloped and rebuilt. The sanctuary is now seeing its fourth major extension, which began in 2007 and will be completed in 2013. During the first phase the Ottoman-era section will be replaced by a series of multi-storey prayer halls, 80 m (262 ft) high, and its capacity will be increased to accommodate

two million worshippers. Following the problems of the 2006 Hajj, the old *Jamarat Bridge* is now being replaced by one twelve storeys high[45] A replica of London's Big Ben (and five times its size), called the Royal Clock Tower, has already been built just south of the sacred mosque. Prayers will be announced from it daily, and it will include a Lunar observation centre and a museum.[46] Monorails taking pilgrims to Mina from Mecca came into operation in 2010. New developments adjacent to the Haram will feature two fifty-storey hotel towers and seven thirty-five-storey apartment blocks.

The twenty-first-century architecture and all-pervasive modernization of Mecca lead many to wonder if the Hajj has become less spiritual. When the Moroccan anthropologist Abdellah Hammoudi performed the Hajj in 1999, he found Mecca 'to be hesitating between the sublime and a film set'[47] and complained of the constant 'evasion' of technology and crass consumerism. Michael Wolfe, the American historian of Hajj and Mecca, thought 'that the streets of Mecca resembled Houston'[48] and found them just as alienating. Others have complained of developments that diminish the spiritual experience of Hajj.

But despite all the changes that have taken place in the holy places in recent years, the Hajj remains an awesome and wondrous endeavour that combines a challenging physical regime with a demanding spiritual quest. It is truly an integrated mind-body-soul experience. Most pilgrims are unable to find adequate words to describe the true depths of their feelings or the profound nature of their experience.

There was a plainness about it, empty in the good way. The Kaaba was beautiful but not fancy like the rest of the Haram, blank enough to not impose a message . . . It remained inanimate, neither speaking nor moving to acknowledge my stare, but I loved the bricks as though they could love me back.

MICHAEL MUHAMMAD KNIGHT 2009,
JOURNEY TO THE END OF ISLAM[49]

I grew up in a family home with a carpet on the wall with Mecca, Medina and the Dome of the Rock. In one magical year I managed to see all three with my own eyes. When I first saw the Dome of the Rock I cried like a baby; when I saw the Ka'ba my heart nearly stopped beating. I went back to Mecca this year and once again I cried, not as soon as I saw the Ka'ba but just before I entered the gate. When my daughter asked why I was crying my wife answered for me: 'It's because Daddy knows what's round the corner.' That's real power, not in words or actions. It's a presence that reverberates in the heart of every Muslim, a place like no other on earth.

AAQIL AHMED 2011

Fig. 191
In God's Eye
Photo: Shadia Alem, 2010

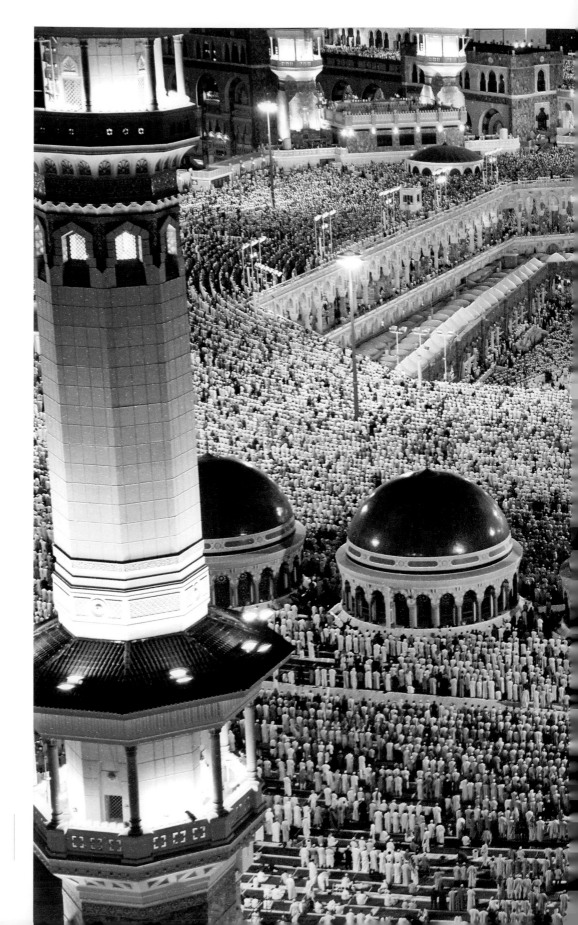

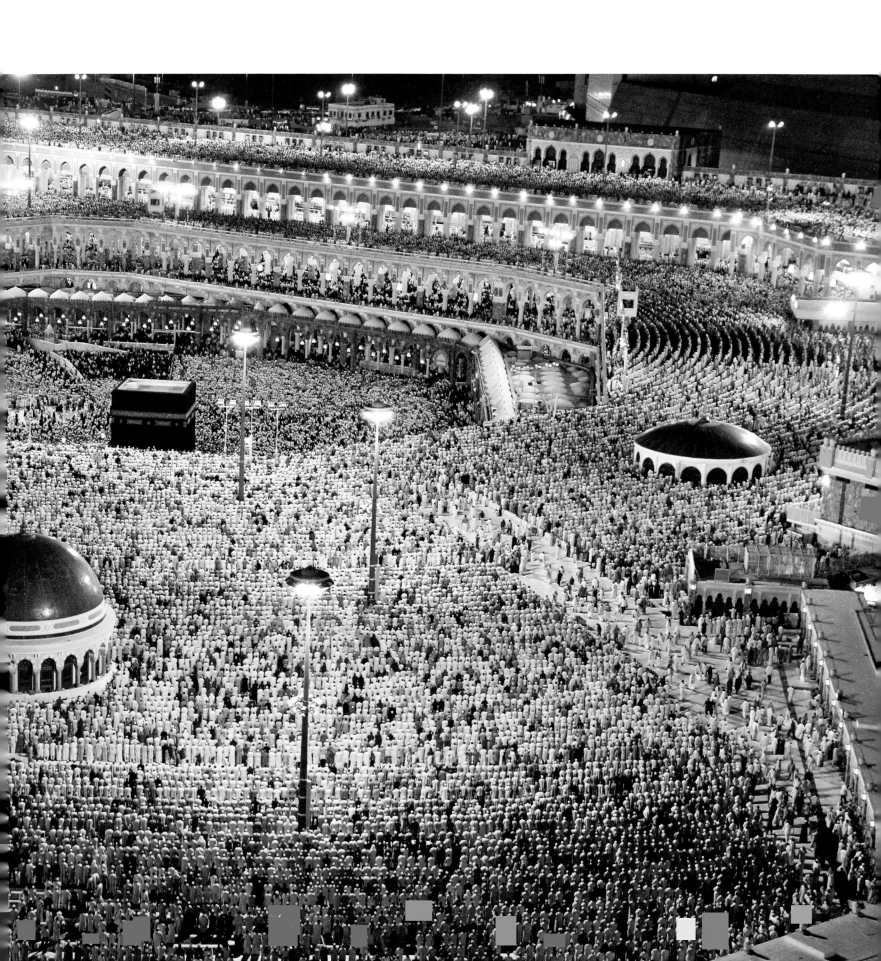

The Modern Art of Hajj

'The idea is simple and, like its central element, forcefully attractive. Ahmed Mater gives a twist to the magnet and sets in motion tens of thousands of particles of iron that form a single swirling nimbus. Even if we have not taken part in it, we have all seen images of the Hajj ... Ahmed's black cuboid magnet is a small simulacrum of the black-draped Ka'bah, the "Cube" – that central element of the Meccan rites. His circumambulating whirl of metallic filings mirrors in miniature the concentric *tawaf* of pilgrims and their sevenfold circling of the Ka'bah ... [his] magnets and that larger lodestone of pilgrimage can also draw us to things beyond the scale of human existence.'[1]

The response of artists today to the experience or the idea of Hajj is manifested in a great many ways through photography and other media. Some of these works are seen elsewhere in this book. Here, three artists are highlighted whose work encapsulates different perspectives on Hajj. Saudi artist and doctor Ahmed Mater created an early version of *Magnetism* in 2007. Powerful and evocative, this has developed into both an installation of magnets and iron filings and an accompanying series of photogravures. British artist Idris Khan created a sculptural installation called *Seven Times* (fig. 193), made up of a hundred and forty-four steel blocks arranged in a formation that corresponds to the footprint of the Ka'ba (about 8 x 8 m).[2] With prayers sandblasted in layers over the steel blocks, this work was inspired by his father's Hajj. 'He felt he had to do it, he wanted to do it. And he changed when he came back, the experience of being there, how overwhelming it was'.[3] Kurdish-Iraqi artist Walid Siti is inspired by the Ka'ba in a different way. The work illustrated here (fig. 194) is from a series 'Precious Stones', in which he highlights the significance of stones to the Kurdish people. For the artist, stones represent the mountains, which Kurds regard as their only friends, and the stone of Mecca a focus of prayer and source of solace in a world of conflict and displacement.

Fig. 192
Magnetism, 2011
Ahmed Mater (b. 1979)
Photogravure etching
63 x 42 cm
British Museum, London

Ahmed Mater was born in 1979 in Tabuk,
north-west Saudi Arabia. He trained as a
doctor and studied art at the al-Meftaha
Arts Village. He lives and works in Abha.

Fig. 193 Left
Seven Times, 2010
Idris Khan (b. 1978)
144 sandblasted cubes made of
oil-sealed steel
Victoria Miro Gallery, London

In the minimalist structure of Seven Times
*Idris Khan is deliberately echoing Carl
Andre's* 144 Graphite silence. *Repetition
is what fascinates him, particularly the
'formal aesthetic power of stylized ritual:
"If you have ever watched footage of
people walking round the Ka'bah seven
times and stopping, it's a truly beautiful
thing. I wanted to capture that".*[5] *Born in
Birmingham in 1978, Idris Khan received his
MFA from the Royal College of Art in 2004
and lives and works in London.*

Fig. 194 Right
White Cube, 2010
Walid Siti (b. 1954)
Acrylic and crayon on paper
68 x 110 cm
British Museum, London

*The white cube is depicted as a transparent
open space, around which are concentric
circles of text. These are forms of letters not
intended to be read. Walid Siti was born
in Dohuk, Iraqi Kurdistan, in 1954. He is
a graduate of the Institute of Fine Arts in
Baghdad and the Academy of Fine Arts,
Ljubljana, Slovenia. He lives and works
in London.*

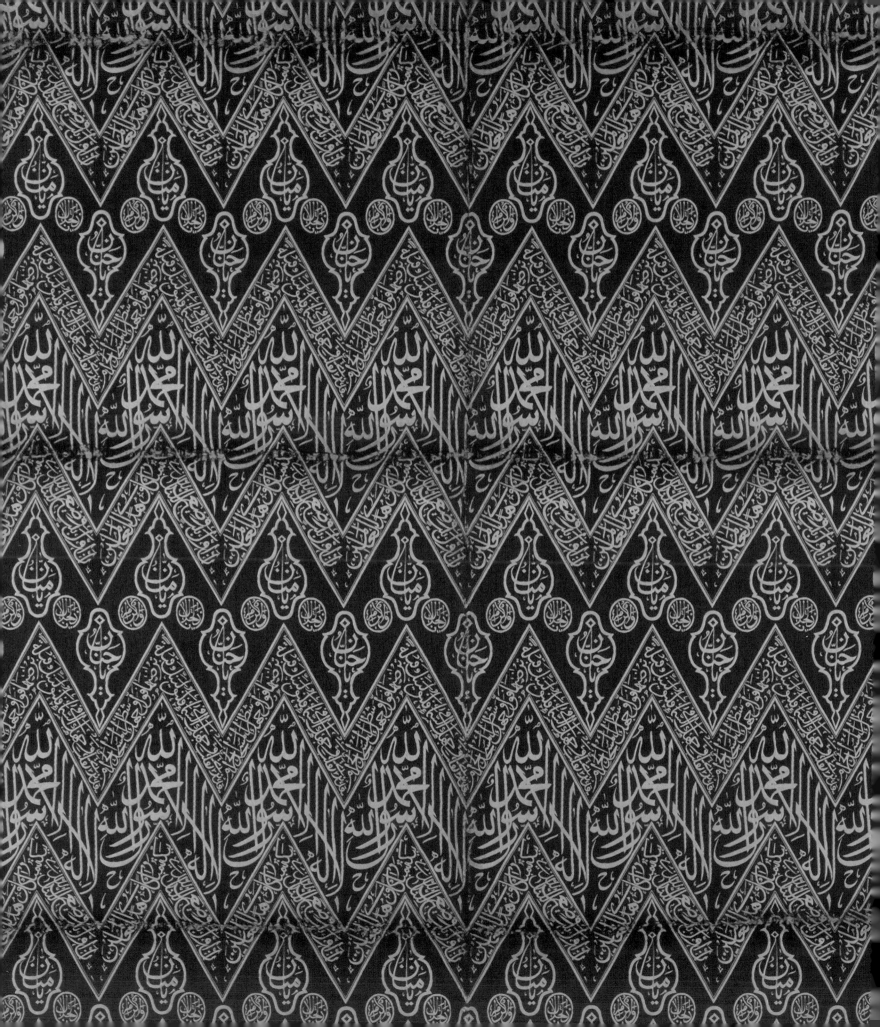

Textiles of Mecca and Medina

Fig. 195
Section from the internal *kiswa*
of the Ka'ba
India or Mecca, *c*.1935
Silk lampas
138 x 82 cm
Nasser D. Khalili Collection of Islamic Art

Textiles in this style were traditionally placed inside the Ka'ba. The earliest examples in Topkapi Palace, Istanbul are datable to the 16th century. The predominant colour for these was red, but other colours used for the interior were green and black.[1] The design of this particular example is based on a style found on Ka'ba textiles made in Bursa and datable to about 1800.[2] In the wider panels in thuluth *script is the Islamic Profession of Faith, in the narrower ones alternating verses from surat al-Baqara (2:144) and Al Imran (3:96). In the interstices the flask-shaped cartouches have two of the ninety-nine names of God (sympathetic one, benefactor) with a third (possessor of glory and generosity) in the roundels. Other examples from this textile are in collections at Mecca.[3] This kiswa was made by Indian craftsmen, possibly in Mecca, and presented to al-Sayyid Tahir Sayf al-Din, an Indian dignitary. It replaced the* kiswa *presented by Sultan Abd al-Aziz II in 1861.*

The most iconic of the objects associated with the Hajj are the textiles offered to the Ka'ba. Elsewhere in this book, Kennedy and Irwin have referred to the textiles of the Ka'ba within the political circumstances of the time. Here, along with the textiles of Medina, they will be considered in a little more detail.

The textiles of the Ka'ba comprise a number of different elements, including an overall covering (*kiswa*) and a belt (*hizam*) placed at about two-thirds of the height of the wall of the Ka'ba. Over the door is a curtain (*sitara* or *burqu'*). Inside the Ka'ba are other textiles: a curtain to the door leading to the roof known as Bab al-Tawba, and red and green textiles with chevron designs on the inside walls. Within the sanctuary, the Maqam Ibrahim was also covered with a textile.

In the early period, the sources talk only about the *kiswa*. The word itself means robe,[4] but over time it became increasingly associated with the Ka'ba covering, and from the beginning the sources speak of 'clothing' the Ka'ba. As with the rituals of Hajj, the tradition of covering the Ka'ba with textiles has pre-Islamic origins, part of an ancient tradition of veiling sacred places out of respect.[5]

According to legend, it was the Yemeni king Tubba As'ad Kamil in the year AD 400 who was the first person to offer textiles to the Ka'ba. He is said to have hung it with Ma'afir cloth, a special cloth woven in the Ta'izz district of Yemen.[6] Up to the eve of Islam, the sources continue to mention the practice

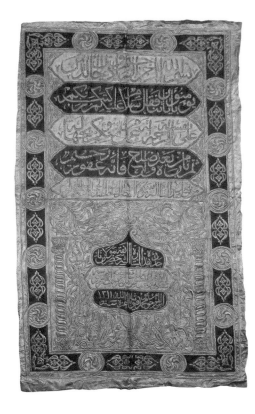

Fig. 196 Right
Curtain for the Bab al-Tawba
Egypt, dated 1311 AH/AD 1893–4
Green silk with red and gold silk
appliqués, embroidered in silver and
silver gilt wire over cotton and silk
thread padding
265 x 158 cm
Nasser D. Khalili Collection of Islamic Art

*A special textile was made for the internal
door of the Ka'ba beginning in the mid-19th
century. The inscription indicates that this
was ordered by the Sultan Abd al-Hamid II
(1876–1909) and presented by Abbas Hilmi,
the Khedive of Ottoman Egypt (1874–1931).*

Fig. 197 Far right
Section from the *kiswa* of the Ka'ba
Egypt or Mecca, late 19th or early
20th century
Silk lampas
158 x 89 cm
Nasser D. Khalili Collection of Islamic Art

The kiswa *is traditionally made up of
thirty-four pieces. This section is black with
chevron designs. In alternate bands: 'Oh
God' and 'May his glory be magnified' (in
mirror script) and the Profession of Faith.*

Fig. 198 Opposite
The belt of the Ka'ba (detail)
1566–74 (and later)
Black silk with red silk appliqués,
embroidered in silver and silver gilt wire
over cotton and silk thread padding
95 x 742 cm
Nasser D. Khalili Collection of Islamic Art

The belt known as the hizam *encircles
the Ka'ba at two-thirds of its height. The
main inscription in bold* thuluth *script
consists of the verses from the sura Al Imran
(3:96–9) identifying the Ka'ba at Mecca.
It begins 'The first House [of worship] to
be established for people was the one at
Bakka. It is a blessed place, a source of
guidance for all people'. The other texts in
this section are from surat al-Isra (17:84),
and in a roundel with gold script against
a red ground is the dedication inscription
'Glory to our lord the sultan the victorious
king Selim Shah, son of Suleyman Shah son
of Selim Khan'. This identifies him as Selim
II (1566–74). In smaller* naskh *script above
and below are the verses of the last suras
in the Qur'an: Al-Ikhlas (112), Falaq (113)
and Nas (114). Some of the decorative
bands may be a little later in date.*

of covering the Ka'ba; leather or woven palm leaves are referred to as well as textiles offered by prominent members of the Quraysh tribe or others.[7] The Prophet Muhammad himself witnessed the ceremony for covering the Ka'ba as a six-year-old child and during the time of his Farewell Pilgrimage it is said that Yemeni cloths were at this time used for the covering.[8] Following the death of the Prophet Muhammad in 632, providing the cloth became henceforth the prerogative of the ruler who considered he had suzerainty over the holy cities, although private individuals are also known to have given textiles for the Ka'ba. A notable example was the wealthy twelfth-century medieval merchant Ramisht from Siraf, who is said to have covered the Ka'ba with Chinese textiles.[9]

During the Islamic period Egypt, already an important centre of textile production before Islam, was where these first textiles were made. Umar ibn al-Khattab clothed the Kaaba with Kubati from the treasury. He used to write concerning it to Egypt [Misr] where it was woven for him, and then Uthman did the same after him. When Mu'awiya ibn Abi Sufyan came, he covered it with two coverings [*kiswa*], Umar's covering of *kubati*, and another of brocade [*dibaj*].'[10]

Kubati means Coptic and these are types of textiles traditionally made by the Egyptian Copts, even after Islam. The factories were in the Tinnis-Damietta

area of Egypt.[11] These and other factories also made the famous *tiraz* textiles, characterized by their royal and benedictory inscriptions. What is interesting about this last reference and later ones is that sources talk about a number of *kiswa*s being offered: 'Umar had ordered two, as we have seen. In the early ninth century there was concern that the fabrics were not robust enough for their purpose, as they needed to last the whole year. In 821 the Abbasid caliph al-Ma'mun (813–33) asked the postmaster of Mecca what was the best type of cover for the Ka'ba, and it was agreed that it should have three coverings: 'red brocade, Coptic cloth and a white fabric from Khurasan.'[12] It is significant that this white Khurasani cloth was also said to have been used for the *ihram* garments.

With all the different terms it is difficult to establish exactly what the *kiswa* of the early period looked like. It is clear that over time a number of colours were used – white, green and yellow as well as black, the dynastic colour of the Abbasids and the colour that was to persist; and that inscriptions were also a feature early on. One question is whether the presence of the word *kiswa* as part of the inscription, as on the Benaki textiles (see figs 200–1), definitively denotes, as Serjeant proposes, that 'the Kaaba coverings always had their title, Kiswa, contained in the inscription', or whether this had some other meaning, perhaps referring to particular workshops.[14]

Fig 199 Above
Panel
Black silk with red silk appliqués embroidered in silver and silver gilt wire over cotton and silk thread padding
92 x 92 cm
Nasser D. Khalili Collection of Islamic Art

Panels such as this are known as samadiyya *on account of the words from surat al-Ikhlas (112),* allahu al-samad *('God the Eternal') in the embroidered text disposed in a circle. Also known as* kardashiya, *these panels were placed on the* kiswa *at the four corners of the Ka'ba, below the belt.*[13]

Fig. 200 Top
Tiraz fragment, dated 310 AH/AD 922–3
Linen
39.5 x 66.5 cm
Benaki Museum, Athens

The Kufic inscription in red reads: 'In the name of God, the Merciful and the Compassionate, blessing of God to the slave of God [Ja'far al-imam al-Muqtadir billah] the amir of the faithful may God support him. What was ordered by the vizier 'Ali ibn Muhammad made in the state workshop of Misr under the care of Shafi', client of the amir of the faithful the year 310. Kiswa.'[15]

Fig. 201 Above
Tiraz fragment, dated 300 AH/AD 912–13
Linen
25.5 x 33.5 cm
Benaki Museum, Athens

The Kufic inscription in blue silk thread reads: '... [al-im]am al Muqtadir billah [the amir of the faithful may God support him, and the year 300] Kis[wa].'

Fig. 202 Near right
Cover from the Prophet's tomb chamber at Medina (detail)
Ottoman Turkey, 17th–18th century
Silk lampas
241 x 134 cm
Nasser D. Khalili Collection of Islamic Art

The inscriptions in alternating bands in thuluth script consist of blessings upon the Companions of the Prophet and prayers addressed to the Prophet Muhammad: 'God, my Lord, there is none but He, Muhammad the beloved of my Lord', and 'Prayers and Peace be upon you, O messenger of God.'

Fig. 203 Far right
Section of a curtain from the Prophet's tomb (detail)
Ottoman Turkey, 17th–18th century
Silk lampas
155 x 53 cm
Nasser D. Khalili Collection of Islamic Art

An evocative description from the early period of the *kiswa* and the ritual around its renewal is provided by Ibn Jubayr, who witnessed it in 1184:

'Saturday, the day of sacrifice at Mina, there was brought by camel from the camp of the Iraqi commander to Mecca the covering for the Holy Kaabah. The new justice walked before it with a garment of Sawad cloth sent by the Caliph. Flags floated above his head; drums were beat behind him ... The covering was placed on the venerated roof above the Kaabah. On Tuesday, the 13th of this blessed month, the Banu Shayba undertook to unfold it, a cloth of bright green, possessing a beauty to enchant all who looked upon it. Above there was a large strip of embroidery with inscriptions; on the side that faced the Venerated Station of Abraham and where the holy door opened ... one read ... "the first house that was founded for men ... " and on the other sides the

name of the Caliph and invocations on his behalf ... to the beholder the Kaabah then presented the most comely sight appearing as an unveiled bride in the finest silk brocade.'[16]

Ibn Jubayr further tells us that it was made up of thirty-four pieces, nine on two of the sides (between the Yemen and Syrian corners, and between the Black corner and the Iraq corner) and eight on the other two sides.

When the Mamluks took over Egypt in 1250 they also took charge of

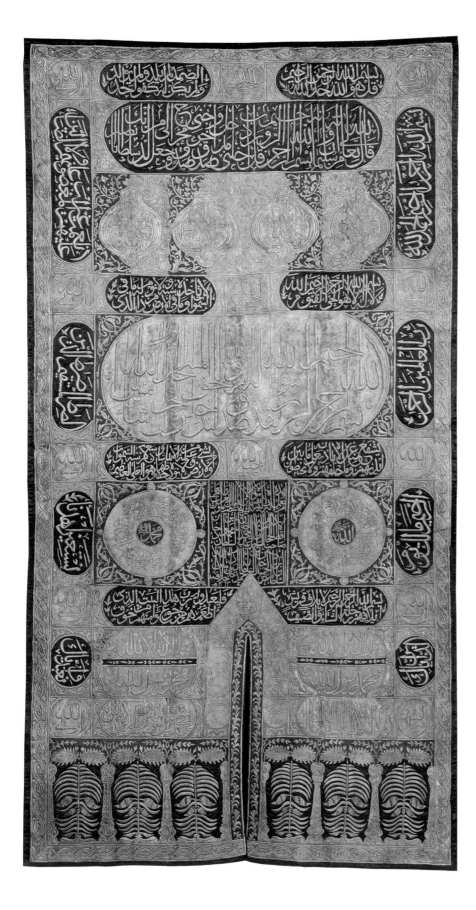

Fig. 204
Curtain for the Ka'ba, dated 1263 AH/
AD 1846–7
Silver and silver gilt wire on black silk
with red silk appliqués
550 x 275 cm
Nasser D. Khalili Collection of Islamic Art

*In a rectangle in the centre is the
commissioning text in the name of the
Ottoman Sultan Abd al-Majid I (1839–61).
Among his titles is 'Lord of the Hijaz region'.
The textile is referred to as al-burda al-
sharifa, the honoured or sublime curtain,
and with the date 1263 AH.*

*The rest is embroidered with Qur'anic
and benedictory inscriptions in a variety
of styles. On the black silk ground in
cartouches around the border are the Fatiha
(1:1–7) and surat al-Iklas (112:1–4). In
the large cartouche at the top starting on
the right is surat al-Naml (27:30) followed
by surat al-Isra (17:80). Further down, the
four cartouches on the black ground are
the Bismillah followed by the throne verse
from surat al-Baqara (2:255). The lower
cartouche on the black ground is from surat
Quraysh (106:1–4).*

*The inscriptions on the silver ground
consist at the top of four roundels, with the
Bismillah in mirror script. A small square
between the verses of the throne verse has
'My trust is in God', and in the cartouche
in large script is the Bismillah followed by
verses from the surat al-Fath (48, first half
of 27). In the large roundels below, in the
centre are 'God, may his glory be mighty'
and 'Muhammad on him be peace', and
around it surat al-Ikhlas (112:1–4).*[17]

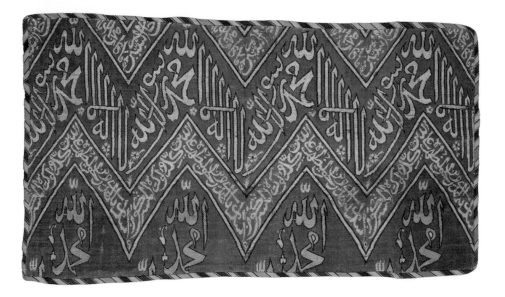

Fig. 205
Section of the cover for the Prophet's tomb
c.1600–1700
Silk lampas
39 x 65 cm
Victoria and Albert Museum, London

It is clear that this fragment was highly treasured. After it had been taken down from the tomb chamber it was cut up and lined with another fabric to preserve it.

Fig. 206
Section of the curtain of the Ka'ba
Probably early 20th century
Silver gilt wire on black silk
36 x 71.5 cm
Lady Margaret Bullard

This fragment of a sitara was presented by Sharif Hussein to Sir Reader Bullard. A distinguished diplomat and Arabist, Bullard was consul in Jedda between 1923 and 1925 and later documented his work and the political situation in Arabia at this time.[19] The inscription in a cartouche is from the Fatiha (sura 1), 'Show us the straight way', which indicates that it came from the left side of a sitara (see fig. 204 for a slightly different arrangement of the same inscription).

sending the *kiswa*, although this was sometimes contested, with the *kiswa* at different times being sent by the ruling house of Yemen or Saljuq Iran. The making of the *kiswa* was a costly business and al-Nasir Muhammad (d. 1361) needed to appropriate the income from three villages in order to provide for this.[18] From the Mamluk period on we can begin to get a real sense of what the *kiswa* and its attendant textiles actually looked like. In Topkapi Palace are dramatically coloured woven textiles which are part of the *hizam*, embellished with inscriptions dating to about 1500.[20] Following the conquest of Egypt by the Ottomans in 1517, Sultan Selim I (1512–20) decided that the *kiswa* should continue to be made in Egypt, a practice that went on until 1844 when the black *kiswa* was manufactured at the newly established factories at Hereke in Istanbul.[21]

The earliest known example of the door curtain was made in Egypt and dates to 1544 during the reign of Suleyman the Magnificent (1520–66).[22] The earliest Ottoman example of the belt dates to the reign of Selim II (1566–74).[23] The design of the *sitara* and the *hizam* was quickly established and although there were a number of variations in the inscriptions and they grew ever more elaborate with embroidery in silver and gold wire, the basic forms have remained virtually unchanged until the present day. Although mostly made in Egypt, they were also sometimes made in Istanbul.[24]

THE INTERIOR TEXTILES OF THE KA'BA AND THE TEXTILES OF MEDINA

Selim I also decreed that the interior textiles should be made in Istanbul, and these are red and green and characterized by zigzag designs. Similar textiles were also made for the Prophet's mosque at Medina and it is the texts of the inscriptions that distinguish them. At Medina these textiles either adorned the Prophet's tomb (see p. 260) or hung on the grille near the tomb.[25] Unlike the outer textiles, the inner textiles of the Ka'ba were only changed on the

accession of a new sultan.[26] The one illustrated here (fig. 195) was made in India or by Indian craftsmen in Mecca in 1935 following earlier models and it is interesting to note that it replaced the *kiswa* presented by Sultan Abd al-Aziz II in 1861, demonstrating how long an internal *kiswa* was left up before being replaced.

Our knowledge of the technical aspects of the making of the *kiswa* and the other outer textiles comes largely from nineteenth-century Egypt. The factory was established by Muhammad Ali Pasha in 1817 in the quarter of Kharanfash in Cairo. Skilled craftsmen were in charge of different aspects of the manufacture and well-known calligraphers were involved in the design of the inscriptions – one such was Abdallah Zuhdi (d. 1878).[27] The work on the textiles was done through contract between the tentmakers (*khiamin*) and the ministry of religious endowments (*awqaf*). The tentmakers would be responsible for cutting out the *kiswa*; the *sitara* for the door of the Ka'ba and the Bab al-Tawba, the *hizam*, the key bag and the *kiswa* for the Maqam Ibrahim. These would then be turned over to the embroiderers. The costs were prodigious and

Fig. 207
Section of the *kiswa* of the Ka'ba
Egypt, 19th century
Silk lampas
86 x 70 cm
Museum Volkenkunde, Leiden

During his time in Mecca in the 1880s, Christiaan Snouck Hurgronje acquired a large collection of items which were then shipped back to Leiden. These consisted mostly of objects of daily life such as musical instruments, painted furniture and drinking vessels made in Arabia or brought by pilgrims from outside. He also acquired pieces of the kiswa, *and the objects were all drawn and illustrated in his magisterial publication, the* Bilder Aus Mekka.

This waistcoat in Malay style is made from a piece of the interior kiswa of the Ka'ba. The style, with medallions shaped like hanging lamps between the zigzag designs, represents a phase in the evolution of these textiles datable to c.1800 and probably made in Bursa. Inside the medallion is one of the names of God, 'ya mubin (evident or clear). The Profession of Faith (shahada) in the wide bands and other verses from the Qur'an.

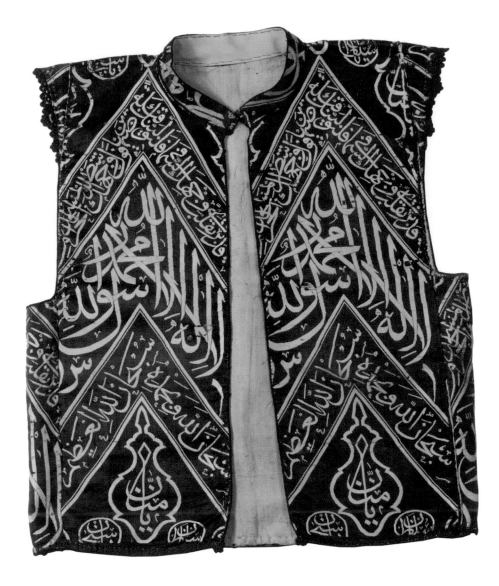

it is known that during the reign of Abbas Hilmi II in 1901, 4,550 Egyptian pounds were spent by the treasury on the sacred textiles for that year. The *kiswa* continued to be sent from the Kharanfash factory in Egypt until 1927, after which the craftsmen made decorative pieces only and the other work (the dyeing and weaving of the outer *kiswa*) was outsourced to other factories.[28]

Edward Lane in Cairo in the 1830s describes in detail the ceremony surrounding the parade of the *kiswa* before its departure to Mecca:

This and almost every shop ... were crowded with persons attracted by the desire of witnessing the procession. About two hours after sunrise the four portions which form each side of the 'Kisweh' were borne past ... each of the four pieces placed upon an ass with the rope

with which they are to be attached ... after an interval came about twenty men bearing on their shoulders a long frame of wood upon which was extended one quarter of the 'Hezam' [belt]. The Hezam is in four pieces which when sewed together to the Kisweh form one continuous band to surround the Kaabeh entirely ... The inscriptions are in gold well worked in large beautiful characters surrounded by a border of gold; and at each end where the upper and lower borders unite, the Hezam is ornamented in a tasteful manner with green and red silk. The 'Burko' [the sitara or door curtain] ... was next borne along stretched upon a high flattish frame of wood fixed on the back of a fine camel. It was of black brocade, embroidered in the same manner as the Hezam, with inscriptions from the Kur-an in letters of gold much more richly ornamented.[29]

The family who had charge of the renewal of the *kiswa* was traditionally the Banu Shayba, who had had responsibility for the care of the sanctuary since before Islam and who had been confirmed in this role by the Prophet himself. The Banu Shayba therefore prepared the Ka'ba and the sanctuary for the renewal of the *kiswa*: they would wash it with Zamzam water and perfume it.[30] The Banu Shayba were also responsible for disposing of the Ka'ba textiles once they had been replaced. The *kiswa*, the belt and the interior textiles were cut up. So many more examples of the door curtain (*sitara*) have survived that more of these appear to have been preserved intact. Particular sections were reserved, for example for the Sharif of Mecca or other dignitaries, but the Banu Shayba were able to sell the other pieces in special shops near the Bab al-Salam.[31] The chevron-patterned textiles of Medina were also cut up once they were replaced. During the Ottoman era a large number of such fabrics from Mecca and Medina were returned to Istanbul, where they joined the sultans' 'sacred relics' or individuals acquired them to be placed on their tombs or turned into garments, jackets, belts or hats.[32]

Now the *kiswa* and attendant textiles are made on specialized looms in Mecca. The first *kiswa* to be made in Saudi Arabia was in 1927, when King Abd al-Aziz opened a factory in Mecca.[33] An age-old tradition continues there with master craftsmen and calligraphers using both traditional methods and the latest computer technology to design and manufacture these sacred textiles.

Fig. 209
Photograph from *kiswa* factory archive
19th–20th century
Nasser D. Khalili Collection of Islamic Art

A craftsman embroidering part of the sitara *or possibly the* hizam. *Documents indicate that the raw materials needed to make the textiles included 785 metres of natural silk for the* kiswas, *100 metres for the belt and the curtains, several varieties of cotton and linen, zinc and glue for the inscriptions, 13,414 mithqals of white silver thread (each* mithqal *is about 4 g), 62,771 kg of gold-plated silver thread and 100 g of silver painted with gold for the six lower sections of the* sitara *for the Ka'ba.*[34]

Notes

Introduction, pp. 18–25

1. Eliade 1959, p. 21.
2. Eliade 1958, p. 19.
3. Bamyeh 1999, p. 36.
4. Davies 1994, p. 2; Eliade 1991, *Images and Symbols*, pp. 9–26.
5. Eliade 1958, pp. 99–101; Clements 1965, pp. 2–6; Clifford 1972, pp. 4–10.
6. Boord 1994, p. 18.
7. John 4:21–4.
8. Origen, *Against Celsus*, (trans. J. Bellamy) *c*.1660, 3:34, 7:35.
9. Guru Nanak, *Japji Sahib* (*pauri* 6, 10, 21).
10. Geoffrey Chaucer, *The Canterbury Tales*, General Prologue, pp. 463–7.
11. See Qur'an 106.
12. Eliade 1991, *Images and Symbols*, pp. 42–7.
13. *Rig Veda* III.8.3; *Satapatha Brahmana* III.7.1.4, V.2.1.9, VI.4.2.
14. Genesis 28:11–17, Jerusalem Bible translation.
15. Ibn Hisham, *Sira* 263 (trans. Guillaume 1955, p.181).
16. Eliade 1958, pp. 382–5.
17. Genesis 2–3.
18. I Kings 6:15–38; 2 Chronicles 3:8–13. Barker 1991, pp. 26–9; Clements 1965, p. 65.
19. Psalm 122.
20. Wensinck 1916, p. 15; Eliade 1958, pp. 231, 376.
21. Qur'an 2:30–37; Bennett 1994, p. 94.
22. John Donne, 'Hymne to God my God, in my sicknesse', lines 21–2.
23. Bennett 1994, pp. 108–10.
24. Dupront 1973, p. 190; Brown 1982, p. 87.
25. Burkert 1980, pp. 27–34.
26. Eliade (trans. Trask) 1991, pp. 35–6.
27. *Satapatha Brahmana* II.2.2.2.8; Heesterman 1993, pp. 215–18.
28. Genesis 21:8–21.
29. Shariati 1978, pp. 32–3.
30. Bennett 1994, p. 106.

Spirit and Rituals, pp. 26–67

1. Qur'an 3:96–7.
2. Much of this story is handed down by tradition and referred to even by respected Muslim scholars such as Abdel Haleem Mahmoud, Director of al-Azhar: Mahmoud 1977, pp. 18–32.
3. Qur'an 14:35–41.
4. Hadith: Bukhari narrated by Ibn Abbas.
5. In Arabic, *zamzam* means plentiful water. Hagar is said to have tried to make a pond around the water as it gushed out of the sand.
6. Qur'an 2:127–8; 22:26–7.
7. Traditions speak of it as being brought by Ishmael from a neighbouring hill, or Gabriel bringing the stone and Abraham setting it in the wall.
8. Qur'an 2:125.

9. Qur'an 2:125.
10. Qur'an 6:79; 16:120–2.
11. Qur'an 37:101–10.
12. Mahmoud 1977, pp. 43–4.
13. Qur'an 37:107.
14. There were other places in Arabia to which pilgrimage was made. It is known that Abraha (a Christian ruler of Yemen) set out in 570, the year Muhammad was born, with an army including war elephants to destroy the Ka'ba and direct the pilgrimage to the new cathedral in San'a. The Qur'an tells us (sura 105) that the army was destroyed by divine intervention and the Ka'ba was saved.
15. Qur'an 2:136; 2:285.
16. Qur'an 2:142–4.
17. Sabiq 1987, vol. 1, p. 557.
18. Qur'an 2:197.
19. People travelling by air should have this wash before boarding the plane.
20. We are grateful to Jan Just Witkam for this information.
21. Qur'an 2:197.
22. Only two gates are mentioned in the Hadith literature: the Bab al-Salam and the Bab Bani Shayba. More gates have been added in successive expansions of the mosque. In the King Fahd development (1988–2005) many more gates were added, including the King Fahd gate to the new extension.
23. Sabiq 1987, vol. 1, p. 611.
24. Qur'an 2:201.
25. Many pray especially inside *hijr* Ishmael, a low semi-circular wall adjacent to the side of the Ka'ba following its door anti-clockwise. This is said to have been part of the area of the original Ka'ba.
26. Asani and Gavin 1998, pp. 180 ff.
27. We are extremely grateful to Muhammad Isa Waley for this translation and for his contribution to the text on the Futuh al-Haramayn. See also Milstein 2006.
28. A legend says that Adam and Eve, after expulsion from the garden and separation, met each other at Arafat, and the name means that they knew (recognized) each other there. Abraham is said to have gone to Arafat and stayed there. The Prophet Muhammad also stayed there during his Farewell Hajj and this is where he gave his farewell sermon, standing on the small hill, Jabal al-Rahma.
29. Qur'an 22:28; 22:37. Since the late twentieth century abattoir facilities have been provided where the meat is frozen or canned and sent later to the poor in different countries. Before this, the excess meat would have been preserved by drying it in the sun.
30. Qur'an 2:198.
31. Hadith: Sahih al-Bukhari (many editions) and Sabiq 1987, vol. 3, p. 13.
32. Hadith: Ibn Abi Shaybah, Ahmad, al-Tabarani and al-Baihaqi (many editions).
33. Hadith: Bukhari and Muslim (many editions).

34. Al-Masʿudi pp. 257–8, in ʿMakka – IVʾ by King in *Encyclopaedia of Islam (EI2)*.

35. King 1999, p. 97. We are most grateful to Silke Ackermann and to Jan Just Witkam for their help with this section.

Journey to Mecca: Part 1, pp. 68–135

1. Hage 2005, pp. 24–5.

2. On the early history of the Kaʿba and the Muslim Hajj, see Peters 1994, *Hajj*, pp. 1–69. For the leadership of the Hajj down to the end of the Umayyad period, see McMillan 2011.

3. Hawting 1980, p. 45.

4. Cho 2008, p. 149

5. Bayhan 2008, p. 208.

6. Hage 2005, pp. 32–3.

7. Hage 2005, p. 29.

8. The definition of the Family of the Prophet is a complex matter which aroused considerable controversy. There was no doubt that his direct descendants through his daughter Fatima and his cousin and son-in-law Ali were ʿFamilyʾ. But the title was also claimed by others whose relationship was more distant, notably the Abbasids, who were descended not from the Prophet himself but from his uncle al-Abbas ibn Abd al-Muttalib. This status was an important element in the Abbasid claim to the caliphate, but their pretensions were rejected by the Shiʿa and others.

9. Al-Yaʿqubi 1883, p. 188.

10. The Kharijites were a dissident group of Muslims who believed that any Muslim could be caliph (i.e. not just members of the Prophetʾs tribe of Quraysh) and that any who disagreed with them were unbelievers who should be killed. They attracted considerable support among some of the Bedouin tribes and began a violent insurgency in the Syrian desert and southern Iran.

11. The fullest discussion of Ibn al-Zubayrʾs building, from textual sources, remains Creswell 1969, vol. I, pp. 62–4.

12. For al-Azraqiʾs account see Peters 1994, *Hajj*, pp. 62–3.

13. The Banu Shayba family has been known since the time of the Prophet as the doorkeepers of the Kaʿba, a role which they still perform.

14. One cubit is approximately half a metre (about 20 inches).

15. Ibn Jurayj (d. 767) was a Meccan traditionist. Like al-Azraqi, he is said to have been of Greek slave origins, his ancestor being called Gregorios.

16. Assuming a cubit of half a metre, this would give a height of 13.5 m (nearly 45 ft). The present building is said to be approximately 15.4 m (about 50 ft). While the correspondence is not exact, it is clearly of the same order of magnitude, and any discrepancies can be accounted for by uncertainties in mensuration and the length of the cubit.

17. The thin, translucent alabaster still used for glazing windows in Yemen today.

18. See article ʿKaʿbaʾ by Wensinck in *Encyclopaedia of Islam (EI2)*.

19. Urwa ibn al-Zubayr, quoted in Peters 1994, *Hajj*, from the *Ansab al-Ashraf* of al-Baladhuri.

20. The point being, of course, that the dog was considered unclean and only the most desperate hunger would have persuaded Muslims to eat it.

21. Al-Tabari 1879–1901, vol. II, pp. 850–1.

22. Al-Yaʿqubi 1883, pp. 177–8.

23. André-Salvini *et al.* 2010, p. 94; al-Rashid 1980, pp. 229 ff.

24. Al-Rashid 1980, p. 230; André-Salvini *et al.* 2010, p. 430.

25. For the history and archaeology of the Darb Zubayda see al-Rashid 1980. See also the spread on some of the objects from the Darb Zubayda on p. 102.

26. For female patronage of the Hajj see Tolmacheva 1998.

27. Al-Tabari 1879–1901, vol. III, p. 81.

28. For the texts see al-Rashid 1980, pp. 229–41.

29. Al-Rashid 1980, p. 42.

30. For this Hajj see al-Tabari 1879–1901, vol. III, pp. 482–3.

31. The caliphate at this time had a bimetallic currency. The silver dirham, about the size of a modern ten-pence piece but thinner, was the common currency of those areas that had been part of the old Persian empire in pre-Islamic times (Iraq and Iran). The gold dinar, about the size of a five-pence piece, was used in the provinces that had been part of the old Byzantine empire (Syria, Yemen and Egypt). The exchange rate varied but was about 15 dirhams to the dinar.

32. The *khutba* was the Friday sermon in which the name of the ruler was mentioned, so indicating the political allegiance of the town or city.

33. King 1984, p. 115; King 1999, pp. 50–1.

34. See Thackston 2001 (Persian text with English translation).

35. Thackston 2001, p. 27.

36. Thackston 2001, p. 40.

37. Thackston 2001, p. 77.

38. Muslims could be excused the Hajj for pressing reasons, of which famine could be considered one (Qurʾan 3:97).

39. Thackston 2001, p. 79.

40. The *farsakh* or *parsang* was slightly under 6 km (3¾ miles), so according to Nasir the unfortunate pilgrims still had about 600 km (nearly 400 miles) to go. In fact, the distance from Medina to Mecca is nearer half that, though still a huge distance to cover in the time.

41. The layout of this tile is comparable to tiles in the Louvre, in the Turkish and Islamic Art Museum, Istanbul, and another in Kure. The poem was identified by Charlotte Maury.

42. Thackston 2001, p. 87.

43. Thackston 2001, p. 88.

44. Erdmann 1959, p. 193.

45. Erdmann 1959, p. 193. It is signed Mehmet, son of Osman of Iznik.

46. Hadith. See also Peters 1994, *Hajj*, pp. 238–40.

47. Qurʾan 3:96. Becca (Bakka) is an ancient variant of Mecca.

48. The Ghaznavids were a powerful and strongly Sunni dynasty who ruled much of eastern Iran from their capital at Ghazna, between Kabul and Qandahar, *c.* 998–1040.

49. Thackston 2001, p. 91.

50. Allan 1982, cat. 17. See also Atil 1981, cat. 33. Drawings for the designs on the key bags are in the *kiswa* archive in the Khalili collection of Islamic art see note 27 in V. Porter's chapter on textiles in this book.

51. For the Arabic text see Wright and de Goeje 1907, reprinted 2007; English translation Broadhurst 1952.

52. Poem translated by Muhammad Isa Waley.

53. http://www.vam.ac.uk/moc/collections/toys/toy_theatre/trentsensky_ toy_theatre/index.html.

54. It is interesting to note that the Arabic *diwan* is the origin of the word for customs in French (*douane*), Italian (*dogana*) and Spanish (*dohana*), all part of the lingua franca of medieval Mediterranean trade and shipping.

55. Wright and de Goeje (eds) 1907, pp. 39–40; Broadhurst (trans.) 1952, pp. 31–2.

56. Wright and de Goeje (eds) 1907, p. 120; Broadhurst (trans.) 1952, p. 117.

57. Wright and de Goeje (eds) 1907, pp. 77–8; Broadhurst (trans.) 1952, pp. 72–3.

58. Wright and de Goeje (eds) 1907, p. 80; Broadhurst (trans.) 1952, p. 75. Ibn Jubayr writes the passage in *saj'*, the sonorous rhyming prose of classical Arabic, to stress the importance of the moment.

59. Wright and de Goeje (eds) 1907, p. 80; Broadhurst (trans.) 1952, p. 76.

60. Wal 2011, pp. 42–5.

61. Grabar (intro.) 2003, p. 10; Al-Mojan 2010, p. 317.

62. Shah 1980, pp. 139–40.

Journey to Mecca: Part 2, pp.136–223

1. Malcolm X 1968, p. 152.

2. Lane 1836, p. 434.

3. See Jomier 1953; Peters 1994, *Hajj*, pp. 93–4, 165–6.

4. Behrens-Abouseif 1997, p. 89. A yellow silk *mahmal* is in Topkapi Palace, Istanbul: see al-Mojan 2010, p. 277.

5. Thenayian 1999, p. 58. The Yemeni *mahmal* is depicted along with the Egyptian and Syrian ones on tiles in the Harem in Topkapi Palace.

6. Ankawi 1974, pp. 155–7; Irwin 1986, pp. 56, 61 n.; Thorau 1992, pp. 198–9; Peters 1994, *Mecca*, pp. 148–50.

7. Ibn Battuta, in Gibb (trans.) 1956, pp. 58–9.

8. Shoshan 1993, p. 71.

9. This is in Topkapi Palace (al-Mojan 2010).

10. Jomier 1953.

11. Shoshan 1993, pp. 70–2.

12. On the Mamluk Hajj in general, see Ankawi 1974; on the Ottoman Hajj in general, see Faroqhi 1994.

13. Al-Jazari, *Al-Durar al-fara'id al-muazzam fi akhbar al-hajj was tariq Makka al-mu'azzama*, in Jomier 1953; Faroqhi 1994, pp. 33–5.

14. Ibn Battuta, in Gibb 1956, p. 250.

15. Lucas 1744, pp. 138–9, translated by V. Porter. See Denny 1974 for references to Nicolas de Nicolay in the caption to fig. 96 and for the information on the Hajj banner in fig. 97.

16. Jomier 1953, p. 173.

17. Peters 1994, *Hajj*, p. 95 (anonymous European).

18. Tamari 1982, pp. 447–67. We are most grateful to Sami Abd al-Malik and Andrew Petersen for the information in this section and on the Syrian Hajj route and the forts.

19. Petersen 2009, pp. 81-94; See also Petersen 2012.

20. Dankoff and Kim 2010, p. 305.

21. See Petersen 2012 chapter 8, and Edib 1825 Bianchi (trans.).

22. Petersen 1995; Petersen and Kennedy 2004; Petersen 2012.

23. Çelebi (ed. and trans.) Dankoff 2000, p. 294.

24. Pringle 2009.

25. Dankoff and Kim 2010, p. 304. A *parsang*, an old Persian measure of distance, was between about 5 and 6 km (3–4 miles).

26. On North African pilgrimages, see Ibn Battuta, in Gibb 1956; Norris 1977; Netton 1996.

27. On pilgrimages from sub-Saharan Africa, see al-Naqar 1972; Birks 1978.

28. Astengo 2007. We are grateful to Peter Barber for this caption.

29. Bovill 1968, pp. 87–8; al-Naqar 1972, pp. 11–16.

30. A *mithqal* is equivalent to about 4.25 gm, the weight of a dinar.

31. Al-Naqar 1972, pp. 18–25.

32. See Insoll 2003 and Nixon 2009.

33. See Insoll 2003 and O'Brien 1999. We are grateful to Tim Insoll for his contribution to this section and also to Sam Nixon for his guidance.

34. Nixon 2009; Nixon 2010.

35. Nixon 2009; Nixon 2010.

36. Wright [not dated]; Hunwick 1992. We are grateful to Abdel Kader Haidara and Tim Insoll for this information.

37. See Stern 1967.

38. Dreyer 2007, p. 158.

39. Faroqhi 1994, p. 106.

40. Faroqhi 1994, pp. 93–9.

41. See al-Mojan 2010, p. 107, for an illustration of the *mizab* made in Egypt in 1551, during Suleyman's reign.

42. See Esin 1963; Newhall 1987; Goodwin 1993; Peters 1994, *Mecca*. For other restorations from the Abbasid to the Saudi era, see al-Mojan 2010, pp. 73–168, and Behrens-Abouseif 1997.

43. Atil 1981 cat. 34. Two are in the Museum of Islamic Art in Cairo Wiet 1932, nos. 338-42.

44. An example is in Topkapi Palace, Istanbul, in the chamber of the Sacred Relics, dated 1612 and with the name of Ahmet I. See Basha 2009, p. 276 fig. 95 for the full text on the *mizab* cites here.

45. See Dunn 1986.

46. I am grateful to Nalin Tomar and Joss Graham for this information.

47. Qaisar 1987.

48. Burton 1885–8, vol. 4, pp. 405–16.

49. The word 'monsoon' derives from the Arabic *mawsim*, meaning season.

50. On navigation in the Arabian Sea, Indian Ocean and South China Sea, see Abu Lughod 1989, pp. 251–60; Pearson 1994, *Pilgrimage*, pp. 148–51.

51. For navigation problems in the Red Sea, see Abu Lughod 1989, pp. 241–2; Pearson 1994, *Pilgrimage*, pp. 151–4.

52. Barbir 1980, pp. 137, 155, 170–1.

53. Brocquière 1848, p. 301.

54. Brocquière 1848, p. 302.

55. Ché-Ross 2000, p. 194.

56. Varthema 1963, p. 55.

57. Varthema 1963, pp. 76–8, 81.

58. On the Portuguese in the Indian Ocean and Red Sea, see Serjeant 1963; Pearson, *Pilgrimage*, 1994, pp. 89–90, 155–6; Guillmartin 1974, pp. 7–15.

59. Farooqi 1989, pp. 18–20, 114–15.

60. Farooqi 1989, pp. 120–6.

61. Faroqhi 1994, pp. 78–91, 147.

62. See Barbir 1980.

63. Ayalon 1972, p. 37.

64. See Farooqi 1989.

65. See Goodwin 1993.

66. On the funding and organization of the Syrian Hajj in the 18th century, see Rafeq 1966, pp. 52–76; Barbir 1980.

67. Dankoff and Kim 2010, p. 347.

68. Dankoff and Kim 2010, p. 340.

69. I am grateful too Nina Swaep for this translation.

70. Dankoff and Kim 2010, p. 342.

71. Dankoff and Kim 2010, p. 342.

72. Bayhan 2008, pp. 124–5.

73. Petersen 2012, Chapter 9.

74. See Petersen and Kennedy 2004; Petersen 2008 and Petersen 2012.

75. Stegar 1970, p. 97.

76. Cohen 1973, p. 91. One source of Bedouin wealth was the supply of barley to the Ottoman garrisons on the Hajj route.

77. Nizami 1991, pp. 180–1.

78. Facey 2009, p. 167. See also Barber, 2005 : 242

79. See Sabini 1981, pp. 65–178 for a detailed account of this conflict.

80. Norris 1977, p. 25.

81. Farahani 1990, p. 65.

82. Hossein Kazemzadeh 1912, pp. 155–7 in Peters 1994, *Hajj*, p. 281.

83. Farahani 1990, p. 67.

84. See Burckhardt 1829.

85. See Burton 1855–6.

86. Burton 1855–6, vol. 2, p. 161.

87. Wal 2011, pp. 13, 17, 18; Vrolijk, Velde and Witkam 2007, p. 20.

88. Hurgronje 2007, pp. xvii–xviii ff. Witkam also discusses in his introduction whether Hurgronje was a genuine convert, and debates the truth of whether Hurgronje was also circumcised.

89. Wal 2011, p. 20.

90. Wal 2011, pp. 30–2.

91. Hurgronje 2007, pp. 234–5, 258–63, 275, 279–81, 310–12.

92. See Tagliacozzo 2009.

93. See Hurgronje 2007.

94. Facey 1996, p. 18; see p. 27 for Sadiq Bey's photo of the Ka'ba taken in 1880.

95. Omar 2003, pp. 245–6. I am grateful to Annabel Gallop for her assistance on this manuscript.

96. I am grateful to Mirjam Shatanawi and Nina Swaep for their help with this document And to Ali Akbar for identifying the place of origin of the pilgrim in fig. 144

97. Ché-Ross 2000, p. 187.

98. I am grateful to Salman Abdul Mathalib and Syukri Zulfan, to Annabel Gallop and to Nina Swaep, who have all worked on this document.

99. Peters 1994, *Hajj*, pp. 282–3.

100. See Harrison 1994.

101. Sherry and Moser 1968, p. 312.

102. Ché-Ross 2000, p. 200.

103. Low 2007, p. 69, quoting Rae 1891 pp. 211–12.

104. Conrad 1900, p. 12.

105. Stegar 1970, p. 72.

106. Peters 1994, *Hajj*, p. 301.

107. See Miller 2006.

108. Peters 1994, *Hajj*, pp. 301–2.

109. Farahani 1990, p. 171.

110. Hurgronje 2007, p. 234.

111. Farewell 1963, pp. 77–8.

112. Begum of Bhopal 1870, p. 74.

113. http://www.bonhams.com/eur/auction/17823/lot/57.

114. See Begum of Bhopal 1870.

115. Lane 1890, pp. 401–2.

116. See Bullard 1961.

117. See Ali Beg 1896.

118. Ali Beg 1896, pp. 219–20 ff.

119. See Jarman 1990.

120. Lane 1890, p. 448.

121. Doughty 1888, vol. 1, p. 10.

122. Burton 1879, vol. 1, pp. 273–4.

123. Burton 1879, vol. 1, pp. 273–4.

124. Blunt 1882, p. 10.

125. See C.E.S. Gavin, 'Mecca and Medina in Early Photo Documents', in
 Peters 1994, *Mecca*, pp. xiii–xvi; Facey 1996; Hage 1997; Wal 2011;
 Othman *et al.* [not dated]; Kioumgi and Graham 2009; Basha 1925;
 Bey 1880; Bey 1884; Bey 1895.

126. 'Travel, Atlases, Maps and Natural History', London, 6 May 2010,
 Sotheby's catalogue, pp. 88–9. See also Kioumgi and Graham 2009.
 We are grateful to John Slight for his contribution to this section.

127. See al-Munaiyir 1971; Khairallah 1991, pp. 84–94; Nicholson 2005,
 which has an exhaustive bibliography related to the Hijaz Railway on
 pp. 188–9.

128. Wavell and Khan 1912, p. 76.

129. Al-Munaiyir 1971, p. 16.

130. See al-Munaiyir 1971.

131. Al-Munaiyir 1971, pp. 47–8.

132. Al-Munaiyir 1971, p. 114.

133. Al-Munaiyir 1971, p. 81.

134. André-Salvini *et al.* 2010, p. 575.

135. Maunsell 1908.

136. Al-Munaiyir 1971, p. 58.

137. Wavell and Khan 1912, pp. 58–63.

138. See Wilson 1989.

139. See Barr 2006 for a succinct account of this period.

140. Teitelbaum 2001, pp. 241, 248.

141. See Bullard 1961.

142. Cobbold 1934, p. 1.

143. Cobbold 1934, Facey intro. 2008, pp. 1–80.

144. Grafftey-Smith 1970, p. 151.

145. See Headley's obituary in *Islamic Review*, September 1935, pp. 322–5.

146. Peters 1994, *Hajj*, p. 352.

147. See Rush 1993, vol. 6, pp. 1–85.

148. Ibn Battuta, in Gibb 1956, p. 189.

149. Pitts 1704, p. 97.

150. Ali Bey 1816, vol. 2, p. 76.

151. Stegar 1970, p. 139.

Hajj After 1950, pp. 220–51

1. Nomani 2005, p. 130.

2. Al Faisal 2009.

3. Al Faisal 2005.

4. Sheikh 1953.

5. Anon. 1974.

6. Sheikh 1953.

7. Bushnak 1978.

8. Long 1979, p. 129.

9. Even though the emphasis is on all-encompassing equality there can in fact
 be differences according to race or class, and those who can afford it may
 choose to perform Hajj in greater luxury than those who are less fortunate.

10. Shariati 2003, p. 15.

11. Mubarakpuri 2002, p. 104.

12. Mubarakpuri 2002, p. 105.

13. Damluji 1998, p. 64.

14. The Master Plan was produced by a number of Western consultants,
 each responsible for a specific part of the project. The overall consultant
 responsible for various 'action areas' in Mecca was the American
 company Robert Matthew, Johnson Marshall and Partners, with Parson
 Brown International, a Scottish consultancy, responsible for Mecca
 'street beautification'. Other consultants were responsible for highway
 networks for Mecca, urban public transport and developments inside
 the sacred mosque. Each consultant worked through a particular
 ministry, such as the Ministry for Municipal and Rural Affairs, Ministry
 of Public Works or Ministry of Communications.

15. Saudi Arabia, Royal Decree No. 43, 8 Shawwal 1381 AH (14 March 1962).

16. Long 1979, p. 56.

17. Kamal 1964, p. 69.

18. Al Faisal 2005.

19. Brownson 1978, pp. 127–9.

20. Bianchi 2004, p. 4.

21. The OIC was established during a historic summit in Rabat, Morocco, on
 25 September 1969, in response to the burning of al-Aqsa Mosque in
 Jerusalem that year by an Australian religious fanatic. See Ihsanoglu 2010.

22. The 'Instructions Regulating Agreements Between Hajj Missions and
 the Ministry', issued by the Ministry of Hajj, Saudi Arabia, state: 'To
 continue to implement the Resolution of the States of the Organization
 of the Islamic Conference of the year 1987 G. pertaining to the fixing
 of the pilgrims' percentages of one thousand pilgrims per one million
 of the population of the states concerned, in view of the limited space
 at the Holy Sites, particularly as regards Mina. Such fixing is necessary,
 as it is impossible to accommodate the multitudes of the pilgrims of
 Allah's Inviolable House without organization. Hence, their numbers
 should be determined according to the quotas allotted pursuant to such
 Resolution.' http://www.hajinformation.com/main/m40.htm

23. Angawi 1978, p. 11.

24. Anon. undated brochure, p. 5.

25. Anon. 1977.

26. Meadows *et al.* 1972.

27. Notes from the Hajj of Qaisra Khan, 2010, British Museum.

28. This extension is described in detail in Damluji 1998.

29. Tavakolian 2011.

30. Problems occurred in 1998, 2001, 2003, 2004 and 2006. In the
 last one, 346 people were killed when a pilgrim bus discharged its
 passengers on the eastern access ramp to the Jamarat Bridge. The
 pilgrims emerging from the bus rushed towards the Jamarat and some
 tripped, causing a lethal crush. See the table of 'Hajj-related disasters in
 recent years' in Bianchi 2004, p. 11.

31. Wolfe 1993, p. 221.
32. Turkistani 2002.
33. Saleh 1978.
34. This information was given to us by Peter Symes. See also Symes 1999.
35. Hajj policy, Ministry of Religious Affairs, Government of Pakistan, http://www.hajjinfo.org/policy2009.htm.
36. Bianchi 2004, p. 179.
37. Surges in Turkish pilgrims have coincided with the rise of strong party leaders who championed the cause of those wishing to perform the Hajj: Adnan Menderes in the 1950s, Suleyman Demirel in the 1960s, Necmettin Erbakan in the 1970s and Turgut Ozel in the 1980s.
38. Bianchi 2004, pp. 150–1.
39. In 1987 a riot by pro-Iranian Muslims during Hajj caused the deaths of over 400 people.
40. The delegation was until recently organized by the Foreign and Commonwealth Office and led by Lord Patel.
41. Hemming 2008; following quote: pers. comm. to editor (VP).
42. Hammoudi 2005, p. 139, notes that the most common complaint he heard from his fellow pilgrims was 'the hajj doesn't exist anymore; it's all about trade'.
43. Parker and Neal 1995.
44. These statistics have been updated from Anon. 2002.
45. Graham-Rowe 2011.
46. See the advertisement for 'Emaar Residences', with a picture of the clock tower, inviting people to 'live a few steps away from the holy heart of the universe', in *Guardian*, 2 September 2010. Additional information on the clock tower was provided by Dr Nabeel Koshack of the Hajj Research Centre.
47. Hammoudi 2005, p. 111.
48. Wolfe 1993, p. 192. See also Sardar 1978, p. 33.
49. Knight 2009, p. 251.

The Modern Art of Hajj, pp. 252–5
1. Mackintosh-Smith 2010, p. 86.
2. First shown at Victoria Miro Gallery, London, in 2010.
3. Sinclair-Wilson 2011, p. 9.
4. Sinclair-Wilson 2011, p. 28.

Textiles of Mecca and Medina, pp. 256–65
1. Al-Mojan 2010, p. 289; Tezcan 1996, pp. 71 ff. We are grateful to Nahla Nassar for help with this and the other textile captions.
2. Ipek 2011 fig. 4.
3. Al-Mojan 2010, pp. 327, 347.
4. Day 1937, p. 432 and no. 12.
5. Gaudefroy-Demonbynes 1954, p. 6. It should also be noted that originally the interior of the Ka'ba was covered with paintings; see King 2004.
6. Serjeant 1948, p. 85.
7. Gaudefroy-Demonbynes 1954, p. 8.
8. Tezcan 2007, p. 227.
9. Stern 1967, p. 10; Guy 2005, p. 10.
10. Serjeant 1948, p. 64.
11. Serjeant 1948, p. 88.
12. Serjeant 1948, p. 88.
13. Basha 2009, p. 281; al-Mojan 2010, p. 267.
14. Serjeant 1942, p. 56.
15. We are grateful to Mina Moraitou for the information about both *tiraz* fragments.
16. Ibn Jubayr (Broadhurst) 1952, pp. 85, 87–8.
17. Al-Mojan 2010, pp. 284–5.
18. Tezcan 2007, p. 229.
19. See Bullard 1993 (his edited letters) and 1961 (his autobiography).
20. Al-Mojan 2010, pp. 178–84, 276.
21. Tezcan 2007, p. 237.
22. Al-Mojan 2010, p. 192.
23. Al-Mojan 2010, p. 226.
24. Al-Mojan 2010, p. 336 ff.
25. The evolution of these textiles and their uses is discussed in detail by Ipek 2006 and 2011.
26. Vernoit 1997, p. 31.
27. Al-Mojan 2010, pp. 263 ff. An archive relating to the Kharanfash workshop has been acquired by the Khalili Family Trust. See Sothebys sale Tuesday 10 May 2011, Travel, Atlases, Maps and Natural History, Lot 124.
28. Al-Mojan 2010, p. 269.
29. Lane 1836, p. 477.
30. Ali Bey in 1816 describes the honour of being part of this ritual: 'They gave me a silver cup filled with sawdust of sandalwood, kneaded with the essence of roses; and I spread it on the lower part of the wall, that was encrusted with marble and the tapestry which covered the walls and the roof; and also a large piece of aloe wood, which I burned in a large chaffing dish, to perfume the hall.' Ali Bey 1816, pp. 2, 58–9; Peters 1994, *Hajj*, pp. 136–7.
31. Hurgronje 2007, p. 9.
32. Bayhan 2008, p. 199; Tezcan 2007, p. 72; Ipek 2006, p. 313.
33. Al-Mojan 2010, p. 398.
34. Al-Mojan 2010, p. 268.

List of Exhibits

The following objects illustrated in this book feature in the exhibition *Hajj: journey to the heart of Islam*. Details correct at the time of going to press. Further information about objects in the collection of the British Museum can be found on the Museum website at britishmuseum.org.

Half-title page
Piece of Ka'ba curtain (detail) brought back from Mecca as a souvenir
75 x 88.5 cm
Museum Volkenkunde, Leiden (B118-1)

Frontispiece
Panoramic view of Mecca, c.1845
62.8 x 88 cm
Nasser D. Khalili Collection of Islamic Art (MSS 1077)
Published Rogers 2010: 260, cat. 298

Contents page
Pilgrimage certificate, dated 836 AH/AD 1433
212 x 28 cm
British Library, London (Add. Ms 27566)
Published: Reeve 2007: 213

p. 6
Dala'il Khayrat, 19th century
16 x 10.5 cm
National Library of Malaysia, Kuala Lumpur (MSS 1273, fol. 14b)
Published: Bennett 2006: 273, cat. 32

p. 11
We were all brothers, 2010
Ayman Yossri Daydban
77.5 x 153 cm
Mohammed A. Hafiz

Fig. 1
The Queen Mary Atlas, 1555–8
60 x 46 cm
British Library, London (Add. Ms. 5415A, fols 15b and 16a)
Published: Barber 2005

Fig. 3
Miscellany of Iskandar Sultan, dated 813–14 AH/AD 1410–11
18.1 x 12.5 cm
British Library, London (Add. Ms. 27261, fols 362b–363a)
Published: Lentz and Lowry 1989: cat. 35

Fig. 4
Qur'an, c. 8th century
31.5 x 21.5 cm
British Library, London (Or. 2165, fol. 53b)
Published: Baker 2007: 16

Fig. 5
Bird's-eye view of Mecca, 1803
49.7 x 88.3 cm
British Museum, London (PD 1871,0513.28)

Fig. 6
Section from the cover of the Maqam Ibrahim, 19th century
200 x 125 cm
Nasser D. Khalili Collection of Islamic Art (TXT 0243)
Published: Rogers 2010: 339, cat. 401

Fig. 8
Proxy Hajj certificate, dated 1192AH/AD 1778–9
85 x 44.5 cm
Aga Khan Collection, Geneva (HIL 335/1-204)
Published: *Paths of Princes* 2008: cat. 19; Makariou 2008: cat. 74

Figs 10–11
Ihram garments for men and women, 2010
British Museum, London (Acquired through the Modern Museum Fund)

Fig. 12
Kitab Manasik al-Hajj ala Arba'at Madhahib, early 15th century
26.5 x 18 cm
Leiden University Library, Leiden (OR 458)

Fig. 13
Modern guidebook, *Hajj & Umrah made easy*, 2011
15 x 9 cm
British Museum, London

Fig. 14
The sanctuary at Mecca, 17th–18th century
64.7 x 47.5 cm
Nasser D. Khalili Collection of Islamic Art (MSS 745.1)
Published: Rogers 2010: 257, cat. 292

Fig. 20
Pilgrim's manual of holy places, 18th century
Bodleian Library, Oxford (Ms. Pers d.29, fol. 8b)
Published: Barnes and Branfoot 2006: 27

Fig. 21
Futuh al-Haramayn, late 16th century
22.7 x 14.2 cm
Chester Beatty Library, Dublin (CBL Per245, fol. 23b)
Published: Wright 2009: 176 ff.

Fig. 22
Camping at Mina by Sadiq Bey, c.1880
24.2 x 48.7 cm
Victoria and Albert Museum, London (PH.2130-1924)
Published: Hage 2005: 35

Fig. 23
Anis al-Hujjaj (The Pilgrim's Companion) by Safi ibn Vali, c.1677-80
33 x 23.2 cm
Nasser D. Khalili Collection of Islamic Art (MSS 1025, fol. 10a)
Leach 1998: 128, cat. 43

Fig. 25
Dala'il al-Khayrat, late 17th–18th century
20.4 x 12.3 cm
Nasser D. Khalili Collection of Islamic Art (MSS 97, fol. 9b)
Published: Rogers 2010: cat. 287; Rogers 1995: cat. 60

Fig. 27
Dala'il al-Khayrat, c. 17th century
24 x 15 cm
British Library, London (OR 16161 fols 17b, 18a)

Fig. 28
Kitab Mawlid, 19th century
23.5 x 16 cm
National Library of Malaysia, Kuala Lumpur (MSS 2940)
Published: Bennett 2006: cat. 34

Fig. 29
Textile for the Prophet's mosque at Medina
289 x 136 cm
Nasser D. Khalili Collection of Islamic Art (TXT 333)

Fig. 33
World map pasted into the Tarih-i Hind-i Gharbi, dated 1060 AH/AD 1650
23.2 x 13.6 cm
Leiden University Library, Leiden (Or. 12.365)
Published: Witkam 2009

Fig. 34
Atlas of Ahmad al-Sharafi al-Safaqusi, dated 979 AH/AD 1571–2
26.8 x 20.7 cm
Bodleian Library, Oxford (Marsh 294, fol. 4b)
Published: Barnes and Branfoot 2006: 21; King 1999: 54

Fig. 35
Qibla indicator, dated 1582
Diameter 11 cm
British Museum, London (1921,0625.1)
Published: King 1999: 116

Fig. 36
Qibla indicator and compass, dated 1738
Diameter 30 cm
Museum of Islamic Art, Cairo (MIA 3348)
Published: O'Kane 2005: 189; Abbas 2010: 156

Fig. 37
The sanctuary at Jerusalem, 18th–19th century
63.5 x 43 cm
Nasser D. Khalili Collection of Islamic Art (MSS 745.7)
Published: Rogers 2010: cat. 293

Fig. 38
View of the holy sanctuary at Mecca by Sadiq Bey, c.1880
21.3 x 61.5 cm
Victoria and Albert Museum, London (PH.2132-1924)
Published: Hage 2005: 24–5

Fig. 39
Zamzam water flask, 14th –15th century
31 x 15 cm (approx)
Museum of Islamic Art, Cairo (MIA 7614)

Fig. 40
Jami al-Tawarikh by Rashid al-Din, 706 AH/AD 1306–7

39.5 x 27.5
Edinburgh University
Library, Edinburgh (MS Or
20f., fol. 41a)
Published: Talbot-Rice and
Gray 1976; Cho 2008: 149

Fig. 41
Zamzam water flask,
c. 17th century
Museum of Islamic Art,
Kuala Lumpur (2009.6.14)
Published: de Guise 2009: 79

Fig. 42
Tipu Sultan's helmet,
18th century
33 x 42 x 30 cm
Victoria and Albert
Museum, London (3518 IS)

Fig. 43
Zamzam water bottle,
19th century
20 x 8 cm
Museum Volkenkunde,
Leiden (B106-88)

Fig. 44
Zamzam water container
acquired in Mali, 2010
Diameter 7 cm
British Museum, London
(acquired as part of a group
of Hajj-related objects from
Mali by Tim Insoll through
the Modern Museum Fund)

Fig. 45
Zamzam water flask
22.5 x 12 cm
British Museum, London
(Af. +1756, donated by
Sir Augustus Wollaston
Franks)

Fig. 46
The Sandal of the
Prophet and leather case,
19th century
26 x 36 cm, case 6 x 37 cm
British Library, London
(OR. 6774)

Fig. 47
Medina by Sadiq Bey,
c.1880
24.2 x 46.5 cm
Victoria and Albert
Museum, London
(PH.2135-1924)
Published: Hage 2005: 33

Fig. 48
The Ma'la cemetery at
Mecca by Sadiq Bey, c.1880
24.2 x 61.5 cm
Victoria and Albert
Museum, London
(PH.2131-1924)
Published: Hage 2005: 29

Fig. 49
The Guristan Cemetery of
Baqi in Medina
Futuh al-Haramayn
Chester Beatty Library,
Dublin (CBL 245, fol. 51a)

Fig. 50
Medina tile, c.1640
59.8 x 36 cm
Musée du Louvre, Paris
(OA 3919/557)
Published: André-Salvini
2010: 568

Fig. 52
The haram during Hajj by
Sadiq Bey, c.1880
21.2 x 61.5 cm
Victoria and Albert
Museum, London
(PH 2136-1924)
Published: Wieczorek et al.
2008: 129

Fig. 54
Black Cube II
Kader Attia, 2005
200 x 200 cm
Galerie Christian Nagel,
Berlin

Fig. 69
The sanctuary at Mecca,
17th–18th century
64.7 x 47.5 cm
Nasser D. Khalili Collection
of Islamic Art (MSS 745.2)

Published: Rogers 2010:
257, cat. 291

Fig. 74
Qibla indicator and
compass, c.1800
8 cm x 12.5 cm
Benaki Museum, Athens
(14715)

Fig. 75
A treatise on the sacred
direction by al-Dimyati,
12th century
19 x 12.5 cm
Bodleian Library, Oxford
(Marsh 592, fol. 88b)

Fig. 77
Mecca tile, mid-17th
century
61 x 38 cm
Victoria and Albert
Museum, London
(427-1900)
Published: Stanley 2004: 7

Fig. 78
Mecca tile panel,
17th century
73 x 49.5 cm
Benaki Museum,
Athens (124)
Published: Ballian 2004:
156, fig. 209

Fig. 79
Mecca tile, dated 1074 AH/
AD 1663
38 x 35 cm
Museum of Islamic Art,
Cairo (MIA 3251)

Fig. 81
Key for the Ka'ba, dated 765
AH/AD 1363–4
Length 34 cm
Museum of Islamic Art,
Cairo (MIA 15133)
Published: Atil 1981: cat. 33

Fig. 82
Key for the Ka'ba,
mid-14th century
Length 29 cm
Museum of Islamic Art,

Doha (MW472)
Published: Allan 1982:
cat. 17

Fig. 84
The travels of Ibn Jubayr,
dated 875 AH/AD 1470
28.4 x 19.6 cm
Leiden University Library,
Leiden (Or.320, fols 2–3)

Fig. 85
Kulliyat of Sa'di, dated
1566
40 x 28 cm
British Library, London
(Add. 24944, fol. 245a)

Fig. 86
Toy theatre set, early
19th century
40 x 28 cm
Private collection, London

Fig. 87
Photograph of pilgrims
on Hajj by Abbas Hilmi II,
1909
32 x 44 cm
Mohammad Ali
Foundation, from the
archives of the Khedive
Abbas Hilmi II deposited at
Durham University Library,
Durham (335/1-204)

Fig. 88
Dala'il al-Khayrat, dated
1048 AH/AD 1638–9
20.7 x 14.8 cm
Chester Beatty Library, Dublin
(CBL Ar 4223, fol. 3b)
Published: Wright 2009:
fig. 121

Fig. 89
Shahnama of Firdausi,
mid-16th century
36 x 21.5 cm
Nasser D. Khalili Collection
of Islamic Art (MSS 771)
Published: Rogers 2010:
cat. 286; Shrieve Simpson
2010: 127–46

Fig. 90
View of Arafat by
Abd al-Ghaffar, 1888
27.8 x 21.4 cm
Leiden University Library,
Leiden (Or. 12.288 L:5;
Published: Hurgronje:
1888-9, vol. 3; Wal 2011:
42–5

Fig. 91
Maqamat of al-Hariri by
Yahya al-Wasiti, 1237
39 x 34 cm
Bibliothèque Nationale de
France, Paris (Arabe 5847,
fols 94b, 95a)
Published: Ettinghausen
1962: 104–24; Grabar
2003

Fig. 92
Pilgrimage certificate, dated
1433
Coloured inks and gold
on paper 212 x 28 cm
British Library, London
(Add. MS 27566)
Published: Reeve 2007: 213

Fig. 95
Kiswa for the Mahmal,
c.1867–76
Height 390 cm (including
finial and fringe)
Nasser D. Khalili Collection
of Islamic Art (TXT 442)

Fig. 97
Hajj banner, dated 1094
AH/AD 1683
369.5 x 190.5 cm
Harvard Art Museums,
Cambridge, MA
(HUAM 1958.20)
Published: Denny 1974:
67–82.

Fig. 101
Bahjat al-manazil by
Mehmed Edib, dated 1240
AH/AD 1790
19.9 x 13 cm
Chester Beatty Library,
Dublin (T461, fols
218b–219a)

Fig. 105
Qibla compass, *c.*1800
Diameter 13.2 cm
Benaki Museum, Athens
(10184)
Published: Alawi 2006:
153, cat. 75

Fig. 106
The caravan of pilgrims
from the Maghreb Anis
al-Hujjaj (The Pilgrim's
Companion) by Safi ibn
Vali, *c.*1677–80
33 x 23.2 cm
Nasser D. Khalili Collection
of Islamic Art (MSS 1025,
fol. 15a)
Published: Rogers 2010:
284, cat. 336

Fig. 108
Catalan Map, *c.*1525
82 x 110 cm
British Library, London
(Add. MS 31318 B)

Fig. 110
Gold coin mould from
Tadmekka, Mali
9th –10th century
8 x 5 x 5 cm
Institut des Sciences
Humaines, Bamako
Published: Nixon 2010:
40–51

Fig. 111
Fatimid dinars, minted in
al-Mansuriya and
al-Mahdiya
Diameter 2.1–2.3 cm
British Museum, London
(al-Mansuriya, AD
1017, 1870,0709.155;
al-Mahdiya, AD 1001,
BM 1854, 0819.65;
al-Mahdiya, AD 1020,
1877,1103.7; al-
Mansuriya, AD 1019,
1846,0523.169)

Fig. 113
A Hajj journey by Umar ibn
Sa'id al-Futi al-Turi
22 x 18 cm

Mamma Haidara Library,
Timbuktu (4479)

Fig. 114
Blue and white porcelain
dish, 1403–24
Diameter 38 cm
British Museum, London
(1937,1012.1, donated by
Mrs Walter Sedgwick)
Published Harrison-Hall
2001: 116, cat. 3:35

Fig. 115
The travelogue of Ma
Fuchu, dated 1861
15 x 26.5 cm
Aga Khan Collection,
Geneva (AKM 00681,
pp. 18–19)
Published: *The Paths of
Princes*: 84, cat. 22

Fig. 116
Candlestick, dated 887 AH/
AD 1482–3
46 x 37 cm
Benaki Museum, Athens
(13040)
Published: Ballian 2004

Fig. 117
The *mizab* of the Ka'ba,
restoration inscription
20.5 x 155 cm
Nasser D. Khalili Collection
of Islamic Art (CAL 300)
Published: Rogers 2010:
cat. 283

Fig. 118
Astrolabe, dated 728 AH/
AD 1327–8
Diameter 22 cm
Museum of the History of
Science, Oxford (50853)

Fig. 119
Bengali trade cloth,
19th century
121 x 119 cm
British Museum, London
(As 1992,05.16)

Fig. 120
Crossing the sea of Oman

and View of Surat from the
Maghreb Anis al-Hujjaj
(The Pilgrim's Companion)
by Safi ibn Vali, *c.*1677–80
33 x 23.2 cm
Nasser D. Khalili Collection
of Islamic Art (MSS 1025,
fols 2b, 3b)
Published: Rogers 2010:
cat. 333, 332; Leach 1998:
128, cat. 43

Fig. 121
The port of Jedda from the
Maghreb Anis al-Hujjaj
(The Pilgrim's Companion)
by Safi ibn Vali, *c.*1677–80
33 x 23.2 cm
Nasser D. Khalili Collection
of Islamic Art (MSS 1025,
fol. 22b only)
Published: Rogers 2010:
cat. 341; Leach 1998: 128,
cat. 43

Fig. 122
The Gentil Album, *c.*1774
37 x 53.5 cm
Victoria and Albert
Museum, London (IS
25:26-1980, fol. 25)
Published: Varthema 2010

Fig. 124
Kitab-i Bahriye of Piri Reis,
*c.*1670
24 x 34cm
Nasser D. Khalili Collection
of Islamic Art (MSS 718,
fols 3b–4a)
Published: Madison and
Savage Smith 1997: cat.
173; Rogers 1995: cat. 75

Fig. 125
Mouradgea d'Hosson
*Tableau Général de l'Empire
Ottoman*, 1787
51 x 34 cm
Arcadian Library, London
(8966, fol. 47)
Published: Bayhan 2008:
222–3.

Fig. 126
'Mecha in Arabia',

dated 1672
12 x 26.5 cm
British Museum, London
(PD F,1.106)

Fig. 127
Qur'an copied by Mehmed
Shakir, dated 1224 AH/AD
1809–10
16.1 x 10.5 cm
Nasser D. Khalili Collection
of Islamic Art (QUR7)
Published: Rogers, Stanley,
Bayani 2009/2: cat. 37

Fig. 128
Costumes Turcs, vol. 1,
*c.*1790
37 x 22 cm
British Museum, London
(ME 1974,0617.01)

Fig. 129
Chamfron and cheek pieces,
18th century
54.5 x 74 (max.)
Nasser D. Khalili Collection
of Islamic Art (MTW 995)
Published: Rogers 1995:
cat. 89; Rogers 2010: 418

Fig. 131
Ottoman gold coins of
Sultan Abd al-Hamid I
(1774–89)
Diameter 2.2–3.7 cm
British Museum, London
(CM 1935,0401.1356;
OR.9420; 1877,0706.16;
1994,0915.784;
1994,0915.783;
1994,0915.788)

Fig. 132
Chart of the Red Sea and
Gulf of Aden, *c.*1835
24.1 x 195.6 cm
Royal Geographical Society,
London (mr Asia S.4)
Published: Barber,
2005: 242

Fig. 135
Richard F. Burton's *A
Pilgrimage to Meccah and
Medinah* (London, 1855)

19.8 x 13.8 cm
Arcadian Library, London
(14900)

Fig. 137
Metal pilgrim flask
Diameter 9 cm
British Museum, London
(ME OA+3740, donated by
Isobel Burton)

Fig. 140
Plates from *Bilder Aus
Mekka*, 1888
36.2 x 27 cm
Leiden University
Library (OR.26.404108;
Or 26.404:113;
Or.26.404:120)
Published: Hurgronje,
Christian Snouck 1888–9;
Wal 2001: 20

Fig. 142
Diary of the King of Bone
42.5 x 26.5 cm
British Library, London
(Add. 12354, fols 43b–44a)
Published: Omar 2003

Fig. 143
Pilgrim's permit, 1906
47 x 57 cm
Tropenmuseum,
Amsterdam (4353-1)

Fig. 144
Hajj certificate, dated 1331
AH/AD 1912–13
28.6 x 20 cm
Tropenmuseum,
Amsterdam (A-6481)

Fig. 146
The Masjid al-Haram in
Mecca, late 19th century
42.5 x 32.5 cm
Tropenmuseum,
Amsterdam (A-5992)

Fig. 147
The prayer book of
Tuangku Imam Bonjol,
dated 1229 AH/AD 1814
15.9 x 9.8 cm
Leiden University Library,

Leiden (MS Leiden Or.
1751)
Witkam 2009: 27–32

Fig. 148
Abdullah's Voyage from
Singapore to Mecca by
Abdullah Munshi, 1858–9
19 x 14 cm
British Library, London
(ORB 30/457)
Published: Raimy Ché-Ross
2000

Figs 149–52
Prayer beads
78 cm
Tropenmuseum (H -2263)

Hat
12 x 16 cm
Tropenmuseum,
Amsterdam (5735-8b)

Hat
8 x 14 cm
Tropenmuseum,
Amsterdam (37-1)

Copeland Late Spode dish
Diameter 26 cm
Tropenmuseum,
Amsterdam (674-54)

Figs 153–5
Pilgrimage ticket, Thomas
Cook and Sons Mecca,
1886
6.7 x 15.2 cm

Report by agents of Thomas
Cook and Sons, October
1886
20.5 x 33.5

Mecca pilgrimage booklet,
1886
13.8 x 21.5 cm
Thomas Cook Archive,
Peterborough

Fig. 157
Illuminated document,
dated 1296 AH/AD 1879
38.5 x 22.7 cm
British Library, London

(Or.16742/1)

Fig. 162
Stereoscopes for viewing
the stereoviews in 3-D and
photographs by Sa'udi,
c.1900
Private collection

Fig. 163
Pocket watch, early 20th
century
Diameter 5 cm
Private collection

Fig. 165
Map of the Hijaz railway,
1904
57.5 x 84.5 cm
Royal Geographical Society,
London (mr Asia Div.186)

Fig. 169
T.E. Lawrence, *Seven Pillars
of Wisdom* (London, 1926)
26.7 x 20.4 cm
Arcadian Library, London

Fig. 171
Letter from Lady Cobbold to
her grandson, Toby Sladen,
1933
26 x 20 cm
Angus Sladen

Fig. 170
Road to Makkah, 2011
Abdulnasser Gharem
70 x 330 cm
Muhammad Hafiz
Published: Hemming 2011:
168

Fig. 185
Pilgrim receipt, 1375 AH/
AD 1955–6
7.1 x 12.8 cm
British Museum, London
(CM 1984,0605.1995)

Fig. 186
10-rupee Hajj note, 1950
8.2 x 14.5 cm
British Museum, London
(CM 1984,0605.2000)

Fig. 188
The Road to Mecca, 2010
Maha Malluh
75 x 95 cm
British Museum, London
(ME 2011,6030.1,
purchased through the
Contemporary and Modern
Middle Eastern Art fund)

Fig. 189
The diary of Saleena
Nurmohamed, 2006–7
20 x 16 cm
Dr and Mrs Nurmohamed

Fig. 190
Souvenirs of Hajj
purchased in Mecca and
Medina, 2010
British Museum, London
(purchased through the
Modern Museum Fund)

Fig. 192
Magnetism, 2011
Ahmed Mater
63 x 42 cm
British Museum, London
(acquired thanks to a gift
from Mr Abdulaziz al-Turki)

Fig. 193
Seven Times, 2010
Idris Khan
Victoria Miro Gallery,
London

Fig. 194
White Cube, 2010
Walid Siti
68 x 110 cm
British Museum, London
(ME 2011,6014.1,
purchased through the
Contemporary and Modern
Middle Eastern Art fund)

Fig. 195
Section from the internal
kiswa of the Ka'ba, c.1935
138 x 82 cm
Nasser D. Khalili Collection
of Islamic Art (TXT 460)

Fig. 196
Curtain for Baba al-Tawba,
dated 1311 AH/AD
1893–4
265 x 158 cm
Nasser D. Khalili Collection
of Islamic Art (TXT 0386)

Fig. 197
Section from the *kiswa* of
the Ka'ba Egypt, late 19th
or early 20th century
158 x 89 cm
Nasser D. Khalili Collection
of Islamic Art (TXT 0038)

Fig. 198
The belt of the Ka'ba,
1566–74 and later
95 x 742 cm
Nasser D. Khalili Collection
of Islamic Art (TXT 258)

Fig. 199
Panel, late 19th century
92 x 92 cm
Nasser D. Khalili Collection
of Islamic Art (TXT 263)

Fig. 200
Tiraz fragment, dated 300
AH/AD 922–3
39.5 x 66.5 cm
Benaki Museum, Athens
(14807)
Published: Repertoire
1932: no. 1052

Fig. 201
Tiraz fragment, dated 310
AH/AD 912–13
25.5 x 33.5 cm
Benaki Museum, Athens
(14828)
Published: Repertoire
1932: no. 921

Fig. 202
Cover from the Prophet's
tomb, 17–18th century
241 x 134 cm
Nasser D. Khalili Collection
of Islamic Art (TXT 241)
Published: Rogers 2010:
344, cat. 407

Fig. 203
Section of *kiswa* from
the Prophet's tomb,
17th –18th century
155 x 53 cm
Nasser D. Khalili Collection
of Islamic Art (TXT 37)
Published: Rogers 2010:
345, cat. 406

Fig. 204
Ka'ba curtain, dated 1263
AH/AD 1846–7
550 x 275 cm
Nasser D. Khalili Collection
of Islamic Art (TXT 406)

Fig. 205
Section of *kiswa* for
the Prophet's tomb,
c.1600–1700
39 x 65 cm
Victoria and Albert
Museum, London (39-
1889)

Fig. 206
Section of the curtain
of the Ka'ba, early 20th
century
36 x 71.5 cm
Lady Margaret Bullard

Fig. 207
Section of the *kiswa* of the
Ka'ba, 19th century
86 x 70 cm
Museum Volkenkunde,
Leiden (1973-152)

Fig. 208
Waistcoat, c. 19th century
Museum of Islamic
Art, Kuala Lumpur
(1998.1.4156)

Fig. 209
Photograph from *kiswa*
factory archive, 19th –20th
century
Nasser D. Khalili Collection
of Islamic Art

References and Further Reading

For pilgrimage accounts and narratives, please see the separate bibliography in this book entitled Hajj Travel Narratives.

Abbas, M. 2010, *Manarat al-funun wa'l hadarat al-islamiyya*, Museum of Islamic Art, Cairo

Abbot, N. 1946, *Two Queens of Baghdad: Mother and wife of Harun al-Rashid*, Chicago

Abdel Haleem, M.A.S. (trans.) 2005, *The Qur'an*, Oxford

Abu Lughod, J.L. 1989, *Before European Hegemony: The world system, A.D. 1250-1350*, New York

Addas, C. 1989, *Ibn Arabi ou la Quête du Soufre Rouge*, Paris

Al Faisal, R. 2005, 'El Hajj', *Universes in Universe*, October, http://universes-in-universe.org/eng/nafas/articles/2005/al_faisal

Al Faisal, R. 2009, *Hajj*, Reading

Allan, J.W. 1982, *Islamic metalwork: The Nuhad Es-Said Collection*, London

André-Salvini, B., Juvin, C., Makariou, S., Demange, F. and Al-Ghabban, A. 2010, *Routes d'Arabie: Archéologie et histoire du Royaume d'Arabie Saoudite*, Paris

Angawi, S.M. 1978, 'Preface', in Sardar, Z. and Badawi, M.A.Z. (eds), *Hajj Studies*, London, vol. 1, pp. 11–14

Ankawi, A. 1974, 'The Pilgrimage to Mecca in Mamluk Times', *Arabian Studies*, vol. 1, pp. 401–25

Anon. undated brochure, *Hajj Research Centre*, King Abdul Aziz University, Jedda

Anon. 1974, 'The Pilgrims' Progress', *Saudi Aramco World*, November/December, pp. 40–44

Anon. 1977, 'Mecca: Policy development and future development', Hajj Research Centre, King Abdul Aziz University, Jedda, Report MEC 2 77

Anon. 2002, 'Welcoming Guests of God', *Saudi Aramco World*, May/June, pp. 8–29

Archer, M. 1992, *Company Paintings: Indian paintings of the British period*, London

Asani, A.S. and Gavin, C.E.S. 1998, 'Through the Lens of Mirza of Delhi: The Debbas Album of early twentieth century photographs of pilgrimage sites in Mecca and Medina', *Muqarnas*, vol. 15, pp. 178–99

Astengo, C. 2007, 'The Renaissance Chart Tradition in the Mediterranean', in Woodward, D. (ed.), *The History of Cartography, Volume 3: Cartography in the European Renaissance*, Chicago

Atil, E. 1981, *Renaissance of Islam: Art of the Mamluks*, Washington, DC

Ayalon, D. 1972, 'Discharges from Service, Banishments and Imprisonments in Mamluk Society', *Israel Oriental Studies*, vol. 2

Baker, C., *Qur'an manuscripts, calligraphy, illumination, design*, London

Ballian, A. (ed.) 2004, *Benaki Museum: A guide to the Museum of Islamic Art*, Athens

Bamyeh, M.A. 1999, *The Social Origins of Islam: Mind, economy, discourse*, Minneapolis

Barakat, H.N. 2003, *Al-Kalima*, Kuala Lumpur

Barber, P. (ed.) 2005, *The Map Book*, London

Barber, P. 2005, *The Queen Mary Atlas*, London

Barbir, K.K. 1980, *Ottoman Rule in Damascus 1708–1758*, Princeton

Barker, M. 1991, *The Gate of Heaven: The history and symbolism of the temple in Jerusalem*, London

Barnes, R. and Branfoot, C. (eds) 2006, *Pilgrimage: The sacred journey*, Oxford

Barr, J. 2006, *Setting the Desert on Fire: T.E. Lawrence and Britain's secret war in Arabia, 1916-1918*, London

Basha, Ibrahim Rif'at 1925, repr. 2009, *Mir'at al-Ḥaramayn*, 2 vols, Cairo

Bataller, R.P. i 2007, *Les cartes portolanes: la representació medieval d'una mar solcada*, Barcelona

Bayhan, N. (ed.) 2008, *Imperial Surre*, Istanbul

Behrens-Abouseif, D. 1997, 'The Mahmal Legend and the Pilgrimage of the Ladies of the Mamluk Court', *Mamluk Studies Review*, vol. I

Bennett, C. 1994, 'Islam', in Holm, J. with Bowker, J. (eds), *Sacred Place*, New York, pp. 88–114

Bennett, J. 2006, *Crescent Moon: Islamic art and civilisation in Southeast Asia*, Adelaide

Bey, S. 1880, *The Mahmal's Torch*, Cairo

Bey, S. 1884, *The Star of the Hajj*, Cairo

Bey, S. 1895, *The Guide to the Hajj*, Cairo

Bianchi, R.R. 2004, *Guests of God: Pilgrimage and politics in the Islamic world*, Oxford

Birks, J.S. 1978, *Across the Savannas to Mecca: The overland pilgrimage route from West Africa*, London

Blunt, W.S. 1882, *The Future of Islam*, London

Boord, M. 1994, 'Buddhism', in Holm, J. with Bowker, J. (eds), *Sacred Place*, New York, pp. 8–32

Bovill, E.W. 1968, *The Golden Trade of the Moors*, Oxford, 2nd edn

Brocquière, B. de la 1848, 'The Travels of Bertrandon de la Brocquière, A.D. 1322 and 1433', in Wright, T. (ed. and trans.), *Early Travels in Palestine*, London

Brown, P. 1982, *The Cult of the Saints: Its rise and function in Latin Christianity*, Chicago

Brownson, M.J. 1978, 'Mecca: The socio-economic dynamics of the sacred city', in Sardar, Z. and Badawi, M.A.Z. (eds), *Hajj Studies*, London, vol. 1, pp. 117–36

Buhl, Fr., 'Mahmal', in *Encyclopaedia of Islam* (EI2)

Bullard, R. 1961, *The Camels Must Go: An autobiography*, London

Bullard, R., (ed.) E. Hodgkin and M. Weir 1993, *Two Kings in Arabia: Letters from Jeddah, 1923-5 and 1936-9*, Reading

Burckhardt, J.L. 1822, *Travels in Syria and the Holy Land*, London

Burckhart, T. 1976, *The Art of Islam: Meaning and message*, London

Burkert, W., (trans.) P. Bing 1980, *Homo Necans: The anthropology of Ancient Greek sacrifice*, Berkeley

Burton, R.F. 1879, *The Land of Midian, Revisited*, 2 vols, London

Burton, R.F. (trans.) 1885–8, *Supplemental Nights to the Book of the Thousand Nights and a Night*, 4 vols, Benares

Bushnak, A.A. 1978, 'The Hajj Transportation System', in Sardar, Z. and Badawi, M.A.Z. (eds), *Hajj Studies*, London, vol. 1, pp. 87–116

Campo, J.E. 1987, 'Shrines and Talismans: Domestic Islam in the Pilgrimage Paintings of Egypt', *Journal of the American Academy of Religion*, vol. 55, no. 2, pp. 285–305

Ché-Ross, R. 2000, 'Munshi Abdullah's Voyage to Mecca: A preliminary introduction and annotated translation', *Indonesia and the Malay World*, vol. 28, no. 81, pp. 173–213

Cho, Yo Min 2008, 'How Land Came into the Picture: Rendering history in the fourteenth-century *jami al-tawarikh*', PhD dissertation, University of Michigan, http://deepblue.lib.umich.edu/bitstream/2027.42/61559/1/mycho_1.pdf

Clements, R.E. 1965, *God and Temple*, Oxford

Clifford, R.J. 1972, *The Cosmic Mountain in Canaan and the Old Testament*, Cambridge, MA

Cohen, A. 1973, *Jerusalem in the Eighteenth Century: Patterns of government and administration*, Jerusalem

Conrad, J. 1900, *Lord Jim: A tale*, Edinburgh

Creswell, K.A.C. 1969, *Early Muslim Architecture*, 2 vols, Oxford

Crone, P. 1987, *Meccan Trade and the Rise of Islam*, Oxford

Damluji, S.S. (ed.) 1988, *The Architecture of the Prophet's Holy Mosque. Al Madinah*, London

Damluji, S.S. (ed.) 1998, *The Architecture of the Holy Mosque Makkah*, London

Davies, D. 1994, 'Introduction: Raising the issues', in Holm, J. with Bowker, J. (eds), *Sacred Place*, New York, pp. 1–9

Day, F. E. 1937, 'Dated Tiraz in the Collection of the University of Michigan', *Ars Islamica*, vol. 4, pp. 420-447

Denny, W. 1974, 'A Group of Islamic Silk Banners', *Textile Museum Journal*, vol. 4, no. 1, pp. 67–82

Digby, S. 2006, *Richard Burton: The Indian making of an Arabist*, Jersey

Donaldson, D.M. 1930, 'Ibn Jubayr's Visit to Al-Medina', *Journal of the American Oriental Society*, vol. 50, pp. 26–42

Doughty, C. 1888, *Travels in Arabia Deserta*, 2 vols, Cambridge

Dreyer, E.L. 2007, *Zheng He: China and the oceans in the early Ming dynasty*, New York

Dupront, A. 1973, 'Pèlerinage et lieux sacres', in *Mélanges F. Braudel*, vol. II, Toulouse, pp. 189–206

Eickelman, D.F. and Piscatori, J. (eds) 1990, *Muslim Travellers: Pilgrimage, migration and the religious imagination*, LondonEliade, M., (trans.) R. Sheed 1958, *Patterns in Comparative Religion*, New York

Eliade, M., (trans.) W.R. Trask 1959, *The Sacred and the Profane: The nature of religion*, New York

Eliade, M. 1991, *Images and Symbols: Studies in religious symbolism*, Princeton

Eliade, M., (trans.) W.R. Trask 1991, *The Myth of the Eternal Return, Or, Cosmos and History*, Princeton

Erdmann, K. 1959, 'Ka'bah-Fliesen', *Ars Orientalis*, vol. 3, pp. 192–7

Erkal, M. 1986, 'The Pilgrimage Organization in Turkey', in Khan, Z-I. and Zaki, Y. (eds), *Hajj in Focus*, London, pp. 137–49

Esin, E. 1963, *Mecca the Blessed, Madinah the Radiant*, New York

Ettinghausen, R. 1962, *Arab Painting*, New York

Facey, W. 1996, *Saudi Arabia by the First Photographers*, London

Facey, W. 2005, 'Queen of the India Trade', *Saudi Aramco World*, November/December, pp. 10–16

Facey, W. 2009, 'Jiddah: Port of Makkah, Gateway of the India Trade', in Blue, L., Cooper, J., Thomas, R. and Whitewright, J. (eds), *Connected Hinterlands: Proceedings of the Red Sea Project IV held at the University of Southampton, September 2008*, Oxford, pp. 165–76

Farewell, B. 1963, *Burton: A biography of Sir Richard Francis Burton*, London

Farooqi, N.R. 1989, *Mughal-Ottoman Relations*, Delhi

Faroqhi, S. 1994, *Pilgrims and Sultans: The Hajj under the Ottomans*, London

Gaudefroy-Demombynes, M. 1923, *Le pèlerinage à la Mekke*, Paris

Gaudefroy-Demombynes, M. 1954, 'Le Voile de la Ka'ba', *Studia Islamica*, no. 2, pp. 5–21

Gibb, H.A.R., 'Arabiyya', in *Encyclopaedia of Islam* (EI2)

Goodrich, T.D. 1990, *The Ottoman Turks and the New World: A study of Tarih-i Hind-i garbi and sixteenth century Ottoman Americana*, Wiesbaden

Goodwin, G. 1993, *Sinan: Ottoman architecture and its values today*, London

Grabar, O. 2001, 'A Preliminary Note on Two Eighteenth-century Representations of Mecca and Medina', *Jerusalem Studies in Arabic and Islam*, vol. 25, pp. 268–74

Grabar, O. (intro.) 2003, *Maqamat Al-Hariri, Illustrated Arabic Manuscript from the 13th century*, Paris, Bibl. Nat., ms. Arabe 5847, facsimile edn., London

Grafftey-Smith, L. 1970, *Bright Levant*, London

Graham-Rowe, D. 2011, 'Faith in Numbers', *Wired*, 3 January

Green, N. 2006, 'Ostrich Eggs and Peacock Feathers: Sacred objects as cultural exchange between Christianity and Islam', *Al-Masaq*, vol. 18, no. 1, pp. 27–66

Guillmartin, J.F. 1974, *Gunpowder and Galleys: Changing technology and Mediterranean warfare at sea in the sixteenth century*, Cambridge

Guise, L. de (ed.) 2009, *En Route to Mecca: Pilgrims' voices throughout the centuries*, Kuala Lumpur

Guy, J. 2005, 'Early ninth-century Chinese export ceramics and the Persian Gulf connection: the Belitung shipwreck evidence', Taoci, vol. 4, pp. 9-20. *Revue annuelle de la Société française d'étude de la Céramique orientale*, actes du colloque 'Chine—Méditerranée: routes et éxchanges de la céramique avant le XVI siècle', Paris

Hage, B. el- 1997, *Saudi Arabia Caught in Time, 1861–1939*, Reading

Hage, B. el-, (ed.) 2005, *Photographies anciennes de La Mecque et de Medine 1880-1947*, Paris and Riyad

Hambly, G.R.G. (ed.) 1998, *Women in the Medieval Islamic World*, New York

Hamilton, A. 2011, *Bridge of Knowledge: Western appreciation of Arab and Islamic civilization in the Arcadian Library*, London

Harrison, M. 1994, *Public Health in British India: Anglo-Indian preventative medicine, 1859-1914*, Cambridge

Harrison-Hall, J. 2001, *Ming Ceramics: A catalogue of the late Yuan and Ming ceramics in the British Museum*, London

Harvey, L.P. 1987, 'The Moriscos and the Hajj', *Bulletin (British Society for Middle Eastern Studies)*, vol. 14, no. 1, pp. 11–24

Hawting, G.R. 1980, 'The Disappearance and Rediscovery of Zamzam and the "Well of the Ka'ba"', *Bulletin of the School of Oriental and African Studies*, vol. 43, no. 1, pp. 44–54

Hawting, G.R. 1984, 'We were not ordered with entering it but only with circumambulating it': "Hadith" and "fiqh" on entering the Ka'ba', *Bulletin of the School of Oriental and African Studies*, vol. 47, no. 2, pp. 228–42

Heesterman, J.C. 1993, *The Broken World of Sacrifice: An essay in ancient Indian ritual*, Chicago

Hemming, H. (ed.) 2008, *Edge of Arabia: Contemporary art from Saudi Arabia*, London

Hemming, H. 2011, *Abdulnasser Gharem Art of Survival*, London

Hollstein, F.W.H. 1949, *Dutch and Flemish Etchings, Engravings and Woodcuts c.1450-1700*, Amsterdam

Hunwick, J. 1992, 'An Introduction to the Tijani Path', *Islam et Societés au Sud du Sahara*, vol. 6, pp. 17–32

Hurgronje, C.S. 1888–98, *Mekka, Bilder-Atlas Zu Mekka, Bilder Aus Mekka*, 3 vols, Leiden

Hurgronje, C.S. 2007, (trans.) J.H. Monahan (1931), intro. J.J. Witkam, *Mecca in the Latter Part of the Nineteenth Century: Daily life, customs and learning. The Moslems of the East Indian Archipelago*, Leiden

Ibn Hisham. Abd al-Malik, *Sirat rasul Allah*, (trans.) Guillaume, A. 1955, The Life of Muhammad Karachi (OUP)

Ihsanoglu, E. 2010, *The Islamic World in the New Century: The Organisation of the Islamic Conference, 1969–2009*, London

Information Office of the People's Government of Fujian Province 2005, *Zheng He's Voyages down the Eastern Seas*, Beijing

Insoll, T. 1999, *The Archaeology of Islam*, Oxford

Insoll, T. 2003, *The Archaeology of Islam in Sub-Saharan Africa*, Cambridge

Ipek, S. 2006, 'Ottoman *ravza-i mutahhara* covers sent from Istanbul to Medina with the *surre* processions', *Muqarnas*, vol. 23, pp. 289–316

Ipek, S. 2011, 'Dressing the Prophet: textiles from the *haramayn*', *Hali*, Issue 168, pp.49-51, Summer

Irwin, R. 1986, *The Middle East in the Middle Ages: The Early Mamluk Sultanate 1250-1382*, Beckenham

Isma'il, M.K. *et al.* 1998, *The Architecture of the Holy Mosque: Makkah*, London

Jairazbhoy, R.A. 1986, 'The Architecture of the Holy Shrine in Makkah', in Khan, Z-I. and Zaki, Y. (eds), *Hajj in Focus*, London, pp. 151–70

Jarman, R.L. (ed.) 1990, *The Jedda Diaries, 1919-1940*, Farnham Common

al-Jazuli, Abu Abd Allah, (trans.) A.H. Rosowsky 2006, *Guide to Goodness (Dalail al- Khayrat)*, Lahore

Johnson, K. 2000, 'Royal Pilgrims: Mamluk accounts of the pilgrimages to Mecca of the Khawand al-Kubra (Senior Wife of the Sultan), *Studia Islamica*, no. 91, pp. 107–31

Jomier, J. 1953, *Le Mahmal et la Caravanne Égyptienne des Pélerins de la Mecque (XIIIe-XXe siècles)*, Cairo

Khairallah, S. 1991, *Railways in the Middle East 1856-1948*, Beirut

Khan, S. 2007, *Tell Me About Hajj*, New Delhi

King, D.A. 'Makka - IV' in *Encyclopaedia of Islam* (EI2)

King, D.A. 1984, 'Architecture and Astronomy: The ventilators of medieval Cairo and their secrets', *Journal of the American Oriental Society*, vol. 104, no. 1, pp. 97–133

King, D.A. and Lorch, R.P. 1992, 'Qibla charts, qibla maps and related instruments' in J.B. Harley, J.B. (ed.), *The History of Cartography, vol. 2, book 1: The History of Cartography in traditional Islamic and South-Asian Societies*, Chicago, pp. 189–205

King, D.A. 1999, *World-Maps for Finding the Direction and Distance to Mecca: Innovation and tradition in Islamic science*, Leiden

King, G. R. D. 2004, 'The Paintings of the Pre-Islamic Ka'ba', *Muqarnas*, vol. 21, Essays in Honor of J. M. Rogers, pp. 219-229

Knysh, A. 2000, 'Ibn al-Arabi', in Menocal, M.R., Scheinlein, R.P. and Sells, M. (eds), *The Cambridge History of Arabic Literature: The Literature of Al-Andalus*, Cambridge, pp. 331–44

Komaroff, L. 2011, *Gifts of the Sultan: The arts of giving at the Islamic courts*, New Haven and London

Koru, F. 1986, 'Hajj Organization under the Ottoman State', in Khan, Z-I. and Zaki, Y. (eds), *Hajj in Focus*, London, pp. 125–35

Kramer, M.S. 1996, *Arab Awakening and Islamic Revival: The politics of ideas in the Middle East*, New Brunswick, NJ

Lane, E.W. 1836 (various edns 1842, 1860, 1890, 1981, etc.), *An Account of the Manners and Customs of the Modern Egyptians*, London

Lentz, T. and G. Lowry, 1989, *Timur and the Princely Vision*, Washington and Los Angeles

Lequesne, C. 2004, 'Quseir Fort and the Archaeology of the Hajj' in *Trade and Travel in the Red Sea Region BAR International Series*, 1269, pp. 145–56

Lewis, B., 'Hadjdj', in *Encyclopaedia of Islam* (EI2)

Long, D. 1979, *The Hajj Today*, Albany

Low, M.C. 2007, 'Empire of the Hajj: Pilgrims, plagues and Pan-Islam under British surveillance, 1865–1926', MA dissertation, Georgia State University

Lucas, P. 1744, *Voyage du Sieur*, vol. II, Paris

Mackintosh-Smith, T. 2010, in Booth-Clibborn, E. (ed.), *Ahmed Mater*, London

Maddison, F. and E. Savage-Smith, 1997, *Science, Tools and Magic 2 volumes. (The Nasser D. Khalili Collection of Islamic Art)*. London

Mahmoud, A.H. 1977, *Al-Hajj ila bayt allahi al haram*, Beirut

Alawi, B. *(ed.) 2006 L'age d'or des sciences arabes* Paris

Makariou, S. 2007, *Chefs-d'Oeuvre Islamiques de l'Aga Khan*

Maunsell, F.R. 1908, 'The Hejaz Railway', *The Geographical Journal*, vol. 32, no. 6, December, pp. 570–73, 575–7, 579–81, 583–5

McCorriston, J. 2011, *Pilgrimage and Household in the Ancient Near East*, Cambridge

McMeeking, S. 2010, *The Berlin–Baghdad Express: The Ottoman Empire and Germany's bid for world power, 1898-1918*, London

McMillan, M.E. 2011, *The Meaning of Mecca: The politics of pilgrimage in early Islam*, London

Meadows, D.H. *et al.* 1972, *Limits to Growth: A report for the Club of Rome's Project on the Predicament of Mankind*, New York

Menocal, M.R., Scheindlin, R.P. and Sells, M. (eds) 2000, *The Cambridge History of Arabic Literature: The Literature of Al-Andalus*, Cambridge

Miller, M. 2006, 'Pilgrim's Progress: The business of the Hajj', *Past and Present*, vol. 191, no. 1, May, pp. 189–228

Milstein, R. and Aksoy, S. 2000, 'A Collection of Thirteenth-Century Illustrated Hajj Certificates', in Schick, I.C. (ed.), *M. Ugur Derman 65th Birthday Festschrift*, pp. 101–34, Istanbul

Milstein, R. 2006, 'Mapping the Sacred in Sixteenth Century Illustrated Manuscripts of *Futuh al-Haramayn*', in Wasserstein, D.J. and Ayalon, A. (eds), *Mamluk and Ottoman Studies in Honour of Michael Winter*, London, pp. 166–94

Ministry of Culture [not dated], *Egyptian Textiles Museum*, Cairo

Mishra, S. 2011, *Pilgrimage, Politics and Pestilence: The Hajj from the Indian Subcontinent 1860-1920*, Oxford

al-Mojan, M.H. 2010, *The Honourable Kabah: Architecture and Kiswah*, Mecca

Monroe, E. 1973, *Philby of Arabia*, London

Mubarakpuri, S.S.-R. 2002, *History of Mecca*, Riyad

al-Munaiyir, M.A. ibn A., (trans. and intro.) M. Landau 1971, *The Hejaz Railway and the Muslim Pilgrimage: A case of Ottoman political propaganda*, Detroit

al-Naqar, U. 1972, *The Pilgrimage Tradition in West Africa*, Khartoum

Netton, I.R. 1996, *Seek Knowledge: Thought and travel in the House of Islam*, Richmond

Newhall, A. 1987, 'The Patronage of the Mamluk Sultan Qa'it Bey, 872-901/1468-1496', PhD dissertation, Harvard University

Nicholson, J. 2005, *The Hejaz Railway*, London

Nixon, S. 2009, 'Excavating Essouk-Tadmakka (Mali): New archaeological investigations of early Islamic trans-Saharan trade', *Azania: Archaeological Research in Africa*, vol. 44, no. 2, pp. 217–44

Nixon, S. 2010, 'Before Timbuktu: The great trading centre of Tadmakka', *World Archaeology Magazine*, no. 39, February/March, pp. 40–51

Nizami, K.A. 1991, 'The Naqshabandiyyah Order', in Hossein, N.S. (ed.), *Islamic Spirituality: Manifestations*, London

O'Brien, S. 1999, 'Pilgrimage, Power, and Identity: The role of the Hajj in the lives of Nigerian Hausa Bori adepts', *Africa Today*, vol. 46, pp. 11–40

O'Connor, P. 2010, *The Modern Hajj*, Saarbrucken

O'Kane, B. 2005, *The Treasures of Islamic Art in the Museums of Cairo*, Cairo

Omar, R. 2003, 'The Diary of Sultan Ahmad-as-Salleh and the History of Bone, South Sulawesi, 1775-1795', MA dissertation, University of Hull

Oostdam, D. 2004, *West-Arabian Encounters: Fifty years of Dutch-Arabian relations in images (1885-1935)*, Leiden

Othman, Z., Perennes, J.-J., de Tarragon, J.-M. (intro.) [not dated], *Pilgrims to Makkah 1908*, Riyad

Paret, R. and Chaumont, E., 'Umra' in *Encyclopaedia of Islam* (EI2)

Parker, A. and Neal, A. 1995, *Hajj Paintings: Folk art of the Great Pilgrimage*, Washington, DC

Paths for Princes, 2008, *Masterpieces from the Aga Khan Museum Collection*, Geneva

Pearson, N.M. 1994, *Pilgrimage to Mecca: The Indian experience, 1500-1800*, Princeton

Pearson, N.M. 1994, *Pious Passengers: The Hajj in earlier times*, London

Peters, F.E. 1994, *The Hajj: The Muslim pilgrimage to Mecca and the Holy Places*, Princeton

Peters, F.E. 1994, *Mecca: A literary history of the Muslim Holy Land*, Princeton

Petersen, A. 1994, 'The Archaeology of the Syrian and Iraqi Hajj Routes', *World Archaeology*, vol. 26, no. 1, June, pp. 47–56

Petersen, A. 1995, 'The Fortification of the Pilgrim Route during the first three centuries of Ottoman rule (1516-1757)', *Studies in the History and Archaeology of Jordan*, vol. V, pp. 299–305

Petersen, A. and Kennedy, D. 2004, 'Guardians of the Pilgrim Wells: Damascus to Aqaba', *Saudi Aramco World*, vol. 55, no. 1, January/February, pp. 12–19

Petersen, A. 2008, 'Continuity and Renewal: The medieval Hajj route through Syria and Jordan', in d'Hulster, K. and Steenbergen, J. van (eds), *Continuity and Change in the Realms of Islam*, Leuven, pp. 496–504

Petersen, A. 2009, 'The Ottoman Conquest of Arabia and the Syrian Hajj Route', *Proceedings of the British Academy*, vol. 156, pp. 81–94

Petersen, A. 2012, *The Medieval and Ottoman Hajj route in Jordan; an archaeological and historical study*, Oxford

Piscatori, J. 2005, 'Managing God's Guests: The Pilgrimage, Saudi Arabia and the politics of legitimacy', in Piscatori, J. and Dresch, P. (eds), *Monarchies and Nations: Globalisation and identity in the Arab State of the Gulf*, London

Pringle, D. 2009, 'Aqaba Castle in the Ottoman period 1517-1917', in Peacock, A.C.S. (ed.), *The Frontiers of the Ottoman World*, London, pp. 95–112

Qaisar, A.J. 1987, 'From Port to Port: Life on Indian ships in the sixteenth and seventeenth centuries', in Das Gupta, A. and Pearson, M.N. (eds), *India and the Indian Ocean, 1500-1800*, Calcutta, pp. 331–49

al-Qu'aiti, S.G. 2007, *The Holy Cities, the Pilgrimage, and the World of Islam*, Louisville

Rafeq, A.-K. 1966, *The Province of Damascus 1723–1783*, Beirut

al-Rashid, S.A. 1980, *Darb Zubayda: The Pilgrim road from Kufa to Mecca*, Riyad

al-Rashid, S.A. 1986, *Al-Rabadha: A portrait of early Islamic civilization in Saudi Arabia*, Riyad

Reeve, J. (ed.) 2007, *Sacred. Books of the Three Faiths: Judaism, Christianity, Islam*, London

Repertoire 1932, *Répertoire chronologique d'épigraphie arabe*, Cairo

Robinson, A.E. 1931, 'The Mahmal of the Moslem Pilgrimage', *Journal of the Royal Asiatic Society of Great Britain and Ireland*, no. 1, January, pp. 117–27

Roff, W.R. 1982, 'Sanitation and Security: The imperial powers and the nineteenth century Hajj', *Arabian Studies*, vol. 6, pp. 143–60

Roff, W.R. 1985, 'Pilgrimage and the History of Religions: Theoretical approaches to the Hajj', in Martin, R. (ed.), *Approaches to Islam in Religious Studies*, Tucson, pp. 78-86

Rogers, J.M. 2010, *The Arts of Islam: Masterpieces from the Khalili Collection*, London

Rogers, J.M., Stanley, T. and Bayani, M. 2009, *The Decorated Word: Part Two (The Nasser D. Khalili Collection of Islamic Art)*, London

Rush, A. (ed.) 1993, *Records of the Hajj*, 10 vols, Gerrards Cross

Ruthven, M. with Nanji, A. 2004, *Historical Atlas of the Islamic World*, Oxford

Sabini, J. 1981, *Armies of the Sand: The struggle for Mecca and Medina*, London

Sabiq, al-S. 1987, *Fiqh al-Sunna*, 3 vols, Beirut

Saghi, O. 2010, *Paris-La Mecque: Sociologie du pèlerinage*, Paris

Saleh, A.H. 1978, 'Modern Concept of Hajj Management: The experience of Malaysia', in Sardar, Z. and Badawi, M.A.Z. (eds), *Hajj Studies*, London, vol. 1, pp. 73–86

Sardar, Z. 1978, 'The Spiritual and Physical Dimensions of Hajj: A systems overview', in Sardar, Z. and Badawi, M.A.Z. (eds), *Hajj Studies*, London, vol. 1, pp. 27–38

Sardar, Z. 2011, *Reading the Qur'an*, London

Serjeant, R. B. 'Material for a History of Islamic Textiles up to the Mongol Conquest' *Ars Islamica*, 1942, vol. 9, pp. 54–92; 1943, vol. 10, pp. 71–104; 1946, vol. 11/12, pp. 98–145; 1948, vol. 13, pp. 75–117. Repr. 1972, Beirut

Serjeant, R.B. 1963, *The Portuguese off the South Arabian Coast: Hadrami Chronicles*, Oxford

Shah, A. 1980, *The Assemblies of Al-Hariri*, London

Shalem, A. 2007, 'Made for the Show: The Medieval Treasury of the Ka'ba in Mecca', in O'Kane, B. (ed.), *The Iconography of Islamic Art*, pp. 269–83, Edinburgh

Shariati, A., (trans.) A.A. Behzadnia and N. Denny 1978, *Hajj*, Houston

Shariati, A. 2003 (1st edn 1965), *The Hajj*, Kuala Lumpur

Sheikh, A.G. 1953, 'From America to Mecca on Airborne Pilgrimage', *National Geographic Magazine*, July, pp. 1–62

Sherry, N. and Moser, T. (eds) 1968, *Lord Jim*, New York

Shoshan, B. 1993, *Popular Culture in Medieval Cairo*, Cambridge

Shrieve Simpson, M. 2010, 'From Tourist to Pilgrim: Iskandar at the Ka'ba in illustrated Shahnama manuscripts', *Iranian Studies*, vol. 43, no. 1, pp. 127–46

Sinclair-Wilson, R. 2011, 'Seven Times and Other Works by Idris Khan', MA dissertation, University of Cambridge

Sirriyeh, E. 2005, *Sufi Visionary of Ottoman Damascus, 'Abd al-Ghani al-Nabulusi, 1641–1731*, New York

Slight, J.P. 2011, 'The British Empire and the Hajj, 1865–1956', PhD dissertation, University of Cambridge

Sonbol, A. (trans.) 1998, *The Last Khedive of Egypt: Memoirs of Abbas Hilmi II*, London

Sourdel, D. and Sourdel-Thomine, J. 2006, *Certificats de Pèlerinage d'Epoque Ayyoubide*, Paris

Sourdel-Thomine, J. 1971, *Clefs et Serrures de la Ka'ba*, Paris

Stern, S.M., 1967, 'Ramisht of Siraf, a merchant millionaire of the twelfth century, *Journal of the Royal Asiatic Society*, no.1/2, pp. 10–14

St Jorre, J. de 1999, 'Pioneer Photographer of the Holy Cities', *Saudi Aramco World*, January/February, pp. 36–47

Stanley, T. 2004, *Palace and Mosque: Islamic Art from the Middle East London*

Stronge, S. 2009, *Tipu's Tigers*, London

Symes, P. 1999, 'The Haj Notes of Pakistan', http://www.pjsymes.com.au/articles/hajnotes.htm

al-Tabari, M. ibn J., ed. M.J. de Goeje *et al.* 1879–1901, *Ta'rikh al-rusul wa'l-muluk*, 3 vols, Leiden

Tagliacozzo, E. 2009 'The Skeptic's Eye: Snouck Hurgronje and the Politics of the Pilgrimage from the Indies, in Tagliacozzo, E. (ed.) *South East Asia and the Middle East*, Stanford, CA, pp. 135–55

Talbot Rice, D. and Gray, B. (eds) 1976, *The illustrations to the 'World history of Rashid al-Din'*, Edinburgh

Tamari, S. 1982, *Darb al-Hajj in Sinai: An historical and archaeological study*, Rome

Tavakolian, N. 2011, *The Fifth Pillar: the Hajj pilgrimage*, London

Teitelbaum, J. 2001, *The Rise and Fall of the Hashemite Kingdom of Arabia*, London

Tezcan, H. 1996, *Astar al-Haramayn al-Sharifayn*, Istanbul

Tezcan, H. 2007, 'Ka'ba covers from the Topkapi Place collections and their inscriptions' in Suleman, F. (ed.) *Word of God, Art of Man* Oxford, pp. 227- 238

al-Thenayian, M. 1999, *An Archaeological Study of the Yemeni Highland and Pilgrim Route between San'a and Makkah*, Riyad

Thorau, P. 1992, *The Lion of Egypt: Sultan Baybars I and the Near East in the thirteenth century*, London

Tolmacheva, M. 1998, 'Female Piety and Patronage in the Medieval Hajj', in G.R.G. Hambly (ed.), *Women in the Medieval Islamic World*, New York, pp. 161–79

Tschanz, D.W. 2004, 'Journeys of Faith, Roads of Civilization', *Saudi Aramco World*, vol. 55, no. 1, January/February, pp. 2–11

Turkistani, A. ibn S. 2002, 'Hospitality in Hajj', *Saudi Aramco World*, May/June, pp. 14–15

Vernoit, S. 1997, *Occidentalism, Islamic Art in the 19th Century (The Nasser D. Khalili Collection of Islamic Art)*, London

Vida, G.L. della 1952, 'A Portuguese Pilgrimage at Mecca in the Sixteenth Century', *The Moslem World Magazine*, October

Vrolijk, A.J.M., Velde, H.M. van de and Witkam, J.J. 2007, *Christiaan Snouck Hurgronje (1857–1936), Orientalist: Catalogue of an exhibition on the sesquicentenary of his birth, 8 February 2007*, Leiden

Wal, D. van der 2011, *Christiaan Snouck Hurgronje: The First Western Photographer in Mecca, 1884–1885*, Amsterdam

Warner, N. 2007, 'Commerce and Spirituality: The urbanism of Ridwan Bey', in Bennison, A.K. and Gascoigne, A.L. (eds), *Cities in the Pre-Modern Islamic World: The urban impact of religion, state and society*, London, pp. 196–224

Wasti, S.T. 2005, 'The Ottoman Ceremony of the Royal Purse', *Middle Eastern Studies*, vol. 41, no. 2, pp. 193–200

Watt, W. Montgomery and Winder, R.B. 'al-Madina' in *Encyclopaedia of Islam* (EI2)

Wensinck, A.J. 1916, *The Ideas of the Western Semites concerning the Navel of the Earth*, Amsterdam

Wensinck, A.J., 'Ka'ba', in *Encyclopaedia of Islam* (EI2)

Whitcomb, D. 1994, *Ayla: Art and industry in the Islamic port of Aqaba*, Chicago

Whitcomb, D. 1996, 'Urbanism in Arabia', *Arabian Archaeology and Epigraphy*, vol. 7, no. 1, pp. 38–51

Wieczorek, A., Tellenbach, M. and Sui, C.W. 2008, *To the Holy Lands: Pilgrimage centres from Mecca and Medina to Jerusalem*, Munich

Wiet, G. 1932, *Catalogue Général du Musée Arabe du Caire: Objets en cuivre*, Cairo

Wilson, A.T. 1937, *Richard Burton (The Fifth Burton Memorial Lecture)*, London

Wilson, J. 1989, *Lawrence of Arabia: The authorised biography of T.E. Lawrence*, London

Witkam, J.J. 2007, 'The battle of the images: Mekka vs. Medina in the iconography of the manuscripts of al-Jazuli's *Dala'il al-Khayrat*', in Pfeiffer, J. and Kropp, M. (eds), *Technical Approaches to the Transmission and Edition of Oriental Manuscripts*, Beiruter Texte und Studien, No. 111, Beirut, pp. 67–82, 295–300

Witkam, J.J. 2009, 'Images of Makkah and Madinah in an Islamic Prayer Book', *Hadeeth ad-Dar*, vol. 30, pp. 27–32

Wolfe, M. 1997, *One Thousand Roads to Mecca: Ten Centuries of Travelers Writing about the Muslim Pilgrimage*, New York

Wright, E. 2009, *Islam. Faith, Art, Culture: Manuscripts from the Chester Beatty Library*, London

Wright, Z. [not dated], 'Al-Hajj Umar al-Futi Tal', http://tijani.org/al-hajj-umar-al-futi-tal/

Yahya, F. 2006, 'A *Dal'il Al-Khayr't* Manuscript in the Perpustakaan Negara Malaysia (MSS 1273)', MA Dissertation, School of Oriental and African Studies, University of London

al-Ya'qubi, A. ibn A.Y., ed. M. Houtsma 1883, *Ta'rikh*, Leiden, vol. II

York Leach, L. 1998, *Paintings from India (The Nasser D. Khalili Collection of Islamic Art, Volume)*, London

Hajj Travel Narratives

This is a bibliographical guide to the principal narratives by pilgrims who wrote accounts of their Hajj; it is not meant to be exhaustive.

Ad-Din, Abu Bakr Siraj 1967, 'Pilgrimage to Mecca', *Studies in Comparative Religion*, vol. 1, no. 4

Ahmed Hassan, Hafiz 1871, *Pilgrimage to the Caaba and Charing Cross*, London

Alawi, Amir Ahmad, (trans. and intro.) M. Hasan and R. Jalil 2009, *Journey to the Holy Land: A pilgrim's diary*, Delhi

Al-e-Ahmad, Jalal, (trans.) M. Hillman 1986, *Lost in the Crowd*, Washington, DC

Ali Beg, Mirza Irfan 1896, *A Pilgrimage to Mecca by Mirza Irfan Ali Beg, Deputy Collector, Manipuri*, Benares

Ali Bey al-Abassi 1816, *Travels of Ali Bey*, 2 vols, Philadelphia

Amin, Mohammed 1978, *Pilgrimage to Mecca*, London

Asad, Muhammad 1954, *The Road to Mecca*, New York

Batanuni, Muhammad Labib 1909, *Rihlah al-Hijaziyah li-Wali al-ni'am al-Ḥajj Abbas Ḥilmi Basha al-Thani Khadiw Misr*, Cairo

Begum of Bhopal, Sikander, (intro.) S. Lambert-Hurley 2008, *A Princess's Pilgrimage: Nawab Sikander Begum's pilgrimage to Mecca*, Bloomington

Begum of Bhopal, Sikander 1870, *A Pilgrimage to Mecca*, Calcutta

Begum of Bhopal, Sultan Jahan 1909, *The Story of a Pilgrimage to Hijaz*, Calcutta

Bey, Sadiq 1881, *Mashaal Al-Mahmal, Risalat fi Sir Al-Hajj Al-Misri baran min yawm khourougihi min Masr ila yawm awdatihi mazkour biha kayfeyat adai al faridat li hadra Muhammad Sadek Bey Miralay Arkan Harb wa Amin Al Sorat an talat Sanat*, Cairo

Bogary, Hamza, (trans.) O. Kenny and J. Reed 1991, *The Sheltered Quarter: A tale of a boyhood in Mecca*, Austin

Brackenridge, H.H. and Freneau, P., (ed.) M.D. Bell 1975, *Father Bombo's Pilgrimage to Mecca, 1770*, Princeton

Burckhardt, John Lewis 1829, *Travels in Arabia*, London

Burton, Richard Francis. 1855–6, *Personal Narrative of a Pilgrimage to El-Medinah and Makka*, 2 vols, London

Çelebi, Evliya, (eds and trans.) R. Dankoff and S. Kim 2010, *An Ottoman Traveller: Selections from the Book of Travels of Evliya Çelebi*, London

Çelebi, Evliya, (ed. and trans.) R. Dankoff 2000, *Seyahatname* IX, Leiden

Chérif, Ahmed 1930, *Le Pèlerinage de la Mecque* 8, vol. VI, Beirut

Cobbold, Lady Evelyn 1934, *Pilgrimage to Mecca*, London

Cobbold, Lady Evelyn 1934, (intro.) W. Facey and M. Taylor 2008, *Pilgrimage to Mecca*, London

Dinet, Etienne and Baamer, Silman Ben Ibrahim 1930, *Le Pèlerinage à la Maison Sacrée d'Allah*, Paris

Edib, M. 1825, *Menasik-i hacc-i sherif, Istanbul, 1816–17*, in M. Bianchi (trans.), *Itinéraire de Constantinople à la Mecque*, Paris

Farahani, Muhammad Hussein, (ed. and trans.) H. Farmayan and E.L. Daniel 1990, *A Shi'ite Pilgrimage to Mecca (1885–1886): The Safarnameh of Mirza Mohammad Hosayn Farahani*, Austin

Finati, Giovanni 1830, *Narrative of the life and adventures of Giovanni Finati, native of Ferrara; who, under the assumed name of Mahomet made the campaigns against the Wahabees for the recovery of Mecca and Medina, and since acted as interpreter to European travellers in some of the parts least visited of Asia and Africa*, London

Galland, Julien-Claude 1754, *Recueil des rits et cérémonies du pélerinage de la Mecque, auquel on a joint divers écrits relatifs à la religion, aux sciences et aux moeurs des Turcs*, Paris

Hammoudi, Abdellah, (trans.) P. Ghazaleh 2006, *A Season in Mecca: Narrative of a pilgrimage*, Cambridge

Hirashima, H.Y. 1972, *The Road to Holy Mecca*, Tokyo

Ibn Battuta, (ed. and trans.) H.A.R. Gibb 1956-71, *The Travels of Ibn Battuta A.D. 1325–1354*, 4 vols, Cambridge

Ibn Battuta, (ed.) R.E. Dunn 1986, *The Adventures of Ibn Battuta: A Muslim traveler of the fourteenth century*, Berkeley

Ibn Jubayr, (trans.) R.J.C. Broadhurst 1952, *The Travels of Ibn Jubayr*, London

Ibn Jubayr, (eds) W. Wright and M.J. de Goeje 1907, repr. 2007, *The Travels of Ibn Jubayr*, Leiden, Cambridge

Ibn Al-Mujawir Al-Dimashqi, Jamal al-Din, (ed.) O. Lofgren 1954, *Sifat Bilad Al Yaman Wa Makkah Wa B'ad Al-Hijaz*, Leiden

Ibn Tuwayr al-Jannah, Ahmad, (trans.) H.T. Norris 1977, *The Pilgrimage of Ahmad, Son of the Little Bird of Paradise: An account of a nineteenth-century pilgrimage from Mauritania to Mecca*, Warminster

Jung, Mahomed Ullah ibn S. 1912, *A Pilgrimage to Mecca and the Near East*, Hyderabad

Kamal, Ahmad 1964, *The Sacred Journey, Being a Pilgrimage to Makkah*, London

Keane, John Fryer, (intro.) W. Facey 2006, *Six Months in Meccah: An account of the Mohammedan pilgrimage to Meccah. Recently accomplished by an Englishman professing Mohammedanism*, London

Khalifa, Saida Miller, (foreword) A.H. Mahmoud 1977, *The Fifth Pillar: The story of a pilgrimage to Mecca and Medina*, Hicksville

Khusraw, Nasir-i, (trans., intro. and notes) W.M. Thackston Jr 1986, *Book of Travels*, New York

Knight, Michael Muhammad 2009, *Journey to the End of Islam*, New York

Maltzan, Heinrich Freiherr von 1865, *Meine Wallfahrt nach Mekka. Reise in der Kustengegend und im Innern von Hedschas*, Leipzig

Niebuhr, Carsten 1792, *Travels through Arabia and Other Countries in the East*, London

Nomani, Asra Q. 2005, *Standing Alone*, New York

Pasa, Eyüb Sabri 1884–89, *Mir'at ül-Harameyn*, 3 vols, Istanbul

Philby, Harry St John Bridger 1943, *Pilgrim in Arabia*, London

Pitts, Joseph 1704, *A True and Faithful Account of the Religion and Manners of the Mahometans*, London

Roches, Leon 1884–85, *Trente Deux Ans à Travers l'Islam 1832–1864*, vol. II, *Mission à la Mecque, le Maréchal Bugeaud en Afrique*, Paris

Rosenthal, Eric 1930, *From Drury Lane to Mecca*, London

Rutter, Eldon 1928, *The Holy Cities of Arabia*, London

Sa'udi, Muhammad Ali Effendi, (eds) F. Kioumgi and R. Graham 2009, *A Photographer on the Hajj: The travels of Muhammad 'Ali Effendi Sa'udi (1904–1908)*, Cairo

Shah, Sayed Idries 1957, *Destination Mecca*, London

Shah, Sirdar Ikbal Ali 1928, *Westward to Mecca; A journey of adventure through Afghanistan, Bolshevik Asia, Persia, Iraq and Hijaz to the cradle of Islam*, London

Shah, Sirdar Ikbal Ali 1933, *The Golden Pilgrimage*, London

Spiro Bey, S. 1932, *The Moslem Pilgrimage. An authentic account of the journey from Egypt to the Holy Land of Islam, and a detailed description of Mecca and Medina and all the religious ceremonies performed there by the pilgrims from all parts of the Mohammedan world*, Alexandria

Stegar, Winifred 1970, *Always Bells*, London

Varthema, Ludovico de 1963, 'The Itinerary of Ludovico de Varthema', in Hammond, L.D. (ed.) and Jones, J.W. (trans.), *Travelers in Disguise: Narratives of Eastern travel by Poggio Bracciolini and Ludovico de Varthema*, Cambridge, MA

Wavell, A.J.B. and Khan, Hadji 1912, *A Modern Pilgrim in Mecca and a Siege in Sanaa*, London

Wolfe, Michael 1993, *The Hadj: An American's pilgrimage to Mecca*, New York

Wolfe, Michael 1997, *One Thousand Roads to Mecca: Ten Centuries of Travelers Writing about the Muslim Pilgrimage*, New York

X, Malcolm with Haley, Alex 1968, *The Autobiography of Malcolm X*, Harmondsworth

Illustration Acknowledgements

Index